Islamic Art in Context

Islamic Art in Context

Art, Architecture, and the Literary World

Robert Irwin

PERSPECTIVES

PRENTICE HALL, INC.,

and HARRY N. ABRAMS, INC., PUBLISHERS

Acknowledgements

I am grateful for a grant from the Society of Authors which enabled me to complete work on the manuscript of this book, to Laurence King for his swift enthusiasm for the proposal, and to the series editor at Calmann & King, Jacky Colliss Harvey. I am grateful to many reviewers in the UK and the United States, particularly Tim Barringer and Ülkü Bates, for agreeing to read, comment on, and correct my text. Any errors that remain are mine. I have also benefited from conversations with Hugh Kennedy, Rachel Ward, Robert Chenciner and Marion Ellingworth, and Juri Gabriel. I am grateful to *Honest Ben's Convenience Store and Off-licence* in Black Prince Street, London SE11, for allowing me to monopolise the shop's xerox machine for prolonged periods. Finally, I dedicate this book to Helen Irwin, who has not only put up with Islamic art for so long but even come to like it.

Frontispiece Parade of the Guild of Ottoman Potters, pages 136–37 (detail)

Series Consultant Tim Barringer (University of Birmingham)
Series Manager, Harry N. Abrams, Inc. Eve Sinaiko
Senior Editor Jacky Colliss Harvey
Designer Karen Stafford, DQP, London
Cover Designer Judith Hudson
Picture Editor Peter Kent

The Library of Congress has cataloged the trade edition of this book as follows:

Irwin, Robert.
 Islamic art in context : art, architecture, and the literary world
 / Robert Irwin.
 p. cm. — (Perspectives)
 Includes bibliographical references and index.
 ISBN 0-8109-2710-1
 1. Art, Islamic. I. Title. II. Series: Perspectives (Harry N. Abrams, Inc.)
N6260.I75 1997
704.9'4897 — dc21 96–46755

The Prentice Hall ISBN for this book is 013–599812–3

Copyright © 1997 Calmann & King Ltd
Published in 1997 by Harry N. Abrams, Incorporated, New York
A Times Mirror Company
http://www.abramsbooks.com

Prentice Hall, Inc.
Simon & Schuster/A Viacom Company
Upper Saddle River NJ 07458
http://www.prenhall.com

Contents

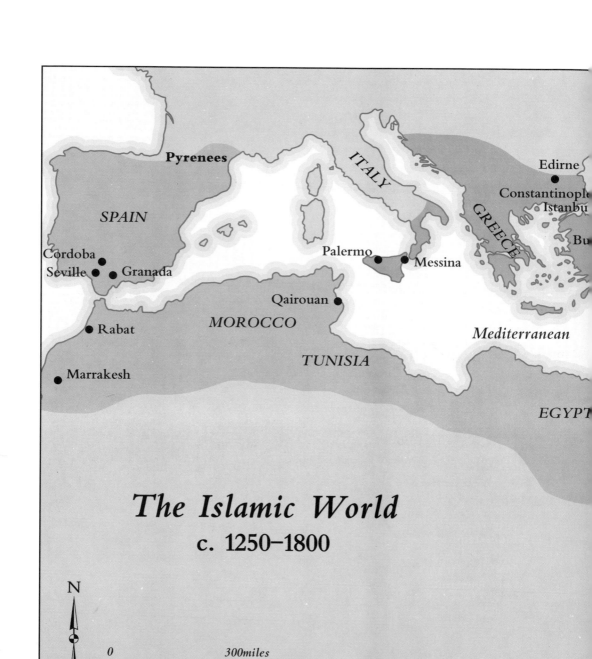

Pyrenees

SPAIN

ITALY

GREECE

Edirne

Constantinople
Istanbul

Bu

Cordoba
Seville • • Granada

Palermo • • Messina

Mediterranean

Qairouan •

MOROCCO

• Rabat

TUNISIA

• Marrakesh

EGYPT

The Islamic World
c. 1250–1800

N

| 0 | 300miles |
| 0 | 800km |

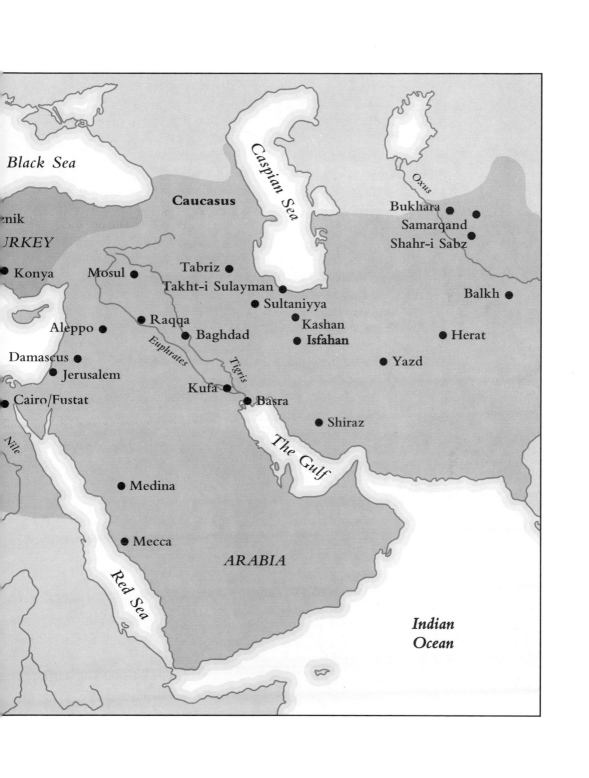

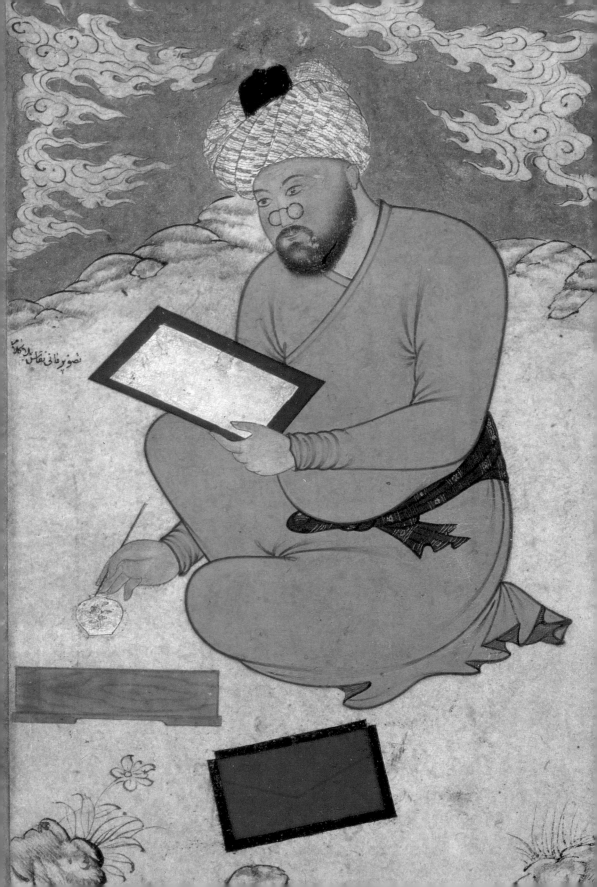

Introduction

I t should be said at the outset that this book is not a strict chronological survey of Islamic art. Rather, it adopts a more thematic and discursive approach, in order to investigate some important issues which would be difficult to deal with in a chronological framework. It discusses objects produced in the semi-arid zone extending from Spain and Morocco to Afghanistan, but not the Muslim art of India, South-East Asia, or sub-Saharan Africa. The period it covers extends from approximately the fifth century AD to the end of the seventeenth century. Many studies of Islamic art cease at around 1600, a date that certainly represents an important pinnacle of cultural achievement in the Muslim world. However, it seemed desirable to me to extend the coverage of the book to include such matters as the rise of the cult of the individual artist (FIG. 1) and the growing importance of guilds. I also hope that the literature about architecture and painting which begins to be produced in the Muslim world from the sixteenth century onwards will shed some retrospective light on the works of earlier centuries. (The Christian calendar has been used for dates throughout, but the timeline at the end of the book – see pages 258–61 attempts to redress the balance by giving dates in both the Muslim and Christian calendars.)

Courtiers and intellectuals in the Islamic world loved to debate such topics as poetry, ethics, food, and sex; and the results of their discussions were often written down. However, they rarely if ever discussed the visual arts or the philosophy of aesthetics, nor did they write books about paintings or buildings. Therefore, in order to find written evidence about the way medieval Muslims thought and wrote about their art, I have had to scavenge widely, and in this book I draw upon a varied range of written sources in what must be seen as being a personal and to some extent an eclectic choice. The works from which I quote include poetry, *belles-*

1. Imaginary portrait of Mani from Safavid Iran, 16th century. Illuminated manuscript, 2¹/₂ x 6¹/₄″ (6.4 x 16 cm). British Museum, London.

It became a convention of Islamic art to compare the most important of the later Islamic miniaturists to Mani; and the fact that all of Mani's paintings had vanished was regularly cited by Muslim authorities as an example of the vanity and transience of all art.

lettres, travel narratives, chronicles, mystical meditations, treatises on optics, and much else.

It is a convenient, serviceable shorthand to call the subject matter of this book "Islamic art," despite the fact that it begins over a century before the Prophet Muhammad first preached the message of Islam. It should also be remembered that by no means all art to be so conventionally described was produced by or for Muslims. When Western art historians talk or write about "Islamic art," they are not talking about a body of material that is in any sense the equivalent of a like body of material in European Christian art. A book on Christian art in Europe would almost certainly restrict itself to a narrow range of specifically religious material, including perhaps cathedrals, churches, altarpieces, censers, and chasubles. By long-standing convention, books on Islamic art discuss any and all works of art and architecture produced by craftspeople who either lived under Muslim regimes or who were Muslims living under Christian regimes, such as the *mudejar*s of Spain. Moreover, students hitherto only familiar with Western art may be surprised to find so much space devoted to what in Europe or America would be classified as "minor arts," such as ceramics and metalwork, but, as will be demonstrated, the Western distinction between major and minor art forms does not apply within the Islamic cultural area.

The idea of an "Islamic art" is itself in many ways a Western construct. Muslim artists tended to think of themselves as Mosulis, Heratis, or Cordobans rather than as citizens of any religious or dynastic empire. As for the Western word "art," in its fine sense of "the application of skill to subjects of taste," the corresponding Arabic word *fann* does not correspond very precisely. In the Middle Ages *fann* (pl. *funun*) meant a type, a mode, or a manner. By extension it came to mean a type of skill or craft. Only in modern times has the word acquired a more aesthetic sense, as in *al-funun al-mustazrafa*, "the fine arts."

The study of Islamic art in the West is still in its infancy, and our comprehension of it is far less developed than that of quattrocento Italian or seventeenth-century Dutch art. In this book, I attempt to place Islamic art in a social, economic, and intellectual context and, as I said, in order to do so, I draw heavily on various literary sources. Such material provides some evidence, however faint, about what medieval Muslims saw when they looked at their art and how they described that art to themselves. I also discuss works of art including buildings that once existed but have now been lost, rather than threading a narrative around only those works that happen to have been preserved in the museums of

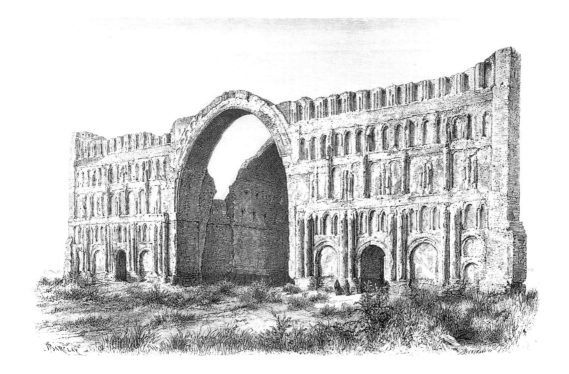

the West. It is frightening to discover from literary sources how much has perished. Very nearly the entire corpus of Islamic art has been subject to earthquakes, wars, iconoclasm, cultural looting, and simple day-to-day wear, so that in many cases only fragments remain to provide the material for art-historical conjectures (FIG. 2). Literary materials can fill some of the gaps, but even so, what is proposed here is only a way (not the way) of looking at Islamic art. Much may still be clarified by archaeology and technical analysis.

Whilst I have tried to provide some coverage of the whole field of Islamic art, the objects discussed in detail necessarily represent a personal selection. I know, for example, that I am unreasonably fond of *minai* and *lajvardina* ceramics. But there are other factors at work. Most Western historians of Islamic art tend to overvalue the figurative at the expense of the abstract and the calligraphic. I have gone along with this bias to an extent, on the basis that it is easier to relate figurative works to literary materials. However, I have also included some discussion of examples of calligraphy, mindful that for medieval Muslims calligraphy was the most important art form of all, despite the fact that for many Western readers the appreciation of this somewhat austere discipline remains difficult.

2. Nineteenth-century engraving of the great *iwan* or portal of the palace of Khusraw I at Ctesiphon (early 7th century).

Sasanian architects pioneered the *iwan*, a large vaulted chamber with an open end, which was to become a key feature of Islamic architecture. The engraving is a valuable record of a site where little of what is shown here survives today.

From time to time I make use of topographical terms such as the "Middle East." Many of these terms cannot be used with precision, as the area they refer to has been changed many times. Reference to the map at the beginning of this book (see pages 8–9) will clarify the way in which they are used here; in this case, "Middle East" is used in its current sense of all the countries of Asia west of Tibet, excluding the Indian subcontinent. On the other hand, when I refer to "Syria" in this book, I am referring not just to the territory that forms the present-day republic, but to the medieval region of Sham, a territory that also included Palestine, Israel, Lebanon, and part of south-east Turkey. "Asia Minor" is used to refer to what are now the most western territories of Turkey, and "Anatolia" for the interior plateau of these regions. For transliterated words I have dispensed with diacriticals, and used the most common standard forms adopted in modern texts such as the *Encyclopedia of Islam*. A glossary is included in the endmatter of the book (see pages 262–63). For the purposes of clarity this book uses the common English version of a name rather than the Arabic or Iranian one (for example, Jerusalem, not al-Quds). Iran and Iranian are used to refer to the territory now occupied by the Republic of Iran. Persia and Persian are used to refer to a broader written and visual culture.

Inevitably, there are a number of technical, historical, and political terms in this book that will initially be unfamiliar to some readers. Many of these, such as caliph or emir, are explained in the first chapter, as part of the history of the origins of the Islamic state. The majority of specialised artistic terms are explained in the text at the point where they are first introduced. Again, the glossary at the back of the book provides thumbnail explanations to which the reader is encouraged to refer.

The issue of the non-representational nature of Islamic art is something that any study of the subject needs to address. The one "fact" that people who know little in even general terms about Islamic art think they know is that representational art is forbidden in Islam. This, however, as we shall see, is an oversimplification of a complex issue, but it remains one of the commonest misconceptions about Islamic art. It is true that many devout Muslims opposed the use of any images of a representational nature in art or architecture; and that the preference for decoration of a calligraphic and abstract nature, which is in itself one of the chief glories and achievements of Islamic art, may be related to the widespread opposition to and dislike of figurative art. Some authorities held that figurative art had been explicitly forbidden by the Koran and the Prophet Muhammad, the founder

of Islam. But as we shall see, many Muslims believed that it was permissible, in certain circumstances at least, to paint or sculpt the representations of living things.

Chapter One of this book deals with the pre-Islamic roots of Islamic art, particularly with sources in the cultures of the Byzantine and Sasanian civilisations. Chapter Two focuses on the rise of Islam and the developing structure of the Islamic state, and describes briefly the main movements, periods, and dynasties in the history of Islam to provide a chronological framework for the more thematic discussion of Islamic art and architecture that follows in the rest of the book. Chapter Three begins this thematic approach, charting the development and use of the mosque, its role within Islamic society, its decoration and furnishing, and describing related religious foundations and institutions, before focusing in detail on some of the most important religious buildings in the Islamic world. Chapter Four continues this discussion in the context of the fine and decorative arts, and deals in more detail with the question of figurative and non-figurative art, as well as the history of princely patronage. The palace as a vital centre of architectural and artistic patronage and display is discussed in Chapter Five. Chapter Six focuses on the lives and careers of specific artists, together with the techniques and materials of Islamic art. The interaction of art and literature is discussed in Chapter Seven, in particular the way authors wrote about art and the illustration of literary texts. Chapter Eight looks at the characteristic presence of astrological and "magical" elements in Islamic art as a consequence of the influence of Islamic discoveries in the sciences. Chapter Nine deals with the hitherto somewhat neglected importance of art and architecture in the Islamic world's contact with other cultures, in particular the artistic traffic between Islam and the Christian West and Islam and China. The Conclusion of this book attempts to assess and sum up our knowledge of Islamic art, as well as indicating which important questions must be considered as still open.

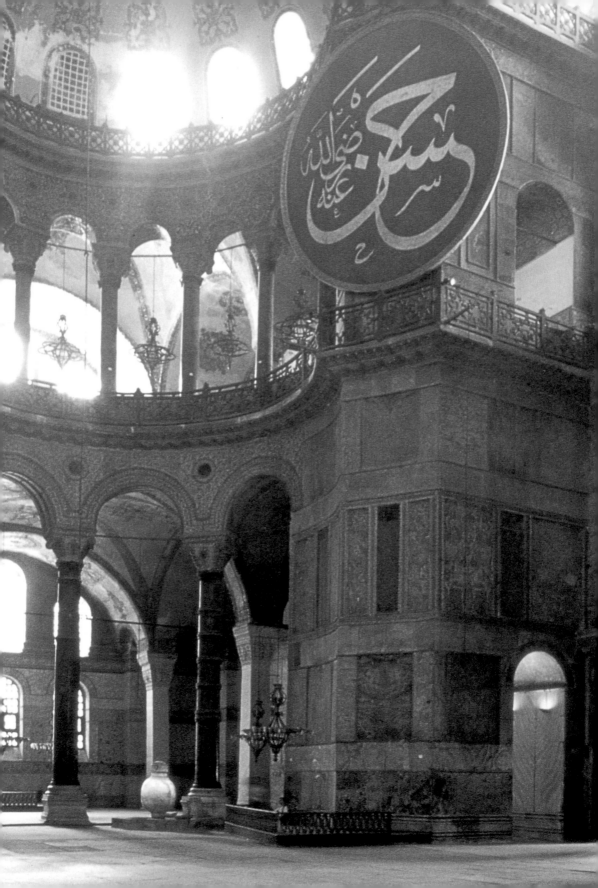

ONE

The Historical Background

T he rise of Islam amongst the largely nomadic Arab peoples of the Arabian peninsula in the seventh century AD was an event that astounded contemporary commentators, and its subsequent emergence as the dominant power across the whole of the area now referred to as the Middle East, and even further afield, was impossible for them to have anticipated. According to a saying attributed to the Prophet Muhammad, "Islam destroys all that preceded it." However, it is not now accepted as accurate to see the teachings of Islam as creating a watershed in the arts and architecture of this immense and diverse region. Modern scholars particularly stress the early influence of the art of antiquity on that which was to be produced in the countries which we now regard as "Islamic." These influences were transmitted to Islamic art chiefly through the cultural heritage of the Sasanian (Iranian) and Graeco-Roman Byzantine empires (FIG. 4). An examination of the background to Islam is therefore essential to any study of its art and architecture.

In the fifth and sixth centuries AD, prior to the rise of Islam, the peoples of the Arabian peninsula played only a marginal part in what was already a highly urbanised and sophisticated culture, dominated by the two great superpowers of this era, the Byzantine and Sasanian empires, which sandwiched the peninsula to the north-west and north-east respectively (FIG. 5).

The Byzantine Empire

The Byzantine empire had been created out of the eastern half of the Roman empire, after the decline of the imperial Roman state in the west. Its most important city was Constantinople

3. The Hagia Sophia mosque in Istanbul, begun AD 532 by Justinian I, converted into a mosque by Mehmed II (r. 1451–81).

The Hagia Sophia became an object of emulation for Ottoman Turkish architects. The illustration shows the mosque with its recently installed and inspiring lighting scheme.

4. Muslim *fals* or copper coin with the image of a stereotypical Byzantine emperor, 7th or 8th century AD. Copper, diameter ¾" (2 cm). British Museum, London.

5. The Pre-Islamic Middle East.

Mediterranean
Sea

NORTH
AFRICA

N

0 300km

(present-day Istanbul), on the Bosphorus, officially declared the capital of this eastern empire by the emperor Constantine (c. AD 274–337) in AD 330. The Byzantine empire itself comprised at this time most of the Balkans, Asia Minor, Syria, Palestine, and Egypt and was beginning to range westwards as far as areas of the North African coast. The official state religion, ever since the conversion of Constantine in about AD 313, had been Christianity – the Greek Orthodox church. However, the borders of the empire enclosed many other Christian sects and communities, as well as a substantial Jewish population.

As one would expect, with its strong Graeco-Roman roots, what one might call the cultural "currency" of Byzantine art was greatly influenced by its pagan classical inheritance. Byzantine scholars, for example, were steeped in the works of such pre-Christian figures as Homer, Thucydides, and Sophocles. Byzantine silver often features both classical and mythological subjects, and pagan decorative imagery was to be found even in religious contexts (FIG. 6).

Before the rise of Islam, the Byzantine empire had experienced its most recent heyday in the reign of the emperor Justinian (r. AD 527–65). During this period the great church of Hagia Sophia, that most well-known of all Byzantine monuments (and one which was to inspire generations of Islamic architects), was built in Constantinople (FIG. 3, see page 17). Justinian also rebuilt the Syrian city of Antioch after 540: the Byzantine historian Procopius (c. 499–c. 565) relates in his treatise *Buildings* how "he [the Emperor] laid it out with stoas and agoras, dividing all the blocks of houses by means of streets and making water-channels, fountains and sewers, all of which the city now boasts. He built theatres and baths for it, ornamenting it with all the other buildings by which the

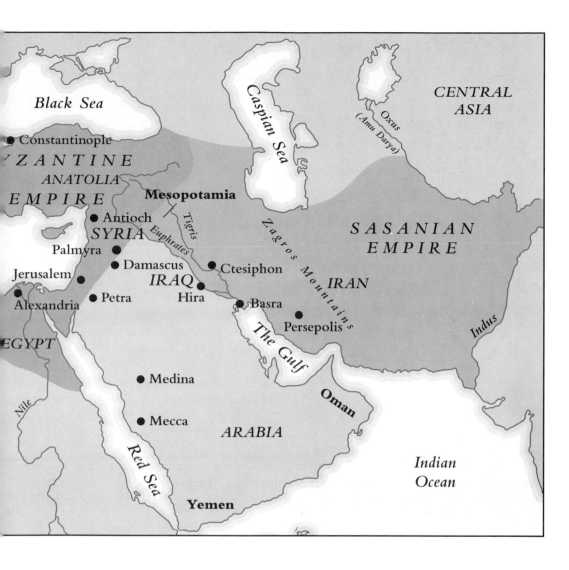

Black Sea

Constantinople

BYZANTINE

ANATOLIA

EMPIRE

Mesopotamia

Antioch

SYRIA

Palmyra

Jerusalem

Damascus

IRAQ

Ctesiphon

Alexandria

Petra

Hira

Basra

EGYPT

Medina

Mecca

ARABIA

Caspian Sea

Oxus
(Amu Darya)

CENTRAL ASIA

Tigris

Euphrates

Zagros Mountains

SASANIAN EMPIRE

IRAN

Persepolis

Indus

The Gulf

Oman

Nile

Red Sea

Indian Ocean

Yemen

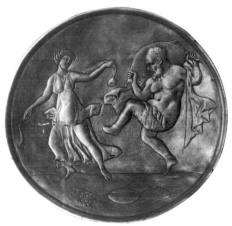

6. Byzantine silver plate decorated with pagan imagery of a dancing maenad and Silenus carrying a wine skin. Silver. State Hermitage Museum, St. Petersburg.

prosperity of a city is wont to be shown." However, the great plague, spreading through Egypt, Syria, and Asia Minor, reached Constantinople late in 541 or early in 542. This, and renewed military conflict later in the century with its powerful Sasanian neighbour, was to lead to a change in the typically urban civilisation of the Byzantine empire. Monumental public buildings were neglected, broad avenues were encroached on by shops and shanties, theatres and forums of the classical past were abandoned. The reasons for the change are not altogether clear, but demographic decline, the fall of urban revenues, and the preference for pack animals over wheeled vehicles may all have had a role in shaping the new ways in which urban space was used. But one can say that the sort of city thought of as typically Islamic – divided into quarters with narrow twisting alleyways – was already coming into being in the fifth and sixth centuries.

The Sasanians

The Sasanian dynasty had been founded by Ardashir I (AD 208–40) when he overthrew the Parthian empire in AD 224. The Sasanians became Rome's (and later, naturally the Byzantine empire's) fiercest challenger in the East. Their empire stretched from the Indus and Oxus rivers in the east to the Euphrates and Byzantine-controlled regions of Mesopotamia in the west. Successive generations of Sasanian rulers had sought to expand their empire, and had once even taken Syria and the Nile Delta from the Byzantines. Conflict between the two superpowers of the region was endemic but never ruinous, and during the reign of the emperor Justinian these areas had been reconquered by the Byzantine army.

The official Sasanian religion was Zoroastrianism, named after the sixth-century BC prophet and visionary Zoroaster. This was a dualistic faith which conceived all creation as a never-ending struggle between the forces of good and those of evil. Like the Greek Orthodox church in the Byzantine empire, Zoroastrianism was not the only religion practised in the Sasanian territories. Its main rival was another dualistic religion, Manicheanism, whose importance to Islamic art is that its founder, Mani (AD 216–77; see FIG. 1), was – according to Arab and Persian tradition at least – also the nonpareil of painters and used paintings to illustrate his message.

Relations between the Sasanian and Byzantine cultures were complex. The Sasanians were well acquainted with the themes and techniques of Roman and Byzantine architecture, and in the course of their wars had captured large numbers of Greeks and other

Byzantine subjects. Some of their captives seem to have been skilled artisans, and they were used as part of the labour force for grand building projects. In addition, there are frequent references to Sasanian employment of Byzantine architects. There were also many Syriac speakers within the frontiers of the Sasanian empire, particularly in what is now Iraq and north-west Iran, and educated Syriac speakers were commonly familiar with Graeco-Roman culture, which may help explain why Sasanian drinking vessels can feature Dionysiac imagery (FIG. 7). The Sasanians also seem to have taken their characteristic decorative use of the scrolling vine from the Romans via Byzantine art. Sasanian vine scrolls are typically rather fleshy and not very sinuous; in the Islamic period, this sort of vine scroll would evolve into the arabesque. Nor, it should be noted, was the cultural traffic between the two all one way, for the Byzantines were fascinated by such Sasanian motifs as the peacock, the palm, and the winged crown, which were all absorbed into the repertoire of Byzantine decorative motifs.

7. Sasanian plate decorated with the Triumph of Dionysos, 4th century. Silver-gilt, diameter 8¾" (22.6 cm). British Museum, London.

An example of the survival of pagan classical imagery on the silverware of both the Christian Byzantines and the Sasanian Persians. Other images from Graeco-Roman culture found on such examples of Sasanian silverware include the winged horse Pegasus, and even figures from the dramas of Euripides.

8. Dome cap from the ceiling of the bathhouse of the Umayyad palace at Khirbat al-Mafjar in modern Israel (AD 740–50). Stucco. Israel Department of Antiquities and Museums, Jerusalem.

The Umayyads were amongst the first dynasties of Islamic rulers, and were in power from AD 661 to 750. The heads and foliage decorating this stucco dome cap clearly show the influence of imagery of the late classical period, filtered through Byzantine art. It also shows how secular art – at least of the Umayyad period – could make free use of representations of the human figure.

The Cultural Heritage

Examples such as the later Islamic use of the Sasanian vine scroll suggest just how strongly the forms and themes of art in the early Islamic period were influenced by, and should be seen as a continuation of, those of the Byzantine and Sasanian empires. It is impossible in this book to give a complete list of all the influences one might trace from these two civilisations in Islamic art, but examples of two or three of the most important in each case are indispensable. Indeed, Islamic art can be seen as being as much an heir to the culture of the late classical period as was the art of Christendom in the West and that of Byzantium itself (FIG. 8).

The Byzantine Inheritance in Islamic Art

The issue of the non-representation of living creatures in Islamic art has already been raised in the introduction to this book, but the drift away from representational art and a corresponding preference for geometric and stylised vegetal decoration did not begin with the preaching of Islam. Already in sixth-century Byzantine art there is a steady decline in the use of portraiture, and where human figures in this period are depicted, they seem to embody "types" rather than appearing to be portraits modelled from the life. For example, where portraits appear in manuscripts (FIG. 9), they are plainly shaped more by conventions of suitable physiognomy than by any real concern with replicating the actual appearance of the person. From as early as the fourth century there had also been a decline in the production of freestanding sculptures, and Byzantine sculptors instead began experimenting with various

Opposite

9. Frontispiece to a copy of Ibn al-Mubashir's 11th-century *Mukhtar al-Hikam* (*Selection of Wise Sayings*), showing a group of Greek philosophers, first half of the 13th century. Illuminated manuscript, 9¾ x 5½" (25 x 14.2 cm). Topkapi Saray Museum, Istanbul.

The *Mukhtar* (1053) is an anthology of sayings of the Greek philosophers, though the vaguely oriental dress of this group does not immediately suggest their nationality.

forms of abstract ornament, including a new style of deep-cutting on capitals that gave a lacework effect – strikingly similar to the appearance of the stonework in the much later Umayyad palaces in Damascus and Cordoba (FIG. 10).

In architecture too, the cultural inheritance from the Byzantines was of great importance. The development of the typical structure and furnishings of the Muslim mosque, which will be discussed in more detail in the third chapter, also had Byzantine precedents. For example, the *mihrab*, or prayer niche, had a forerunner in the use of niches in Byzantine secular architecture. The *minbar*, or Muslim pulpit, probably derived from the Byzantine *ambo*, or lectern; while the *maqsura* (a special enclosure in the mosque for the ruler and his entourage) is likely to have been modelled on the Byzantine *kathisma*, or royal box. Byzantine sixth-century experiments with domes were continued by Muslim architects, and the deployment of the dome as an honorific marker over the area in front of a *mihrab*, or over a mausoleum, may have derived from the similar use of the dome as an honorific marker in later Roman palaces. The desert palaces of the early Islamic Umayyad dynasty in seventh- and eighth-century Syria can easily be confused with Roman villas (and nineteenth-century scholars and archaeologists did indeed so confuse them). Islamic architects of the Turkish Ottoman dynasty were using features from Byzantine church architecture as late as the sixteenth century. Finally, we may note that for centuries the Byzantine foot, of 12$^{1}/_{4}$ inches (31.2 cm), was the standard measure in Muslim architecture.

10. Corinthian capital from Cordoba, 10th century. Marble, height 14$^{1}/_{4}$" (36.2 cm). Museo Arqueologico Provincial de Cordoba.

The Influence of the Sasanians

The Sasanian civilisation also had a great influence on Islamic culture. Sasanian emperors maintained an elaborate court ritual, which was later to be closely imitated by the early Islamic rulers of the Umayyad and Abbasid dynasties. Sasanian silver dishes commonly feature rulers engaged in hunting (FIG. 11) or feasting and drinking (FIG. 12), and Islamic painted and ornamented cups are tangible witnesses of this culture. It was also commemorated in later Arab poetry.

For Islamic architects, the Sasanian palace at Ctesiphon was to have more influence than any other building. It was the yardstick by which all similar grand constructions were judged and in particular furnished the model for many later Abbasid palaces.

Ctesiphon was located on the Tigris, a little to the south of the future site of the Muslim capital of Baghdad. The actual date of its construction is not certain, but it was perhaps begun by the Sasanian ruler Khusraw I (Anushir-van or Chosroes I; AD 531–79). It was built of kiln-baked bricks, and in the centre of its long, multi-tiered ornamental facade was the vast arch of an *iwan* (a large, open, vaulted chamber), which served as the opening to a deep, barrel-vaulted audience hall (see FIG. 2).

Inside the audience hall there were said to be three thrones kept permanently ready for the other three great rulers of the world – the emperor of Rome, the emperor of China, and the Khagan of the Turks – ready, that is, for when they should come to submit to the Sasanian emperor. This aspect of the decoration of Ctesiphon may have influenced the frescoes of the Umayyad palace at Qusayr Amra (c. 724–43) near the town of Amman in Jordan, which showed the six great rulers of the world waiting in attendance on the caliph. Also at Ctesiphon a jewelled crown suspended on a golden chain hung over the throne of the Sasanian emperor, and there is an echo of this in the carved stone chain and crown in the music room

11. Sasanian-style plate showing a royal hunter, 7th–8th century. Silver, diameter 7½" (19 cm). Staatliche Museen zu Berlin/Preussischer Kulturbesitz Museum für Islamische Kunst.

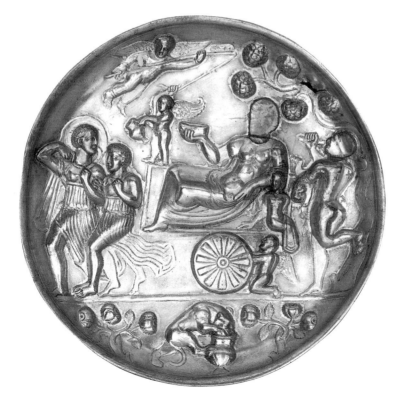

12. Iranian dish showing a feasting prince, probably 8th century. Silver, diameter 7¾" (19.7 cm). British Museum, London.

The poet Abu Nuwas (c. AD 747–813) describes the Sasanian king Khusraw I at the centre of such a scene: "Let us pass round the golden cup Persia has decked with divers images: Khusraw in the midst and, on the sides, antelopes pursued by riders armed with bows."

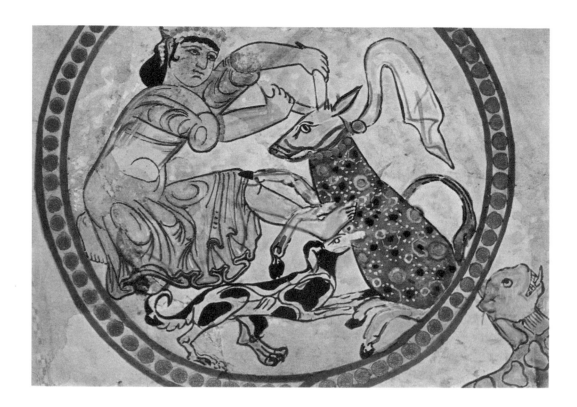

13. Reconstruction of a fresco from the Jawsaq al-Khaqani palace, Samarra, 836.

The frescoes for this palace of a Muslim ruler continue the Sasanian style of decoration for audience chambers at Ctesiphon and other pre-Islamic Persian palaces. The figure has been variously identified as a huntress or a bull-dancer.

of the Umayyad prince Walid at the desert palace of Khirbat al-Mafjar.

The audience chamber at Ctesiphon was itself heavily decorated with frescoes (FIG. 13). When in 637 the Muslim Arab general Said ibn Abi Waqas entered the palace after the defeat of the Sasanian armies of Yazdagird III, he turned the chamber into a place of prayer, but left untouched the fresco of the conquest of Antioch by the Sasanian emperor Khusraw I. It was still there two centuries later when the poet al-Buhturi (821–97) celebrated it in verse:

> When you behold the picture of Antioch, you are alarmed
> as between Byzantium and Persia
> The Fates there waiting, while Anushirvan urges on the ranks
> under the royal banner
> Robed in green over gold, proudly flaunting the dye of red
> turmeric.

The poet goes on to imagine the palace as it once was, with its singing girls and pavilions.

The characteristic Islamic literary tradition of musing over the ruins of vanished dynasties drew upon verse forms first developed

in pre-Islamic times by poets lamenting at abandoned desert camp sites. Sasanian Ctesiphon was an obvious subject for later Islamic poets such as al-Sharif Murtada (d. 1044): "Behold what the sovereign Sasanians built,/How time battered it, tore it down, effaced it./ Court-yards, once the canopy of heaven,/ Then by adversities brought down to earth." In Islamic thought, art and architecture were always closely associated with the theme of the transience of life's pleasures.

Sasanian artisans' experiments with stucco as a decorative medium (FIG. 14) were also later to be picked up by Islamic architects. There are clear signs of the influence of Sasanian motifs in the ninth-century Abbasid capital of Samarra (FIG. 15). Umayyad decorative schemes also picked up the Sasanian fondness for beaded decorative borders, and there was a widespread use throughout Islamic art of the characteristically Sasanian heavy vegetal scroll and other features (FIG. 16).

Finally, the Sasanian silk industry, which was established in Iran, was also of great importance to Islamic rulers who continued the Sasanian practice of distributing silk robes to courtiers and officials as a mark of royal appointments or favour. Textiles were also important as a means of transmission for typically Sasanian motifs into other cultures. Amongst the most popular in later Islamic art were fabulous mythical beasts such as the griffin (FIG. 17) and the *senmurv* (which had the forepart of a dog or lion and the hindlegs and tail of a bird).

14. Decorative rosette from Ctesiphon, 6th–7th century. Stucco, diameter 3'3³⁄₈" (1 m). Islamisches Museum, Berlin.

15. Decorative panel from Samarra, 9th century. Stucco, 3'8" x 8'6¹⁄₂" (1.17 x 2.6 m). Islamisches Museum, Berlin.

Pre-Islamic Arab Culture and Legends

Before the rise of Islam, the largely nomadic peoples of the Arab peninsula were already playing a role, albeit somewhat marginal, in relations between the Byzantines and the Sasanians. Both empires, for example, maintained Arab client regimes on their borders, such as that of the Arab kingdom of the Ghassanids, which controlled territory to the east of Damascus in the Syrian desert during the sixth century AD and functioned as a buffer state for the Byzantines against the Sasanians and their allies.

Even in pre-Islamic history, Arab culture was distinctive and well developed, and the peninsula saw the rise of a number of kingdoms, major cities, and artistic styles. Arab culture also flourished outside the peninsula, in Syria. This was especially the case dur

One of the earliest centres of what was effectively Arab civilisation was the city of Petra, in what is now the Kingdom of Jordan. This was the capital of the Nabataeans, a people who One

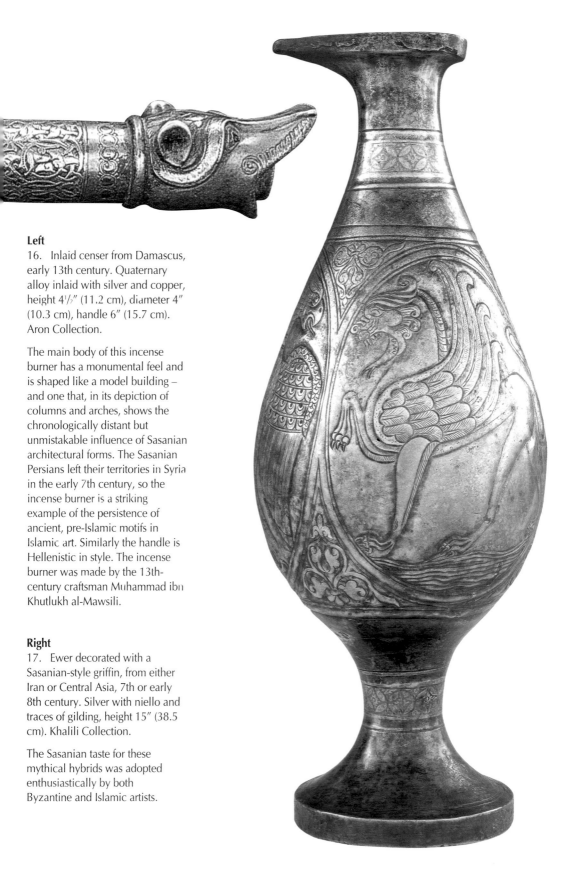

Left

16. Inlaid censer from Damascus, early 13th century. Quaternary alloy inlaid with silver and copper, height 4½″ (11.2 cm), diameter 4″ (10.3 cm), handle 6″ (15.7 cm). Aron Collection.

The main body of this incense burner has a monumental feel and is shaped like a model building – and one that, in its depiction of columns and arches, shows the chronologically distant but unmistakable influence of Sasanian architectural forms. The Sasanian Persians left their territories in Syria in the early 7th century, so the incense burner is a striking example of the persistence of ancient, pre-Islamic motifs in Islamic art. Similarly the handle is Hellenistic in style. The incense burner was made by the 13th-century craftsman Muhammad ibn Khutlukh al-Mawsili.

Right

17. Ewer decorated with a Sasanian-style griffin, from either Iran or Central Asia, 7th or early 8th century. Silver with niello and traces of gilding, height 15″ (38.5 cm). Khalili Collection.

The Sasanian taste for these mythical hybrids was adopted enthusiastically by both Byzantine and Islamic artists.

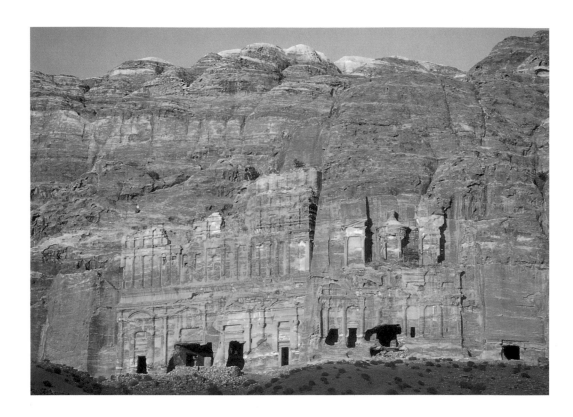

18. The "Palace" tomb (left) and the "Corinthian" tomb (right) cut into the cliffs at Petra in present-day Jordan.

The architecture of the "Corinthian" tomb shows the Arab Nabataeans experimenting with the Hellenistic style of architecture. It may perhaps have been the burial place of a 1st-century king of Petra, which was the capital of the Arab Nabataean empire. Petra was later absorbed into the Roman empire. After it was abandoned in the 6th century, its houses and tombs furnished the fantastic settings for numerous Arabic stories about magic and buried treasures.

One of the earliest centres of what was effectively Arab civilisation was the city of Petra, in what is now the Kingdom of Jordan. This was the capital of the Nabataeans, a people who saw themselves as distinct from their nomadic Arab neighbours, despite many similarities of culture and religious belief. From about 200 BC to AD 106 Petra was an important Arab city in the Near East. Petra's wealth came from its position on the overland trade routes from India and China to the Mediterranean. The influence of Mediterranean culture can be seen in Petra's magnificent Hellenistic architecture (FIG. 18) and funerary sculpture, which demonstrate how pervasive a background Graeco-Roman art was to all cultures of the area.

From the second century AD onwards, Palmyra had replaced Petra as the most important Arab city (FIG. 19). Palmyra lay on the route from Damascus to the Euphrates and had control of the watering places on the caravan routes. In 271 its Arab queen Zenobia had revolted against Roman rule but had been defeated, and much of Palmyra's flamboyant architecture and sculpted tower tombs date from the subsequent period of Roman occupation.

Palmyra, or Tadmur as it was known to the Arabs, was captured by Muslim forces in 634. A city of legend, allegedly built

by Solomon, it was much celebrated in Islamic poetry, as in this poem by Wuhayb ibn Mutarraf al-Tamimi:

> Many a place have I seen, but nought
> Have I seen so beautifully founded and built as Palmyra.
>
> A place entirely of chiselled stone:
> When one looks at it, it fills one with awe.
>
> According to the law, cities resemble bodies
> And Palmyra is truly head of all of them.

The Byzantines maintained the vassal Arab kingdom of the Ghassanids. The Sasanians too had their client rulers among the pre-Islamic Arabs. The other major sixth-century kingdom was

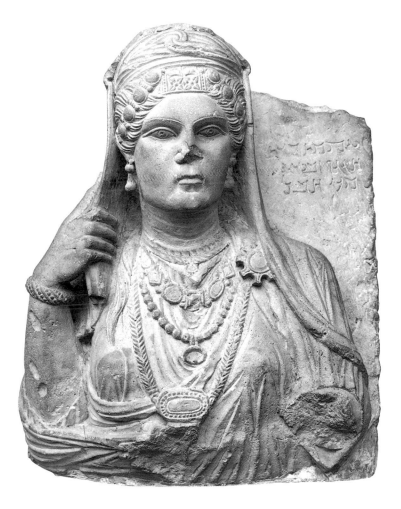

19. Funerary bust from Palmyra of a lady of the pre-Roman period, AD 150–200. Limestone, life-size. British Museum, London.

The inscription identifies the woman as "Aqmat, daughter of Agago."

that of the Sasanian-sponsored (but Christian Arab) Lakhmids. Their capital was at Hira, in what is now southern Iraq, and the Lakhmid territories were reputed to contain the fabled palace of Sadir. Along with the equally legendary palace of Ghumdan in what is now the Yemeni city of Sana, Sadir was to be used time and time again by Islamic writers and poets as the means of glorifying actual palaces erected in Baghdad, Cordoba, and elsewhere. These mythical monuments of lost civilisations represented to Muslims both magnificence and impermanence, they were subjects of marvel – and of suspicion. Muslims characteristically took warning from the ruins of such buildings and the fates of their creators. According to a *Sura* (chapter) of the Koran (89:5–15), "The Dawn":

> Hast thou not seen how thy Lord did with Ad,
> Iram of the Pillars
> the like of which was never created in the land,
> and Thamood, who hollowed the rocks in the valley,
> and Pharaoh, he of the tent-pegs,
> who all were insolent in the land
> and worked corruption therein?
> Thy Lord loosed upon them a scourge of chastisement;
> Surely thy Lord is ever on the watch.

The original audience of the Koranic revelation would have been very familiar with the legends to which the Koran was alluding. Ad, Thamood, and the Pharaoh of the tent-pegs were part of the mythology of pre-Islamic Arabia, one of many ancient Arabian myths commemorating lost peoples who were damned because they rejected the messages of God's prophets, a number of which eventually found their way into the medieval story collection of the *Arabian Nights*.

The Islamic Sense of the Past

Literary evidence and vernacular legends, such as those quoted above, make it clear that medieval Muslims were very conscious of living in the shadow of mighty ruins (FIG. 20). Although it is obvious, it still seems worth stressing that there were then more and better-preserved ancient ruins to cast such shadows than there are now. As the famous fourteenth-century North African thinker Ibn Khaldun worked on his *Muqaddima* (*Prolegomena*), a philosophic introduction to the study of history, the visible presence of the past weighed heavily upon him:

The Yemen where the Arabs live is in ruins, except for a few cities. Persian civilisation in Arab Iraq is likewise completely ruined. The same applies to contemporary Syria … Formerly the whole region between the Sudan and the Mediterranean had been settled. This fact is attested by the relics of civilisation there, such as monuments, architectural sculpture, and the visible remains of villages and hamlets.

As has been said, Arab poets revelled in the sad pleasures of ruins. In time, this theme came to be applied to Islamic buildings too. Thus al-Umari (1301–47) records that an Umayyad palace in Damascus had written on it a poem which began: "Would that I knew, thou palace, what had become of thy people!/And where are they that raised high thy walls?/What hath befallen thy proud masters, the kings/Who made thee strong, then passed away from thee?"

To the Islamic world, Roman, Sasanian, and Pharaonic ruins were places of occult wonder and menace (FIG. 21). In the tenth century, the alchemist Ibn Umail took pains to write a detailed description of the statues and paintings of the ancient Egyptian city of Ashmunayn (then still more or less intact), as it was widely believed that the ancient Egyptians had used symbolic frescoes in order to preserve their knowledge and transmit it, so that it might survive some previously foretold catastrophe – such as the Deluge. Greek art was similarly thought to have an instructional rather than an aesthetic purpose. The ninth-century scholar Hunayn ibn Ishaq wrote in his *Nawadir al-Falasifah* (*Anecdotes of the Philosophers*) how the rulers of the Greeks and other nations "erected houses of gold, decorated with a variety of pictures, which were to serve to refresh hearts and attract eyes. The children stayed in these picture houses in order to be educated with the aid of the pictures found in them."

As often as not, Muslims who sought instruction from the images of the past creatively reinterpreted those images. Thus, for example, a stone carving at Naqsh-i Rustam in south-west Iran, showing the Sasanian ruler Shapur, was later taken by Muslims as a representation of the legendary strongman Rustam, a favourite hero of Islamic popular literature. Christian iconography could also undergo such strange metamorphoses. When the pilgrim Ludolph von Suchem visited the Church of St. Anne in Jerusalem in 1350, he found that under the Muslim occupation the place had been turned into a teaching college. However, a painting of the Blessed Virgin and her parents, Anne and Joachim, had been left untouched. Von Suchem reported that:

> This painting in my time used to be devoutly and religiously explained to the Christians by an old Saracen woman called Bagutes. She used to live next to the church and declared that the picture of Joachim stood for Muhammad and the painting of trees for Paradise where Muhammad kissed girls. And she referred the whole of the painting to Muhammad and set it forth with fervour and would tell many more wondrous stories of Muhammad with tears in her eyes.

The earliest generation of Muslims do not seem to have been troubled by the presence in the art of past civilisations of pagan figurative images, or images of living things, even in what had become for them a Muslim religious context (FIG. 22). For example, the columns of the seventh-century mosque in the Iraqi town of Jufa were topped by Persian capitals, looted from

Opposite
21. Miniature depicting an occult ritual, from the *Kitab al-Bulhan* (*Tract on Astrology, Divination, and Prognostication*), written in Baghdad in 1399. Illuminated manuscript, 9½ x 6¼" (24 x 15.8 cm). Bodleian Library, Oxford.

The miniaturist has depicted here the ancient site of the Temple of Ikhmim. The *Kitab al-Bulhan* was a fortune-teller's book and its illustrations were used to attract the attention of passing customers. In this wholly fanciful depiction, the Pharaonic Egyptian Temple of Ikhmim is represented by the great arch, displaying painted images. The figure is dressed like a Christian monk and is apparently meant to represent some kind of hermit; he seems to be making an offering to some unknown deity or demon. The "saw-horse" is a bookstand or lectern, supporting what would have been a collection of pagan spells.

22. "King Nushirvan and the owls," from an Iranian copy of Nizami's (d. 1209) *Khamsa* (*Quintet*), 1494–95. Illuminated manuscript, 12 x 7³/₄" (30.5 x 19.4 cm). British Library, London.

The *Khamsa* was composed over a period of time and is consequently impossible to date accurately. One of its sections relates how King Nushirvan became separated from his companions while out hunting, and, alone apart from his vizier, passed by a ruined and deserted village. In the village two owls (which in Persian poetry symbolise desolation) are saying that, if King Nushirvan does not mend his ways, his whole land will be as ruined as the owls' nesting site. An Islamic audience not only marvelled at ancient ruins but drew moral conclusions from them on such subjects as transience and pride.

Hira, that featured monsters, heads, wings, and other figurative imagery.

Sites of pre-Islamic worship were sometimes conceived of as possessing mysterious powers. Thus the Umayyads' Great Mosque of Damascus was built on the site of a Byzantine church dedicated to John the Baptist. The church in turn had been built on the *temenos* (sacred precinct) of a Temple of Jupiter, which before that had been the site of the Temple of Haddad, the ancient Ammonite storm god. Similarly, in Jerusalem the Umayyad Dome of the Rock was erected within the Jewish Temple precinct. Much later, in the 1270s, when Abaqa, the Mongol ruler of Iran, built himself a summer palace in the north-east of the country, he was at pains to locate it within a sacred Zoroastrian site with buildings dating from the Sasanian period. The dynasties that preceded the preaching of Islam and the monuments erected by those dynasties served both as subjects of marvel to later generations and as pretexts for pious reflection. Ancient architecture taught Muslims lessons about the transience of all pleasures. As the Koran (3:137) puts it: "Many ways of life passed away before your time/Then, go about the earth and behold what happened."

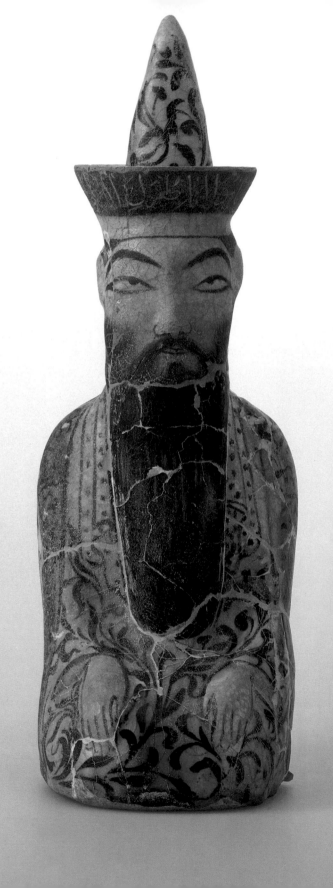

TWO

The Islamic World

The vastness and diversity of the territories governed by Islamic dynasties – stretching from the Moroccan shores of the Mediterranean to northern India – make it essential to begin any study of Islamic art with a survey of Islamic history and religion. These two are indivisible, and some understanding of them, especially for the Western reader, is essential before the culture and art they produced can be entered into in detail. However, available space dictates that such an introduction can only be a survey – a means of identifying and locating some of the most important events, concepts, names, and sites that will occur throughout this book.

In the early 600s the centuries-old conflict between the Byzantines and the Sasanians was being fought with particular intensity. The Sasanian emperor Khusraw II (Chosroes II; r. 591–628), captured Jerusalem in 614 and briefly occupied Egypt in 619. The Byzantine emperor Heraclius (d. 641) subsequently led a successful counter-offensive which carried him as far as Ctesiphon, which he sacked in 628. The squandering of military and financial resources in these campaigns must certainly have played a role in crucially weakening the two empires and laid them open to attack from the Muslim Arab armies, which began operating out of the Arab peninsula from the 630s onwards (FIG. 24).

The Rise of Islam

The Prophet Muhammad was born in either AD 570 or 571 in Mecca, one of the chief towns of the Hejaz region of western Arabia. The Hejaz had economic and cultural links with both the Byzantine and the Sasanian empires, and a mixed population of Christians, Arabs, and Jews.

Around 610 the Prophet received the first of a series of visionary revelations from the Archangel Gabriel, who in subsequent

23. Tughril Beg at prayer, from Kashan, late 13th century. Glazed ceramic, height 17″ (43 cm). Khalili Collection.

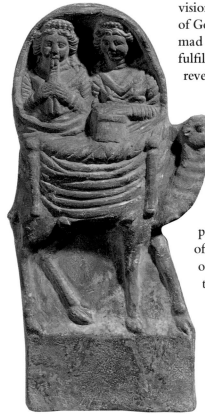

visions was to dictate to him the entirety of the Koran – the word of God as communicated to the Prophet. The Islam that Muhammad preached in the decades that followed was presented as a fulfilment of the Jewish and Christian religions, and as the final revelation of God's word. From the first, belief in the tenets of the Islamic faith defined and identified its believers as members of a new community. Monotheistic, it extolled the coming together of all believers in a single community to worship the same God, obey the same laws, and fight the same holy war, or *jihad*.

Part of Islam's strong appeal to its early converts was its simplicity and austerity. In addition, it gave form to the long-standing sense of a single cultural identity that was particularly and unusually strong amongst the tribal societies of Arabia. Since the new community thus created required both organisation and protection, it also brought into being at the same time a political system and a common goal.

The number of Islam's converts and military successes was unprecedented. By the time of Muhammad's death in 632, his followers were in control of the cities of Mecca and Medina, and much of western Arabia. Under the caliphs (from *khalifa*, meaning "successor" or "deputy") who succeeded him, Muslim Arab armies defeated the Byzantines at Ajnadayn in southern Palestine in 634 and the Sasanians at Qadisiyya in southern Mesopotamia in 636, thus conquering a spread of land that included Palestine, Syria, Iraq, and most of Iran (FIG. 25).

24. Pre-Islamic Syrian (Damascus) statuette of musicians on a camel, Roman period. Terracotta. Louvre, Paris.

The camel played a crucial role in both the Arab economy and in warfare. Early Arab poetry provides plentiful evidence of the Arabs' appreciation of the beauty of camels, horses, and cattle. It is probably significant that the word for beauty (*jamil*) and the word for camel (*jamal*) share the same consonantal root.

The Umayyad and Abbasid Dynasties

The early history of the caliphate was turbulent. In 656, against a background of tribal conflict, the caliph Uthman was assassinated, and his kinsman Muawiya became involved in a struggle for the succession with Muhammad's own cousin and son-in-law, Ali ibn Abu Talib. This was only resolved by the assassination of Ali in 661, after which Muawiya (r. 661–80) made the caliphate the possession of his clan, the Umayyads, from 661 to 750.

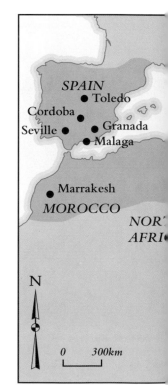

Opposition to their rule continued, however, especially on the part of the *Shia* Ali, or "Party of Ali," who supported the sole right of the Prophet's descendants to lead the Islamic community. What began as a succession dispute in the seventh century in the long run developed into the major religious schism of Islam – that between the Sunnis and the Shias.

Despite internal factions, armies sent out by the Umayyad caliphs continued to add to the territories of Islam. North Africa was conquered in the late seventh century, Transoxania (the region beyond the River Oxus) in the early eighth, an Arab army reached the Indus in 710, a combined force of Arabs and Berber troops from North Africa invaded Visigothic Spain in 711, and in Central Asia Muslims defeated the Chinese at the Battle of Talas in 751. The Arabs had acquired an empire that stretched from the Atlantic to the edges of China and India.

In 750 the Umayyads were overthrown by a rebellion that began in Khurasan (eastern Iran) and culminated in the succession to the caliphate of the Abbasid dynasty, a clan descended from the Prophet's uncle, al-Abbas. The Abbasids transferred the seat of government from the Umayyad capital of Damascus in Syria to

25. The Islamic Middle East.

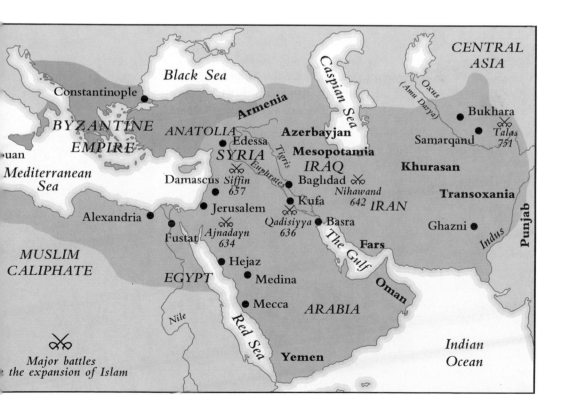

a new capital at Baghdad, some 35 miles (56 km) away from the old Sasanian capital of Ctesiphon.

In the long run the Abbasid caliphs turned out to be not so very different from the dynasty they had displaced, but their revolt and seizure of power at first stimulated apocalyptic expectations. Baghdad was first called the *Madinat al-Salam* ("City of Peace") and was perhaps conceived of as a millennial city. There is no archaeological evidence for the original layout of imperial Baghdad, but the literary evidence states that it was planned as a circular city, with a double wall pierced by four radial roads converging on the caliph's palace and adjoining mosque at the city's centre. Symbolically, the caliph had placed himself in the centre of Baghdad, which in turn was the centre of the world.

The Abbasid caliphs used increasing numbers of *mamluks*, or slave soldiers, in their armies, and in 836 tensions between these *mamluks* and the citizens of Baghdad led to the removal of the capital from Baghdad to Samarra, a site further up the River Tigris. Yet though Samarra was the cultural capital of the Islamic world (FIG. 26) and the Abbasid court furnished many models and practices for later dynasties, from at least the early ninth century onwards various provincial rulers were governing in effective independence from the caliphate. In thrall for much of the ninth century to a sort of praetorian guard of *mamluk* officers, the Abbasid caliphs never succeeded in regaining more than partial control of their affairs. (Only later did these *mamluk* officers dispense with the fiction of serving a ruler and establish their own, Mamluk dynasty.) From 945 until 1055 they were the puppets of a clan of warlords from the Caspian coast (the Buyids), and parts of their former empire threw off even nominal allegiance to the caliphate.

Fatimid Egypt and Muslim Spain

Abbasid sovereignty had not been recognised in North Africa since 850, and in the opening decade of the tenth century Ubaydallah al-Mahdi (r. 906–34), a member of the Fatimid clan who claimed direct descent from Fatima, the Prophet Muhammad's daughter, and from Ali, spearheaded a Shia rebellion and took power in Tunisia. In 969 a Fatimid army occupied Egypt and founded a new city at Cairo. The Fatimid caliphs of the tenth, eleventh, and twelfth centuries presided over an empire which at its height included most of North Africa, Sicily, Yemen, the Hejaz, and parts of Syria. It was not a secular regime but rather a religious dynasty, whose propagandists played upon millennial expectations. Its territorial ambitions ran wider yet, with its adherents attempting to spread its message throughout the Islamic world.

The history of the Muslims in Spain begins with an Umayyad prince, Abd al-Rahman (r. 756–88), who fled there to escape the Abbasid takeover of power, and who succeeded in establishing an Umayyad emirate or principality (*amir* means literally "one who gives orders") that included all of Spain except for Galicia.

The Spanish Umayyad regime was, at first at least, a sort of Umayyad Syria in exile – Abd al-Rahman named his new palace to the north-west of Cordoba "al-Rusafa" after his grandfather's palace on the Euphrates, and he ordered Syrian plants to be imported for its garden. The Umayyad emirs (who later called themselves caliphs) ruled over Muslim Spain until 1031, when the Muslim territories fell apart and were divided among a series of petty principalities.

The Samanid, Ghaznavid, and Seljuq Dynasties

Under the Abbasid caliphs, Persians had come to play an increasingly important part in the administration and culture of the Islamic state, and as the Abbasid empire fragmented, an Iranian dynasty of governors, the Samanids (819–1005), arose in the eastern provinces of Khurasan and Transoxania. The Samanids made Bukhara in Transoxania a leading centre of Islamic culture and, in particular, they presided over a revival of poetry. It was a Samanid ruler who commissioned the *Shahnama* (*Book of Kings*), the poet Firdawsi's (c. 935–c. 1020) great epic of Persian history and legend, which was to figure so largely in the artistic iconography of the following centuries (FIG. 27). Samanid culture was later greatly admired by the Turkish Ghaznavids, who took over much of their former territory. Besides ruling over Khurasan, Afghanistan, and most of Iran, the Ghaznavids' repeated raids into India led to their eventually establishing themselves in the Punjab; and they adorned their capital, Ghazni in eastern Afghanistan, with Indian works of art. Mahmud of Ghazna (r. 998–1030) became a hero in the eyes of later generations of Indian Muslims, and was a model for later Turkish and Mongol rulers – a good Muslim who was also a successful general and a patron of the arts (FIG. 28).

The downfall of the Ghaznavids came through their use of Oghuz Turks recruited from the steppes to the north to serve as mercenaries. In the 1030s, under the leadership of the Seljuq clan, many of these Turks rebelled and in 1055 the Seljuq leader, Tughril Beg (r. 1038–63; FIG. 23, see page 39), having driven the Ghaznavids out of Khurasan, entered Baghdad. He induced the Abbasid caliph to grant him the title of *sultan* (literally "power"). The Greater Seljuqs, as his dynasty is known, ruled over Iran, Iraq, and most of Syria, albeit in the name of the caliph. A little later

27. The fire ordeal of Siyavush, from a *Shahnama* (*Book of Kings*) for Muhammad Juki, 15th century. Illuminated manuscript, 13¼ x 8½" (34 x 22 cm). Royal Asiatic Society, London.

Siyavush was one of the legendary Persian heroes of the *Shahnama*. According to Firdawsi's poem, the prince was forced to pass through a mountain of fire to prove his innocence when his stepmother falsely accused him of having tried to seduce her. Despite successfully passing this ordeal, Siyavush was later falsely accused of another crime and killed, and is consequently one of the great martyrs of Persian legend.

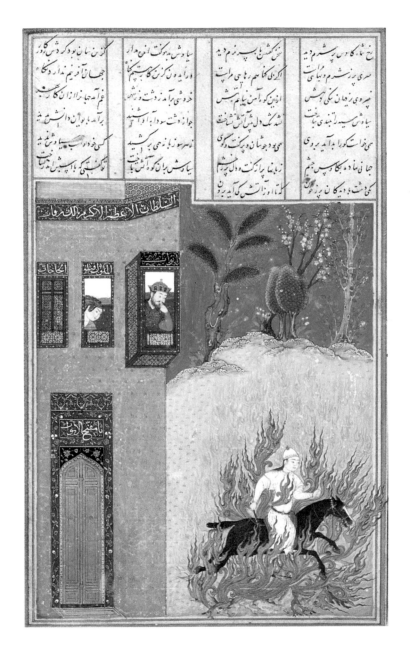

in the eleventh century a separate branch of the family moved into Anatolia and established the Seljuq sultanate of Rum on what had previously been Byzantine territory.

Islam Established

The massive recruitment of Turkish slave soldiers by the Abbasid caliphs, followed by the rise of first the Ghaznavids and then

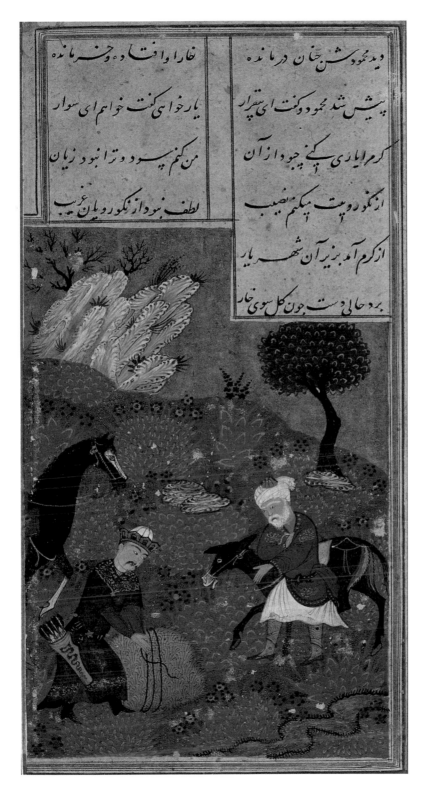

28. Mahmud of Ghazna and the woodcutter, from a copy of Farid al-Din al-Attar's *Mantiq al-Tayr* (*The Conference of the Birds*), 15th century. Illuminated manuscript, approximately 6 x 3" (15 x 8 cm). Bodleian Library, Oxford.

Although Mahmud of Ghazna was an historical figure, he made the transition from history to legend, and all sorts of stories concerning his courage, generosity, and wisdom became attached to him retrospectively. This is one of the many short, improving tales inserted in Farid al-Din al-Attar's mystical poem *The Conference of the Birds*. Mahmud, out hunting, is not recognised by the woodcutter, and gives the latter a hand when his overloaded donkey collapses. In a subsequent meeting the woodseller recognises the mighty ruler. When Mahmud, famously generous, tries to buy the wood for a good price, the woodseller demands even more, claiming that his wood must sell for a lot of money now, since it had been touched by such an auspicious ruler.

Opposite
29. Aerial photograph of
the site of the 10th-century
palace of al-Madinat al-
Zahra outside Cordoba.

the Seljuqs, signified the coming of the age of the Turks, who
were to predominate in both the armies and governments of
the eastern Muslim lands for centuries to come. In the far west,
Spain was ruled by a succession of princes and North African clans.

Turkish Pre-eminence and the Mamluk Sultans

The Turk Zengi (r. 1127–46), the son of a slave who had been
in the service of the greatest of the Seljuq sultans, Malik Shah
(r. 1072–92), took over effective control of parts of Iraq and
Syria in the early twelfth century. Zengi's son Nur al-Din made
himself master of Damascus in 1146 and attempted to reconquer
Egypt from the Fatimids. From 1169 onwards, effective control of
that country was usurped by one of his officers, Saladin, and after
Nur al-Din's death in 1174, Saladin moved into Syria and added
it to his growing empire.

Saladin, like various Muslim leaders both before and after him,
justified his seizure of power by arguing that the Muslims in
the region needed to be defended against the Christian Crusaders.
The army of the First Crusade had arrived in Syria in 1097 and
conquered Jerusalem in 1099, and in the wake of a series of remark-
able victories against the Muslims, Crusaders had established
the Christian Kingdom of Jerusalem, as well as lesser principali-
ties based in Tripoli, Antioch, and Edessa. Zengi, Nur al-Din,
Saladin, and later in the thirteenth century a series of Mamluk
sultans of Egypt and Syria all presented themselves as leaders of
a *jihad,* which had as its primary aim the removal of the Crusaders
from Muslim lands. But although Zengi had captured Edessa in
1144 and Saladin had taken Jerusalem in 1187, after the latter's death
in 1193, rule in Egypt and Syria was divided amongst his quarrel-
some Ayyubid descendants. Thus, it was not until 1291 that the
Mamluk sultan of Egypt and Syria, al-Ashraf Khalil (r. 1290–93),
was finally successful in conquering the remaining Crusader
possessions on the coast of Syria and Palestine.

Later Muslim Rule in Spain

In the early eleventh century the Umayyad caliphate in Spain
fell apart and Cordoba and the palaces outside the city were sacked
by rebellious Berber soldiers (FIG. 29). Although the fiction of a
unified caliphate was maintained until 1030, Muslim Spain was by
then parcelled out among a group called the *Taifa* or "party" kings.
The towns of Malaga, Seville, Granada, Toledo, and Valencia
assumed new importance as centres of Taifa courts and patronage.

Divided amongst themselves as they were, the Taifa kings
found it difficult to resist the advance of the Christian *reconquista*

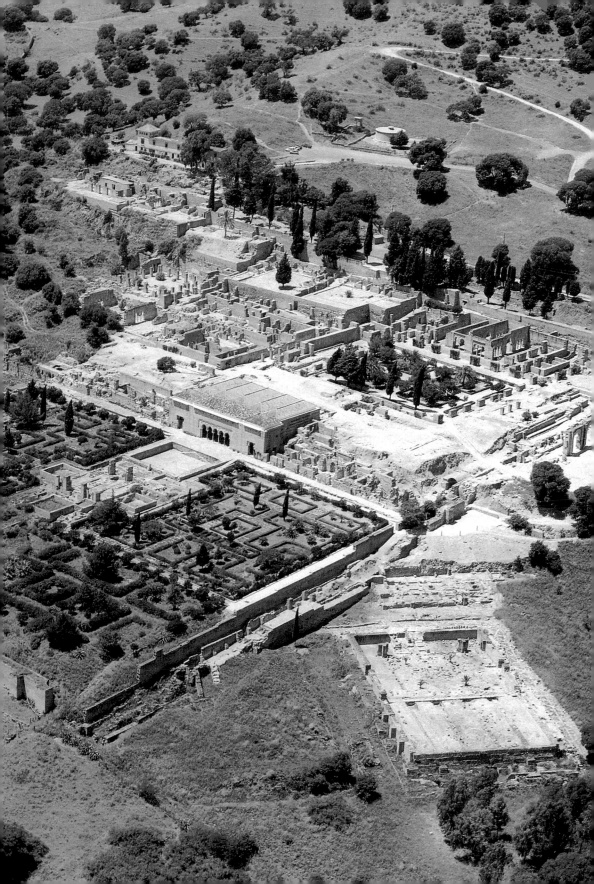

from northern Spain. In 1085, after the loss of Toledo to the Christians, Yusuf ibn Tashfin (1061–1106) crossed over from North Africa on the pretext of helping the Spanish Muslims. Tashfin was a leader of the Almoravids – militantly puritanical Berbers who in the eleventh century had built up an empire in North Africa. Although the Almoravid armies won some early battles against the Christians in Spain, they were really more successful in swallowing up the territories of the Taifa kings. In the 1140s Almoravid rule in North Africa was undermined by the leaders of a rival Berber confederacy, the Almohads, who preached a different form of revivalist, ascetic Islam. The Almohads captured the Almoravid capital of Marrakesh in 1147, and subsequently crossed over into Spain as well, establishing themselves there, with Seville as their capital.

In the long run, the Almohads proved no more successful than the Almoravids had been in stemming the tide of the *reconquista*, and after a major defeat at Las Navas de Tolosa in 1212, they withdrew from Spain altogether. The defence of what remained of Muslim territories in Spain passed to the hands of an Arab dynasty, the Nasirids, who established a sultanate in Granada in southern Spain in the 1230s, which survived until 1492. They won relatively few victories against the armies of neighbouring Christian Castille, but nevertheless the last few centuries of Muslim rule in southern Spain were a golden age for Andalusian culture, and it was under the patronage of the Nasirid sultans that the palaces of the Alhambra were built (FIG. 30). In 1492 the united armies of Catholic Castille and Aragon conquered Granada and brought Muslim rule in Spain to an end.

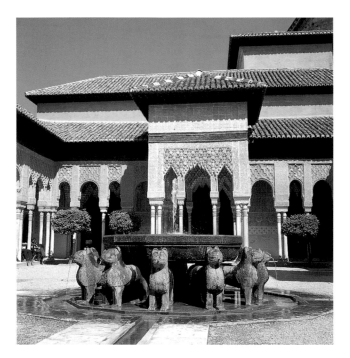

30. The Fountain of the Lions, in the Court of the Lions at the Alhambra, Granada, built for the Nasirid ruler Muhammad V in the 1370s.

The Later Mamluk Period

Mamluks, or slave soldiers, had played a leading part in the running of many Muslim regimes. In particular, from 1250 to 1517 sultans who had either risen from the ranks of the *mamluks*, or who were the sons or grandsons of sultans of *mamluk* origin, ruled over Egypt and Syria (FIG. 31). *Mamluk* officers also enjoyed a near-monopoly of the key positions in

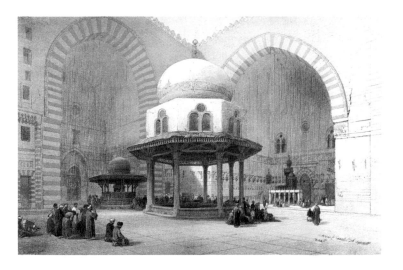

31. Nineteenth-century engraving by David Roberts of the courtyard of the Sultan Hasan Mosque in Cairo, part of the Sultan Hasan complex, 1356–63.

The Sultan Hasan complex was one of the many grand religious building projects to be undertaken during this period, despite the political and economic difficulties being faced by the Mamluk rulers of Egypt at the time. As most of the best building sites had already been used, the Sultan Hasan complex was built on rising ground outside the then city walls.

the palace, army, and provincial administration. They were instructed in the elements of Islam by mostly Arab religious scholars, and trained to defend Muslim lands against the Christian Crusaders and the pagan Mongols.

However, from the second half of the fourteenth century onwards, there are all sorts of indications that the Mamluk sultanate was in difficulties. Egypt and Syria suffered heavily from the Great Plague of 1347–49 (the European "Black Death") and from subsequent epidemics. There were repeated famines. European Crusaders and pirates raided the ports and industrial centres of the Nile Delta, and agriculture suffered from rural depopulation and raids by nomadic Bedouin Arabs. The Mamluk soldiery repeatedly mutinied and went on pay strikes. Against this background, in 1400 the Turko-Mongol warlord Timur (r. 1370–1405) invaded Syria and sacked Damascus.

The Mongols and Timurids

The Mongols appear in history at the end of the twelfth century. In the opening decades of the thirteenth century, Chinggis (or Genghis) Khan (1167–1227) unified the Mongol tribes on the steppe lands to the north of China and thereafter Mongol armies invaded China and the Middle East. In 1220 Transoxania was conquered and in the 1220s roaming Mongol armies spread devastation in the Middle East as far west as the Caucasus. Mongol occupation of the Middle East to the south and west of the Oxus began in the 1250s. In 1256 they occupied northern Iran and in 1258 captured Baghdad and murdered the city's last Abbasid caliph. In 1260 the Mongols were defeated by a Mamluk army from Egypt

at Ayn Jalut in Palestine, which prevented their further spread westwards. They established an Ilkhanate, a territorial principality that included Iran, Iraq, and parts of Anatolia and the Caucasus. The Ilkhan Ghazan (r. 1295–1304; Ilkhan means "subordinate Khan") became a Muslim and from then on Islam was the official religion of the principality.

Timur (also known in the West as Tamerlane or Tamburlaine; c. 1336–1405), who had begun his career as a rustler and brigand in Transoxania, made a determined attempt to reconstitute the Mongol world empire (two of his wives were descended from Chinggis Khan). The empire he ultimately created consisted essentially of Persia, Iraq, Khurasan, and Transoxania, but he also campaigned in Syria, Anatolia, the Caucasus, Russia, Afghanistan, and India and, at the time of his death in 1405, was preparing to invade China.

The Safavids and the Ottoman Turks

The Timurids continued to rule in Khurasan until the beginning of the sixteenth century, but former Timurid territory in the west – that is Iran and Iraq – passed into the hands of various nomadic Turkoman dynasties in the fifteenth century, before being occupied by the Safavids in the first decade of the sixteenth century. The eponymous founder of the fortunes of the Safavid dynasty, Shaykh Safi al-Din (d. 1334), had been head of a Sunni Muslim Sufi order, but his descendant Shah Ismail (r. 1501–24) took power at the head of a messianic Shia movement and he and his successors ruled over the greatest Shia empire since the suppression of the Egyptian Fatimid caliphate in the late twelfth century.

The Ottomans (from Osman or Uthman I, 1259–1326) had originally been the paramount clan in a raiding tribe of Turks who began about 1300 to establish a permanent territory in Asia Minor. Taking advantage of the break-up of Mongol territories in the area, they began to make raids against Byzantine settlements as well. Ottoman forces first invaded Europe in 1345, and in 1453, after repeated Turkish assaults, finally captured the ancient Byzantine capital of Constantinople. The city's conqueror, Mehmed II (r. 1451–81; FIG. 32), endowed all sorts of foundations to promote Islam within the conquered city and, as was the case with many Muslim patrons, his artistic sponsorship was part of a wider programme for the promotion of the Islamic faith and social welfare generally. Thus, from the early sixteenth century onwards the Middle East was divided between two rival empires, that of the Shia Safavids of Iran and that of the Ottoman Turks.

32. GENTILE BELLINI (c. 1429–1507) Portrait medallion of Mehmed II, 1480. Bronze, diameter 3³/₄″ (9.5 cm). British Museum, London.

Mehmed II, like his contemporaries and allies among the princes of Renaissance Italy, followed the model of a humanist patron in inviting artists and scholars to his court. The Venetian painter Gentile Bellini was in Constantinople from September 1479 to January 1481.

The Sufi and Dervish Orders

The fourteenth-century Safi al-Din, founder of the Safavid dynasty, has already been described as a Sufi shaykh. It is impossible to understand the main developments in the political and cultural history of the Islamic world from at least the twelfth century onwards without taking into account the contribution made by Sufi orders (FIG. 33). To do so, it is necessary to go back to the early centuries of the Islamic world.

Sufism was not and is not a single movement. The term is used to describe a disconcertingly wide range of mystical belief and devotional practice within Islam. While some Sufis never deviated from the beliefs and practices of mainstream Islam, and engaged solely in pietism and asceticism, others were influenced by Christian mysticism, Jewish kabbalism, or Central Asian shamanism. Thus, some of the great medieval masters of Sufism were and are regarded as pillars of Islamic orthodoxy (whether of the Sunni or Shia kind), while others are widely held to have strayed into heterodoxy (FIG. 34). In brief, Sufis are mystics. Among the best-known of the early Sufis were Rabia (d. 801), Dhul Nun al-Misri (d. 859), and Abu Yazid al-Bistami (d. 874). Some Sufis preached Islam in pagan lands (it is likely, for example, that the Seljuq Turks were converted to the Islamic faith through the actions of tenth-century Sufis who travelled the Turkish steppes).

Shaykh, which can mean simply "an old man," is a term used for the chief of a tribe, a religious leader, or the head of a guild. It is also used in particular of a Sufi "master"; one who guides and teaches Sufi disciples, often within the framework of a dervish order. Dervish orders (*darvish* is the Persian word for a Sufi or Muslim mystic), with established hierarchies of masters and disciples, and chains of mystical transmission, seem to have begun to form around the late twelfth century. Amongst the earliest were the Shadhilis and Suhrawardis. Thereafter

33. Turkish miniature of dervishes dancing, from a copy of Husayn Bayqara's (r. 1469–1506) *Majalis al-Ushshaq* (*Sessions of the Lovers*), 16th century. Illuminated manuscript, approximately 9 x 6" (25 x 15 cm). Bodleian Library, Oxford.

Although disapproved of by some, listening to music, whirling, and dancing were practised by many Sufi orders. The dancing might represent the movement of the soul towards God.

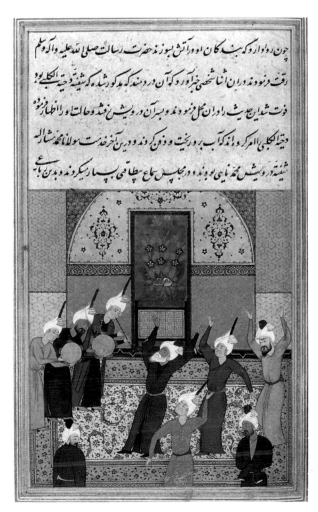

34. The execution of the Sufi al-Hallaj, from al Biruni's *Kitab al-Athar al-Baqiyya* (*Chronology of Ancient Nations*), Tabriz, c. 1307. Illuminated manuscript, whole page 12²/₃ x 7⁷/₈″ (32.2 x 20 cm). Edinburgh University Library.

While many regarded al-Hallaj as a mystic martyr, others regarded him as a heretic. Usually haloes were used by Arab and Persian painters for visual effect, rather than as a mark of sanctity. In this particular miniature, however, it may be significant that whereas al-Hallaj's executioners have haloes, al-Hallaj himself does not.

35. Basin from the shrine of the 12th-century Sufi shaykh Ahmad Yasavi, c. 1397. Bronze, height 5′2″ (1.6 m). State Hermitage Museum, St. Petersburg.

The Mongol ruler Timur was careful to cultivate Sufi shaykhs and their followers, and the shrine to Shaykh Ahmad Yasavi was raised under his patronage.

the Sufi dervish orders grew in numbers and power. The Naqshbandi order, for example, attracted adherents in India, Transoxania and the lands north and east of it, South-East Asia, the Caucasus, and the Middle East. The great Chagatay Turkish poet and art patron Mir Ali Shir Navai (1441–1501) was a Naqshbandi, and members of the order were prominent at the courts of Samarqand and Bukhara. Naqshbandi missionaries converted the Kazakhs to Islam in the sixteenth century; they were also active in Malaya and Java and played an important role in the cultural formation of the Ottoman elite. Similar claims could be made for many other Sufi orders (FIG. 35).

Sufism and Islamic Art

Understanding the writings and aesthetics of Sufism is essential to any study of Islamic art. Not only were Sufis sometimes involved in craft guilds and practices, but their writings can be used to give valuable indications of the role the arts were seen to play within the Islamic world.

Sufis were fond of quoting a saying attributed to the Prophet, "God is beautiful and loves beauty," and beauty played an important part in Sufi thinking. The religious thinker al-Ghazali (1059–1111), who taught and wrote under the patronage of the Seljuq vizier Nizam al-Mulk (1018–92), and who converted to Sufism late in life, tells the story in one of his books of a competition between a Chinese and a Greek painter. The Chinese artist painted an elaborately realistic scene on one wall, while the Greek merely polished his wall

so that it reflected the Chinese scene with enhanced brilliance. To al-Ghazali this was a parable for the Sufi's endeavour to purify himself, so that he becomes a mirror for the Divine Light.

Al-Ghazali's *Kimiya l-Saadat* (*The Alchemy of Happiness*), written around the year 1106, touches on aesthetic matters. Man loves the perfection found in beautiful things because he wants to become perfect himself. Beauty is not a purely external thing. Al-Ghazali conceived of artistic beauty as a reflection of inner beauty. One had to train the eye of the heart to perceive inner beauty: "There is a great difference between him who loves the painted picture on the wall on account of the beauty of its outer form and him who loves the Prophet on account of his inner form." The inner beauty of artists was made manifest in the external beauty of the works of art they produced.

Jalal al-Din al-Rumi (1207–73), a Persian who settled eventually in Anatolia, was one of the great mystical teachers and a prolific writer who used poetry and fable to teach mystical truths. His major work, the *Mathnawi* (*Rhymed Discourses*), which is 27,000 couplets long, is an exposition of Sufi doctrine via fable, stories, and reflections, in which the arts and crafts feature frequently in metaphors and allegories. Thus Rumi takes as one of his examples the *hammam*, or bathhouse, which typically had frescoed walls – but yet the heat of the *hammam*'s furnace can give no life to the frescoed figures.

Islamic romances are sometimes given a mystical gloss by Sufism that offers important insights into the role of their imagery. For example, the love of Zulaykha, Potiphar's wife, for the biblical Joseph was celebrated by several writers, among them the Persian poet Jami (1414–92). In Zulaykha's unsuccessful attempt to seduce Joseph, she had rooms decorated with erotic paintings of herself and him (FIG. 36). This story, which is superficially about lust, was commonly interpreted as a parable about the mystical quest of the soul for the Beauty of God. Even texts that were not intended by their author to have mystical meanings were supplied with them by Sufi commentators. Thus Rumi read the *Kalila wa-Dimna* (*Kalila and Dimna*), a collection of animal fables, as a series of Sufi allegories, and the fact that lustreware tiles carrying inscriptions from

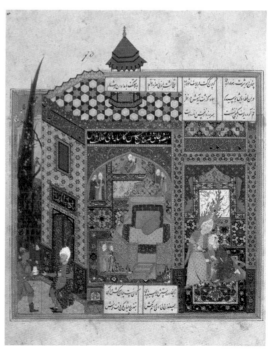

36. Persian miniature showing Yusuf (Joseph) and Zulaykha entering the pavilion of love, from a copy of Sadi's (d. 1292) *Bustan* (*The Garden*), 16th century. Illuminated manuscript, whole page 9⁷/₈ x 6³/₅" (25.1 x 16.8 cm). Nationalbibliothek, Vienna.

37. MUHAMMADI
(fl. 1560–87)
Persian album drawing of a
young dervish, c. 1575.
Whole page 8 x 5" (20.5 x
12.6 cm). India Office,
London.

It became fashionable in
16th-century Persia to paint
pictures, realistic or
idealised, of mendicant
dervishes. Note his travelling
equipment, including a
metal bell, a leather pouch,
a knife, a wooden ladle, and
a metal bowl. Muhammadi
was born in Herat, and this
work is in the Qazvin style,
characterised by simple line
drawing and a restricted
range of colours.

Firdawsi's epic *Shahnama* were placed in mosques suggests that parts at least of this poem could be read at a spiritual level. An image of its hero, Rustam, when viewed with the eye of an initiate, may have been more than the image of a strongman and popular hero; the fantastic expeditions of Alexander the Great, which also feature in the *Shahnama*, were certainly read by some as an allegory of the mystic's journey to God. If Sufi readings of these texts were commonplace, it may be that many of the viewers of the illustrations to these texts did not see them with profane eyes. The details of a miniature painting might be mystically decoded, so that a bird in a cage might be taken to represent the soul trapped in the world, a tress of hair is figuratively the Divine net that entraps the lover of beauty, a cypress alludes to the Paradise fountain of Kawthar, a gate is potentially an entrance to Paradise, and so on.

Shahid, which means "martyr" but also "witness," was the term used for the Sufi contemplator of earthly beauty who longed to pierce the veil of appearances and achieve a direct vision of the Divine (FIG. 37). Such a contemplator would indeed need to "die" to himself in order to approach God, and in this way, the notions of looking and martyrdom were intimately linked. Certainly, the contemplation of beauty played an important part in the devotions of many Sufis. The famous Andalusian mystic Ibn al-Arabi (1165–1240) declared that "love of women belongs to the perfections of the gnostics, for it is inherited from the Prophet and is a Divine love." To see God in the form of a woman was the most perfect vision of all, according to Ibn al-Arabi. Although many disapproved of the practice, some Sufis sought to attain ecstasy (FIG. 38) through the contemplation of human physical beauty, while the Bektashi Sufis used contemplation of landscape as a means of approaching the Divine. When an allegorically minded initiate entered a building, he did not necessarily enter the same building as his profane companions.

Inscriptions in buildings sometimes speak directly about their symbolic meanings. For example, the fourteenth-century palace of the Alhambra, the residence of the Muslim rulers of Granada, has an inscription on a courtyard wall that reads: "The water in the basin in my centre is like the soul of a believer who rests in the remembrance of God." In a more diffuse way, the sense of all things

as impermanent save the One who is God and the dissolution of all forms might be suggested by the elaborately cut-away tracery carving of the arches in the Alhambra. There is also literary and epigraphic evidence of architectural domes being conventionally compared to the celestial dome of the heavens.

However, textual attestations to the mystical meanings of architectural features are relatively rare and, while it may seem plausible that there was a Sufi way of "reading" Persian book illustrations, we have no direct evidence that this was the case. There is some slight danger of exaggerating the religious and mystical nature of Islamic culture. A great deal that has been written on the "spirituality" of Islamic art relies on emphasis rather than evidence. It should also be borne in mind that there is an inbuilt bias in the surviving evidence. Religious buildings and objects tended to be protected by pious veneration and sometimes by legal and financial provisos. Secular objects, illustrated works of *belles-lettres*, princely palaces, and domestic architecture did not enjoy this sort of protection and consequently fewer of them have survived to the present day. It is to religious and secular buildings – in particular the mosque, and its central position both metaphorically and literally within the Islamic faith and Muslim community – and then to secular art and patronage that we will turn in the next two chapters.

38. Uzbek miniature of a Sufi watching the poet Sadi in ecstasy, from a manuscript of Jami's (1414–92) *Subhat al-Abrar* (*Rosary of the Pious*), 1564–65. Ink, colours, and gold on paper, 11 x 6¹/₂" (28 x 17 cm). Al-Sabah Collection, Kuwait.

The *Subhat* was a didactic religious poem. This copy was made for the library of Abdallah Bahadur Khan, ruler of Bukhara in Uzbekistan.

Religious and Secular Architecture

T
he centrality of the mosque within the Islamic faith makes a study of its origins and development, as the first "Islamic" form of building, the first consideration in any discussion of Islamic architecture, especially as many features and concepts in Islamic secular and religious architecture overlap. Single urban complexes, for example, will often feature both secular and religious buildings. This chapter examines first of all the development of the architecture of the mosque in general, taking examples from across the Islamic world and giving at the same time some details of the mosque's place within Islamic society, and then looks in detail at some distinctive examples of Islamic architectural patronage.

The Development of the Mosque

Prayer is one of the five pillars of Islam – the other four are alms-giving, fasting, pilgrimage, and the remembrance of God. The devout Muslim will pray five times a day, and in general the prayer can be performed at home or wherever one finds oneself, but once a week at noon on Friday all adult males are bound to assemble together in their community's main mosque – the so-called Friday Mosque, or *masjid al-jami* – to pray together and hear a sermon. In the early Islamic period there would be only one Friday Mosque in each city, but in time it became impossible for a single building to accommodate all of a great city's worshippers. Therefore, great metropolises, like Damascus (FIG. 40), Baghdad, Cairo, and Istanbul, have several Friday Mosques.

There are also lesser, local mosques, where prayers are offered but no sermons are delivered. Such a mosque, used other than on Fridays at noon, is known as *masjid*, which means literally "a place of prostration."

39. The *mihrab* of the Great Mosque at Cordoba, 11th century. Gold and glass mosaic on marble.

40. Courtyard of the Great Mosque of Damascus, 706–15.

The Great Mosque occupies the site of a former Christian church, which itself stood on the site of a *temenos* or sacred enclosure of a pagan temple. At the time of the Friday noon prayer, the courtyard would have been full of worshippers, so it served as an extension of the covered area of the mosque for prayer. With its raised transept at the centre of the facade on the prayer side of the enclosure, the Great Mosque served as a model for a number of other mosques in the caliphate, and was one of the great imperial mosques of the Umayyads.

The first mosque, the first place where Muslims came together for prayer, was actually the courtyard of the Prophet's house. This simple, practical space, broader than it was deep, conveniently accommodated worshippers who performed the prostrations of prayer in parallel lines (FIG. 41). With its palm roof to shade some of the worshippers, it remained the model for the first purpose-built mosques, as for example the first mosque in what is now the Iraqi town of Kufa, erected in 638.

In the earliest years of the Islamic conquest, mosques were established where churches, pagan temples, or houses were commandeered and converted to Muslim use. In Jerusalem and Cordoba, for example, Muslims took over parts of churches; and for a while, in Homs in western Syria, Damascus, and Aleppo (north-west Syria), they shared the same building with Christian congregations.

There are no liturgical processions in Islam, unlike Christianity, so it is convenient that the main prayer area should be wide rather than deep. The flat roofs of the first mosques could be supported by regularly spaced pillars, creating a "hypostyle" form of building. The Christian pilgrim Arculf, who visited Jerusalem around 670, reported that "In that famous place where the Temple once stood, near the [city] wall on the east, the Saracens

now frequent an oblong house of prayer which they pieced together with upright planks and large beams over some ruined remains. It is said that the building can hold three thousand people." The simplicity of this type of structure facilitated the extension of mosques to accommodate their ever-growing numbers of worshippers. At Kufa the original mosque of 638 was rebuilt on a much grander scale in 670, and the Great Mosque of Cordoba, erected in 784–86 by the first Spanish emir, Abd al-Rahman, was subsequently expanded in 961–66 and again in 987–90.

The Function of the Mosque

A mosque served its community as meeting-place, council chamber, courtroom, treasury, and centre for military operations. Administrative announcements were made and political allegiances sworn in the mosque; traders and scholars gathered there; and books were commonly "published" by being read out aloud in the mosque. The homeless were allowed to sleep in its precincts, and even dinners might be held there. It replaced the classical agora or forum as the main meeting-place in a city. Only over the centuries did its space become sacralised and closer to the Western concept of a holy area.

42. Early 8th-century mosaics of landscapes and buildings from the interior of the Great Mosque in Damascus.

The little houses throw shadows while the trees have shaded trunks, but it is noteworthy that no people or animals appear in these landscapes.

60 *Religious and Secular Architecture*

The Decoration of the Mosque

Although, as has been said, it was widely held that it was wrong to decorate mosques with images of men and animals, mosque walls might be covered with images of buildings and vegetation, or with abstract patterns. The interior of the Great Mosque of Damascus, built by the Umayyad caliph al-Walid I (r. 705–15), was decorated by Byzantine mosaicists with a series of images of buildings in leafy landscapes (FIG. 42). It has been suggested that these represent the habitations and gardens of Paradise waiting to be inhabited by Muslims. The tenth-century geographer al-Muqaddasi, who was the son of an architect, stated that the mosaics showed all the cities and trees of the known world, but it is equally possible that this decorative programme was simply a way of covering the walls attractively.

The most ornate decoration in a mosque tends to be concentrated round the area of the *mihrab*, or prayer niche, which is usually opposite the entrance of the mosque and always aligned so that when a Muslim faces the wall with the *mihrab* at its centre, he is praying towards Mecca (FIG. 43 and see FIG. 41). The *mihrab* is thus a kind of visual aide-memoire, and it is misleading to think of it in Western terms as a kind of sacred altar.

Most often the *mihrab*'s arch and the area of wall around it were decorated with coloured marble or stucco. The *mihrab* of the Great Mosque of Cordoba (FIG. 39, see page 57) provides a splendid example of mosaic decoration, again by Byzantine mosaicists, perhaps in deliberate imitation of the early Umayyad decorative scheme at the Damascus mosque. The *mihrab* given by the Mongol ruler Uljaytu (r. 1304–17) for the Friday Mosque in Isfahan, Iran, provides a particularly splendid example of elaborate stucco work (FIG. 44). From the thirteenth century onwards, there are also spectacular examples of *mihrab*s in Iranian mosques decorated with lustreware tilework.

In Friday mosques a *minbar*, or pulpit, was placed to the right of the *mihrab*. The *khutba*, the weekly sermon in which the ruler's name was acknowledged, was preached from the *minbar*. *Minbar*s

43. Lustreware tilework *mihrab* (the "Salting" *mihrab*), early 14th century. Glazed ceramic tiles, 24¹/₂ x 16¹/₂" (62 x 42 cm). Victoria and Albert Museum, London.

The origin of the *mihrab* is obscure, as is the etymology of the word, which seems to be related to *harb*, meaning "war." Possibly the *imam*, or prayer leader, preached of Islamic victories in front of it; or in the very earliest years of Islam, the niche may have housed the caliph's or governor's throne. Whatever the original meaning, in later centuries the *mihrab* came to be thought of by some as a sort of symbolic doorway into the spiritual world.

44. Uljaytu's *mihrab* for the Great or Friday Mosque (the Masjid-i Jami) in Isfahan, 1310. Stucco.

This ornately carved *mihrab* is decorated with a range of calligraphic scripts. The featured texts are sayings of the Prophet. According to one: "God builds a house in Paradise for him who builds a mosque."

45. Sultan al-Ashraf Qaytbay's (r. 1468–96) *minbar.* Wood inlaid with ivory, 20′ x 9′11½″ x 44½″ (6.1 m x 3 m x 113 cm). Victoria and Albert Museum, London.

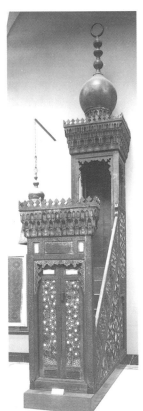

were commonly made of stone or wood (FIG. 45). They were large and could be highly ornate, inlaid with ivory, mother-of-pearl, and different kinds of wood. In effect, they were a sort of miniature architecture, reflecting on a smaller scale the forms and decorative themes of the building around them. In the early Islamic era, the *minbar* was more than just a platform for the preacher. It, like a throne, was a symbol of political authority and a place from which the ruler gave his orders, and as such it was sometimes attacked and vandalised to express dissatisfaction with a ruler's performance.

The Lighting and Furnishing of a Mosque

The form and effect of lighting in a mosque was of great importance. According to the *Surat al-Nur*, or "Chapter of Light" (*Sura* 24), in the Koran:

> God is the Light of the heavens and the earth;
> the likeness of His light is as a niche
> wherein is a lamp
> (the lamp in a glass,
> the glass as it were a glittering star)
> kindled from a Blessed Tree …

From at least the twelfth century onwards these verses were given a mystical interpretation, and mosque lamps often had these verses painted on them. The great religious thinker al-Ghazali in his

Mishkat al-Anwar (*The Niche for Lights*) had meditated on the religious symbolism of light, describing the seventy thousand veils of light and darkness which separate the believer from God, who is the Light. Massed arrays of gilded mosque lamps could be used to achieve spectacular effects as their lights reflected off one another (see FIG. 3). Arnold von Harff, a German knight who visited Jerusalem in the 1490s, recorded seeing five hundred mosque lamps burning in the Dome of the Rock. The heyday for the production of enamelled and gilded mosque lamps was in the thirteenth and fourteenth centuries under the patronage of Mamluk sultans and emirs. Characteristically, these lamps, which were suspended on chains from the roof beams, have wide bodies and wide flaring necks (FIG. 46), but it should not be assumed that every lamp having this shape was necessarily destined for a mosque, as manuscript illustrations show the same sort of lamp in use in secular dwellings.

Mosques seem sparsely furnished by comparison with Christian churches. The Koran lectern, or *kursi*, is one of the few specimens of furniture commonly found in a mosque (FIG. 47). Some grander mosques also had a special enclosure called a *maqsura*, a part of the mosque fenced off to accommodate the ruler and his entourage, offering them a degree of protection from assassination.

46. Mamluk mosque lamp, 14th century. Glass with gilt and enamel decoration, height 13¾" (35 cm). British Museum, London.

This lamp is one of a number made for the Mamluk emir Shaykhu al-Umari (d. 1357).

47. Turkish *kursi*, 13th century. Wood, 19½" x 3'9½" (50 x 115.5 cm). Staatliche Museen zu Berlin.

Kursis are made of stone or wood and the latter may be elaborately carved and decorated with inlaid ivory and mother-of-pearl.

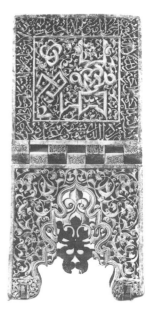

Later Developments in Mosque Architecture

Minarets may now be seen as entirely characteristic of Muslim religious architecture, but the very first mosques had none. The call to prayer was customarily made from the roof of the mosque itself. Equally, while it is now widely taken for granted that the purpose of a minaret is to provide the muezzin, who gives the five daily calls to prayer, with an elevated platform from which to make them, it is not so clear that this was its original purpose. The word minaret is related to *nur*, the word for light, and it is possible that not only was the form of the minaret influenced by that of the ancient Pharos or Lighthouse at Alexandria, but also that many of the early minarets were not designed as places for making the call to prayer.

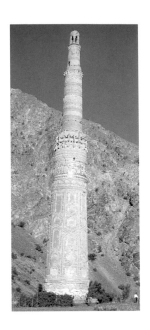

48. The brick-built minaret at Jam in Afghanistan, 12th century.

This solitary minaret is completely preserved at its full height of 213 feet (65 m).

Indeed, some were not attached to mosques at all (FIG. 48). Rather, they seem in some cases at least to have functioned as lighthouses, guiding travellers across both seas and deserts. Others served as watchtowers, and still others were put up as monuments to commemorate Muslim victories.

The earliest minaret attached to a mosque was allegedly put up at Basra in southern Iraq in the 660s, though it has not survived. Early mosques had only one minaret (FIG. 49) – if any – but over the centuries there was a slow proliferation in their number. These additional minarets had a decorative rather than a functional purpose; in later centuries as minarets increased in height and became more slender, they were to all intents and purposes useless as places from which to make the call to prayer. Since the minaret was unknown in the lifetime of the Prophet, some strict Muslims denounced (and continue to denounce) minarets as ostentatious and unnecessary innovations.

Apart from the addition of minarets, there were other ways in which the mosque's simple hypostyle structure could be added to or elaborated upon. An additional space, the *ziyada*, might be created around its main precinct, to seclude it from the bustle and noise of the street – as for example in the case of the mosque of the Egyptian governor Ibn Tulun in Cairo, built in 879. The Great Mosque in Damascus had a raised central transept from

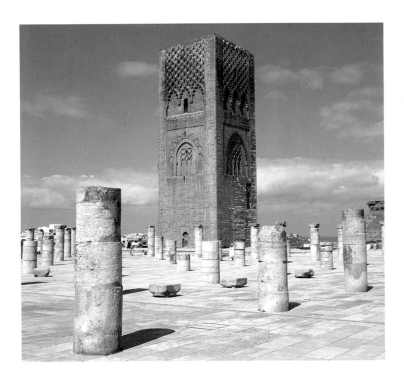

49. Minaret of the Mosque of Hasan at Rabat, Morocco, 12th century.

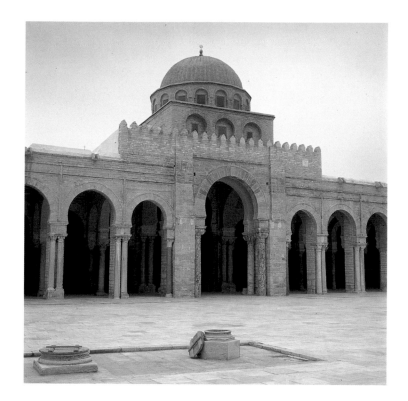

50. Courtyard of the Great Mosque at Qairouan, Tunisia, originally built c. 670, with later work carried out in 836, 862, and 875.

the entrance of the prayer area towards the *mihrab*. The space just in front of the *mihrab* might be roofed by a dome, often supported by elaborate vaulting, involving the use of squinches or *muqarnas* (honeycomb or stalactite vaulting). This dome was another way of emphasising the special status of the *mihrab* and the direction of prayer.

In the long run, the hypostyle mosque, such as the Great Mosque at Qairouan in Tunisia (FIG. 50), gave way to more elaborately laid out types. A favoured alternative was based on an open, four-sided courtyard, with an *iwan* or porch in the centre of each side. This type of mosque became popular in Iran from the twelfth century onwards and spread from there to other regions. The largest *iwan* would serve as the prayer hall, while the others were probably used by religious teachers. As a further elaboration, one or all the *iwans* might be framed by a *pishtaq*, an elaborately decorated architectural frontispiece. The Great or Friday Mosque in Isfahan, rebuilt in both the eleventh and twelfth centuries, provides an example in which the high arches and *pishtaqs* framing the *iwans* are decorated in glazed tiles, and the main entrance to the mosque might similarly be framed by a carved or tiled *pishtaq*. Grandiose mosques advertised imperial pretensions. For example,

Religious and Secular Architecture 65

when the Friday Mosque in Isfahan was first substantially rebuilt around 1085 for the Seljuq sultan Malik Shah (r. 1072–92), an inscription marking the event was placed around the drum of the dome in front of the *mihrab*. Later Iranian dynasties made further additions and improvements and commemorated what they had done in further inscriptions.

The Mosque Complex

The many functions of the mosque within Islamic society led naturally to an accretion of other architecture around the mosque. For example, the Selimiye Mosque complex in Edirne in northwest Turkey (FIG. 51), built for the Ottoman sultan Selim II (r. 1566–74) by the great architect Sinan (d. 1588), included a boys' school, a *madrasa* or teaching college, lodgings for Koran readers, a covered market, a *ziyada*, and a cemetery.

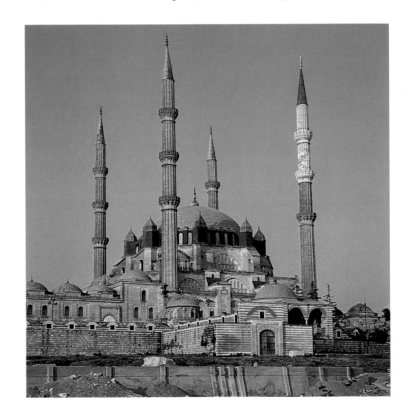

51. The Selimiye Mosque at Edirne, Turkey, 1569–75.

The massive, spreading dome of the mosque was an architectural boast, the apogee of the domed square. According to its architect, Sinan, it was built in deliberate imitation of the Hagia Sophia in Istanbul. It is set off by four slender minarets, each over 230 feet (70 m) high.

The Mosque and the *Madrasa*

From the earliest period of Islam onwards, mosques had served as centres of education, although early mosques contained no special accommodation for this. In response to the intellectual threat posed by Shia preaching, Sunni Muslims began to build

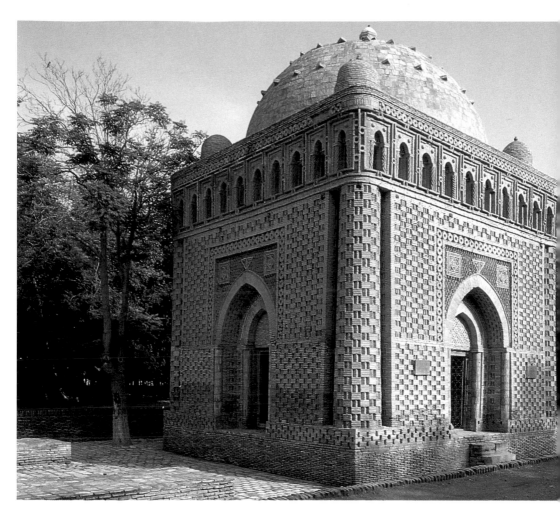

Din, a convert to Islam from Judaism who became a vizier in the service of the Mongols in Iran in the early fourteenth century, set up a *waqf* to ensure the dissemination of the text of his history of the world. This not only provided for repeated copying of his manuscript, but also required each copy to be attested on completion by the *qadis* (religious judges) of Tabriz who served as official witnesses. A special prayer was then to be said over the completed text in a mosque.

Islamic Mausolea

In the early centuries of Islam, ostentatious tombs were not tolerated and devout Muslims preferred to be buried in unmarked graves. According to a saying attributed to the Prophet, even prayer at a grave was forbidden. However, in time a mortuary architecture did develop (FIG. 54).

54. The Mausoleum of Ismail the Samanid in Bukhara, early 10th century.

The Iranian dynasty of the Samanids ruled in Khurasan and Transoxania from 819 to 1005. The mausoleum is one of the masterpieces of Islamic brickwork. The play of light and shade on its patterns creates effects that approximate to polychromy. The basic form of the building – a cube surmounted by a dome – is typical of mausolea.

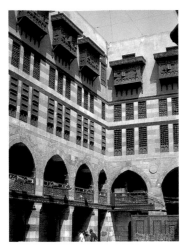

Above

52. Courtyard of the great *khan* or caravanserai in Cairo of Qansuh al-Ghuri, the penultimate Mamluk sultan (r. 1501–16).

Above the lower two porticoed floors are apartments rented by pilgrims, merchants, or craftworkers.

Opposite

53. Left half of the double frontispiece to volume VII of the Koran of the Egyptian Baybars Jashnagir, 1304–06. Illuminated manuscript, 18½ x 12½" (47 x 32 cm). British Library, London.

Korans of this magnificence are typical of those whose creation was financed by a *waqf*. Jashnagir, a Mamluk emir, became sultan briefly in 1309 before being deposed and killed the following year.

porated in the complex of buildings round the mosque. At the Sultan Hasan Mosque a market, apartment buildings, and a waterwheel were located just to the west of the religious building.

Islamic religious law gave *waqf*s considerable protection from seizure by secular authorities, leading to the creation of *waqf ahli* ("family *waqf*"), a sort of family trust, in which the endower of the *waqf* stipulated that members of his family should manage the endowed mosque, *madrasa*, or other charitable foundation, and that they should be paid from its funds for doing so. In an unstable political world this was seen as a relatively safe way of handing on one's wealth to one's descendants, and of protecting it not only from sequestration by the state, but also from taxation.

It is impossible to understand the history of Islamic architecture without taking into account the aims and functions of *waqf*. For instance, it goes some way towards explaining the impetus to patronise religious architecture; but dependence on *waqf* income was also a factor behind the eventual dilapidation of many religious buildings, for the endowments were unable to provide for inflation. Only the grandest religious foundations, like the hospital built in Cairo in 1284–85 by the Mamluk ruler Qalawun (r. 1279–90), could attract recurrent endowments from successive patrons. Large religious complexes, or *imaret*s, supported by *waqf*s, played a crucial role in the Islamisation of Constantinople after its conquest by the Ottoman sultan Mehmed II in 1453. For example, the Fatih Mosque, founded by Mehmed after the conquest, with its numerous staff, its dependent soup kitchens, supporting shops, and enterprises, dominated and practically constituted an entire neighbourhood in the city.

*Waqf*s are important in other ways as well. Each needed legal documentation, or *waqfiyya*, setting out the administration of an institution and its intended building plan, sometimes in such detail that the building is described room by room. *Waqfiyya*s are not necessarily totally reliable guides to how the founder's intentions were carried out, but, for all that, as documentary evidence they can be invaluable. Many *waqf* documents, for example, demonstrate that a large amount of economic power was wielded by women, not just as the managers but even as the founders and patrons of religious endowments.

Public fountains, horse troughs, and expensive objects such as illuminated Korans (FIG. 53) or gilded mosque lamps could also be endowed and protected by a *waqf* – the earliest surviving Koran *waqf* dates from the second half of the ninth century. Rashid al-

madrasas, teaching colleges attached to mosques, where the students could be lodged and taught the religious sciences – the study of the Koran, traditions concerning the Prophet, and Islamic law. Other subjects, like astronomy and the composition of poetic verses, may also have been informally taught, but study of the religious law took precedence.

The first *madrasas* seem to have appeared in the eleventh century in the province of Khurasan in north-east Iran and spread from there westwards through the Seljuq lands. The most celebrated of the early *madrasas*, the Nizamiyya, was established by the Seljuq vizier Nizam al-Mulk in Baghdad in 1067. The institution of the *madrasa* spread to Syria in the early twelfth century and thence to Egypt after Saladin's takeover in 1169. As far as its architectural form is concerned, it is not always easy to distinguish a *madrasa* from a mosque or a domestic house, but a typical *madrasa* was likely to be built around an open courtyard with four *iwans* – with the *iwan* on the *qibla* side (the direction of Mecca) generally being larger and deeper than the others.

In Sunni Islam there are four major *madhhabs* or schools of law, which differ amongst themselves on major and minor issues in religious law and on the details of liturgy, and in the past it has been suggested that each of the four *iwans* of a *madrasa* was intended to house one of the law schools. This does not seem very likely. For one thing, adherents of the various law schools have never been evenly distributed throughout the Islamic world. Second, it is a matter of common sense that at different times of the day one or the other of the *iwans* will become uninhabitable when it bears the full brunt of the sun's rays. It seems more likely, then, that the four-*iwan* structure has more to do with symmetry and the need for shade throughout the day.

The scale of the teaching endowment in a *madrasa* could be considerable. That attached to Cairo's Sultan Hasan Mosque, built between 1356 and 1363, supported 506 students, of whom 400 were reading law, and the mosque also employed 120 Koran readers.

The *Madrasa* and the *Waqf*

The teachers and students at a *madrasa* were supported by income from religious endowments – land or some other income-producing source, such as property rents, that had been set aside to provide money in perpetuity for a pious purpose. This sort of endowment was known as a *waqf*. The money so generated was used first to construct the mosque, *madrasa*, or other suitable building and thereafter for maintenance and staffing of the foundation. Sometimes income-producing shops or lodgings (FIG. 52) would be incor-

The first figures thus to be honoured, usually with a dome, or *qubba*, over their resting place, were holy men, but from the tenth century onwards, rulers and emirs also arrogated this mark of privilege to themselves. The Greek mother of the Abbasid caliph Muqtadir (r. 908–32) was allegedly the first to build a mausoleum, at Rusafa in northern Syria. Subsequently, rulers began to enshrine their tombs by placing them in mosques. The precincts of *madrasa*s were also favoured sites for the location of sultans' and emirs' tombs, and the military elite seem to have sponsored more *madrasa*s than there was strictly an educational need for. Indeed, in Egypt from the thirteenth century onwards, interest in the culture and ritual architecture of death rivalled that of Pharaonic times.

While mausolea were often attached to *madrasa*s, the other favoured option was to attach them to a Sufi hospice or monastery. (If one is going to use the word monastery, one should bear in mind that Sufis did not take a vow of celibacy, nor was it normal for a Sufi to spend most of his life within the cloister.) The Sufi foundation, or *khanqa*, was governed by a shaykh and housed Sufis who spent periods of time in what were usually fairly austere surroundings, praying and performing devotions. The *khanqa*, like the *madrasa*, originated in eastern Iran and spread westwards in the eleventh century (the Seljuq period). The earliest *khanqa*s were simply devotional centres for pious individuals, and both structurally and functionally were often extremely similar to *madrasa*s. Characteristically, they had a prayer hall, a kitchen, and cells for the individual residents.

Architectural Patronage

In the medieval Islamic world, as in Christendom, expensive works of art such as building projects required a patron. However, it is usually more difficult to trace the relationship between artist and patron in Islamic society. This is in large part because of the absence of contract documents such as are found in Renaissance Italy. Although there are a vast number of anecdotes about patronage, in for example Abu'l-Faraj al-Isfahani's (897–967) *Kitab al-Aghani* (*The Book of Songs*), these concern poets and musicians (FIG. 55), rather than architects, sculptors, or painters. Moreover, in the early centuries of Islam patronage of the arts was not conceived of as a specific activity, but as an element of the generosity that was an important attribute of any Arab leader. The Persian Barmecide clan of administrators in the Abbasid period acquired a legendary reputation for generosity, for example, but although they built fine palaces in Baghdad they do not seem to

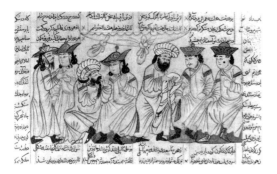

55. Persian miniature of a poet and his Mongol patrons from the *Anthology of Diwans*, 1315. Illuminated manuscript, 3¼ x 6¾" (8.5 x 17.5 cm). India Office, London.

have favoured particular named architects. Since Islamic architects were thus often anonymous, buildings tend to be associated with their patrons rather than their designers.

The First Architectural Patrons

The Umayyad caliph Abd al-Malik (r. 685–705) has claims to be considered Islam's first architectural patron, as he commissioned the building of the Dome of the Rock in Jerusalem in the late 680s, but Walid I (r. 705–15) was the foremost architectural patron of the Umayyads. It was Walid who commanded the rebuilding of mosques on key religious sites in a more lavishly decorated style and on a grander scale, effectively turning them into imperial mosques. These included the Great Mosque at Damascus, the mosque at Medina (707–09) on the site of the Prophet Muhammad's house in that holy city, and the al-Aqsa Mosque in Jerusalem (709–17). The patronage of religious architecture at Damascus and Jerusalem advertised the status of Syria at the heart of the Umayyad caliphate, the caliphs' piety and their desire to emulate the splendour of Christian churches in the region, as al-Muqaddasi's remark reveals:

> The caliph al-Walid beheld Syria to be a country that had long been occupied by Christians and he noted there the beautiful churches still belonging to them, so enchantingly fair and so renowned for their splendour as the Church of the Holy Sepulchre and the churches of Lydda and Edessa. So he sought to build for the Muslims a mosque in Damascus that should be unique and a wonder to the world. And in like manner, is it not evident that his father, Abd al-Malik, seeing the greatness of the martyrium of the Holy Sepulchre and its magnificence, was moved lest it should dazzle the minds of the Muslims and hence erected above the rock the dome which is now seen there?

In cities, the *Dar al-Imara*, or "House of Rule," was normally placed right next to the mosque, so that the ruler could proceed there with minimum risk and inconvenience. Various Umayyad princes also built palaces in the desert (FIG. 56), which may have served as a way of bringing patronage of a sort to the provinces (the purpose of these palaces will be discussed in Chapter Five). The Umayyads do not seem to have maintained any sort of official architectural workshop. Rather, workers were summoned to a site to do specific jobs.

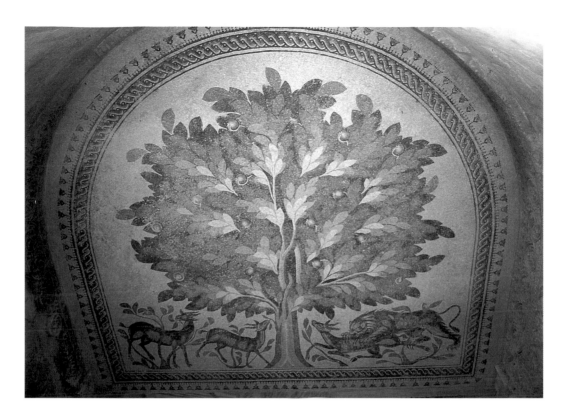

Samarra: The Building of a City

When in 836 the Abbasid caliph al-Mutasim (r. 832–42) was forced to move his capital from Baghdad to Samarra, he provided an example of a rather different sort of early Islamic architectural patronage. According to the ninth-century historian al-Yaqubi (d. 874):

> Al-Mutasim had architects brought and told them to choose the most suitable positions, and they selected a number of sites for the palaces. He gave each of his followers a palace to build ... Then he had plots of ground marked out for the military and civil officers and for the people, and likewise the Great Mosque. And he had the markets drawn out round the mosque with wide market rows, all the various kinds of merchandise being separate ... according to the arrangement after which the markets of Baghdad were designed. He wrote for workmen, masons, and artisans such as smiths, carpenters, and all other craftsmen to be sent, and for teak and other kinds of wood, and for palm trunks to be brought from Basra ... Baghdad ... and from Antioch and other towns on the Syrian coast, and for marble workers and men experienced in marble paving to be brought.

56. Mosaic on the floor of the audience chamber in the bathhouse at Khirbat al-Mafjar, Israel, 8th century.

The mosaic shows a so-called "Tree of Cruelty" with a border of an abstract design. Khirbat al-Mafjar is one of the most famous of the Umayyad desert palaces, and the quality of this mosaic, which may have been created by imported Greek artisans, gives some indication of the luxury and refinement of the interiors of such palaces.

Having thus expedited the creation of his new capital, the caliph presented the new town as an investment to his subjects, and they received grants of land in Samarra on condition they built markets, mosques, and bathhouses, or *hammams*, within their allotted territory.

With architects and craftworkers summoned from all over the Islamic world, Samarra in turn exported its style to the provinces of the Abbasid empire. For example, the vast Samarran Friday Mosque (848–52), twenty-five bays wide by nine bays deep, was imitated on a smaller scale by that of Ibn Tulun (879) in Cairo.

Architectural Patronage under the Seljuqs

The Seljuq period offers us one of the few written works to make a statement about the uses of architectural patronage, the *Siyasat-nama* (*Book of Government*) of Nizam al-Mulk, who served the Seljuq sultans Alp Arslan (r. 1063–72) and Malik Shah as vizier. In the opening chapter of the *Siyasatnama*, written for Malik Shah in the 1080s, Nizam al-Mulk listed the acts of the ideal ruler. Such a ruler will "bring to pass that which concerns the advance of civilisation, such as constructing underground channels, digging main canals, building bridges across great waters, rehabilitating villages and farms, raising fortifications, building new towns, and erecting lofty buildings and magnificent dwellings; he will have inns built on the highways and schools for those who seek knowledge; for which things he will be renowned for ever …" Evidently Nizam al-Mulk thought of his master as a potential director of public works, rather than as a patron of the arts in a narrower sense.

57. Entrance to the Seljuk caravanserai at Agzi Kara Han, near Aksarah on the Silk Road in Turkey, 1231–39.

A form of public works favoured particularly by the dynasty of the Lesser Seljuqs of Rum was the building of caravanserais (FIG. 57) to serve as lodging places for travellers and merchants. In the thirteenth century they were built along the network of trade routes in Anatolia. Typically, the Anatolian caravanserai was lightly fortified against bandits and had towers placed at the corners and sometimes along the walls. A single gate led into what was usually an open, two-storey, arcaded courtyard. A portal at the far end of the courtyard led into a large covered hall. There were also stables and storerooms on the ground floor,

while the upper rooms were occupied by staff and travellers. A few caravanserais had mosques on raised platforms in the centre of their courtyards. The caravanserais tended to be austerely functional in appearance, save for the lavish decoration of their outer portals, where the stonework was elaborately carved and made use of *muqarnas* to achieve spectacular effects. Such gateways signal something rather grander than one would expect for a combined warehouse and lodgings for travelling salesmen. However, some of the caravanserais were designed in the first instance for the use of the sultan when he was travelling about his lands. Humbler folk could use his caravanserais only when he was not there.

There is no surviving evidence of active personal interest in art or architecture on the part of the Greater Seljuq sultans. They built extensively in Baghdad, where they demolished many of the old Abbasid palaces, thereby making a veiled statement of supremacy over the Abbasid caliphs. But they also built up Isfahan in Iran and often chose to reside and govern from there. The Great Mosque in Isfahan was substantially rebuilt during the reign of Malik Shah and the inscription on its south dome celebrates the name of the Seljuq sultan and his ministers. The bombast is characteristic of the Seljuqs, and of dynasties such as the Zengids (after Zengi) and Ayyubids who followed them:

> The construction of this cupola has been ordered during the days of the magnificent sultan, august king of kings, the king of the East and the West, the pillar of Islam and of Muslims, Muizz al-dunya wal-din, Abul-Fath Malik Shah son of Muhammad son of David, the right hand of the caliph of God, Commander of the Faithful – may God glorify his victories – [and] the slave eager for the mercy of God, al-Hasan ibn Ali ibn Ishaq [that is, the vizier Nizam al-Mulk] by Abul-Fath the son of Muhammad the Treasurer.

The Great or Friday Mosque at Isfahan (FIG. 58) is usually discussed as if it were the creation of Seljuq patronage – which it was. But the mosque we see now is not the one the Seljuqs built in the eleventh century. The mosque today has a *mihrab* dating from the Mongol period; a *madrasa* was added by the Muzaffarids, a minor post-Mongol Iranian dynasty; while the portal and winter prayer hall date from the Timurid period. The minarets date from the Safavid period, as does the striking facing of ceramic tilework. So in a sense, the work begun by the Seljuqs in the late eleventh century was not finished until the seventeenth.

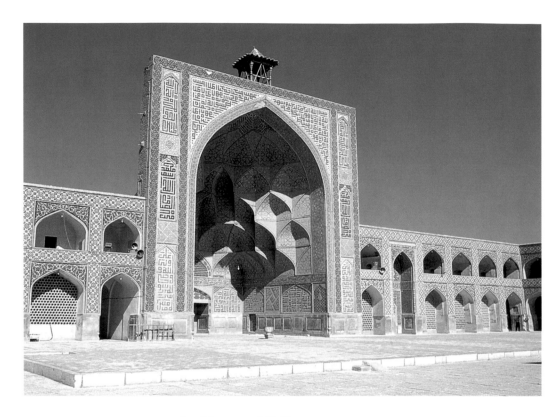

58. The Great or Friday Mosque at Isfahan.

This mosque, built on the site of earlier mosques, was commissioned by the Seljuq sultan Malik Shah I (r. 1073–92), and in its original form was a simple structure with a sanctuary area on the south side, fronted by an *iwan*.

Architectural Palimpsests

A similar point can be made about most of the important Islamic architectural monuments. The al-Azhar Friday Mosque in Cairo was founded by the Fatimid general Jawhar in 970, so it is almost invariably discussed in the context of tenth-century architecture. But what we see today is a palimpsest, the work of many centuries and several patrons (FIG. 59). After the overthrow of the Shia Fatimid regime by Saladin in 1171, some of its decoration was removed and the mosque was downgraded by the Sunni Ayyubid regime. It regained its status under the Mamluk regime, when the Mamluk sultan Baybars (r. 1260–77) rebuilt the minaret at the entrance on a grander scale and carried out extensive repairs on what was by then a building in a ruinous state. One of his emirs, Aydamur al-Hilli, restored the prayer hall. More repair work was carried out after a great earthquake at the beginning of the fourteenth century. In 1303 the emir Salar rebuilt the *mihrab* and had the surrounding area redecorated, and at some time in the early fourteenth century marble facing was added. From 1309 to 1310 Taybars al-Khazindari, a senior Mamluk emir, built a *madrasa* within the complex. In 1339 the emir Ala al-Din Aqbugha built a hospice for Sufis and Koran readers in the precincts. In the

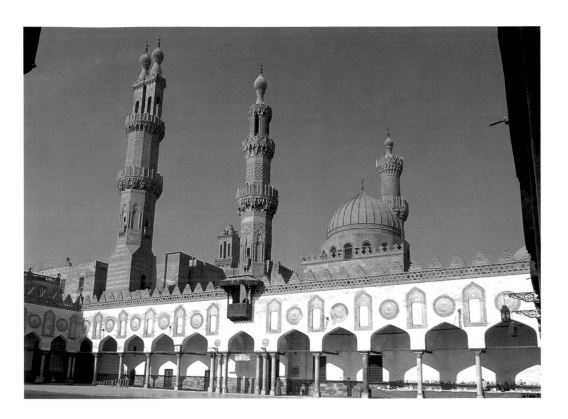

late fourteenth century the sultan Barquq (r. 1382–89; 1390–99) replaced Baybars's minaret with a shorter one, then in turn the sultan al-Muayyad Shaykh (r. 1412–21) replaced Barquq's. The Mamluk sultan al-Ashraf Qaytbay ordered an extensive restoration programme in 1469 and, among other things, demolished the west door and substituted a new one with an added minaret. In 1476 he knocked down a lot of little buildings on the terraces and from 1494 to 1496 carried out a general restoration, probably adding another minaret. The sultan Qansuh al-Ghuri added yet another minaret in 1510. The status of al-Azhar as a centre of piety and scholarship increased under the Ottomans and so did the amount of building and restoration work, while repairs, demolitions, and additions to the al-Azhar Mosque have continued to be made right up to the present day. It needs the eye of the antiquarian to see the original Fatimid mosque. Islamic buildings are not merely decorated with texts, but are themselves documents of Islamic patronage.

59. The courtyard of the al-Azhar Friday Mosque in Cairo, 10th century and later.

The Great Mosque at Isfahan (see FIG. 58) and the al-Azhar Mosque in Cairo are both examples of buildings whose purpose and status changed over the centuries. As for the al-Azhar, it was initially the chief mosque in Fatimid Cairo and a centre for Shia instruction and propaganda. When Saladin took control in Egypt, it was taken over by Sunni Muslims and became only one mosque among many in Cairo.

FOUR

Art and Artistic Taste

The concept of "Islamic" art and architecture is somewhat paradoxical. Very often the real subject turns out to be in some way "un-Islamic." As has been said, the primary use of the first mosques was not as religious centres. Minarets were held to be reprehensible by some Muslims, who may also have disapproved of mausolea and avoided setting foot in palaces and ostentatiously decorated houses.

As for painting, sculpture, and the decorative arts, when considering how medieval Muslims looked at them it should be borne in mind that many would have regarded them with distaste (FIG. 61). The question of the non-representational nature of Islamic art has already been touched on in the introduction to this book, and the previous chapter discussed examples of architectural decoration, which suggested that this issue is by no means as clear-cut as is often assumed. This chapter will continue that discussion, looking first at religious and then at more secular writings on the fine and decorative arts, and then at the practices and tastes of specific patrons.

The Arts and the Authorities

60. Iranian silk velvet coat, early 17th century. Height 4' (1.23 m). Livrustkammeren (Royal Armoury), Stockholm.

The production of this sort of luxury textile flourished under the interventionist royal patronage of the Safavid shahs.

Those Muslims who found image-making of any sort unacceptable could draw upon the teachings of early Islam to justify their views. According to the Koran (5:92): "O believers, wine and arrow-shuffling,/idols [*taswir*] and divining-arrows are an abomination,/some of Satan's work; then avoid it." The word *taswir* can refer to any sort of image. In later centuries this word and related forms, derived from the root verb *sawwara*, were used to refer to painting in particular; but *taswir* could also refer to a

61. Seljuq relief sculpture of an angel from the citadel of Konya in Anatolia, Turkey, c. 1221. Stone, 60 x 37" (153 x 94 cm). Ince Minare Museum, Konya.

One of a pair of angels sculpted for the entrance to the Seljuq citadel in Konya. Perhaps the image was intended to protect the citadel magically. Although many Muslims disapproved of graven images, figural sculpture was produced in various parts of the Muslim world, especially in Seljuq Turkey (see FIG. 89).

sculpture and more particularly an idol, and it is all but certain that, in the context of the seventh century, the original Koranic proscription applied only to pagan idols (FIG. 62) and not to all and any forms of figurative representation by artists. (Muslim fear of statues as foci for the worship of pagan gods shaded into Muslim fear of statues as devices for the practice of sorcery. The Chaldaeans and Nabataeans of Syria and Iraq were particularly associated in the minds of their Arab conquerors with the manufacture of statues and talismans for magical purposes.)

However, in the centuries that followed, some religious scholars did interpret Koranic texts in an all-embracing manner. They also found support for their iconophobic position in *hadiths*. Thus, for example, the Prophet was alleged to have declared that "An angel will not enter a house in which there is a dog or a painting." Since God was the great *musawwir* (fashioner or shaper), anyone who tried to shape images in the form of living things was seeking to arrogate to himself godlike powers. The Prophet was also reported to have said: "Those who make these pictures

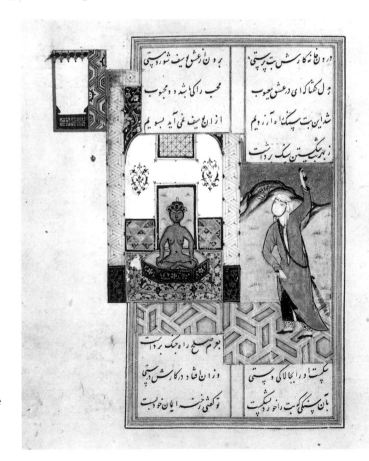

62. Persian miniature of Zulaykha destroying an idol, from the *Sifat al-Ashiqin*, (*Attributes of the Lovers*), 16th century. Illuminated manuscript, 7¾ x 4¾" (19.7 x 12.1 cm). British Library, London.

The *Sifat* was written at some point in the 16th century by al-Hilali (d. 1528), a Turk who wrote in Persian.

will be punished on the Day of Judgement by being told: Make alive what you have created."

It is important to acknowledge that the guidance provided by *hadiths* did not run all one way. Some suggest a limited tolerance of figurative imagery. Thus, though the Prophet had destroyed all the images of gods in the pre-Islamic pagan shrine of the Kaaba in Mecca, he allowed a painting of the Christian Virgin with the infant Jesus to remain; and, as the Prophet's child bride Aisha was known to have played with them, dolls were allowed for girls and were held to foster maternal instincts.

The copying of trees, plants, and buildings by artists was generally held to be permissible, although some religious authorities maintained that people and other living creatures should not be shown with shadows. (The depiction of cast shadows is indeed rare in Islamic painting.) There are some surviving manuscript illustrations in which the necks of all the humans and animals have been cut across with a pen (FIG. 63), so that they may be deemed to be technically the representations of dead things.

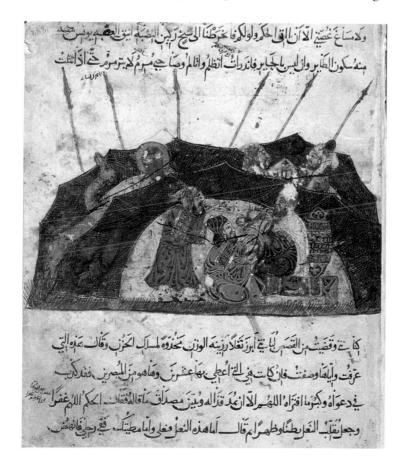

63. Miniature from a copy of the *Maqamat* of al-Hariri (1054–1122), showing a Bedouin encampment and figures, 13th century. Illuminated manuscript, 10½ x 8½" (26.5 x 21.5 cm). State Hermitage Museum, St. Petersburg.

The necks of the figures have been scored across at a later date by a pious puritan.

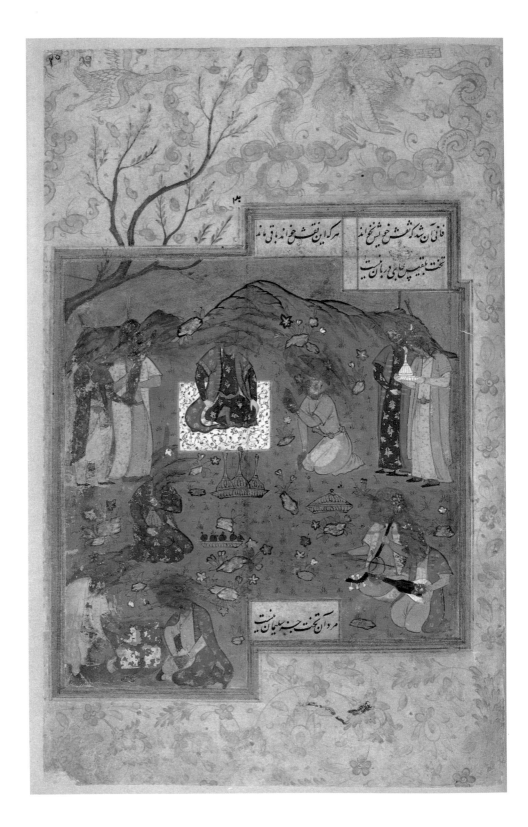

According to one story, a painter asked a *hadith* specialist: "But once and for all, am I not to practise my trade and represent animate beings?" "Yes," replied the specialist, "but you can always chop the animals' heads off so they won't look alive and you can do your best to make them look like flowers" (FIG. 64).

Greed and ostentation were similarly criticised. According to the Koran (9:34), "Those who hoard gold and silver and do not spend it in the path of the Lord, tell them about a painful punishment." One *hadith* reported that the Prophet had said: "He who drinks from a silver vessel will have hellfire in his belly." Similar *hadith*s reinforced a populist, anti-elitist hostility to all forms of extravagance. Ahmad ibn Hanbal (d. 855), a famous transmitter of traditions concerning the Prophet, advocated a narrowly literal observation of Islamic doctrines, rituals, and everyday practices as they had been observed among the first generation of Muslims.

However, some (non-Hanbali) casuists argued that, though it was forbidden to drink from gold or silver vessels, it was permitted to eat off them. Others held that it was wrong to drink or eat from them, but that nevertheless there was no ban on their manufacture. The fourteenth-century globe-trotter Ibn Battuta described a Persian emir serving some of his guests on gold and silver, while the more pious were given wood and glass vessels. The widespread repugnance felt by the more strictly devout Muslims towards drinking from vessels of precious metal must surely have been one of the factors behind the production both of plainer containers (FIG. 65), and later of ones of glass and ceramics with lustre or gilded decoration. Inlaid brasswork, in which the inlaid gold or silver formed only a small component in the decoration of the vessel, must also have been produced, in part at least, to cater for those who could not bring themselves to eat or drink from cups and dishes of pure gold or silver. In such cases religious constraints actually stimulated new forms of art (FIG. 66).

Dislike of ostentation also had implications for architecture. The Prophet was reported to have remarked: "Verily the most unprofitable thing that eats up the wealth of a believer is building." Large buildings were a sign of arrogance, extravagance, and decadence, and, according to a *hadith*, excessive building (*tatawul fi al-bunyan*) would be one of the signs of the Last Days. Pious traditionists preached that the men who built mosques of reeds were better than those who came later and built theirs of mud bricks, and they in turn were better men than those who built mosques with fired bricks and gypsum mortar.

Opposite

64. Persian miniature of a princely *fête champêtre* from a copy of Nizami's *Khamsa*, 1574–75. Illuminated manuscript, whole page 9¾ x 6" (25 x 15.5 cm). India Office, London.

The faces of the figures were erased by a later owner of the work.

Below

65. Bowl with aniconic, calligraphic decoration from Abbasid Iraq, 9th–10th century. Earthenware painted in cobalt blue with an opaque white glaze, height 2½" (6.4 cm), diameter 8" (20.4 cm). Khalili Collection.

The inscription translates as "Blessing. Made for Salih."

66. The "Bobrinski Bucket," 1163. Inlaid brass, height 7¼" (18.5 cm). State Hermitage Museum, St. Petersburg.

The famous "Bobrinski Bucket" was made in Herat in 1163. An inscription on its rim declares that it was made for Rashid al-Din Azizi ibn Abul Husayn al-Zanjani (perhaps a rich Herati merchant). However, the likelihood is that this object of high quality was essentially finished before a buyer was found and that the name of the "patron" was only added after the sale was agreed. Increasing numbers of inlaid brass objects have survived from the 12th century onwards, and such pieces, with designs inlaid in gold and silver, were often made for middle-ranking emirs and merchants and imitate the decoration of the gold and silver objects made for rulers.

The Umayyads, particularly Hisham (r. 724–43) and Walid II (r. 743–44), were great builders, but their architectural enthusiasm provoked considerable hostility among their subjects, so much so that Yazid III (r. 744) was forced to pledge in his accession oath not to lay brick on brick or stone on stone or to build canals. Similarly, in Egypt in the 1350s there was a lot of hostility to the extravagance of the Mamluk sultan al-Nasir Hasan (1334–62) and his building mania. In particular, there was opposition to the construction, beginning in 1356, of a grandiose mosque in Cairo, which was designed to house his own tomb. When one of its minarets collapsed in 1361, killing three hundred people, this was taken by some as an omen and as God's judgement on the Sultan's overweening architectural ambition (FIG. 67). Indeed, he was deposed a couple of months later.

The views of the puritans and rigorists tended to be heard in periods of crisis – plague, famine, or military defeat. At such times, decrees might be issued against ostentation in dress, the wearing of gold or silver, and all forms of moral laxity. But the fact that sumptuary legislation was so frequently repeated indicates that it was never more than temporarily effective. However, if the policemen of the arts were rarely successful in imposing their interpretation of the religious law on artists, craftworkers, and consumers, at least their writings shed an interesting light on some aspects of Islamic art and artistic taste.

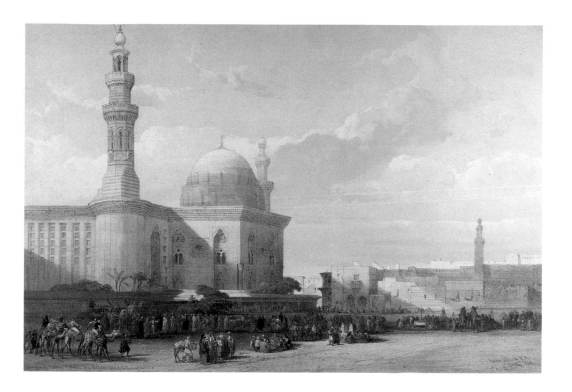

Regulating the Market Place

Pious "policemen" produced a variety of treatises that sought to control and regulate the arts and crafts. One such type of book dealt with *niya*, or (good) intentions in ritual, work, and life. Taj al-Din al-Subki, chief *qadi*, or religious judge, in Damascus in the 1360s, produced the *Kitab Muid al-Niam wa-Mubid al-Nikam* (*The Restorer of Favours and the Restrainer of Chastisements*), which contains some detailed information on the perception of various artistic activities of the time. When al-Subki discusses what sultans should and should not do, he states that they should not build mosques only to have their own name glorified (it is worth remembering that al-Subki was writing shortly after the building of the Sultan Hasan Mosque). In his discussion of the duties of house painters, he warns them that they may not portray living things on the walls; and all kinds of gilding of objects were banned, save for gilding copies of the Koran.

The *muhtasib*, or market inspector, worked under the supervision of the chief *qadi*, and he derived his authority from a verse in the Koran (7:157): "Let there be one nation of you, calling to good, and bidding to honour and forbidding dishonour; those are the prosperous" (FIG. 68). Amongst other responsibilities the *muhtasib* inspected weights and measures and the quality of

67. Nineteenth-century engraving by David Roberts of the Sultan Hasan Mosque in Cairo, showing its one remaining portal minaret.

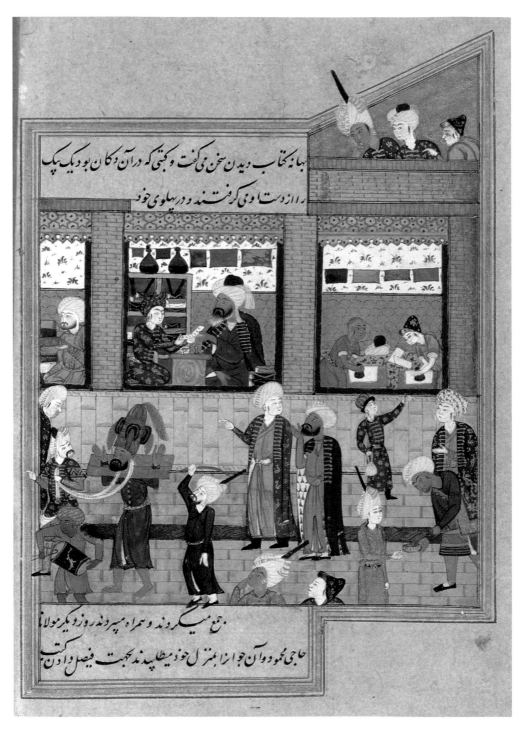

68. Persian miniature of the punishment of a book thief, from the
Majalis al-Ushshaq, painted c. 1560. Illuminated manuscript, whole
page 11 x 6" (27.5 x 15.5 cm). Bibliothèque Nationale, Paris.

goods in the market. Treatises on *hisba* or market inspection drew their moral authority from the duty of every Muslim to promote right and prevent wrong. *Hisba* manuals were produced to guide this official in the exercise of his wide-ranging remit, and these can include valuable information on the arts and crafts. Thus, for example, in the twelfth century, a *muhtasib* known as Ibn Abdun produced a *hisba* manual, which was designed for local use in Seville: he lays down the regulations for the sizes of building materials, ordains that tiles and bricks must be made outside the city walls, and says that glassmakers must be stopped from making glasses intended for wine drinking (a similar prohibition applied to potters).

A treatise by Ibn Ukhuwwa (d. 1329), who wrote during the Mamluk period, shows that the *muhtasib*'s role was not purely negative. He also acted to enforce decent standards of craft production. When he discusses potters and porcelain makers, the author goes into technical detail: "To oversee them shall be appointed a trustworthy man who knows their craft and corrupt practices. The *zubadi* vases [made of cream-coloured porcelain] shall be made only of ground pebbles and not of sand, except what is imported and used for feasts. The porcelain must be of an even texture, of the accustomed mould, perfectly glazed … They must be sound so that food can be placed in them without their breaking in the hand of any person holding them." Faulty vessels must be set aside and used for purposes other than food. The *muhtasib* appointed *arif*s (fiscal agents, overseen by the *muhtasib* himself) to act as representatives for the various trades, rather than leaving this to independent spokesmen from the guilds themselves. Thus, for example, Ibn Bassam (the fourteenth-century author of yet another treatise on *hisba* in the Mamluk period) stipulates that there should be an *arif* to represent the glassmakers.

The subject matter of *hisba* overlapped with those treatises that dealt with *bida*, or reprehensible and un-Islamic innovation. Katib Celebi, a prolific seventeenth-century Turkish writer, explains *bida* thus: "By innovation is meant any new development in matters sacred or mundane appearing during or after the second age [that is, after the period of the first four 'Rightful' caliphs and the Umayyads]; that is anything which did not exist in the time of the Prophet (on him be the peace and blessing of God) and his noble Companions (God be pleased with them), and of which there is no trace in any of the three categories of *Sunna* and concerning which there is no tradition." But Katib Celebi tempered the strictness of this view with a pragmatic realism. He held that good innovations included such things as minarets and the manufacture of

books, while bad innovations were things like heresy and newly invented forms of worship. Celebi also thought that in the cases of innovations that were disapproved of (rather than strictly forbidden) but that had taken a hold on the community, there was no point in fighting popular custom.

Early Patrons and Patronage of the Arts

The Umayyad caliphs did indeed commission the decoration of palaces with an abundance of figurative imagery, but images of men and animals do not feature in the decoration of religious buildings of this period. Thus, for example, the mosaic programme in the Great Mosque of Damascus features buildings, trees, and plants in profusion, but no people appear in the landscapes (see FIG. 42). Evidence that the depiction of living creatures was felt to be inappropriate in a religious context can also be found in the outer walls of the Jordanian desert palace of Mshatta, where three out of four of the walls have animals moving through the foliage carved into the stone, whereas the fourth wall, the *qibla* wall, shows vegetation only (FIG. 69). The earliest Islamic coinage had figurative decoration (FIG. 70), like earlier Byzantine and Sasanian coins. But after the currency reform of the Umayyad caliph Abd al-Malik (r. 685–705) in the 690s, coins bore inscriptions in

Below and right
69. Details of the decoration on the wall of the palace of Mshatta, Jordan, probably 740s. Stone, height of whole 16′7″ (5 m). The detail below shows the *qibla* wall, decorated with vegetation but no birds or beasts. The detail of the Mshatta gate tower, right, shows a floriated triangle and lions in vegetation. Staatliche Museen, Berlin.

Left
70. Obverse (far left) and reverse (left) of a dinar from the reign of Abd al-Malik, with figurative imagery, c. 691–93. Gold, diameter ³/₄″ (2 cm). Khalili Collection.

Below
71. Umayyad aniconic coin, 705. Gold. Ashmolean Museum, Oxford.

Arabic and nothing else (FIG. 71). Most of the dynasties that came after similarly minted coins with inscriptions but no imagery.

Pressure from Sunni and Shia rigorists sometimes persuaded rulers and patrons to turn against the patronage of sculptors and painters. This could give rise to acts of iconoclastic vandalism. Thus the paintings in the Jawsaq al-Khaqani palace in Samarra were obliterated by the notoriously austere Abbasid caliph al-Muhtadi (r. 869–70). According to the chronicler al-Masudi, writing in the early tenth century, the Caliph "cut down on the luxury of clothes and carpets, of food and drink. He had the vessels of gold and silver brought out of the royal treasury and broken up in order to be converted into dinars and dirhams. On his orders the painted figures that decorated the rooms were obliterated." Sometimes religious puritans turned against pre-Islamic artefacts. For example, in 722 or 723, Yazid II (r. 720–24) ordered that all the relics of pre-Islamic paganism in Egypt should be destroyed, though this inevitably proved to be impractical. (Muslim assaults against the pre-Islamic legacy in Egypt continued throughout the medieval era – in 1378 the sphinx lost part of its face to the assaults of a fanatical Sufi; FIG. 72.)

Below
72. The Sphinx of Giza (in Arabic *Abul-Hawl*, or "Father of Fear"), showing the damage to its nose.

Despite the name of this particular example, in general sphinxes feature in Islamic art as good omens.

Textiles and Patronage
Textiles came to assume particular importance in the ritual of the Abbasid court and were the object of specific patronage. Indeed, textiles were intimately linked to the sense of identity of the Abbasid dynasty: the Abbasid caliph, his officers, and partisans wore a uniform of black, which had been adopted as the Abbasid colour not only

because of its apocalyptic overtones, but also because the armies that had risen against the Umayyad dynasty had fought under black banners (in fulfilment of a saying of the Prophet that "a party shall come from the East with black banners"), and because the wearing of black could be interpreted as mourning for the sons of Ali, slain by the Umayyads. The quality of Abbasid textiles was such that two centuries later some examples were part of the treasury of the Fatimid caliphs in Cairo, and had actually increased in value, so eagerly were they collected.

The distribution of robes by the caliph was a sign of his favour and no important official appointment was made without the bestowal of one to mark the event. The robes distributed to official appointees and other favoured persons were made at a state-run textile factory known as the Dar al-Tiraz. A *tiraz* robe characteristically had a band of inscription on the upper part of the sleeve that gave the place and date of manufacture and the name of the caliph. According to the North African historian Ibn Khaldun (1332–1406), "It is part of royal and governmental pomp and dynastic custom to have the names of rulers or their peculiar marks embroidered on the silk, brocade, or pure silk garments that are prepared for their wearing." Sadly, no examples of Abbasid textiles have survived, but Ibn Khaldun informs us that such robes were designed to increase the prestige of the ruler and those whom he honoured by bestowing such garments upon them.

The collecting of textiles became one of the most important ways of storing wealth: the caliph Harun al-Rashid, for example, on his death in 809 left four thousand pieces of a certain kind of decorated cloth called *washi*. Al-Masudi has also left us details of the way in which a woman's taste influenced the production and patronage of certain types of textiles. Zubayda, Harun al-Rashid's wife, was famous for her extravagant display and introduced "the fashion for slippers embroidered with precious stones." She also established the custom of uniformed page girls wearing turbans and clothes produced in royal *tiraz* factories. Al-Masudi informs us that "it was then that the fashion for having young slave-girls with short hair, wearing *qabas* [tight-sleeved coats] and belts, became established at all levels of society."

Female Patronage

There can be no doubt that women played a significant role as patrons of art and architecture (though no women architects or painters are known). For example, Hubshiyya, the Byzantine mother of the Abbasid caliph al-Muntasir (r. 861–62), built an octagonal canopy, the Qubbat al-Sulaybiyya, across the river from

Samarra. This is the earliest surviving Islamic mausoleum. However, beyond the fact that she was of slave origin and that she was responsible for this building, we know nothing about her. Arab writers felt a compunction about mentioning women and it is often, alas, the case that we know much more about the building than about the woman who founded it. For example, the Palace of the Lady Tunshuq al-Muzaffariyya, which was completed some time around 1388, is one of the most imposing medieval buildings in Jerusalem. Yet it is impossible to discover who the Lady Tunshuq was. She must have been wealthy, but no chronicle provides any conclusive evidence regarding her parents, husband, or children, or where she was born and lived before she arrived in Jerusalem.

To venture a generalisation, it seems women enjoyed more status under Turko-Mongol regimes from the thirteenth century onwards than they had previously done in Arab or Iranian society. From the fourteenth century onwards, queens and princesses begin to appear enthroned as equals in illustrated Persian manuscripts. In Ottoman Turkey two mosques, one at Uskudar and the other at Edirnekapi (a district of Istanbul), were commissioned from Sinan by Mihrimah, daughter of Suleyman the Magnificent. All the same, even when a foundation bears a woman's name, it is not always clear that the woman named actually got the building under way. In 1539 Sinan built a grand mosque-college complex (including a *madrasa*, a soup kitchen, an elementary school, a hospital, and a fountain) in the Aksaray quarter of Istanbul. Although the complex bears the name of Haseki Hurrem, Suleyman's wife, it is reported that the Sultan kept the building secret from his wife and only brought her to it when it was completed. It is, in any case, absolutely clear that Suleyman assisted her in the realisation of her foundations elsewhere in Istanbul and in the rest of the Ottoman empire. Nonetheless, it must be true that the imperial harem was a major customer for portable luxury objects. It is unfortunate that we are still so poorly informed about how taste within the harem was formed.

Patronage under the Mongols and Timurids

As has been said, in the early centuries of Islam there were no royal workshops as such, and craftworkers were hired and brought together for specific projects. However, libraries seem to have become important centres for the sponsorship of the arts in the period after the Mongol invasions, under the Ilkhans and their successors in Iran. It is possible that the source of inspiration for this institutional

innovation may have come from the Chinese academies of history and painting with which the Mongols had become familiar in the east. One broad consequence of this development is that illustrated books, and those who worked on books, on their calligraphy, their page layout, their gilding, and the designs of the leather bindings, became of central importance for developments in other fields of art and architecture. Thus under the Timurids designs that were first developed for books provided templates for work done in other media – in stone-cutting, tiles, ceramics, mother-of-pearl, saddlework, and tent-making. (It is hardly possible to be dogmatic on such a matter, but it seems that in the early centuries of Islam it was the designs produced in work in precious metals that were then imitated in other media such as ceramics.) Chinese influence may lie behind the restrained and sombre palette seen not only in the illustrations to books like the "Demotte" *Shahnama*, but also in the dark colours favoured in the Iranian Sultanabad and *lajvardina* ceramic wares produced in this period (FIG. 73). The Mongol elite and in particular the Ilkhan Ghazan took a great interest in the history of their people as well as of the wider world that they had plans to conquer. This taste, which resulted in the production of illustrated histories, continued in the Iranian and Turkish cultural area under the patronage of such dynasties as the Timurids and the Ottomans.

Ghazan was credited by his vizier, Rashid al-Din, with a range of craft skills: the Ilkhan was reputed to be expert in woodwork and goldsmithery, he painted, and he made saddles, bridles, and spurs. The notion that a ruler, or indeed any leading member of the military elite, should possess some artistic or artisanal skill seems to have been widespread among the Mongols and Turks.

Timur's son and successor, Shah Rukh (r. 1405–47), seems to have regarded Ghazan as his exemplar. His patronage and that of his wife, Gawharshad (d. 1447), were conceived of in largely religious terms. Here it is worth noting that women played a much more important role both in politics and in art patronage in the Ilkhanid and Timurid empires than they had done under earlier Arab and Turkish regimes. Timur's chief wife, Saray Mulk

73. Iranian *lajvardina* plate, late 13th century. Glazed ceramic, diameter 14″ (35.7 cm). Louvre, Paris.

The remarkable state of preservation of this plate makes it clear that, like much *lajvardina* ware, it was for display rather than use.

Khanum, had built a *madrasa* opposite the Friday Mosque in Samar-qand. Another queen, Tuman-Agha, built a Sufi *khanqa* (foundation). Gawharshad commissioned a mosque-*madrasa* complex in Herat, as well as paying for restoration work or improvements on existing religious monuments.

Baysunqur, the son of Shah Rukh, who predeceased his father in 1434, was an expert calligrapher and bookbinder who also painted and wrote poetry. However, what makes him particularly interesting to students of Islamic artistic patronage is his establishment of what was effectively a design workshop in the 1420s. We know an unusual amount about this workshop because of an *arzadasht*, or petition document; this was a sort of progress report by the head of the establishment that was sent to Baysunqur around 1429. The workshop or *kitabkhana* (literally, a store for keeping books, but in practice a library and workshop for the production of manuscripts and other artefacts) employed forty calligraphers, plus designers, painters, bookbinders, stone-cutters, and workers on luxury tents. Some twenty-two projects in hand were reported on. Thus a great deal of artistic patronage was channelled through and overseen by a princely "library."

Not all the great patrons of the Timurid period were of royal blood. Mir Ali Shir Navai (1441–1501) was the courtier and cup-companion of Husayn Bayqara, the Timurid ruler in Herat from 1470 to 1506. Navai is chiefly famous today as the greatest poet to write in Chagatay Turkish. He was also a wealthy man and as such enormously important as a patron of architecture and art. He spent great sums of money perpetuating his memory through buildings; according to him: "Whoever builds a structure that is destined [to remain], when [his] name is inscribed therein,/For as long as the structure lasts, that name will be on the lips of the people." Navai was also a patron of the arts of the book. Bihzad, who was to become widely recognized as the greatest miniature-painter of his age (FIG. 74), was given a start in his career by being employed as head of Navai's library.

It is in part thanks to the *Baburnama* (*The Book of Babur*), the memoirs of the Timurid prince Zahir al-Din Babur, that we know about the activities of Navai and the Timurid artist-princes of Samarqand and Herat. Briefly ruler of Samarqand and later of Kabul, Babur ended up as ruler of north-west India from 1526 to 1530, where he founded the Mughal empire. Babur's memoirs reveal him to have been extremely aware of the beauty of landscape. His visual sensibility was shaped by his familiarity with Persian painting: when he saw a striking arrangement of apples and leaves on a particular tree, he commented that "if painters

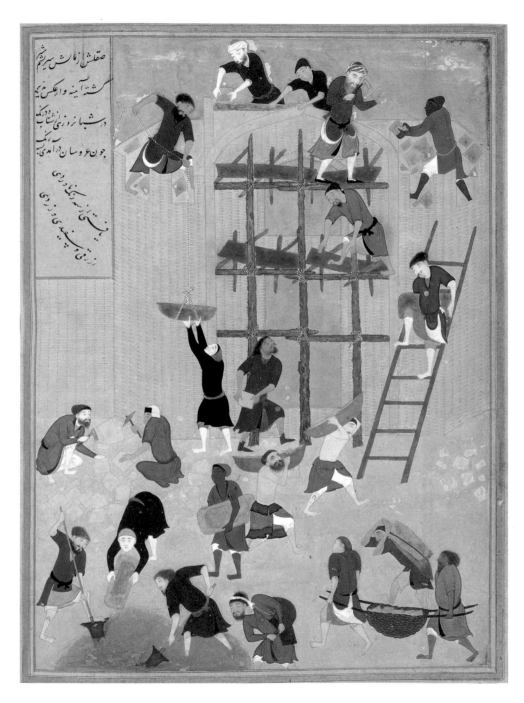

74. BIHZAD (c. 1450–c. 1530)
Miniature of the building of Khawarnaq castle from a copy of Nizami's *Khamsa (Quintet)*, 1494–95.
Illuminated manuscript, 7 x 5¹/₂″ (17.5 x 13.5 cm). British Library, London.

Bihzad was a master of genre scenes. Although this purports to show the construction of a pre-Islamic palace, in fact it illustrates building practices in Bihzad's own time.

exerted every effort they wouldn't have been able to depict such a thing." Clearly, he was a connoisseur and critic of painting, but perhaps also a rather naive one. Thus, in commenting on the art of Bihzad, he confined himself to remarking that "He painted extremely delicately, but he made the faces of beardless people badly by drawing the double chin too big. He drew the faces of bearded people quite well."

Safavid and Later Patronage

Since the Timurid rulers were widely admired, their patronage of artists was also imitated, both by their neighbours, such as the Ottoman Turks, and by the dynasties that came after them – including the Mughals in India, the Safavids in Iran, and the Uzbek Turks in Transoxania. A scholar advised one Uzbek ruler in the following terms: "The sultans of the age and the mighty *khaqans* [princes] have always retained a group of enchanting and marvellous minia-turists in the service of the lofty Throne in order to sharpen their wit and recreate their minds – something on which the peace and tranquillity of heart of all their subjects depends – and they have always shown them favour." By the sixteenth century, a ruler, even if he had little real taste for art, was more or less obliged to simulate such interest and it was felt that sponsoring buildings, luxury books, and other art objects was part of a ruler's duty.

Bihzad can be considered to be part of the Timurid legacy to the Safavid dynasty. It is said that when the Ottoman Turks invaded Iran in 1514 one of Shah Ismail's chief concerns was to keep Bihzad safely hidden in a cave. In 1522 Bihzad was appointed to head the Safavid *kitabkhana*, as the head of its calligraphers, painters, illuminators, margin-drawers, gold-mixers, and gold-beaters.

The so-called "Houghton" *Shahnama*, named after an American collector who once owned the manuscript, should really be known as the "Shah Ismail" *Shahnama* since it was almost certainly Shah Ismail who first got the commission under way in 1522 (FIG. 75). Every page – and there were 759 folio pages – had to be gilded, sized, and burnished. The book, which contained more than 250 illustrations, may have taken ten years to complete. Three senior artists presided over its illustration. Such a project went slowly and the work was only finished well into the reign of Ismail's son and successor, Shah Tahmasp (r. 1524–76). This and similar lavishly illustrated books have been discussed as if they were produced as imperial propaganda, yet this cannot be wholly the case, for only a privileged few would have had access to them. If these books were preaching, it must have been mostly to the converted.

75. Detail of a miniature of the court of Gayumars from the "Tahmasp" or "Houghton" *Shahnama*, 1525–35. Illuminated manuscript, 13¹/₂ x 9" (34.2 x 23.1 cm). Private collection.

Illustrated manuscripts of the *Shahnama* were produced in the 15th century, most notably for the Timurid prince Baysunqur in Herat in 1431 and for his kinsman Muhammad Juki, also in Herat, around 1440. The so-called "Houghton" *Shahnama*, of the early Safavid period, however, is by common consent the most spectacular.

Tahmasp's pious withdrawal late in life from the arts and the closing down of the Tabriz workshop had the effect of dispersing Iranian artists to India, Turkey, and Uzbekistan. However, the prospects for artistic employment in Iran revived a few decades later. Shah Abbas I (1587–1629) revered artists and craftworkers and he is alleged to have kissed the hand of Ali Riza (d. c. 1627) and held the artist's candle for him while he painted. As a vigorous reforming monarch, Shah Abbas recruited large numbers of slaves, mostly of Georgian and Circassian origin, who were trained in the palace school for elite positions in the palace, the administration, and the army. Not only were these slaves trained in military and administrative skills, they were even taught poetry and painting. It was not unknown for officers in the Safavid army to abandon their military employment in favour of art. Sadiqi Beg (1553/54–1609/10) was a Turkish soldier who turned painter and ended up as Shah Abbas's librarian. The Frenchman Jean Chardin, who visited Iran at the end of the century, reported that the Shah paid seventy-two painters an annual salary. It was permissible for library staff to take on private commissions when there was not enough work for them in the library. The traveller Pietro della Vale (1586–1652) mentions an Italian shop selling Venetian paintings in Isfahan and it is also known that Shah Abbas patronised the work of some European painters. The Shah's interest in the arts does not seem to have been purely aesthetic. He was perhaps more interested in public works (FIG. 76) and in promoting industry for export than he was in commissioning the production of luxury books for the pleasure of the court. He did much to encourage silk production (a royal monopoly; FIG. 60, see page 79) and large fine carpets were produced by the royal workshops in Isfahan.

Mehmed II

The artistic patronage of Mehmed II (r. 1451–81), the conqueror of Constantinople, broke with Islamic tradition. Mehmed's conquest had given him possession of one of the great cities of the ancient world, and he thought of himself not just as the heir of the caliphs and sultans who had gone before him, but also as the successor to the Byzantine emperors and even as the heir of

Caesar and Alexander. Mehmed employed Greek painters and collected Greek icons. He employed scholars of Greek and Latin to read to him from the classics and took measures to preserve the city's statuary. He also encouraged a number of Italian artists to work in Istanbul (see FIG. 32).

However, one should not exaggerate the impact of Western artists on Ottoman Turkish art. In the long term, developments pioneered by the palace workshop and by indigenous industries were certainly more significant. The Ottoman palace employed hundreds of artisans known as the *Ehl-i Hiref*, or "Community of the Talented," including painters, goldsmiths, and bookbinders. The far-reaching role of the designers working in the palace workshop can be seen in the designs of the "Large Medallion" Ushak

76. The exterior of the Safavid Royal Mosque (Masjid-i Shah) in Isfahan, 1611–37.

The arabesque decoration of the dome over the sanctuary area makes use of glazed tiles in a way that is typical of Safavid architecture.

77. "Large Medallion" Ushak carpet, western Anatolia, c. 1500. Wool, 17'10" x 8'6" (5.4 x 2.6 m). Private collection.

carpets (FIG. 77). Ushak is a region in western Anatolia, but the patterns of the carpets produced there – floral designs of the International Timurid style – surely derive from court designs for bookbindings and frontispieces. (More generally, the sort of carpet design with a circular or ovoid medallion in the centre and quarter medallions in the corners, framed by an outer border, derives from and mimics the designs for bookbindings in leather and other materials produced by the librarian-designers.)

The development of Turkish luxury textiles (many of which were exported to Europe) would have been inconceivable without the active role of the court. A similar point can be made about ceramic production. Sultan Selim I's sacking of the Safavid Iranian capital of Tabriz in 1514 and his conquest of Mamluk Syria and Egypt in 1516–17 led, among other things, to the acquisition of vast quantities of Chinese porcelain. Early Iznik ware produced in north-west Anatolia from the 1470s onwards – which seems to have been made in the first instance for use by the lower ranks in the palace service – sought to imitate designs of Chinese blue-and-white (such as bunches of grapes with vine leaves). Other Iznik products made use of designs from the courtly repertory of the International Timurid style – designs that were probably copied from books produced under the Sultan's patronage.

Wider markets were soon found, however, and in the long run Iznik bowls, plates, tankards, and jugs were mostly purchased by commoners, and there is heraldic evidence that some Iznik ware was specially commissioned by patrons in Europe. Nevertheless, despite this broad market for their products, it is doubtful whether Iznik potters could have managed without the additional patronage of the Ottoman palace. This was because the sultan and his ministers ordered ceramic tiles in vast quantities from Iznik in order to line the walls of their mosques and other buildings (FIG. 78). When grand architectural projects declined in the seventeenth century, the fortunes of the potters in Iznik also languished. Thus Ushak and Iznik were both heavily dependent on the state, though not exclusively so.

Suleyman the Magnificent

Suleyman the Magnificent (r. 1520–66; FIG. 79) was, as his Western nickname suggests, the most lavish of patrons. But it should also be stressed that, as a poet himself, his first interest was poetry

78. Panel of four Iznik tiles from the tomb of Sultan Selim II at Ayasofya, completed 1574–75. 9⅚ x 9⅚" (25 x 25 cm). Private collection.

and it was to poets that he paid active attention. As far as the visual arts were concerned, calligraphy attracted the most attention from Suleyman and, for that matter, from other Ottoman sultans. Mustafa Ali's late sixteenth-century *Menakib-i Hunerveran* (*Tales of the Skilful*), on the lives of Ottoman artists, devoted most of its pages to calligraphers, for the author took it for granted that calligraphers had a higher status than painters. It is true that Suleyman occasionally visited the Iranian painter and draughtsman Shahquli (d. 1555/56) and watched him work. He also conferred with his chief architect, Sinan (1491–1588). However, there is not much evidence that he actually communicated directly with the painters and designers in his service. In practice, much of what one thinks of as Suleyman's patronage would have been in the hands of his officials, particularly his grand viziers. Again, though the Suleymaniye Mosque in Istanbul bore the Sultan's name and its scale boasted of his imperial power, it was in large part paid for by public subscription.

As was the case with the Timurids, female members of the royal house were important as royal patrons. Suleyman's wife, Hurrem (d. 1558), and daughter, Mihrimah, commissioned and endowed some of the finest buildings of the age (FIG. 80). Sinan,

the royal architect, worked not only for Suleyman's wife and daughter, but also for the Sultan's viziers. The mosques built by Sinan for the Sultan, his women, and ministers should not be thought of as providing employment only to architects and masons. In the case of the Suleymaniye Mosque (built 1550–57), for example, massive quantities of Iznik tiles (the first big commission given to Iznik) were required to cover its interior walls. Additionally, Korans, mosque lamps, stained-glass windows, carpets, and other types of mosque furniture were specially commissioned for the complex. Thus the history of the so-called "minor arts" in Ottoman Turkey was closely dependent on the grand building projects. Those grand building projects were in turn dependent on confidence and money. The high-water mark of the Ottoman empire came with the Turkish siege of Vienna in 1683. Ottoman architects in the eighteenth and nineteenth cen-

79. MELCHIOR LORICHS
(1527–83)
Engraved portrait of
Suleyman the Magnificent
(r. 1520–66), 1559.
British Museum, London.

turies continued to put up fine buildings in Istanbul and the provinces, but the scale of the projects tended to be smaller and there was less call for Iznik tiling and other furnishings. The sultan's and the royal workshop's roles in determining the development of the arts ceased to be so central.

Similarly, in both Turkey and Iran, the great age of patronage of luxury manuscript volumes was coming to a close. Illustrated books were replaced in the favour of royal collectors by single-page drawings and paintings and this gave rise to the presentation album (*muraqqa*). Commoners could afford single-leaf paintings and drawings. The heyday of royal patrons was over; the age of bazaar art had come.

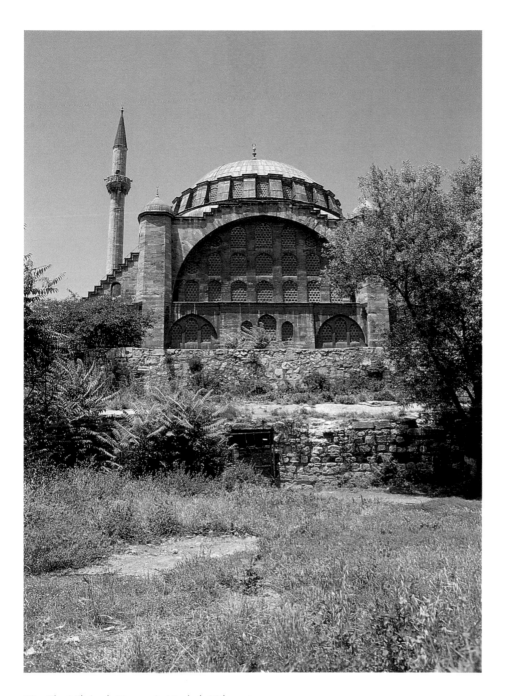

80. The Mihrimah Mosque in Istanbul, 16th century.

Commissioned from the architect Sinan by Suleyman's daughter, Mihrimah, this is one of the great imperial mosques of Istanbul. Like many of Sinan's buildings it exploits its location, being placed in a commanding position on one of the hills of Istanbul. The site originally included many subsidiary buildings, including a *madrasa*, a school, a *hammam*, and shops, but these have been damaged by earthquakes and in some cases have disappeared entirely.

FIVE

Palace Life

S ultan Mahmud of Ghazna (r. 998–1030) once commanded the building of an edible pavilion made out of halva (a sesame sweetmeat). The Seljuq sultan of Anatolia, Ala al-Din Kayqubad (r. 1219–37), caused a palace of glass to be built. Ulugh Beg, grandson of Timur and ruler of Samarqand from 1447 to 1449, ordered a ceramic tower from China to serve as the display pavilion for his collection of miniature paintings. Many Muslim palaces and pleasure chambers built out of brick and stucco proved no more durable than these. We have to rely mostly on medieval literary sources to discover what these buildings looked like and how they were used.

There is no one word in these medieval sources that corresponds precisely to the English word "palace." The word that medieval Arabs used when they discussed what was evidently a palace was *qasr*, which covers a far wider semantic range. *Qasr* can also mean castle, pavilion, belvedere, residential compound, isolated construction, or a permanent building of stone. (Another term, *dar al-imara*, or house of government, is also sometimes used for a palace, although it has more the sense of an administrative building rather than a royal residence.) In Persian and Turkish, the word *saray* is used in place of *qasr*, from which comes the Italian and English word "seraglio."

The Umayyads and the Desert Palace

As we shall see, the precise sense of the word *qasr* may have implications for the way in which we think about some of the earliest Arab palaces – those built in the Umayyad period. These palaces were concentrated in Syria and Palestine, where the power of those early caliphs was based. Naturally, the important palaces and government residences were in the towns such as Damascus but

81. Majnun before Layla's tent, from a Safavid copy of Jami's (1414–92) *Haft Awrang (Seven Thrones)*, 1556–65. Illuminated manuscript, 13½ x 9" (34.2 x 23.2 cm). Freer Gallery of Art, Washington, D.C.

very little has survived of those buildings. The so-called "desert palaces," or *qusur* (the plural of *qasr*), have survived better and have attracted more attention from archaeologists and historians. These "palaces" include Khirbat al-Mafjar, Mshatta (see FIG. 69), Jabal Sais, Qasr al-Hayr al-Gharbi (FIG. 82), and Qasr al-Hayr al-Sharqi. The precise purpose of these country residences has caused much debate in recent times, and a variety of explanations for their proliferation has been put forward.

First, it must be remembered that whatever the countryside around these ruins may look like today, Syria and Palestine in the seventh and eighth centuries were lusher and much more wooded than they are now. In some cases at least, such residences could have served as centres for the administration of agricultural estates, and thus they can be compared to the rural villas built by Andrea Palladio (1508–80) in northern Italy in the second half of the sixteenth century. Additionally or alternatively, they could have served as hunting lodges.

Second, the rural location of these palaces may have served a political purpose, as they allowed the Umayyad caliphs, their clan, and their administrators to make close contact with Arab

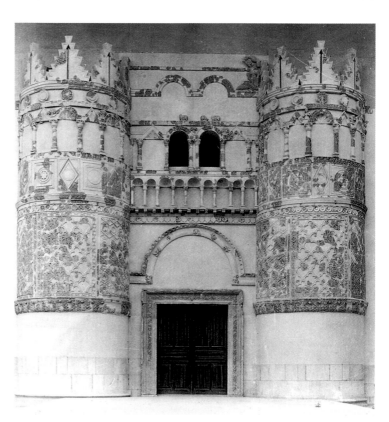

82. The gateway of Qasr al-Hayr al-Gharbi, Syria, 727. National Museum, Damascus.

This is the earliest surviving Islamic example of a facade with stucco decoration.

83. Dancing girl in caryatid pose, mid-8th century. Fresco on the south wall of the bathhouse. Qusayr Amra, Jordan.

The decorative programme of the bath complex is remarkable for its well-preserved state, but chiefly for its variety, both in subject and style. It includes dancing girls, signs of the zodiac, and animals.

tribespeople. Not only would the tribal chiefs have been received and entertained in them, but the palace complexes, which customarily included a *hammam*, or bathhouse, a mosque, and storage rooms, may have provided the local communities with services.

Third, such palaces may have served the Umayyad princes as places of escape from the heat of the summer in the cities, from plague epidemics, and from the cares of administration, and for pleasures best kept from the disapproving surveillance of the more pietistic of their subjects (FIG. 83). Arabic literature of the time bears witness to a cult of *nazh* – of fresh air and pleasurable remoteness. Abu'l-Faraj al-Isfahani's (897–967) literary anthology, *Kitab al-Aghani* (*Book of Songs*), provides a rich source for the *dolce*

84. Reconstruction drawing of the bathhouse at the palace of Khirbat al-Mafjar, 8th century.

Those sections of the palace of Khirbat al-Mafjar that have survived are richly decorated with figurative sculpture, stucco carvings, and mosaic floors. The mosaics display Byzantine technique and imagery, while the stucco is in the Sasanian style.

vita style enjoyed by the Umayyad prince Walid, probably at Khirbat al-Mafjar in the years prior to his brief tenure of the caliphate in 743–44. Walid used the palace as a place of pleasure and as a setting for endless parties, in which he sat surrounded by singers and dancing girls. The pool was sometimes filled with wine, and the bath-house doubled as an audience chamber (FIG. 84).

Yet though Khirbat al-Mafjar and some of the other desert palaces may have been richly decorated, in other respects, compared to the European concept of a palace, the facilities they offered were quite rudimentary. Few of the rooms seem to have had specific functions or permanent furniture. There were no corridors, so to reach a particular room one often had to pass through another. The rooms themselves were almost all fairly small and dark and would have accommodated only a limited number of people. Almost certainly the reason for these features is that Umayyad princes did not reside in their "palaces" in quite the same way that their European contemporaries did. Rather, the buildings of brick and stone – the bathhouse, the mosque, the storerooms, and so on – were ancillary to the life of a prince and his courtiers, which took place above all in tents. Living under canvas (or more often silk or brocade) was not a unique enthusiasm of the Umayyads. It was a pervasive feature of Islamic culture, and one to which this chapter will later return.

Abbasid Palaces: Baghdad and Samarra

We would know more about Umayyad palaces had not so much been deliberately destroyed by the Abbasids who came after them. The essayist al-Jahiz (d. 869), who worked in Basra, commented:

> Kings and princes are naturally inclined to efface the traces of their predecessors, so as to destroy the memory of their enemies. For this reason they have destroyed most towns and fortresses. It happened in the time of the [Sasanian] Iranians

and among the pre-Islamic Arabs. Things have hardly changed with the coming of Islam. Thus the caliph Uthman had the Tower of Ghumdan knocked down and did the same with the ancient monuments of Medina. Ziyad [Ziyad ibn Abihi (d. 675/76), an Umayyad governor in Iraq] destroyed every palace and work of art which had belonged to Ibn Amir [Ziyad's predecessor], just as our rulers [the Abassid caliphs] have destroyed buildings erected in various towns in Syria by the Marwanids [i.e., Umayyads].

Although Abbasid caliphs did make occasional use of the few Umayyad palaces they left standing, such as the one at Rusafa in Syria, they seem to have spent more time in their grand urban palaces. As we have noted, the first Abbasid palace in Baghdad, the Palace of the Golden Gate, was in the centre of what was originally a round city, modelled perhaps on the ancient four-gated, perfectly round city of Firuzabad, which was once the capital of the pre-Islamic Sasanian emperors. The Palace of the Golden Gate, built for the caliph al-Mansur (r. 754–75), was large, but if it did indeed have 4,000 white eunuchs, 7,000 black eunuchs, and 4,000 uncastrated black males, its slave staff alone would have amounted to more than the population of quite substantial European towns of the eighth century. Of the interior of the palace we know that its centrepiece was its great *iwan*, behind which was located a slightly more intimate audience chamber.

Even in al-Mansur's lifetime, we know that other palaces were built in the proliferating suburbs of Baghdad, although nothing but literary evidence survives of any of them. Al-Mansur himself commissioned another palace in 775 outside the city; after it was built, the Palace of the Golden Gate became more of an administrative centre. In the late Abbasid period, after the return from Samarra, the palace area, known as the Dar al-Khalifah (House of the Caliph), consisted of three large palaces and numerous smaller pavilions laid out along the side of the Tigris.

Abbasid caliphs seems to have disdained the idea of "second-hand" palaces and preferred to build their own. Labour was cheap and so were the building materials – mostly unbaked brick, baked brick, stucco, and wood – but they built for pleasure rather than for posterity, swiftly abandoning buildings and moving on to new ones. When the Seljuq sultan Tughril Beg entered Baghdad in 1055 he ordered the destruction of 170 palaces on the right bank of the Tigris in order to clear space for one of his own.

Again, most rooms in Abbasid palaces do not seem to have had specific functions, but were seen rather as stage sets or display

galleries. Their decoration relied on stucco and wood carvings, but even more on textile hangings. On the occasion of the Byzantine embassy to Baghdad in 917, there were said to be 38,000 textiles hanging on display in the buildings of the Dar al-Khalifah and more than 22,000 rugs and carpets lining the way to the caliph al-Muqtadir's presence. The eleventh-century historian of Baghdad, al-Khatib al-Baghdad, left an account of the Byzantine mission, which suggests that the Greek ambassadors were brought to the caliph by what seems to have been a wilfully roundabout route. Having entered by a gateway on the river, they were conducted through marble-columned stables and past the lion and elephant houses. Then they were shown the Jawsaq al-Muhdith (New Kiosk – a kiosk in Islamic architecture is a form of pavilion). In the midst of the kiosk's gardens of melon beds and dwarf palms encased in gilded copper was a glittering artificial pool of liquid white lead, which served as a harbour for ornamental boats. Then the ambassadors were conducted to the Dar al-Shajara (House of the Tree), a pavilion containing a silver tree bearing mechanical singing birds. From there they proceeded to the Qasr al-Firdaws (Paradise Palace), which seems to have been used as an armoury in al-Muqtadir's reign. All in all, the embassy passed through a further twenty-three palace buildings before reaching the caliph in the grandiose Qasr al-Taj (Crown Palace). The Byzantine ambassadors may well have marvelled, yet displays of soldiery, royal treasures, and magical automata can hardly have been unfamiliar to them, for the imperial Abbasid style was modelled on that of the Byzantine court.

Some time in the opening years of the thirteenth century, al-Jazari, working in the Artuqid city of Amid on the Upper Tigris, produced his *Kitab Fi Marifat al-Hiyal al-Handasiyya* (*Book of Knowledge of Ingenious Mechanical Devices*), in which he described in painstaking technical detail how to construct devices that told the time, poured water on demand (FIG. 85), or played music, as well as sophisticated and elaborately ornamented locks for chests and doors. There was a particular stress on objects that would serve at princely dinner parties as wine dispensers and mixers, devices for handwashing, and of course also as conversation pieces. The illustrations to the treatise, which has survived in fifteen copies based directly or indirectly on al-Jazari's manuscript, are effectively portrayals of court scenes. Architecture, when it appears, is stylised, but hardly more so than in other illustrated Arab manuscripts. The figures are stiff, but shaded to suggest volume. Their colours are bright and the images are on the whole most attractive.

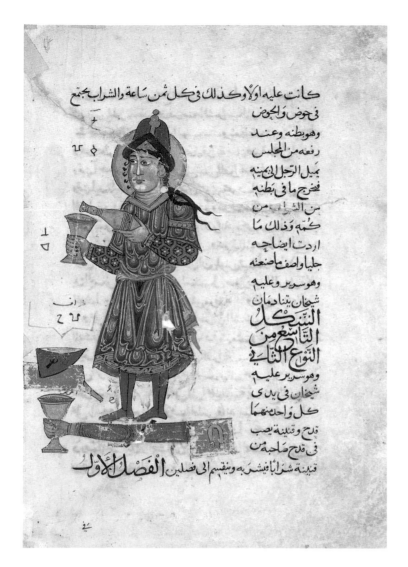

The Arabic text in the image reads (right-to-left):

كانت عليه اوﻻ وكذلك في كل ثمن ساعة والشراب يجتمع
في حوض والحوض
وهو بطنه وعند
رفعه من الجلس
ميل الرجل اليه
فخرج ما في بطنه
من الشـ ـ من
كمه وذلك ما
اردت ايضاحه
جليا واصف ما صنعه
وهو سرير وعليه
شيطان بناد ما من
الشكل
التاسع من
النوع الثاني
وهو سرير عليه
شيطان في يد ى
كل واحد منهما
قدح وقنينة يصب
في قدح صالحه
قنينة شرابا فيشرب وينقسم الى فصلين الفصل الاول

85. Miniature of an automaton water dispenser from a copy of al-Jazari's *Kitab Fi Marifat al-Hiyal al-Handasiyya* (*Book of Knowledge of Ingenious Mechanical Devices*). Syria or Egypt, 1315. Illuminated manuscript, 12¼ x 8⅝" (31 x 22 cm). David Collection.

Archaeological evidence allows us to be comparatively well informed about the Abbasid palaces erected in Samarra between 836 and 892. Samarra, with its gardens, its two enclosed game reserves, its twelve polo grounds, and its four race-courses, is the largest archaeological site in the world (FIG. 86). Like Baghdad and later Cairo, it began as a palace complex and grew into a city. Some thirty palaces were built here in an imperial settlement that straggled for 25 miles (40 km) along the river. Unbaked brick was the commonest building material, but baked brick was also used, faced with marble, teak wood (see FIG. 26), and stucco. The city also housed between seventy and a hundred thousand troops in barrack compounds.

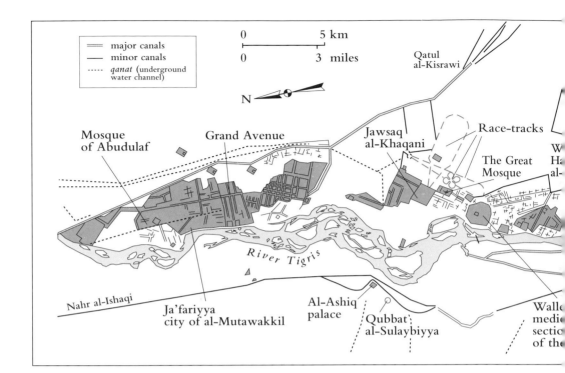

The first Samarran palace, the Jawsaq al-Khaqani, was a labyrinthine construction built by al-Mutasim and his successors. It was vast, spreading over 432 acres (175 ha.), and there was a network of tunnels under the palace for men riding on donkeys to get about more swiftly. Access to the palace was by a broad flight of marble steps from the water's edge, which led up to the Bab al-Amma (Gate of the People), a triple-arched entrance to the throne room within the main complex of buildings. There was a central section where the caliph lived and received guests, and where wine was sometimes drunk (FIG. 87), but around this carefully laid-out public area, there was a higgledy-piggledy agglomeration of rooms and passages. The walls of the palace were extensively decorated with figurative paintings, some of which survived until after the First World War but have since deteriorated to the point where they are no longer decipherable. Apart from communication tunnels, what are known as *sirdabs* were also located underground. The *sirdab*, a subterranean chamber whose double walls were either packed with ice or ran with water, was a way of keeping cool that had first been pioneered by the pre-Islamic Iranians.

According to the Arab geographer al-Yaqut (d. 1299), the caliph al-Mutawakkil (r. 847–61) built himself nineteen palaces. His Balkuwara palace (which he began building in about 849

86. Groundplan of Samarra, capital of the Abbasid dynasty from 836 to 883.

Hunting palace

ie rve

isiyya

Nahr
al-Qa'im

wara

Al-Istabulat

87. Reconstruction by Ernst Herzfeld of a ceramic wine bottle decorated with the image of a monk, from the Jawsaq al-Khaqani palace, Samarra, 9th century.

for his son al-Mutazz) was supposed to have been modelled on what he had been told about the palace of a pre-Islamic king of Hira, which in turn had been modelled on the disposition of an army on a battlefield, with a centre and two wings. The Arab historian al-Masudi wrote in the early tenth century that "people had houses built in the style of the palace of al-Mutawakkil" – a rare explicit testimonial to what one would expect, that the artistic taste and innovations of the ruler were aped by his subjects.

From 892 onwards Samarra was abandoned; Baghdad had once more became the Abbasid capital. Samarra had always been an artificial city, which, lacking an independent economic *raison d'être*, depended heavily on the patronage of the caliphs and perished when that patronage was removed. An aerial survey has shown the outlines of 6,314 buildings in Samarra, but today only nine of those ruins have walls that rise significantly above ground level. What has survived *in situ* has done so solely because it was not worth looting. The stucco may remain in places, but the marble, mosaics, and wood panelling have long since vanished.

Samarra and the Provincial Dynasties

It was inevitable that Samarra should provide the model for the palaces of provincial dynasties that rose to prominence during the Abbasid era. The Turk Ahmad ibn Tulun, who took charge in Egypt in 868 – which he ruled nominally on behalf of the Abbasid caliph, but in fact exercised power like a king – modelled his palace and centre of government on Samarra. The palace has not survived, but his mosque can clearly be seen to be an imitation on a small scale of the Great Mosque at Samarra. Similarly, the bevelled style of carving wood and stucco that became the fashion in Tulunid Egypt has affinities with Samarran decorative motifs. Tulunid court rituals and extravagance doubtless came from the same source of inspiration: Khumarawayh, Ibn Tulun's son and successor (r. 884–96), built a pavilion in the palace garden, which held larger-than-life wooden sculptures of himself, his concubines, and singing girls adorned in (real) gold and jewellery. Khumarawayh was also reputed to spend his nights on an airbed tethered with silken ropes and floating over a lake of quicksilver.

On the other side of the Islamic world, the Ghaznavid palace at Lashkar-i Pazar in south-west Afghanistan seems also to have been modelled on Samarra. It was not a single building, but rather a linked series stretching along the River Helmand. The decoration of the palace relied heavily on marble and on loot from Sultan Mahmud's Indian campaigns. Mahmud himself (r. 998–1030) sat on a throne of red gold decorated with branches and plant

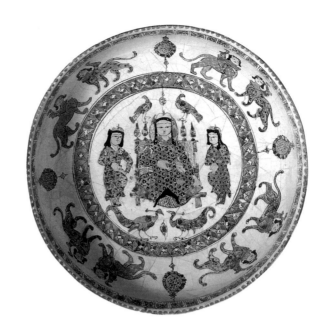

88. Iranian *minai* bowl with enamel decoration, showing an enthroned Seljuq prince, attendants, peacocks, and fanciful beasts, early 13th century. Glazed ceramic, diameter 7³/₄" (19.7 cm). Calouste Gulbenkian Foundation Museum, Lisbon.

The image of the enthroned prince is found for many centuries in Turkish iconography on ceramics, metalwork, and many other forms of art. The Seljuks inherited the iconography shown here from the Ghaznavids.

fronds (FIG. 88). His crown was suspended from a chain above his head, imitating the Sasanian practice, but the weight of the crown was given additional support by four surrounding statues whose arms stretched out to bear it. The remnants of the throne room display a painted frieze of bodyguards standing to attention on the walls, similar perhaps in intention to the life-size stucco figures of attendants from Seljuq palaces (FIG. 89).

Fatimid Cairo and its Palaces

The palace and court life of the Fatimid caliphs in Cairo also evolved in conscious rivalry to and emulation of the Abbasids in Baghdad. Work began on the palace-city of Cairo in 969, but the appearance of the early palace can only be vaguely reconstructed. The Qasr al-Muizzi, the palace of the caliph al-Muizz, was situated to the east of a *maydan*, or parade ground. Al-Aziz, al-Muizz's successor, built another palace to the west of the *maydan*. The parade ground acquired the name Bayn al-Qasrayn (Between the Two Palaces), which to this day is still the name for part of the broad highway running through old Cairo. By the eleventh century the palace seems to have consisted of ten pavilions, which were separate but, as at Samarra, linked by underground passages. Given that the Fatimid caliphs depended on their lineage to legitimise their rule, it was natural that the dynastic cemetery formed an important part of the palace compound, and the bones of the ancestors of the Egyptian caliphs were brought from Qairouan to be

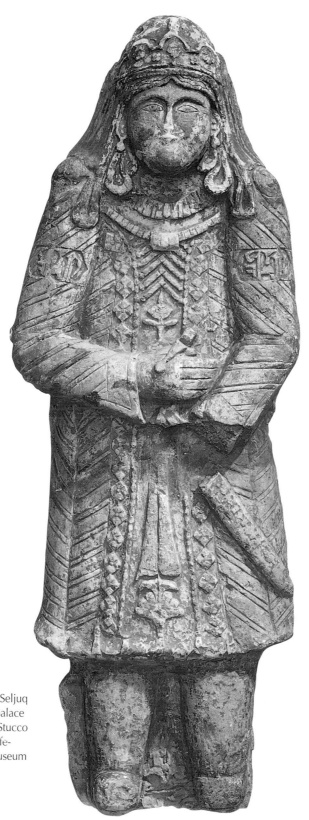

89. Stucco figure of Seljuq
Iranian attendant or palace
guard, 12th century. Stucco
(originally painted), life-
size. Metropolitan Museum
of Art, New York.

90. Egyptian pierced panel of a hunting scene, 11th century. Ivory, 2¼ x 4" (5.6 x 10.2 cm). Louvre, Paris.

Turbulent soldiery sacked and looted the Fatimid palace in 1067, and the dispersal of its treasures on the open market may have led to the wider diffusion of the taste of the court, but not one of these treasures seems to have survived to be identified. Only fragmentary wood carvings, which may once have formed part of the decoration of the palace, remain. These panels mostly portray the fleeting pleasures of life: hunting, feasting, drinking, dancing, and music. This ivory carving of the same period may perhaps give some indication of the quality of the palace's treasures and decoration.

91. Front facade of the Fatimid al-Aqmar Mosque, Cairo, 1125.

The strong decoration includes ribbed arches with medallions, niches, and *muqarnas* panels.

reburied in the grounds of the palace, which therefore doubled as a shrine.

One of the chief aims of the palace was to intimidate with opulence, as the account by the Iranian poet and traveller Nasr-i Khusraw (1003–61) of an audience in the Fatimid palace in the mid-eleventh century makes clear:

> I saw a series of buildings, terraces, rooms ... there was a throne in one of them that took up the entire width of the room. Three of its sides were made of gold on which were hunting scenes depicting riders racing their horses, and other subjects; there were also inscriptions written in beautiful characters. The rugs and hangings were Greek satin and moiré woven precisely to fit the spot where they were to be placed. A balustrade of golden lattice-work surrounded the throne, whose beauty defies description. Behind the throne were steps of silver. I saw a tree that looked like an orange tree, whose branches, leaves, and fruit were made of sugar. A thousand statuettes and figurines also made of sugar were also placed there.

Again, sources give only a vague impression of the buildings themselves. Evidently, it was the contents of the buildings rather than the architecture that impressed visitors. More than anything else, the Fatimid palace was a storehouse of treasures. An inventory of the treasury at the time of the caliph al-Mustansir (1036–94) has survived. As well as antique Abbasid textiles, the treasury contained precious stones, carved rock crystal, chess sets of ebony, ivory, and precious metal, one hundred cups and other items, most of them bearing the name of the Abbasid caliph Harun al-Rashid, sacks of musk from Tibet, great animal-shaped vats for washing clothes, a gold mat used by Harun al-Rashid's son on his wedding night, parasols with gold or silver handles, 36,000 pieces of crystal, 22,000 amber figurines, a gold peacock studded with jewels, a gazelle similarly adorned, a table of chalcedony, a model garden made of silver, a life-size silver sailing boat, and so on and on (FIG. 90).

Fatimid caliphs used processions and public rituals to make their pomp and magnificence more widely known to their subjects. (In this they differed from the Abbasids, who do not seem to have favoured processions.) All sorts of pretexts were found for parades – Muslim religious festivals, public investitures, the flooding of the Nile, even Christian festivals were honoured. The al-Aqmar Mosque (built 1125), with its magnificently sculpted facade, was often the culminating point (FIG. 91).

92. Interior of the 14th-century Qasr al-Ablaq in the Cairo Citadel, in a 19th-century engraving.

The Mamluks in Cairo and the Citadel

Although the later Mamluk sultans were less obsessed with processions, they did preserve some of the public rituals that had been instituted by the Fatimid caliphs. The processional nature of royal display had implications for the architecture of Cairo, as palaces and mosques served as backcloths for court ceremonial. Among the Ayyubid and Mamluk buildings that replaced the earlier Fatimid palaces around the Bayn al-Qasrayn were the Madrasa-Mausoleum of al-Salih Ayyub (1242–44), the Hospital, Madrasa, and Mausoleum of Qalawun (1284–85), the Barquq Mosque and Madrasa (1384–86), the Mosque of al-Nasir Muhammad (1318–35), and the palaces of Baysari and Bashtak (late thirteenth century and 1330s). Their porticoes and facades advertised the piety and power of the military elite who swaggered in procession in the canyon formed by these grandiose buildings.

The seat of government in Mamluk Cairo was the Citadel, begun by Saladin in 1183 or 1184 on high ground to the south of the city. It continued to be added to and rebuilt until the last days of the Mamluk sultanate and beyond. Khalil al-Zahiri, a fifteenth-century Mamluk officer, wrote: "It would take too long to give a detailed description of the palaces, rooms, salons, belvederes, galleries, courts, squares, stables, mosques, schools, markets, and baths which are found in the palace." Some of the most important work within the Citadel was commissioned in the third

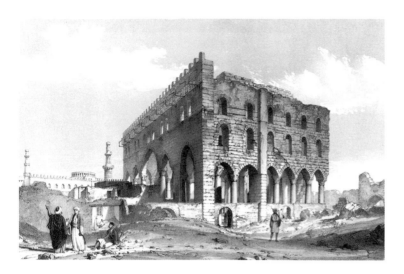

93. Nineteenth-century engraving of the great *iwan* of Sultan al-Nasir's palace, the Qasr al-Ablaq, in the Cairo Citadel. Victoria and Albert Museum, London.

reign (1310–40) of the Mamluk sultan al-Nasir Muhammad. It was he who built the Qasr al-Ablaq ("Striped Palace," so named after the alternating courses of yellow and black stone used in its construction). The Qasr al-Ablaq (FIGS 92 and 93) was a complex maze of buildings, courtyards, and terraces. The most impressive part of the palace was the great *iwan*, where the sultan received ambassadors, reviewed troops, and presided over sessions of justice. Situated behind the *iwan* was a great reception hall, with a vast marble floor and a wooden dome painted green. The northern enclosure within the Citadel included the long barracks buildings of the *mamluk*s. The Hawsh (Enclosure), an area which comprised a group of pavilions set within gardens and including a polo ground, was situated to the south of the Qasr al-Ablaq. The Hawsh was at first a private harem area, within which each wife had her own pavilion, but by the late Mamluk period the Hawsh was increasingly used for public business – the sultans used to give audiences in the magnificent stables.

Joos van Ghistele, a Flemish visitor to the Citadel in the fifteenth century, reported gold and other richly coloured paintings in the Hawsh. Most of the Mamluk art and architecture that survives today is religious and therefore largely aniconic (FIG. 94); our view of the development of Mamluk art would surely be very different if only the secular cycles of frescoes and mosaics which we know to have existed in the Citadel had survived.

In the same way, we might have a very different view of the sort of architecture and interiors favoured by the Mamluk emirs if only more evidence of their dwellings, known as *qaa*s, survived. (A *qaa* is a reception chamber – in this context, this most

94. Mamluk playing card, 15th century. Painted card, 10 x 3³/₄" (25.2 x 9.5 cm). Topkapi Saray Museum, Istanbul.

95. Fragment of an Egyptian carpet with a blazon, late 15th or early 16th century. Wool, 7'2" x 6'10½" (2.2 x 2.1 m). Textile Museum, Washington, D.C.

Mamluk sultans and emirs marked the buildings and objects they had commissioned with heraldic blazons, a non-hereditary heraldry based on office-holding rather than lineage. In the early Mamluk period (13th and 14th centuries), the emirs had worn badges that advertised the fact that the bearer had been one of the *khassakiyya* – that is, he had occupied one of the elite household posts as a young *mamluk* in the palace service. Thus, a young *mamluk* who had served as the sultan's *silahdar*, or arms-bearer, later carried the sword as his emblem when he became an emir. In the late 15th century, the use of such emblems was replaced by that of a three-field composite blazon: in the top field there was a lozenge-shaped napkin, the emblem of the *jamdar*, or wardrobe master, in the middle field the *saqi*'s cup flanked by two powder horns and charged with the *dawadar*'s pencase, and in the lower field another cup. This composite device does not seem to have been borne by one particular emir; rather, it was the emblem of all *mamluk*s in the service of the sultan from the 1460s onwards.

important part of an emir's residence was used to refer to the whole.) We know that several emirs had their residences on the slopes beneath the Citadel's walls, though these have now perished, but the surviving Palace of Bashtak, built in the 1330s on a prime site by the Bayn al-Qasrayn, may give us an idea of how they were arranged. Bashtak was a senior emir in the service of al-Nasir Muhammad, and his palace was originally five storeys high. There were shops on the ground floor; while the reception chamber, the *qaa* itself, was on the main floor, or *piano nobile*. *Mashrabiyya*, wooden lattice-work screens, along a mezzanine gallery allowed the women of the emir's household to look down on the receptions held there. The emir's lozenge-shaped blazon, signifying his former service as the Sultan's steward, is used recurrently as a decorative motif (FIG. 95).

The Tent and the Palace

Islamic art and architecture are very much products of an urban culture, but a discussion of Islamic palaces must also include a consideration of the part played in court life by tents. Even for the Fatimid caliphs in Cairo, tents constituted one of the most precious categories of object in their treasury. One of their tents needed a hundred camels to carry it; another was called the "Slayer," because at least two people were killed every time they tried to pitch it. The fourteenth-century North African philosopher and historian Ibn Khaldun singled out tents as one of the emblems of royal authority and luxury. Certainly, they could be of palatial dimensions. According to Clavijo, the Castilian ambassador, one of Timur's tents, pitched on the plain of Kani-Gil outside Samarqand, was large enough to shade ten thousand people (FIG. 96). Clavijo, who was in Samarqand in 1404, described another

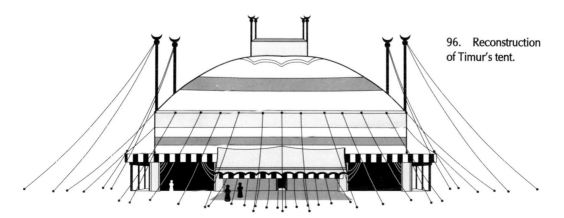

96. Reconstruction of Timur's tent.

of Timur's tents as having gates, a domed ceiling, upper galleries, a turret, and battlements. A fortune was spent on the inner furnishings, including tapestries, silks, and gold brocade; and it is illuminating to know that Timur, who had grown up among the nomadic Chagatay Mongols, relegated the Gok Saray, his palace in Samarqand, to the role of a storehouse and prison. Miniature paintings of the fifteenth and sixteenth centuries provide ample testimony, too, of the enjoyment of an open-air culture by the Timurid court (FIG. 81, see page 103). Many of the most prized artefacts to have survived from the pre-modern Middle East may have been designed for use in the open air. It has been demonstrated that the famous Ardabil Carpet (dated 1539–40 and currently in the Victoria and Albert Museum in London) is too large – nearly 36 feet (11 m) long by over 17 feet (5.3 m) wide – to have fitted in any of the rooms of the famous religious shrine of Ardabil in northwest Persia. It could have been used for open-air audiences and banquets. Iranian garden carpets, of which some of the finest specimens were produced from the sixteenth century onwards, show stylised representations of gardens with paths, waterways, trees, and flowers, and in so doing may mimic on a smaller scale the gardens within which they were placed. It is also the case that much of the high-quality inlaid metalwork produced in Mamluk Egypt and Syria in late medieval times, such as the Mamluk food containers (FIG. 97), was made for use in *alfresco* dining.

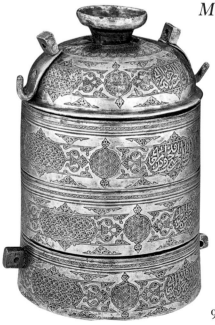

97. Damascan food container, 15th century. Brass, height 7¼" (18.4 cm). British Museum, London.

These containers kept different foods in separate compartments and as a precaution against poison could be locked. It also seems plausible that the characteristically Mamluk great basins with flared rims could have been used to bring water for ablutions in open-air settings.

Muslim Palaces in Spain

The first Muslim palace in Spain, the eighth-century Umayyad palace of Rusafa, has entirely disappeared. However, there are extensive remains (still being excavated) of al-Madinat al-Zahra (City of the Flower), built by the Spanish caliph Abd al-Rahman III (r. 912–61) and named after his favourite wife. This was the summer palace of the Spanish Umayyad caliphs and was situated on high ground about three miles (5 km) to the north-west of their capital, Cordoba. The palace-city, which eventually housed twelve thousand people, was begun in 936 and allegedly took twenty-five years to complete (see FIG. 29). The buildings of al-Madinat al-Zahra flow down the slope of the Sierra Morena, and the way in which its spaces were organised in descending terraces emphasised the hierarchical structure of the Umayyad court. The caliph had his residence and audience chambers (FIG. 98) on the highest level, and the views from his reception

98. The Pamplona Casket showing a ruler flanked by attendants, early 11th century. Ivory, 9¼ x 15 x 9¼" (23.6 x 38.4 x 23.7 cm). Museo de Navarra, Comunidad Foral de Navarra, Pamplona.

Carved ivory caskets were much prized at the court of the Spanish Umayyads and were commonly used to store such precious perfumes as ambergris, musk, and camphor. In a cartouche on the side of the Pamplona Casket, the Umayyad caliph Hisham II (r. 976–1009, 1010–13) is shown enthroned between two attendants, while musicians, riders, and animals fill other cartouches. The casket belonged to one of the Caliph's chief ministers, the Hajib (Chamberlain) Sayf al-Dawla Abd al-Malik. It may well have been made by a royal workshop in the palace of al-Madinat al-Zahra. The inscription on the front of the casket translates as "In the name of God. Blessings from God, goodwill and happiness, and attainment of expectations from pious works ..."

rooms commanded the rest of the sprawling palace. Access to the caliph was difficult, only achieved by passing through a maze of doorways, passages, and antechambers. One of the audience chambers, the three-aisled Salon Rico (FIG. 99), with its rows of horseshoe arches supported on Corinthian capitals, has been successfully restored in modern times. Senior officials dwelt on the middle terrace of al-Madinat al-Zahra, while soldiers and servants occupied the lowest level. The palace-city also contained baths, workshops, and barracks.

The palace, with its 4,313 columns, was a place of marvels. Like the Fatimid and Abbasid palaces, it housed marvellous automata. It also had a quicksilver pond (like Khumarawayh's pool in Egypt); the changing play of sunlight on its surface created enchanting

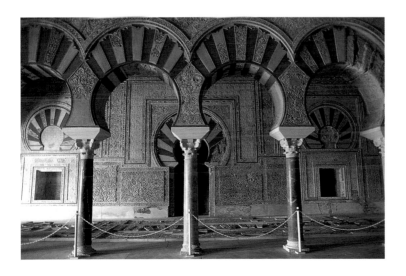

99. Salon Rico, al-Madinat al-Zahra, near Cordoba, 10th century.

effects on the ceiling of the pavilion behind it. (The Umayyads at Cordoba, like the Nasirids in Granada after them, were interested in the effects that could be achieved by the play of light.) In 1013, al-Madinat al-Zahra and al-Madinat al-Zahira – the palace of the Hajib (the Chamberlain who was the caliph's chief minister), which was built in 976 to the south-east of Cordoba – were sacked by rebel Berber troops.

The Alhambra

The Alhambra (Red Fortress), built on a rocky spur overlooking the Nasirid capital of Granada, is one of only two medieval Muslim palaces still standing (the other is the Ottoman Topkapi Palace in Istanbul). It was Muhammad III (r. 1302–08) who turned the site from a hill-top fortress into a palace-city, which is said to have accommodated some forty thousand people. Again, the Alhambra was not a single palace, but rather a succession of fortifications and palaces within a walled enclosure. By the end of the fourteenth century it contained six or seven royal residences. Only two of these, the Comares Palace and the Palace of the Lions, have survived substantially intact until the present day.

One approached the Comares Palace via the Mexuar, a council chamber flanked by barracks and other rooms. The palace was probably mostly used for receptions and public business, and was built around an open space with a rectangular pool, the so-called "Court of the Myrtles." The garden around the pool would have provided an important part of the original effect, but it is impossible to guess what it would have looked like then, for the myrtle bushes that now line the pool are not original. Muhammad V (r. 1354–59, 1362–91) completed the Comares Palace in the 1360s and added the Sala della Barca (Room of the Blessing), which overlooks the Court of the Myrtles and which was probably his private quarters, with alcoves for beds. The Salon of the Ambassadors, located behind the Sala della Barca, was a throne room, as one of its inscriptions testifies: "My Lord Yusuf, the favourite of God, has chosen me for his throne." In another inscription, the Nasirid king Yusuf (r. 1333–54) is compared to the sun, and this solar simile was given symbolic architectural form in the ceiling (FIG. 100), where one sees a stylised representation of the seven heavens.

The Palace of the Lions derives its name from the fountain at the centre of its courtyard (see FIG. 30). The basin of this fountain is supported on the backs of marble lions and bears the inscription: "What else is it in truth, but a mist which sheds forth from the fountain drenchings towards the lions? It [the fountain]

100. Ceiling of the Salon of the Ambassadors, 1370s, in the Alhambra, Granada.

resembles in this the hand of the caliph when it sheds forth help towards the lions of war." The Palace of the Lions probably served as the private quarters of Muhammad V. It includes the so-called Hall of Abencerrajes, with its magnificently complex *muqarnas* ceiling, and the equally fancifully named Hall of the Two Sisters. (Most of the modern names for the various parts of the palace are fanciful.) The Hall of the Kings, dating from the 1370s, led off from the Court of the Lions and was intended to be the new area for public functions and open-air ceremonies.

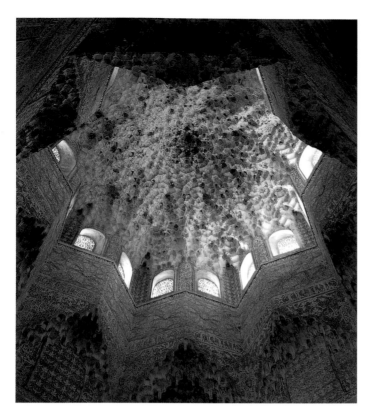

102. Schematic diagram based on a drawing by the architect Owen Jones, showing how complex *muqarnas* decoration was created by the juxtaposition of simple prisms.

101. Stucco decoration in the Hall of the Abencerrajes in the Alhambra, Granada.

The Alhambra is probably the most famous of all the Islamic buildings that provide their own written commentary. It is a text-laden building, an inhabitable book. A literate courtier walking through the palace would learn from one of its towers that "Nothing can match this work," while the boast of the Fountain of the Court of the Lions was "Incomparable is this basin. Allah the exalted one desired that it should surpass everything in wonderful beauty." Gates and doors within the pavilions instructed readers on their functions.

Many of the texts that decorate the Alhambra are placed at quite a low level. This should serve to remind us that the caliph and his courtiers customarily sat on cushions and rugs and that consequently the Alhambra's vistas are designed to be appreciated from a low point of view. Catching and directing the gaze meant everything to those who designed this palace. The grandiose axial layouts that characterised Abbasid palaces in Samarra were abandoned in the Alhambra in favour of surprising and rapidly changing perspectives and points of view, as those who entered the palace were forced to turn and turn again by the skewed layout of courtyards, corridors, and rooms. What is even more striking is the

sheer elaboration of the decoration, the play of intricate crystalline forms, and the use of shapes that were designed to catch the changing light – some five thousand prismatic *muqarnas* shapes were used on the ceiling of the Hall of the Two Sisters alone (FIGS 101, 102, and 103).

103. A column in the Court of the Lions in the Alhambra, Granada.

Another striking feature of the Alhambra is the frequency and ease of transition between open and closed spaces. Gardens were obviously conceived of as extensions of the palace. From a *mirador*, or viewing room, just off the Hall of the Two Sisters, one can look down on the Daraxa garden and, once again, lines of text, in this case poetry from the pen of Ibn Zamrak, a vizier in the service of Muhammad V, have been placed in the *mirador* to guide the eyes: "I am a garden adorned with beauty. Gaze upon my loveliness and you will know this to be true." The Alhambra and its gardens are indeed magnificent, but it is salutary to think that it was the creation of a petty dynasty and was built in a period when Islam was in retreat in Spain. The tenth-century Umayyad palace of al-Madinat al-Zahra was surely once grander and more magnificent and itself seems to have been built in imitation of the yet grander and more opulent palaces in distant Samarra.

The Palaces of the Mongols

The Mongol Ilkhans in Iran and Iraq spent much of their time moving from one tented encampment to another. The only Ilkhanid palace of which substantial ruins still survive is that at Takht-i Sulayman (Throne of Solomon; FIG. 104), south-west of Tabriz, chosen in the 1270s by the Ilkhan Abaqa (r. 1265–82) as the site of his summer palace. The palace was built on the edge of a crater-lake, where there were already palatial and other buildings dating from the Sasanian period. The Mongols incorporated these buildings in their own palace complex and in so doing symbolically presented themselves as the heirs of the Sasanian emperors. They built a new *iwan* and two octagonal pavilions. Much of the decoration – stucco, marble, and lustre and *lajvardina* tiles – has been found on the site. Some of the inscriptions and images in the decoration are drawn from the *Shahnama*, suggesting that perhaps the Mongol rulers wanted to present themselves as the heirs not just of the Sasanians but also of the legendary kings and heroes of Firdawsi's epic poem. Chinoiserie motifs, such as the dragon and phoenix and the lotus blossom, also feature in the decoration of

104. The ruins of the Mongol palace of Takht-i Sulayman, Azerbayjan.

the palace. The dragon and phoenix image was a traditional emblem of Chinese imperial authority and under the Mongols its use was restricted to the Great Khan and his family. However, in the fourteenth century the use of this and other Chinese motifs became much more widespread (for example, we find Mamluk craftworkers making use of Chinoiserie motifs).

The Mongol Ilkhans tended to migrate from Iraq in the winter to places like Takht-i Sulayman in Azerbayjan in the summer. If one wishes, one can see this as a perpetuation of the Mongols' nomadic inheritance. However, use of summer palaces was not something that was restricted to the Mongols. Many Muslim rulers migrated seasonally between palaces, and in general the difference between summer and winter tended to be marked by all sorts of rituals. In Mamluk Cairo, the beginning of summer in May was celebrated with a formal parade at which the sultan and the court appeared in thin white robes rather than the coloured woollen robes that served as winter wear.

The Aq Saray of Timur

Although Timur appears to have preferred encampments to residing in the Gok Saray in Samarqand, he had another palace, the Aq Saray (White Palace), at Shahr-i Sabz to the south of Samarqand on the route to India (FIG. 105). Timur, who ordered its construction in 1380, does not seem to have shared the Abbasid attitude to disposable palaces. Only part of the gateway remains, but its ruins are sufficient to suggest the scale of what has vanished.

Despite its name, what remains of the Aq Saray is blue rather than white, for the walls are encased in ceramic tiles coloured mostly light and dark blue: The epithet "white" here really signified "noble" rather than referring to the literal colour of the building. The aim of the palace was to proclaim the grandeur and sacred status of the ruler. As another of the gateway's inscriptions proclaimed, "The Sultan is the Shadow of God on Earth." The Castilian envoy Clavijo toured the palace which, twenty years after it had been commissioned, was still being built. As he describes it, the grand portal led to a long entrance gallery and archways of brickwork encased in blue tiles. At the end of the gallery there

105. The ruins of Aq Saray, the early 15th-century Timurid palace at Shahr-i Sabz in Uzbekistan.

was another gateway into a large courtyard, three hundred paces wide, and flanked by great *iwans*. (Since Timurid princes conducted much of their business out of doors, the scale and the architectural framing of such open spaces were as important as the decoration of interior rooms.) On the far side was another gate surmounted by the image of a lion and the sun, and this led on to a reception hall panelled in gold and blue tiles and with a gilded ceiling. Beyond and around the reception chamber there were other apartments and a banqueting hall.

The Topkapi Palace in Istanbul

Soon after the conquest of Constantinople, Mehmed II gave orders for the construction of the Eski Saray, the "Old Palace," which apparently consisted of structures built mostly of wood. But even during his reign, the Eski Saray was being superseded by another, newer building. At first the Topkapi, on which work may have begun as early as the 1450s, was only intended to serve as a centre for administration and public ceremonies, and the sultan's harem continued to be lodged in the Eski Saray until 1541, when a fire led to their transfer to the Topkapi. (Thereafter the Eski Saray was used to house out-of-favour members of the harem.) Topkapi literally means "gun gate" (a small section of the palace which no longer exists). As has been noted, it and the Alhambra are the only pre-modern Muslim palaces still substantially intact, and, like the Alhambra, the Topkapi relies more on its location and use of landscape than on monumental architecture to make an impression. In itself it is a sprawling accumulation of low-level buildings put up over the centuries; fires have destroyed many of the older buildings and much of what survives is relatively modern. However, the Hazine (Treasury) is fifteenth-century and so are the kitchens and the physician's building, while the Çinili Kiosk (FIG. 106), or Tiled Pavilion, was erected between 1465 and 1472 by an Iranian architect.

In its original layout, the Topkapi included a lot of summer pavilions by the water's edge. The winter palace that remains is situated on a high ridge, formerly the site of the Byzantine acropolis, and is based on a series of courtyards. The Bab-i Humayun, the Imperial Gate, admits visitors to the first court, which was open to the public and was used as a parade ground (the Çinili Kiosk is situated here). The second court, entered by the Middle Gate, contained buildings for the transaction of public business, the Council Hall, and the Treasury. The Ottoman sultan did not sit with his ministers but rather overlooked the *divan*, or council, from

a grilled window. (This veiling or semi-seclusion of the monarch harks back to Abbasid and Fatimid practice.) There were also kitchens and stables in the second court. The Gate of Felicity led into the third court. This contained the palace school, where slave recruits were instructed in the service of the sultan and the science of arms, since the Topkapi was as much a training establishment as a royal residence. The third court also included a throne room, libraries, mosques, and the sultan's private quarters. The harem area consisted of a huddle of rooms and passages straddling an area that extended along one side from the second to the third courtyard. Lying beyond the third court there was an area of gardens and pavilions. As the centuries passed, the sultans increasingly tended to withdraw into the harem area and seclude them-

106. The Çinili Kiosk (1465–72) in the Topkapi Palace, Istanbul.

selves there. The box-like structure of the Topkapi, where access is progressively more restricted as one proceeds from area to area, is faintly reminiscent of the Forbidden City in Peking.

The Palaces of Safavid Isfahan

The Safavid shahs in Iran were, by contrast, much more accessible to their subjects. In particular, Shah Abbas (r. 1587–1629) was reputed to stroll about the *maydan* of Isfahan in the evenings talking and joking with his subjects and examining the goods on the stalls. This relative accessibility is reflected in the architecture of the Safavid period. The Ali Qapu (meaning "High Gate") overlooks the central *maydan* of Isfahan, a vast rectangular area used for parades, fairs, executions, and so forth. In its original form the Ali Qapu served as the gatehouse into the palace complex, but it was transformed in the early seventeenth century so that its high

107. Front view of the pavilion of the Chihil Sutun in Isfahan, mid-17th century.

loggia balcony could serve as a viewing box and reception area. The building was six storeys high, and of the interior details it is known that the music room on the top floor had niches for the display of porcelain.

The Safavid palace complex itself was more of an ornamental park than anything else, and the flimsy pavilions that were dotted around it have mostly perished, though they are known to us from the reports of European travellers and from paintings. The Chihil Sutun, however, is a garden pavilion from the mid-seventeenth century which has survived (FIG. 107). Chihil Sutun means "Forty Columns": the roof of the portico is actually supported by only twenty columns, but these are reflected in the pool of water overlooked by the pavilion, hence the fanciful "forty." There was also a pond in the columned area and another in the reception area inside. Clearly, the building was designed to have an interplay between stone and water (and of course palaces such as the Takht-i Sulayman and Alhambra did the same, though in very different ways). Like the Ali Qapu, the Chihil Sutun looks best when viewed from the front, and the building was probably used for open-air banquets during which the shah and his feasting courtiers were able to look out across the water and the gardens.

The Ali Qapu, the Chihil Sutun, and other Safavid palaces and pavilions were decorated with images of courtiers enjoying the gardens. The Roman nobleman Pietro della Vale, a keen teetotaller and moralist, visited Iran in the reign of Shah Abbas and remarked on the improper nature of Safavid frescoes: Iranian artists "do not, as we do, follow the practice of painting historical or mythological scenes. All these figures simply show men and women, either alone or in groups, in lascivious postures. Some stand with cups and flagons of wine in their hands drinking." Safavid princes, like Umayyad princes, may perhaps be accused of having revelled in lives of comparative leisure, and of having commissioned works of art that commemorated the pleasure of such a life. They also resembled the Umayyads, with whom this chapter began, in preferring to take their pleasures out of doors, and they made the surrounding landscape part of their palace.

Artists, Guilds, and Craft Technology

I n this and the following chapter we will look at the arts of Islam in their practical, technical, and economic aspects, discussing first the evolution of the guild system and apprenticeships in the different countries of the Islamic Middle East. We will then go on to consider different crafts in detail, beginning with architecture and woodwork. Although in the West architecture might be regarded as a major art along with painting or sculpture, as has been said, this Western division between the major and the minor arts (what might be called the decorative arts or crafts) is misleading when applied to the art of Islam. As we shall see, there was in any case a strong connection between the principles of architectural knowledge and woodworking, with a number of Islamic architects moving from one discipline and set of skills to the other.

After architecture and woodwork, this chapter will consider metalwork (including weaponry, which was particularly prized in the West), ceramics, glassmaking and the carving of semiprecious materials such as crystal, ivory, and jade, and Islamic textile manufacture such as silk-weaving and carpet-making. The arts of the book, which are so essential to Islamic art, will be considered separately in the next chapter.

Although we may hear of soldiers who turned to painting, or sultans who practised calligraphy, Islamic art and architecture were for the most part the creation of anonymous craftworkers. Craft skills tended to be the preserves of particular families and were handed down from one generation to the next. Abu'l-Qasim, the Iranian author of an encyclopedia of 1301, which contains much valuable information on ceramic technology, belonged to a clan named the Abu Tahir, who had dominated the production of

108. Ottoman or Mamluk chamfron, 15th or 16th century. Forged and engraved steel, height 21¼″ (54 cm). Khalili Collection.

lustre pottery in Kashan in north-west Iran for four genera-
tions. The Italian pilgrim Simone Sigoli, who visited Damascus in
the 1380s, reported that metal inlay technique and other skills were
transmitted from father to son.

Apprenticeship and the Guild System

The head craftworker was usually known in Arabic as an *ustadh*
or a *mualim*; the apprentice was a *mutaalim*. (With few exceptions,
the craftworkers were men, so the terms "master" and "crafts-
man" will be used as appropriate.) Apprenticeship contracts from
sixteenth-century Samarqand specify that the apprentice promised
the master craftworker obedience and in return would receive
training (FIG. 109). When the master was satisfied that the appren-
tice had mastered his craft he might present him with an *ijaza*,
a certificate of competence. In some places and times the crafts-
man earned his promotion by presenting a series of works. For
example, Mehmed Aga, who first trained in the Topkapi's Palace

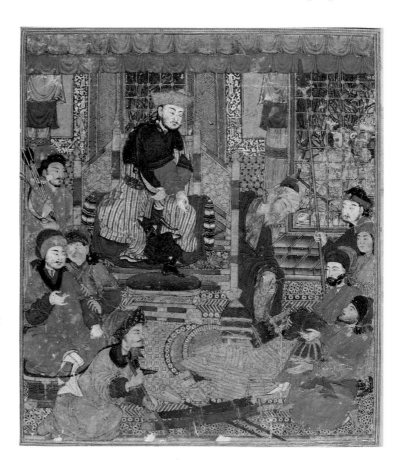

109. Persian miniature from
a copy of Firdawsi's
Shahnama showing Jamshid
teaching the crafts, c. 1370.
Illuminated manuscript, 9¹/₂ x
7¹/₄" (24 x 18.5 cm). Topkapi
Saray Library, Istanbul.

Jamshid is one of the early
legendary kings said to have
introduced elements of
civilisation, such as weaving,
weapon-making, and other
crafts, to his contemporaries.

School as a worker in inlaid mother-of-pearl and later became one of the foremost architects of the early seventeenth century, won his advancement by presenting Sultan Murad III (1574–95) with an inlaid Koran lectern, or *kursi*, and then with a similarly decorated bowcase.

It was once believed that the guild system in the Islamic world began in the ninth century. In fact, though craftsmen were often closely bound together by kinship, locality, and various forms of partnership, nothing one could call a guild as the term is understood in Western art history appears in the Middle East or North Africa until the fourteenth century at the earliest.

A guild in the strict sense is a group formed to protect and promote a craft or trade interest. It is true that one occasionally comes across craft groups that look very like guilds. Thus, when the North African traveller Ibn Battuta was in Isfahan, he noted how the "members of each craft appoint one of their own number as head man over them, whom they call the *kilu*, and so do the leading citizens from outside the ranks of the craftsmen." However, since the main and possibly sole activity of these craft groups was to compete in giving feasts, they more closely resemble social groups than guilds. If craft groups were concentrated in particular quarters in a town, they were sometimes subject to the supervision of a *muhtasib*, the market inspector, who might appoint an *arif* to supervise members of a particular trade or craft, but his job was really to police the craftsmen, not to represent them. Sometimes craftsmen organised themselves into groups for religious purposes: the earliest evidence for something like a guild in the Mamluk lands concerns a Sufi fraternity of silkworkers in Damascus, who had a shaykh at their head and whose members wore a special uniform. In 1492 the Damascus silkworkers united to protest against an oppressive Mamluk tax, but there is no evidence that the Sufi fraternity had an organising role in the protest or that the protest was effective. Under the Ottomans, guilds evolved out of quasi-religious fraternities devoted to offering hospitality to strangers and other good works. Their members were known as *Ahis* (Brothers), and slowly such brotherhoods transformed themselves into craft corporations. By the late fifteenth century groups we can call guilds existed in Turkey.

The interventionist Ottoman bureaucracy tightly regulated the number of craftsmen who might practise in any particular locality. For example, if the craftsman moved, he had to renew his *gedik* – a warrant guaranteeing his place of work and ownership of tools and goods. The Ottoman bureaucracy also sought to use the guilds to impose standards on the workers and regulate materials and

Overleaf

110. Parade of the Ottoman guild of potters from the *Surnama* (*Book of the Circumcision Festival*) of Murad III, c. 1582. Illuminated manuscript, 12½″ x 1′5″ (32 x 44 cm). Topkapi Saray Library, Istanbul.

On one occasion over seven hundred guilds marched through Istanbul, including taxidermists, story-tellers, keepers of lunatic asylums, and executioners.

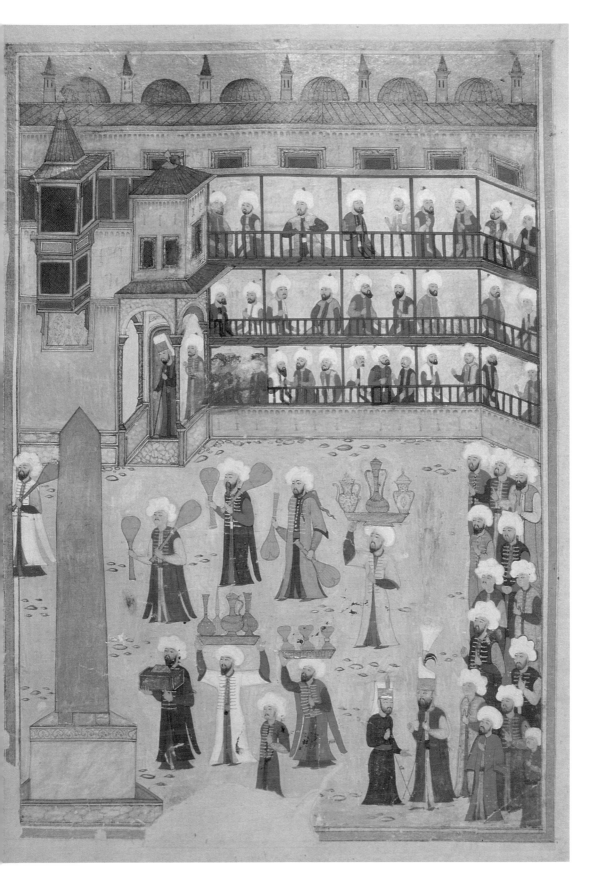

profits. On festive occasions members of the guilds were required to parade before the sultan displaying the tools or products of their occupation (FIG. 110).

The Guild System in North Africa

Guilds spread to Egypt, Syria, and much of North Africa after the conquest of those territories by Selim I in the early sixteenth century. The Turkish writer Evliya Celebi, who visited Cairo in the 1670s, reported that it had almost three hundred guilds. The heads of the guilds do not seem to have been chosen by the members to represent their interests, but rather were effectively state appointments, and were usually chosen by the Chief Judge of Egypt. It would appear that the main purpose of these guilds (*asnaf*) was to facilitate the raising of taxes by the Ottoman authorities. In the building trade, for example, the official appointed as chief architect, the *mimarbaşi,* collected taxes from the guilds of builders, masons, architects, and stonedressers.

In Egypt the head of a guild was called a shaykh, but another officer, the *naqib*, acted as master of ceremonies and keeper of guild lore. The shaykh in Ottoman Egypt used to confer an *ijaza* on anyone wishing to pursue the guild's particular craft. Not only were apprentice-pieces of work examined, but at a higher level the production of master pieces might be celebrated. The sixteenth-century Moroccan traveller Leo Africanus described such a ceremony:

> When it happens that one of the artisans turns out a beautiful, ingenious piece of work which has never before been seen, he is dressed in a brocaded coat, taken from shop to shop, accompanied by musicians in a sort of triumphal walk, and everyone gives him money. I saw a man in Cairo who had received one of these triumphal honours for having made a chain for a flea which he kept chained on a piece of paper ...

In fourteenth-century Fez in Morocco, where there were approximately 150 corporations, craft skills were highly differentiated. Thus there were three corporations for potters – potters who made water pipes, potters for roof tiles, and potters for glazed tiles. Unlike Turkish apprentices, the Moroccan apprentice was not subjected to a formal examination. But, as with Ottoman guilds, each craft had a patron saint. In Turkey the patron saint of the silk-workers was the biblical prophet Job. In the case of the potters of Fez it was Sidi Minoun the Potter, a legendary figure who was supposed to be buried in the potters' quarter.

The Iranian Guilds

In Iran, guilds seem to have evolved from *futuwwa* groups, medieval fraternities of young men who came together for chivalric, hospitable, or mystical purposes. Detailed information about Iranian guilds is available only from Safavid times onwards, but even then the craft groups seem to have had a mystical aspect. According to the *Futuwwatnama* (*Book of Chivalry*) of the textile-makers (*chitsazan*), each craft action, every aspect of weaving and dyeing, had symbolic significance. The patron saint of their guild was Jafar al-Sadiq, the sixth in the chain of Shia Imams in succession from Ali, and a figure who was famous for his knowledge of occult lore; but it was the Archangel Gabriel who was believed to have first taught people how to dye cloth. It was the duty of an *ustadh*, or master craftsman, in the Iranian guilds to transmit not only the practical craft techniques but also their inner spiritual significance.

The head of a guild in Safavid Iran was called a *kakhuda*, and the status of a particular craft, in Iran and for that matter elsewhere, was dependent on the intrinsic cost of its raw materials. Thus workers in gold commanded the most respect in Isfahan, while workers in brocaded silk came a little behind them in prestige. Workers in these prestigious crafts had their workshops in the Royal Bazaar, where they could be closely supervised by the shah's officials. Those found guilty of substandard work were punished by being paraded around wearing a wooden hat.

The State and the Labour Force

Islamic regimes in general played an enormous role as regulators, producers, and purchasers of luxury articles – the role of the state-owned Abbasid *tiraz* workshops in producing luxury textiles has already been mentioned. Major building works in particular, as one would expect, almost invariably owed their inception to the state, and most Muslim regimes seem to have made use of forced labour for such projects. When in the 740s the caliph Walid II was building the desert palace of Mshatta, he made use of labour that was compulsorily drafted in, and, according to the eighth-century chronicler Severus ibn al-Muqaffa, vast numbers died from lack of water. Samanid and Ghaznavid rulers regularly conscripted peasant *corvées*, or forced labour, for their building works, and Saladin made use of the prisoners he had taken during his campaigns in Palestine in order to build the Citadel at Cairo (Crusader captives in Cairo were also employed in weapon-making and other crafts). Medieval Arabic guides to slave-buying particularly single out the craft skills of Greek slaves.

These slave labourers could find great fame and fortune through their craft skills. Selim I's chief architect, Ali, was an Iranian whom he had captured during his campaigns against the Safavid shah Ismail in 1514, while the greatest of all Ottoman architects, Sinan, who himself had been a slave, proved to be a master of logistics and a brilliant director of conscript labour. While working on the Suleymaniye Mosque, he made use of 25,000 janissaries (a regiment formed from the levy of Christian boys forced to convert to Islam) and galley slaves as architectural labour during the winter months, when they were not needed for campaigning.

Different regions specialised in different products: Samarqand was famous for the manufacture of paper; the town of Kashan in north-west Iran produced lustreware; ivory carving was produced in Cuenca in Spain; Damascus seems to have had a monopoly on the production of watered steel. Patrons sometimes took pains to recruit specialised labour from outside their territory. Thus Mamluk emirs made use of Iranian tileworkers for the decoration of mosques in Cairo, and later Suleyman the Magnificent similarly called on craftworkers from Tabriz to work on the tiling of the Dome of the Rock in Jerusalem. These Iranian tileworkers found subsequent employment in Aleppo and elsewhere in Syria.

Warfare and consequent migrations of labour also often resulted in the transplanting of artistic skills to a new area. In the eleventh and twelfth centuries, when Syria and Palestine suffered heavily from wars between the Fatimids, Seljuqs, and Crusaders, large numbers of craftworkers fled south to the relative security of Egypt. In the late thirteenth century the appearance of Mongol armies on the Euphrates seems to have resulted in the flight of metalworkers from Mosul and potters from Raqqa into Mamluk Egypt. In the fifteenth century, political turmoil in Herat and Samarqand caused craftworkers to migrate to Iraq and western Iran.

On the evidence of the literature, it seems that women played an extremely small part in the production of Islamic art. However, that evidence (writings mostly produced by men) may be misleading. There probably were women potters: for example, a blue-glaze ceramic fragment unearthed at Fustat (old Cairo) seems to bear the inscription "work of Khadija." In the modern Middle East women have often been weavers and there is no reason to think that the situation was any different earlier. In his treatise on love, *Tawq al-Hamama* (*The Ring of the Dove*), Ibn Hazm, who was writing in eleventh-century Cordoba, remarks that female spinners and weavers were among those popular with lovers, "because of the ease of access to them." The morals of women who spun, wove, or dyed textiles and thus were likely to deal with

men were inevitably the concern of the *muhtasib*. Ibn Abdun's twelfth-century manual on market inspection urged that women who wove brocades should be banned from markets, because "they were nothing but harlots." Finally, calligraphy was and is the most highly regarded art form. According to some authorities, the practice of it was barred to women. As a saying attributed to the Prophet put it: "Do not allow them to come down to the public sitting rooms, and do not teach them writing." However, this injunction was not rigorously observed. For example, Fatima, "Daughter of the Bald," was one of the most noted calligraphers of early Seljuq times. Zaynab Shuhda al-Katiba (d. 1178) was another leading medieval calligrapher; and calligraphy was often taken up by princesses, such as the daughters of the Safavid shah Ismail.

The Muslim Architect

The word most commonly used for a designer or overseer of construction work in the Islamic world was *muhandis*, from the root *handasa*, meaning "geometry." A *muhandis* might be a geometer, an engineer, a hydraulics expert, a surveyor, or an architect. There was no set architectural training in the medieval Middle East, and even later, according to an eighteenth-century consul in Aleppo, "Builders are not educated in any principle or rule; they learn by routine." Histories of architecture are by convention histories of success, but it is well to bear in mind that the history of medieval architecture in the Muslim lands (as in Christian Europe) is littered with spectacular failures. This is hardly surprising, for not only was there no formal architectural training, but there was also no accurate way of calculating stresses. The collapse of the minaret of the Sultan Hasan Mosque in Cairo in 1361 has already been referred to (see page 84).

The great historian Ibn Khaldun (1332–1406) seems to have conceived of the architect as more of an engineer and a contractor than an artist working in bricks and stone. According to him, a builder must understand hydraulics, know how to manage a plumb line, how to use machines to lift heavy loads using pulleys, and so on. Architecture in the Mamluk sultanate certainly overlapped with military engineering. During the reign of Baybars I (1260–77), the emir Izz al-Din Aybak al-Afram was nominally the Sultan's Emir Jandar, or "guard officer." In practice, though, this senior Mamluk emir seems to have been in charge of all major building projects, supervising demolition, fortification, and irrigation works.

111. A gold-beater repenting in front of the Sufi Rumi, from the *Majalis al-Ushshaq* of Husayn Bayqara, copied in 1552. Illuminated manuscript. Bodleian Library, Oxford.

This is a relatively rare image of a craftsman. Although in general workers in gold and silver enjoyed higher prestige than other craftworkers, nevertheless they were disapproved of by the pious, because of the Prophet's ban on drinking or eating with gold or silver utensils and his ban on men wearing gold and silver ornaments. The image illustrates an episode when Jalal al-Din al-Rumi, a famous 13th-century mystic (1207–73), who was based in Konya, was passing by some gold-beaters when the sound of their hammers sent him into ecstasy and he began to dance. Seeing this, a former pupil, whom circumstances had forced to become a goldsmith, repented his trade and became Rumi's disciple once more.

We know quite a lot about the training of the great architect Sinan (1491–1588), in part because a contemporary, Sai Mustafa Celebi, wrote a biography of him, the *Tezkiretl-Bunyan*. Sinan was a janissary soldier, probably of Greek origin, who had been recruited through the *devshirme* levy on Christian villages. He started as a military engineer employed on defence works, roads, and bridges, before rising to become *mimarbaşi* (chief court architect) in 1538. It is important to note that much of the architecture undertaken by Sinan and his trainees was not creative architecture, but is

better characterised as maintenance, restoration, and engineering work.

One of Sinan's leading disciples, Dalgich, trained first in mother-of-pearl inlay work in the Palace School, which seems to have been a common way of instructing future architects in the elements of geometry, as the example of Mehmed Aga, a famous student of Sinan's, confirms. Mehmed Aga was a *devshirme* recruit who first served in the imperial corps of gardeners and then became a musician as a result of an inspirational dream concerning a band of gypsy musicians. However, he was subsequently persuaded by a Sufi shaykh of the Khalwati order to abandon this frivolous, even satanic art (FIG. 111) and he moved on to mother-of-pearl inlay work, for which a good knowledge of geometry was needed. His mastery of the principles of geometry in turn led to building work. Mehmed Aga was to hold the post of chief court architect from 1606 until 1623.

Doubtless, most of the necessary architectural skills were transmitted orally. Although we know of no medieval manuals giving comprehensive guidance to architects, manuals of geometry covering some of the necessary ground have survived (such as, for example, a fourteenth-century manual by al-Kashi on the plane geometry of *muqarnas*). Models were also sometimes used – a fifteenth-century miniature by Bihzad in a copy of Sharaf al-Din's *Zafarnama* (*Book of Victory*), produced for Timur, shows the master architect supervising the building of the Bibi Khanum Mosque in Samarqand and holding a model of the mosque in his hand.

The Materials of Islamic Architecture

Aside from the evidence provided by existing buildings, there are also a number of manuals and other written sources describing the materials Islamic architects had at their disposal and how they should be used. Ibn Khaldun in the *Muqaddima* provided a somewhat conceptual description of the main types of buildings, distinguishing between those of stone or brick held together by clay and quicklime on the one hand, and those made of bricks of earth and quicklime on the other. He described how the bricks were made by setting the earth between wooden boards, set on a foundation and joined together with pieces of wood fastened with ropes or twine. Then the earth was mixed with quicklime pounded in this frame and then more earth was added (straw and chaff would also be added, though Ibn Khaldun does not mention this). A third technique involved covering the earthen walls with quicklime that had previously been diluted with water. Ibn Khaldun also briefly discussed interior decoration:

Thus, figures formed from gypsum are placed upon the walls. It [the gypsum] is mixed with water, and then solidified again with some humidity remaining in it. Symmetrical figures are chiselled out of it with iron drills, until it looks brilliant and pleasant. The walls are occasionally all covered with pieces of marble, brick, clay, shells [mother-of-pearl], or jet ... set into quicklime. Thus the walls come to look like colourful flower-beds.

The use of plaster (*jiss*) in facing walls of rubble and rough stone had been pioneered by the Sasanian Iranians. The rough stone wall had to be made at least even enough to take the plaster; alternatively one could face it in ashlar (squared stone). The Syrians were the acknowledged specialists in building in stone, while the Iranians were supreme in building with kiln-baked bricks (as opposed to the less durable sun-dried or adobe bricks). *Hisba* manuals sought to regulate the size of bricks in buildings, and sometimes templates of brick sizes were kept on display in the local mosque, where they could be referred to by market inspectors. The bricks could be held together by gypsum or lime. Gypsum (a soft mineral, hydrated calcium sulphate) was easy to find in Syria, Iran, and Iraq, and, after crushing, it fired at a lower temperature than lime. The material lent itself to intricate stucco carving with a chisel. However, lime was a stronger bonding agent and was also used for waterproofing.

Although there were marble quarries in the Middle East, the marble (*rukham*) needed for new building was most often looted from old ones. "Aleppan marble" was actually a patinated limestone. A striking range of vocabulary, including "veined," "starling," "fat and meat," and so on, was used to describe the differently coloured types of marble. Architects in the Mamluk lands were among the leading specialists in the use of coloured marbles and piebald courses of stone and marble.

Woodwork

The Middle East, at least in parts, was once more heavily wooded than it now is. In the twelfth century, lions were hunted in the forests and cane brakes of northern Syria, and Richard the Lionheart fought Saladin in the Forest of Arsuf. Houses were often built of wood in Turkey, northern Syria, and northern Persia. Even when the houses were built of stone, it was common in Persia for the house to have a *talar*, or wooden porch. (The Chihil Sutun pavilion – see FIG. 107 – is an example.) Other regions, especially the Arabian peninsula, Egypt, and North Africa, suffered

from a severe shortage of wood. However, a lot of timber was imported from India and the Sudan. Recent excavations show that houses in the Gulf port of Siraf were commonly made from teak, probably brought by boat from the Malabar coast of India. The palaces of the Abbasid caliphs in Samarra made heavy use of teak.

Paradoxically, because of the relative scarcity of wood, Muslim woodworkers developed highly sophisticated ways of carving and embellishing wood: they made use, among other techniques, of relief carving, sunk carving, drilled lattice-work, undercutting, and slant-bevelling. Since wood was scarce, much attention was given to its working and it was quite common for proud carpenters to sign their creations. Iranian carpenters specialised in an inlay technique known as *khatam-kari*, in which small strips of wood were inlaid in intricate geometrical patterns on a wooden base. Turkish craftworkers favoured mother-of-pearl for inlay on wood, while Egyptian woodworkers specialised in star or polygonal geometric patterns, which often made use of ivory inlay. Egyptian woodworkers also specialised in turned wood, which was often used for lattice screens. This sort of work (*mashrabiyya*) helped compensate for the extreme scarcity of wood panelling in Egypt. In general, Muslim woodworkers were more sophisticated than their counterparts in Christian Europe and, for example, in the fourteenth century Muslim carpenters were hired to work on the ceilings of the Palace of the Popes in Avignon.

Metalwork

In general histories of European art, metalwork tends to be discussed as a minor art form – when it is discussed at all. But it is clear that, in the Islamic lands, working with precious metals was in no sense a poor cousin to painting on canvas or sculpting marble in the round. Rather, metalwork was for a long time the leading art form, serving as a vehicle for the most inventive and elaborate decorations, which influenced forms and decorative motifs subsequently deployed in other media such as ceramics. The preciousness of the materials they used gave metalworkers a high standing in the hierarchy of craftworkers. One sign of that status is that it was quite common for metalworkers to sign their works. Only from perhaps the thirteenth century onwards and in certain regions did the arts of the book come to supplant working with gold and silver as the leading art form.

In the early Islamic period, the great centres for the production of high-quality metalwork tended to be in northern Iran and further to the east in the cities of Khurasan, and Islamic

metalworking techniques and designs were in large part inherited from the Sasanian era. In the Muslim era, Herat was the great centre for metalworking, according to the thirteenth-century cosmographer al-Qazwini. Mosul in the early thirteenth century was also noted for luxury work. According to the traveller Ibn Said, who seems to have been born either in Andalusia or North Africa, and who died in 1274, there were "many crafts in the city, especially the making of inlaid copper vessels, which are exported and presented to rulers, as are the silken garments woven there." The term Mawsili, meaning "of Mosul," is found on objects produced long after the fall of the city to the Mongols, so perhaps the word had come to designate a certain standard of work, rather than indicating that it was actually made in Mosul, or even by a craftworker who had once lived in Mosul. With the coming of the Mongols many metalworkers fled westwards from Iran and Mosul into Mamluk Egypt and Syria.

Despite that emigration, high-quality metal objects continued to be produced in Iran and Afghanistan under the Ilkhanids and Timurids. An enormous amount of skill was lavished on gold and silver vessels. Unfortunately, objects made in these precious metals were most likely to be melted down so that their metals could be reused. Therefore, most of the best pieces of metalwork in museums today are examples of inlay work – that is, of brass, with gold, silver, or copper inlay, and sometimes even this inlay has been stripped, leaving only the grooves where the gold or silver was once inserted.

112. Detail of *repoussé* birds and human-headed lettering round the shoulders of a Herati ewer, c. 1180–1200. Brass with inlay, height of whole 15³/₄" (40 cm). British Museum, London. (See FIG. 131.)

Bronze is an alloy of copper and tin, and the presence of a lot of tin in the alloy gives it a golden sheen. Brass, a mixture of copper and zinc, is harder to work than bronze and high-quality work in brass was a later development. But medieval Arabs did not distinguish clearly in their writings between bronze and brass. Both were called *sufr*. Techniques for shaping the metal included casting, hammering in sheets, or spinning on a lathe, forcing it against a wood or metal "chuck." *Cire perdue* ("lost wax") was a specialised form of casting. Al-Jazari's *Book of Knowledge of Ingenious Mechanical Devices* described the *cire perdue* technique, in which a mould was formed round a wax model before the wax was melted away. Al-Jazari, who was a metalworker as well as a designer of automata, also described a form of casting in green sand instead of the usual clay. The term *repoussé* describes the highly skilled technique of hammering out brass sheets from within the object to create raised surfaces (FIG. 112).

Ibn al-Haytham (known in the medieval West as Alhazen, d. 1039), a mathematician and optical theorist, argued that roughness produced beauty "and for this reason many of the goldsmith's artefacts become beautiful by having their surfaces roughened and textured." The metal, once shaped, could be engraved or inlaid with another metal. Inlay work on brass or bronze seems to have become common from the twelfth century onwards, appearing first in Iran and slowly spreading westwards. Simone Sigoli was in Damascus in the 1380s, where he reported that "they also make a large quantity of basins and ewers of brass and in truth they look like gold; and then on the said basins and ewers they put figures and leaves, and other subtle work in silver, a thing most beautiful to see." Silver was the most favoured metal used for inlay on to an incised bronze or brass body, but sheets or wires of gold, copper, or niello could be used as well or instead. Niello is a black metallic compound, a silver amalgam with other metals, which is melted at a low temperature. A black bituminous substance might also be used as a filling in the incised designs. There was a silver famine in the Islamic lands from the twelfth century onwards and the inlay technique can be seen as a way of making precious metals stretch further. However, it was not just a matter of scarcity of precious metals. As we have already seen, many pious Muslims recoiled from drinking or eating from gold and silver vessels, but vessels decorated with inlay work might constitute an acceptable substitute. The objects with elaborate decorations favoured in the Islamic world included big basins, aquamaniles, censers, handwarmers, candlesticks, mosque lamps, and ingenious mechanical contrivances.

Armourers

Weapons and armour, particularly those produced for ceremonial purposes, can be considered as objects of art (FIG. 108, see page 133). The most productive iron mines in the Middle East were in Iran. Muslim armourers in Spain also had ready access to iron and Toledo steel acquired a special reputation in medieval times. Steel is made from iron with a little carbon. Iran and Syria were particularly famous for their damascened (from Damascus) steel. Jean Chardin (1643–1713), a French Huguenot jeweller who travelled extensively in the Safavid lands, described the technique as practised by Iranian swordsmiths: "Their scimitars are very well damascened and exceed all that Europeans can do, because I suppose our steel is not so full of veins as the Indian steel, which they use most commonly. They forge their blades cold and before they dip them they rub them with tallow, oil, or butter to hinder them from breaking, then they temper them with vinegar and copperas [ferrous sulphate], which being of a corroding nature, shows these streaks or veins which they call Damascus work." The silky patterns produced by the steel's high carbon content could then be accentuated by skilful etching in acids.

Ceramics

113. "Aelopile" (sphero-conical grenade) from Iran or Iraq, 12th century. Glazed earthenware. British Museum, London.

Although it is widely held that such "grenades" were for warfare, they may have been used as perfume censers or cooling devices for pottery kilns.

Muslim potters produced a large and spectacular range of display ware, which made use of similar decorative designs to those employed by metalworkers and book illustrators and which aimed at similar effects. Ceramic art reached its height in different areas at different times – in Iraq in the ninth century, in Iran and Afghanistan in the tenth century, in Syria and Iran again in the twelfth to fourteenth centuries, in Spain in the fourteenth and fifteenth centuries, and in Turkey in the sixteenth century.

Earthenware, which is fired clay, has a natural dirty buff colour after firing (FIG. 113). In fritware, however, powdered quartz is added to the clay body which is then fired at a higher temperature. This produces a harder, finer, semi-transparent body. A potter who worked with frit and made use of multiple firings enjoyed a fairly high status. Such artists were often, like alchemists, the possessors of trade secrets, which might vanish when those who guarded them died out. In the treatise he wrote in 1301, the Iranian Abu'l-Qasim al-Kashani wrote that "this art is in truth a kind of philosopher's stone." He went on to describe how frit was prepared from powdered pebbles of quartz melted together. According to him, the frit mixture was made up of ten parts of ground quartz, one part glass frit, and one part ground clay. Fritware is more malleable and consequently there is a general tendency

Early Muslim potters made use either of soda and potash glazes or of lead glazes. The former, an alkaline glaze, is very transparent, but it allows only a restricted range of colours. Iranian potters tended to use an alkaline glaze (and alkaline glazes tended to be used on fritware, when this was introduced in the 12th century). Egyptians and Syrians, by contrast, tended to favour a lead glaze. This allows a wider range of colours, but those colours tend to run.

for fritware objects to be made in more delicate shapes than earthenware. Porcelain is whiter and yet more delicate than fritware. The Chinese produced porcelain by firing their pots at an even higher temperature than that used for fritware. However, although Muslim potters admired the delicacy and translucence of Chinese porcelain intensely and frequently sought to imitate the Chinese shapes and designs, they did not have access to the right sort of clay for true porcelain, nor were they able to fire their kilns to a sufficient temperature (FIG. 114).

Fritware vessels began to be produced in the twelfth century. Before then, a potter who wanted to make the products look white coated them in a white clay slip. This slipware could be incised for decorative purposes (FIG. 115). Alternatively, if one wanted to decorate a pot or dish, one could coat it with a glaze. Then in the ninth century Muslims pioneered the techniques of white tin glaze (in an attempt to emulate the whiteness of Chinese Tang ware). If one painted on the unfired clay body and then coated it with tin glaze, the colours would not run during firing. Painting on the glaze with cobalt produced blue, copper

116. Relief-decorated plate covered with lustre, from Iran or Iraq, 9th century. Lustreware, height 1⅛" (3 cm). Khalili Collection.

The lustre technique, which could be used to give dishes the appearance of having been made from gold, seems to have been borrowed from glass and to have spread from 9th-century Iraq to Egypt, and from there to Syria in the 12th century. According to the Iranian poet and traveller Nasr-i Khusrau, who was in Cairo in 1047, its inhabitants made "bowls, cups, plates, and other vessels. They decorate them with colours like those of the woven fabric called *buqalamun* [shot silk]."

produced green, and manganese produced purple, but this was still a restricted range of colours.

Lustreware

The development of the tin glaze in turn allowed the innovation of lustreware (FIG. 116), as the lustre was painted onto the tin glaze and then fixed by a second firing in the kiln. The lustre painted onto the tin glaze was a mixture of sulphur, silver oxide, and copper oxide, plus red or yellow ochre suspended in vinegar. It was a difficult technique and only a small handful of craftsmen at any one time seem to have made themselves masters of it.

A great deal of lustreware was produced in Muslim Spain. The Moroccan traveller Ibn Battuta noted that "at Malaga is made the wonderful gilded pottery that is exported to the remotest countries." Raqqa, on the Euphrates, was the prolific centre for the Syrian production of lustreware until about 1260. From the thirteenth century until about 1340, Kashan in north-west Iran was the major industrial centre for the production of lustreware and other kinds of ceramic. It should be noted that at Kashan (as later in the Turkish town of Iznik) the production of pots and dishes was subsidiary to the manufacture of tiles. Indeed, *kashani* is the word for tile in Persian.

Minai and *lajvardina* were, like lustre, techniques for decorating luxury ware to meet the tastes of the elite and, as with lustre, the techniques were difficult and labour-intensive. Those who worked them quite often signed and dated their work. *Minai* means literally "enamel," while *lajvardina* means "lapis lazuli." In the *minai* technique, some colours were applied to the clay body and then covered with an alkaline glaze before being fired at a relatively high temperature. Then additional colours were painted onto the fired glaze and the pot was fired again at a lower temperature. (Like the lustre technique, the *minai* process seems to have been first developed for glassware.) The *minai* technique and its range of colours allowed dishes and pots to be decorated with detailed figurative imagery, similar to manuscript miniatures. The process for *lajvardina* was identical to that used for *minai*, except that the makers of *lajvardina* favoured abstract designs (FIG. 117) and, on the whole, a more sombre range of colours, which were applied in the second firing. Both *minai* and *lajvardina* must be considered to be display ware, as their decorations would not have survived much washing up. (It is perhaps worth noting

117. Iranian *lajvardina* dish, early 14th century. Glazed ceramic, diameter 8¼" (21.2 cm). Louvre, Paris.

Despite its name, no lapis lazuli was used in the production of *lajvardina* (Persian for "lapis lazuli"). However, gold was often used in the decoration of *lajvardina* ware, the gold being hammered into strips, cut up with scissors, and glued onto the vessel.

here that a mixture of brick dust and powdered potash was commonly used for washing up and a Spanish Muslim cookery manual recommended that "an earthenware pot should be replaced every day, a glazed one every five days.")

Sultanabad and Syrian Pottery

Sultanabad ware, named after the town in north-west Iran and produced at about the same time as *lajvardina*, was similarly sombre in tonality, but differed completely in design and in the technique of its production. Sultanabad dishes sought to emulate the grey-green colours of fashionable Chinese celadon ware. However, these bowls and dishes, which mimic Chinese shapes, are coarse and heavy, and the decoration customarily makes use of black outlines painted under the glaze and a thick overglaze slip. Just as *lajvardina* does not use lapis lazuli, so Sultanabad ware was not made in Sultanabad (and, while we are on the subject of misnomers, *minai* is a modern term for what at the time was called *haft rang*, or "seven-colour").

Egypt and Syria under the Mamluks, from the twelfth to the fifteenth century, produced a range of high-quality ceramics. Syrian potters specialised in producing underglaze-painted vessels, in which blue-green or black designs were painted onto a white

slip, but also more luxurious-looking lustreware produced for the court and perhaps for export. Amongst the most elegant objects that were decorated with lustre were albarellos (waisted jars used for the storage and transport of spices and other commodities). At the other end of the market, Egyptian and Syrian potters also produced a coarser type of vessel in which the designs were incised through the slip cover, and then coated in a green, yellow, or brown glaze. It would appear from the frequency with which heraldic devices were used that a great deal was produced for the military, but clearly such crudely decorated earthenware would have had a wider market than that. Potters in the Mamluk lands and elsewhere had to compete with the import of Chinese porcelain on a massive scale. In Iran from the fifteenth century onwards, large-scale imports of blue-and-white and celadon ware stimulated renewed attempts by Iranian potters to imitate the esteemed products of China. Such attempts culminated in the late seventeenth century with "Gombroon" ware (so-called from the port, also known as Bandar Abbas, from where it was exported to Europe), examples of which achieved an unprecedentedly white gloss look.

Iznik

118. Interior of an Iznik ware basin, late 15th century. Glazed ceramic, diameter 16½″ (42 cm). Victoria and Albert Museum, London.

The Ottoman town of Iznik, in western Anatolia, which had previously been a producer of humdrum earthenware, became an important centre for glazed ceramic production in the fifteenth century. There had been no precedent in Turkey for such high-quality ceramics. The earliest type of Iznik ware had a white ground, decorated with underglaze painted blue, which was almost certainly influenced by Iranian blue-and-white ware. Thereafter, ceramic production at Iznik enjoyed a prolonged evolution (a little over two hundred years), as its designers experimented with a range of styles, designs, and colours. Many early vessels were decorated in the International Timurid style (FIG. 118). Subsequent ranges of Iznik ware were decorated with designs of spiral floral sprays, inspired by the backgrounds to the *tughras* (monograms) of Ottoman sultans. Later yet, under the influence of Suleyman the Magnificent's court

119. Iznik ware pot lid, c. 1560. Glazed ceramic, diameter 16½" (42 cm). Louvre, Paris.

The potters of Iznik seem to have managed to achieve higher temperatures in their kilns than any of their predecessors or competitors in the Islamic world. Consequently, they were able to produce larger and finer pieces.

painter, Kara Memi (fl. 1545–66), the stylised decorative foliage characteristic of the Timurid style gave way to more naturalistic arrangements of tulips and other flowers. The palette gradually widened and so-called "Damascus" ware produced at Iznik made use of manganese purple and sage green, as well as various shades of blue (FIG. 119). With "Rhodian" ware (another misnomer for a phase of Iznik ware), sealing-wax red was introduced to the palette.

The production of pots in Iznik, as at Kashan, became subordinate by the mid-sixteenth century to production of ceramic tiles for the building industry. Tiles were used in architectural decoration from the earliest Islamic times onwards. For example, the Abbasid palace of Jawsaq al-Khaqani in Samarra was decorated with tiles. However, an explosion of tile production occurred in the twelfth century in Seljuq Iran centred on Kashan. Besides tiling for buildings, Kashani potters produced *mihrab*s and tombstones which were intricately decorated with lustre or *minai* or *lajvardina*, as well as more workaday monochrome blue tiles. Production of pots and tiles at Kashan seems to have declined in about 1350. However, vast quantities of tiles continued to be produced elsewhere for the revetment of Timurid buildings.

Successive migrations of Iranian tileworkers during periods of turbulence entered the Mamluk and Ottoman lands. Iznik produced underglaze tiles in vast quantities for Suleyman the Magnificent's grand projects, but demand for architectural tiles declined in the seventeenth century. The use of mosaics made of tiles was especially favoured in Iran in the Timurid period. The coloured tiles were cut after firing into interlocking shapes. Eventually the intricate mosaic technique was superseded by that of *cuerda seca* ("dry cord"). In the *cuerda seca* technique, different colours can be put onto the same tile. The colours were prevented from running by outlining the coloured areas with a greasy substance, which was then burned away during the firing. *Cuerda seca* seems to have been developed in Iran as early as the late fourteenth century, but it was especially favoured in seventeenth-century Safavid Iran.

Glass and Glassmaking

Some of the techniques employed by potters were used first or also by the makers of glass. Islamic glassworkers continued and developed the glass technology of antiquity. Syria had been a major centre for its production in Roman times and it continued to be so after the Islamic conquest. "It is clearer than Syrian glass" was a proverbial Arab expression. In part, Syria's supremacy in this field was due to the suitability of a particular sort of wood ash, deriving from the Syrian saltwort, called *al-qali* (from which the English word "alkali" comes). In part, it also resulted from the suitability of the precise type of sand found in the coastal regions in the vicinity of such ports as Acre and Tyre. Glass was made from a fusion of wood ash with sand or with flint silicate. Magnesium could be added to this mixture in order to get a colourless transparent effect. Alternatively, glass could be coloured with metal oxides. The glassmaker needed multiple chamber furnaces for both melting and annealing (slowly cooling) the glass. In order to get a particularly pure sort of glass, a mixture of silicate and sand was melted in crucibles in a furnace and cooled. The frit produced in this manner was then crushed and mixed with silica and remelted to produce pure glass.

Techniques for shaping the glass included blowing into a mould, trailing and blobbing, marvering (the application of threads of coloured glass), indenting, cameo cutting, and cutting with a wheel or a diamond. Lustre was applied on glass between the eighth and

120. Egyptian enamelled and gilded glass vase, early 14th century. Height 12¼" (31 cm). Al-Sabah Collection, Kuwait.

Although the 13th and 14th centuries saw the heyday of enamelling and gilding on glass, and some exquisitely decorated pieces were produced in this period, the quality of the glass itself was often rather poor, being discoloured and misshapen.

twelfth centuries and then the technique more or less vanished, for unknown reasons. It was only revived in the Safavid period. From the thirteenth century onwards, the decoration of glass by enamelling or gilding became common in Syria and Egypt (FIG. 120). (Iran and Iraq seem to have ceased producing high-quality decorated glass a century or two earlier.) The outlines were marked out in red enamel and then a (restricted) range of colours applied as a powder and fixed by a second firing at a low temperature. Essentially the same technique was used for applying enamel colours in metalwork and ceramics.

Crystal, Jade, and Ivory

Glassworking was closely related to crystal-carving. Often, glasscutters imitated the style and the designs of workers in crystal. Most of the carved crystal pieces whose origin can be tentatively identified came from Egypt, where Fatimid caliphs seem to have been especially keen to collect carved rock crystals. By contrast, Timurid princes in the fifteenth century favoured jade or nephrite (FIG. 121). Effectively, the art of carving in jade was

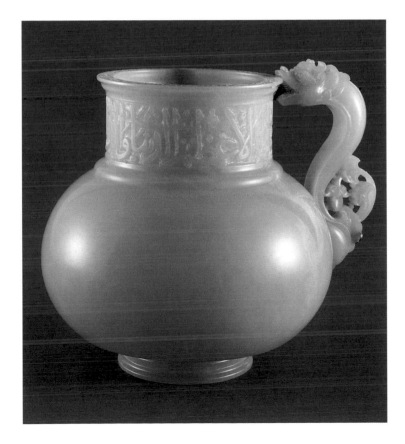

121. White jade cup made for Ulugh Beg, early 15th century. Height 5³/₄" (14.5 cm). Calouste Gulbenkian Foundation Museum, Lisbon.

introduced into the Islamic lands in the Timurid period. The taste of the Timurid courts for work done in this medium was probably influenced by the example of the Chinese court. Nephrite jade was mostly mined from the Kunlun mountains in Central Asia. The shapes created by the carvers of jade tended to follow those of Timurid metalwork. Working in jade continued in Safavid Iran and Mughal India (though the Indians preferred to abrade and polish the jade rather than carve it). However, jade-working seems hardly to have been known elsewhere in the Islamic world.

Like jade-carving, ivory-carving seems to have flourished only in certain regions and at certain times – particularly in Spain and Egypt, whose Muslim regimes had easy access to ivory from sub-Saharan Africa. In Spain, the great age for artistically worked ivory was in the tenth and early eleventh centuries. Carvers made ivory caskets and pyxes (used as containers for precious substances such as ambergris, musk, and camphor, and for cosmetics). Inscriptions indicate that many such containers were intended as precious gifts. The caliphal city of Cordoba was at first the centre for artistically worked ivory, but after the Berber rebellion of the early eleventh century it was replaced by Cuenca in the Taifa kingdom of Toledo. There was a second efflorescence of ivory-carving in twelfth-century Fatimid Egypt. (However, unless pieces bear helpful inscriptions, it is by no means easy to attribute pieces to Egypt, rather than to Spain or perhaps Sicily.) Apart from the carving of freestanding objects in ivory, there was a Coptic tradition of using ivory for inlay on wood for furniture, architectural panelling, and so on. This tradition, which was already well established in pre-Islamic times, continued after the Fatimid period, and some of the finest examples of inlay work with ivory come from the Mamluk period (see FIG. 45).

Textiles and Weaving

Not every medieval Islamic textile piece is a work of art, but numerous categories of luxury textiles, often making use of silk and of gold and silver threads, were designed as works of art and were traded and hoarded as such. Textiles played a much more important role in medieval Islamic society than they do today. The textile and dyeing industry was far and away the largest industry in the medieval Near East and North Africa. It employed more people than any other urban occupation. Ibn al-Mubarrad's sixteenth-century Damascan manual for market inspectors, the *Kitab al-Hisba*, lists one hundred different types of weaver working in the city. Costumes were used as gifts, as symbolic markers of official appointments, as a way of storing wealth, and at times almost as a

kind of currency. However, it was not just a matter of costumes, for the market was dominated by the demand for textiles, such as rugs and wall hangings, to serve as furniture. Since wood was scarce in the Middle East and Central Asia, rugs and mats, rather than chairs and tables, were used for seating and eating areas.

It is difficult to piece together the history of Islamic textiles. They were made of perishable materials and whole categories of textile of which one reads in the texts have vanished completely. Not a single surviving substantial fragment of a carpet predates the Seljuq period. Those textiles that have survived are often difficult to date owing to conservatism in designs. It is also difficult to match the names found in textual sources to textile types. It is not always easy even to distinguish textiles made in the Islamic lands from those made in Italy or China. Chinese workers produced textiles with Islamic designs for export to the Islamic market. Even when a fabric bears an inscription giving its place of manufacture, this information can be misleading. A chance survival of a piece of silk, known as the shroud of San Pedro de Osma, features a design based on monsters in the Sasanian manner, and has an inscription reading: "This was made in Baghdad, may God watch over it." However, everything else about the textile, including the technique of the weave and the calligraphy of the inscription, indicates that it was actually woven in twelfth-century Spain.

Each region had its textile specialities. One factor here is that an extremely wide range of coloured dyes was used, both vegetable and mineral, and therefore dyers tended to specialise in certain techniques and in particular ranges of colour. Also, lengthy apprenticeships among textile workers generally encouraged specialisation. Textiles are well suited to the two-dimensional, abstract and semi-abstract repeat patterns that were generally favoured in the Islamic lands. Some designs achieved a near-universal popularity in those lands. During the month of the Hajj, the pilgrimage to Mecca, there was a large textile market at the pilgrim port of Jedda, and this must have been one of the means by which designs were disseminated from one end of the Muslim world to the other. Sasanian mythological beasts displayed in medallions travelled all the way to Spain and they were still featuring on Iranian textiles in the Safavid period (FIG. 122). There were, however, also regional preferences. For example, there was a craze for patterns featuring ogive curves in the Mamluk lands. Many Ottoman textiles were decorated with *chintamani*, a repeat pattern formed by three balls or moons arranged in a sort of pyramid underlined by a pair of tiger stripes. In Iran, the

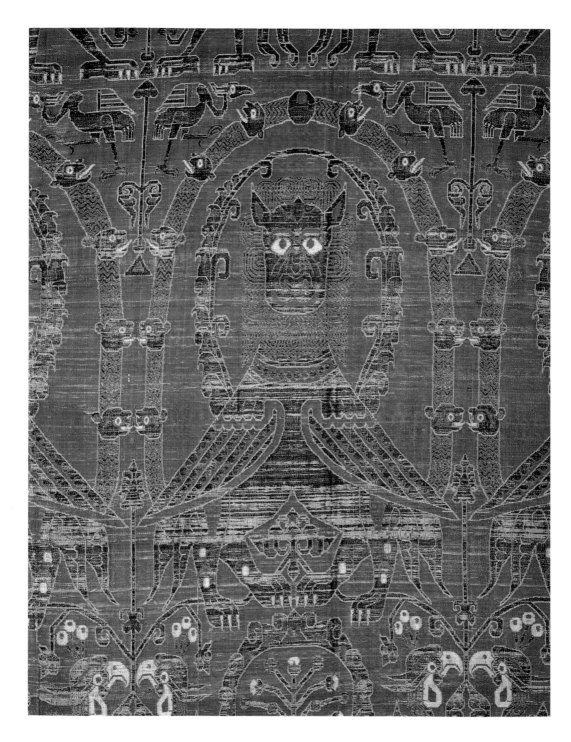

122. Detail of a Spanish silk, the Witches' Pallium, showing a dog-headed bird, 11th century. 3′3¾″ x 7′7⅜″ (1.0 x 2.3 m). Museu Episcopal de Vic, Barcelona.

Safavid elite favoured textiles featuring human figures, usually languid young men or women in gardens (FIG. 123).

Silk-weaving

Most medieval textiles, garments, and hangings for everyday use must have been produced by tribal weavers and by cottage industries (FIGS 124 and 125). However, most of the pieces that have survived to the present day and that are displayed in modern museums as works of art (rather than as fragments of merely historical interest) were produced in larger urban workshops and very often in workshops owned by or working under the direction of the court. Discussion here concentrates on these larger, more luxurious works of textile art. (It was common for designs to be handed down from an expensive textile to a cheap one, for example from velvet to embroidery.) Ibn Khaldun listed the craft of the silk-weaver together with that of the goldsmith, the coppersmith, and the bookbinders and manuscript copyists as luxury crafts that flourished in an urban civilisation. Silk was the preeminent luxury fabric, valued for its lustrous sheen. (An Egyptian fabric called *buqalamun,* or shot silk, was particularly prized for its shimmering iridescence.) Trade in silk was certainly the most important part of the luxury goods trade in the Muslim world and the light weight of silk recommended it to long-distance traders. The fineness of silk threads allowed the weaving of complex patterns and the convincing expression of curved designs. Although silk-weaving techniques had not changed since Pharaonic times, there was an explosion of silk production in Islamic times. Brocaded work in silk originated in Syria and Iraq and spread to other regions from there. Silk was produced more or less everywhere in the Middle East, but Iran, Spain, and Muslim Sicily were the leading centres. Silk textiles tended to be produced in *tiraz* factories, where, among other things, the use of gold thread in the silk could be closely supervised.

Bursa in north-west Anatolia was the first capital of the Ottoman Turks. It was also both a centre for silk-weaving and the great entrepôt for trade in textiles. Bursa's weaving workshops commonly possessed fewer than ten looms. Apprenticeships involved serving in a workshop for two years after having been trained at the loom. The craft corporations took a protectionist stance. Once a week the velvet-weavers of the city would assemble in one place and there they would be assigned to work with various masters, who owned the looms and shops. This was a way of controlling competition and wages. The sultan's decrees sent to Bursa aimed at maintaining a high quality of production and keeping

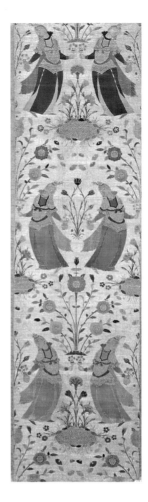

123. Safavid velvet showing willowy women in a garden, early 17th century. Woven polychrome velvet, 6'5" x 1'8" (1.96 m x 57 cm). Royal Ontario Museum, Toronto.

124. Woman at a spinning wheel, from a copy of the *Maqamat* (*Sessions*) of al-Hariri (1054–1122), 1237. Illuminated manuscript, whole page 14¹/₂ x 10¹/₈" (36 x 25.8 cm). Bibliothèque Nationale, Paris.

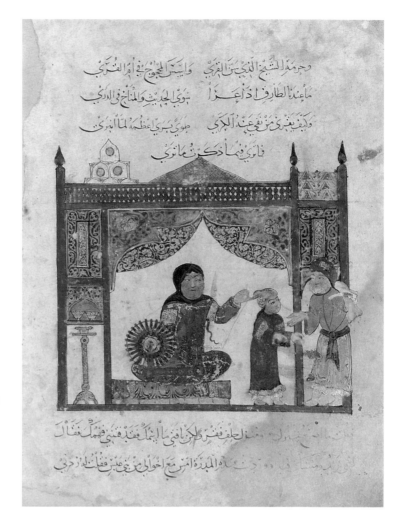

125. Carpet-weaving at Khwaja Jamakh, Iran, photographed in 1944.

The weavers are Qashqai nomads (Turkish-speaking tribespeople) who live in Iran. The loom they use is a simple horizontal one, unlike the vertical form found in urban workshops, and is used for both flat and pile weaving. Its structure means it can be packed flat at short notice when the tribe moves on to a new area.

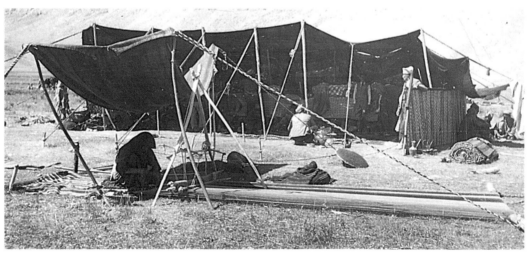

costs down. There were different guilds in Bursa for handling raw silk, for spinning and dyeing it, and for weaving.

In Safavid Iran, as in Ottoman Turkey, the regime involved itself at all levels of textile production and marketing, especially with silk, for Iran's prosperity depended more than anything else on the export of silk. The first Safavid shah, Ismail I (r. 1501–24), set up workshops for dyers and weavers in Tabriz. Shah Abbas (r. 1587–1629) pursued an even more interventionist approach and in his reign the state became the main trader in silk. Prices for the woven products were fixed by negotiation with the guilds. Kashan became the chief centre of production for all kinds of textiles: silks, gold and silver brocades, satins, velours, taffetas, and embroidery work. According to Jean Chardin, a single suburb of Kashan contained over a thousand houses of silk-workers. There were also royal carpet workshops in the city, producing carpets for use by the court and for export. Despite close central control of the production and pricing of luxury textiles, the Shah's decrees also specified the need for regional diversity.

Carpets and Rugs

A carpet is a textile whose pattern has been created by knotting. As has already been noted, no Islamic carpets have survived that were woven prior to Seljuq times. Before then, literary references to carpets tend to be about curiosities – such as the Carpet of Mirth, whose designs formed the basis of a game in which Abbasid courtiers were directed to strike curious postures, or the uncomfortable-sounding Carpet of Chosroes, which was studded with precious stones. Paintings (particularly from Timurid Iran) provide limited additional information about the history of medieval carpets, but it is often difficult to determine whether a particular textile featured in a miniature is a carpet, a cloth, a felt, or a kilim.

Although many carpets and rugs were produced by nomads and by domestic weavers, the really grand carpets had to be produced in urban, often court workshops, if only because they used looms that were larger than could be accommodated in a tent or a rustic cottage. Urban weavers also tended to produce carpets that were more densely knotted and complexly patterned. Knot density was one of the factors that influenced the price of a carpet. The weaver had to work in close consultation with the designer and dyer. One of the duties of the *muhtasib* was to enforce the use of good-quality dyes. For example, Ibn Ukhuwwa (d. 1329), in his manual for *muhtasibs*, said that they should make sure that madder was used to achieve a red-brown colour,

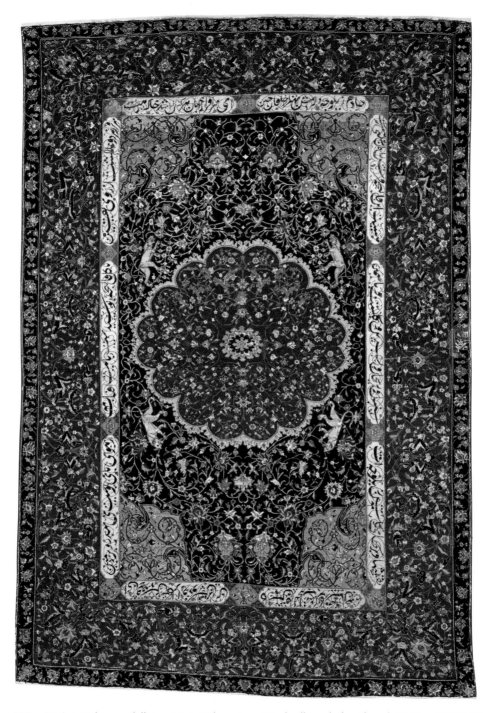

126. Iranian Kashan medallion carpet, 16th century. Wool, silk, and silver thread, 8′1½″ x 6′6″ (2.48 x 1.99 m). Khalili Collection.

This is a large court carpet with a fine wool pile, woven with silver thread on a silk foundation – materials to which nomad weavers would have been most unlikely to have had access.

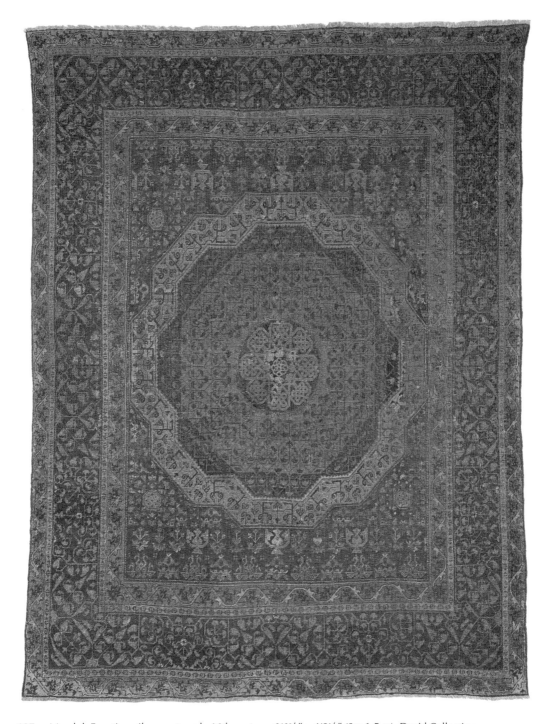

127. Mamluk Egyptian pile carpet, early 16th century. 6'6³/₈" x 4'9¹/₈" (2 x 1.5 m). David Collection.

Distinctive Egyptian papyrus and lancet motifs play a subsidiary role in the formally arranged, kaleidoscopic decoration. These carpets are luxury objects made for extremely wealthy customers.

rather than henna, as the latter was less stable than the former. Some dyes such as cochineal and indigo were expensive and it was (and is) common to go into debt for them. Consequently, many carpet producers in both the towns and the countryside were in effect employed by money-lenders.

By the late fifteenth century, Anatolia, north-west Iran, and Egypt were producing luxury carpets. In many respects, however, Turkish carpet-weavers followed the lead of the Iranians, for instance, in the use of red carpet dye and in the common lay-out, based on bookbinding designs, of a central medallion with quarter medallions in the corners of the main panel. In Iran, the Safavid shahs transformed a cottage industry into a national industry controlled by the court (FIG. 126). Shah Tahmasp (r. 1524–76) went so far as to design carpets himself, and a little later Shah Abbas I established carpet factories in all of Iran's main cities.

The most typical Mamluk carpets are large, densely knotted, and use silky, glossy wool and sometimes silk as well. The range of colours is limited, with much green, light blue, and red. The density of the knotting and the intricacy of the patterning give rise in the best specimens to a marvellous shimmering effect (FIG. 127). Characteristically, the designs are based on one or more large, centrally placed medallions, in which an eight-pointed star radiates into an octagon and then into a square.

The carpets and those who produced them were seemingly invisible to those Mamluk authors who wrote in the fifteenth and sixteenth centuries, so textual evidence for carpet production does not exist; nor until the Mamluk carpets appear from out of the blue is there much evidence for Egypt producing any quality carpets at all (FIG. 128). In the absence of any documentation, carpet experts have felt free to differ about when the first Mamluk carpets were produced – as early as 1450, as late as 1517 (the year of the Ottoman invasion of Egypt). Similarly, whilst most scholars have thought that Egypt was the place where they were produced, others have plumped for Syria, Turkey, or North Africa. Moreover, one can only guess at what factors stimulated the production of these magnificent textiles – perhaps the demands of the Mamluk court (confirming the general picture one gets concerning the revival of artistic and architectural patronage in the reign of the sultan Qaytbay).

Mamluk carpets were probably the first group of carpets in which the smaller elements in the design were subordinated to the central geometric medallion. This medallion might be seen as a stylised representation of a sunburst (and therefore an image of royalty); or a reminiscence of a Central Asian mandala; or

the formalised representation of a fountain in a courtyard; or a mirror-like reflection of the coffered ceiling under which it would be placed. Finally, the carpet's octagon might be read as symbolically representing the Dome of the Rock. The purpose of these carpets is also unknown: Were they for indoors or outdoors, summer or winter, hangings, or table covers? So far, the patterns on Mamluk carpets have told the historian nothing useful about Mamluk society; they testify only to their own beauty, at once enigmatic and austerely magnificent.

Jean Chardin had this to say about the material culture of the East: "All those fine works of painting, sculpture, turning and so many others of which the beauty consists in the explicit and simple imitation of nature is worthless among Asiatic peoples. They believe that because these objects have no utility for their bodily needs, they do not merit further consideration …" Chardin's verdict is pejorative. His background had accustomed him to think of painting on canvas and sculpture in the round as proper art and, though he very much admired Persian textiles, ceramics, and metalwork, his prejudices did not allow him to see such things as works of art in the fullest sense. The history of Muslim art is above all the history of the applied arts. Rulers and royal designers actively interested themselves in these arts. Textiles, ceramics, and metalwork were all collected and displayed for aesthetic reasons. There are no proper grounds for classifying these arts as "minor" ones. However, some would argue that the most intriguing sphere of artistic activity and achievement in the pre-modern Islamic world was in the arts of the book, and it is to this that we will turn in the next chapter. Again in the history of Western art, we are used to thinking of book illustration as a minor art form. But as we shall see, this was not the case in the Islamic lands.

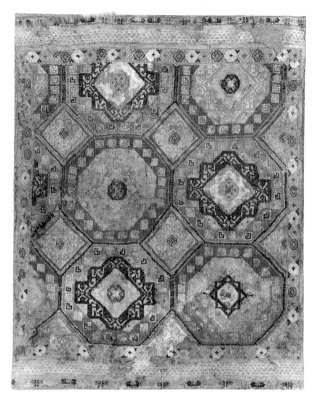

128. Egyptian textile with octagon design, 7th–8th century. Wool and linen, 41³/₈ x 42¹/₂″ (105 x 108 cm). David Collection.

It is possible that the elaborate octagons, which are often the central feature of Mamluk carpets, evolved from simpler octagons such as the Coptic textile design shown here.

SEVEN

A Literary Art

129. Bowl from Nishapur, Iran, 10th century. Glazed earthenware, height 3" (7.2 cm), diameter 9³/₄" (25.1 cm). Khalili Collection.

The slip-painted inscription reads "Generosity is the disposition of the dwellers of Paradise."

The Arab historian al-Masudi claimed in the early tenth century that the spillage of words onto objects – textiles, ceramics, and glass, for example – became fashionable in the mid-ninth century. One of the commonest ways of decorating ceramics in particular was with calligraphy, with inscriptions either expressing wishes for the owner's good fortune or that were morally exhortatory. Islamic culture was highly literary, but like all other medieval cultures it was still to a large degree an oral culture. The ability to read silently (and indeed the desire to do so) was probably relatively rare. So, while looking at pictures in a book was usually a private act, reading was more often audible and public. Therefore, when one read the inscription at the bottom of a dish or round the rim of a cup – such as "health and felicity" or "eternal fortune to the owner" – one was pronouncing the benediction to whatever company might be assembled (FIG. 129).

The practice of decorating objects with words intensified from the twelfth century onwards. For the most part, inscriptions consisted of banal pieties, exhortations, and wishes of good luck, but there were examples of wit or even profundity (FIG. 130). A ceramic bowl produced in the Timurid period bears the charmingly self-deprecatory appeal: "If the soup be good, don't complain about the bowl." Not all inscriptions yielded up their meanings easily. In the case of some objects, their decorative calligraphy is so very difficult to read that decipherment must have whiled away long winter evenings or constituted a sort of parlour game that filled in the gaps at dull dinner parties. Sometimes the Arabic letters were disguised as posturing human figures (FIGS 131 and 132). Artists even occasionally inscribed dishes and cups with lines that looked like Kufic script, but that were purely decorative. Then again, other inscriptions were placed on buildings at angles and elevations where only God and the birds could read them.

130. Egyptian pen-box, c. 1300–05. Thick sheet brass incised and inlaid with gold, silver and niello, 2½ x 3 x 13" (6.5 x 7.9 x 33.2 cm). Aron Collection.

The pen-box is decorated with stars and arabesques in cartouches and roundels, and a number of inscriptions in *naskhi* script. That on the inside of the lid is better preserved than those on the outside of the box and translates as: "Open the pen-case of happiness through elevation, high rank, and continuing glory; its pens, when they take its ink, are the poison of injustice and the conqueror of the stubborn enemy."

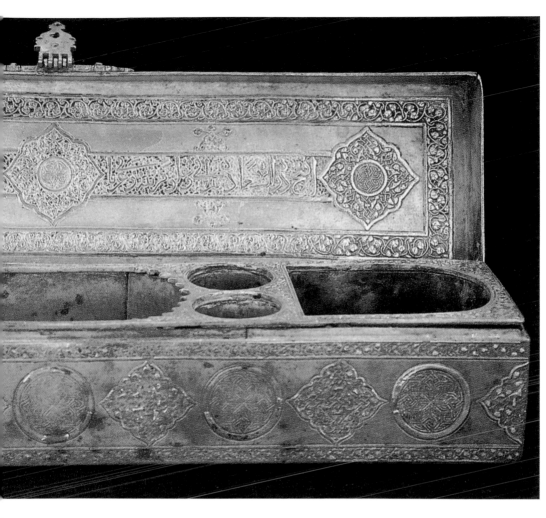

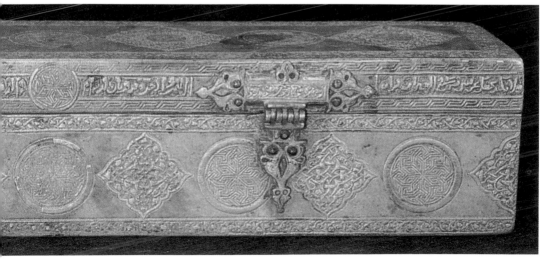

Palaces and shrines were covered with inscriptions (FIG. 133). The student of Islamic architecture is everywhere confronted with the phenomenon of text-laden buildings – of inhabitable books made of stone, brick, and stucco. The Alhambra, as has already been discussed in Chapter Five, is probably the best-known and most noteworthy example of this practice. Many of the verses decorating the Alhambra appear to have been *pièces d'occasion* produced by Ibn Zamrak (d. 1393), the court poet in Nasirid Granada.

The Literary World

Another aspect of the literary art in Islamic culture is the profession of the *nadim*, or cup-companion, and the *zarif*, or dandy. These figures were arbiters of taste at the great courts of Baghdad, Cairo, Cordoba, Istanbul, and Isfahan, and were intimately connected both with the literary style of court life and many of the works made to satisfy literary sensibilities.

The *nadim* and the *zarif*, important figures in the world of high culture, are the closest equivalents one can find to the *dilettanti* and *virtuosi* of European culture. Professional dinner-table companions, who were expert conversationalists with a wide range of knowledge and highly developed tastes, they were also expected to have a discerning eye for assessing the merits of race-horses, slave-girls, jewels, carpets, costumes,

131. Herati ewer with human-headed lettering, c. 1180–1200. Brass with inlay, height 15³/₄″ (40 cm). British Museum, London.

A detail of the ewer is reproduced in FIG. 112.

132. High-stem cup with an animated, anthropomorphic script, from Jazira (Upper Iraq), early 13th century. Inlaid silver, height 5″ (13.2 cm). Khalili Collection.

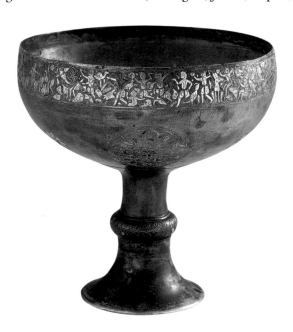

glassware, and ceramics. The etiquette of the *zarif* shaded into a code of love (FIG. 134), and both the *zarif* and the *nadim* were expected to be experts in the small, simple gifts to be exchanged as pledges of love or friendship on such festival days as the Iranian Nayruz, which took place on the spring equinox, 21 March. Traditionally, on such a day one donned new clothes and exchanged gifts in token of friendship (FIG. 135). Abbasid caliphs expected to receive gifts from their subjects and a courtier was ill-advised to turn up on the day without a present. Mihrjan, the autumn equinox, was another gift day in Iraq and Iran.

Many such gifts were further embellished with inscriptions. The *zarif* al-Washsha (860–936), who lived in Baghdad and wrote

133. Detail of the entrance facade of the Ince Minare Madrasa at Konya, Turkey, c. 1260–65.

It was customary in Seljuk Turkish mosques and *madrasa*s to concentrate the decoration around the portico. Here the decoration consists of ribbon-like bands of calligraphy.

134. Persian miniature of the prince Bahram Gur introduced into the Hall of Seven Images, from a copy of Nizami's (d. 1209) poem "Haft Paykar" (Seven Pavilions) in the *Anthology* of Iskandar Sultan, produced in Shiraz, Iran, 1410. Illuminated manuscript, 9$^1/_2$ x 5$^7/_8$" (24 x 15 cm). Calouste Gulbenkian Foundation Museum, Lisbon.

The illustration here comes from a tale in which one day after hunting the legendary Persian prince Bahram enters a mysterious pavilion painted with the images of seven beautiful princesses. Later in the poem, the prince, who has fallen in love with these princesses (each from a different clime), marries them all and installs them in separate pavilions. Each princess then tells him a story, in the course of which she instructs him in a code of love and beauty.

135. Iranian ceramic courtyard toy (?), 12th century. Length 5³/₄" (14.5 cm). Museo Nazionale d'Arte Orientale, Rome.

It is probable that many of the artefacts on display in museums today were produced to be distributed as gifts on Nayruz and other festival days. Children in particular were the recipients of gifts. Surviving ceramic models of buildings, people, and animals may well have been manufactured as toys. Ibn Ukhuwwa's *hisba* manual (see page 87) forbade the selling "of clay images such as the toy animals sold at festivals for children to play with."

on the etiquette of love, dealt with the appropriate verses to embroider on robes, other fabrics, signet rings, or to write in gold wash on apples. In the highly literary court culture of medieval Islam, courtiers were expected to be able to extemporise verses and much of the poetry was composed to be inscribed on objects. Textiles, especially the handkerchief or *mandil*, commonly had verses embroidered on it – such as this:

> I am the mandil of the lover who never stopped
> Drying with me the eyes of their tears.
> Then he gave me as a present to a girl he loves
> Who wipes with me the wine from his lips.

Although from the eleventh century onwards one hears less about the ideals and practices of the *nadim* and the *zarif* and it is possible that such figures fell into some disfavour in the central Arab lands, similar figures were prominent much later both as patrons and as producers of Persian art. The Chagatay poet at the court of Sultan Husayn Bayqara (r. 1470–1506), Mir Ali Shir Navai (1441–1501), who was the Timurid prince Husayn Bayqara's *kukultash* (foster brother) and close companion and the *arbiter elegantiarum* at the court at Herat, was, as we have already seen, also an architectural patron on a major scale, as well as poet and

136. Detail of an Iranian textile with paired dandies, 16th–17th century. Velvet, 29¹/₂ x 62″ (74.9 x 157 cm). Victoria and Albert Museum, London.

During the reign of Shah Abbas (r. 1588–1629) there was a proliferation of album portraits showing dandies, idle and elegant, drinking, playing music, or simply mooning about. Pietro della Vale, an Italian with somewhat puritan tastes who visited Abbas's Isfahan, commented, as we saw in Chapter Five, on the "lascivious postures" of the figures in the works of the Iranian artists. Poems of the period tended to celebrate an elegantly melancholy cult of prostration before the unattainable beloved and this was reflected in the visual arts.

patron of painters. Later, in the sixteenth century, the Iranian miniature-painter Aqa Mirak was referred to as the sixteenth-century Safavid shah Tahmasp's boon companion.

The cult of the dandy reached its apotheosis in the Safavid empire in the sixteenth and seventeenth centuries (FIG. 136). The dandy featured as the subject of album paintings or of the decoration of ceramics. He usually stood in a languid *contrapposto* pose, surely modelled on the poses adopted by painted figures on Chinese vases.

The traditional lore of the courtier and cup-companion was preserved in *belles-lettres* treatises, such as al-Ghuzuli's *Matali al-Budur* (*The Rising of the Full Moons*). This fifteenth-century Egyptian compilation gathered together prose and poetry about cup-companions, dandies, pretty women, gardens, good furniture, chess, story-telling, and other things that give delight. What al-Ghuzuli had to say about *hammam*s is of some interest to the art historian. According to him, public baths were normally decorated with frescoes and the most common themes for the paintings were: first, lovers; second, meadows and gardens; and third, hunting scenes. He cited ancient philosophers on how the first topic had the effect of strengthening the psychology of men and women, the second their physical power, and the third the animal powers of those who look at it. This is obviously a rather primitive aesthetic, but it is an aesthetic all the same. He further argued that artistic pictures had therapeutic effects and protected the soul from melancholy, hallucinations, and evil thoughts. If one cannot find beauty in nature, then "one should contemplate beautiful, artistically made pictures, as painted in books, temples, or noble castles."

The Aesthetic Voice

Ideas of beauty were for the most part formulated by literary people in literary terms. In *belles-lettres* one found discussions of beauty, though not necessarily in an artistic context. *Jamil* is the Arabic word for beauty, though disconcertingly some medieval Arab dictionaries give the first meaning of *jamil* as "melted fat, or melting fat, or fat that is melted, and, whenever it drips, made to drip upon bread, and then replaced over the fire." The same triliteral root *j m l* is the basis of various words referring to camels and *jamal* is the commonest word for camel (see FIG. 24). However, *ajib*, "astonishing" or "marvellous," was just as frequently used as a term of aesthetic appreciation. Moreover, as we shall see, ideas of beauty were often closely linked to the concepts of *itidal*, "symmetry," and *tanasuh*, "harmony."

Beauty was rarely discussed in the context of the visual arts. Rather, ideas on the subject tended to be formulated in relation either to poetry or to the beauty of the human, usually female, form. Turning to consider how women were portrayed in figurative art, we have already seen how sensual, heavy-bodied nudes featured in the frescoes and stucco figures of the early Islamic palaces, particularly of the Umayyads. The taste for that sort of thing declined thereafter and it is hard to imagine either Saladin or Baybars receiving courtiers in a reception chamber frescoed with naked, lascivious women. In Iranian painting (FIG. 137) as it developed in the Timurid and early Safavid period, the women featured are slender, decorous creatures, and in paintings where the women are protagonists, they are often the embodiments of allegorical messages. For example, in the fifteenth century the Iranian Sufi poet Jami retold the story of the passion of Zulaykha for Yusuf (the biblical Joseph). In an attempt to seduce him, she had her rooms filled with paintings of them making love, in the vain hope that this would awaken his sexual desire. However, neither Jami nor the painters who illustrated his poem thought of the story as being one of fleshly lust. Zulaykha's love for Yusuf's beauty prefigures her future love of God, for in Jami's version of her

137. MIR AFZAL TUNI Album painting of a lady watching a dog drink from a bowl, Iran, c. 1640. Illuminated manuscript, 4½ x 6¼″ (11.7 x 15.9 cm). British Museum, London.

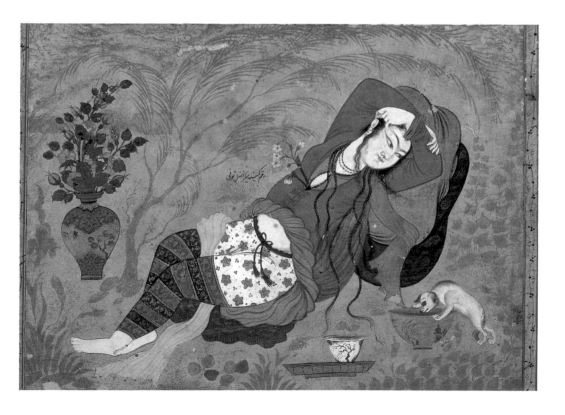

life she repents. Only after many years of solitary austerity does she re-encounter Yusuf, whereupon God restores youth and beauty to her. In Jami's romance (a popular subject for Iranian painters) Zulaykha personifies the soul, infatuated by divine beauty, questing for God. Sex has nothing to do with the matter. So the love story of Yusuf and Zulaykha, like that of Layla and Majnun or Humay and Humayun, had an allegorical burden.

Arab and more especially Persian poets produced atomistic evocations of the female beloved, in which the excellences of her face, beauty spot, hair, cheeks, eyebrows, eyes, and so on were evoked, without conveying any impression of the actual woman in question. Instead, there was an additive and comparative listing of her various separate features: a face like the moon, a slender waist like a cypress, curling hair like a hunter's net, and so forth. In Persian poetry the ideally beautiful woman had a mouth so small that she could hardly breathe air through it – a feature that is reflected in the works of Persian miniature-painters.

Nevertheless, it was possible to take a more integral view of human beauty. The ninth-century essayist al-Jahiz expressed a preference for the *majdula*, who in the dictionaries is described as a woman "who is small in the belly and compact of flesh." Al-Jahiz seems to be arguing for an ideal balance (a concept that perhaps had its origins in Greek philosophy). According to him, the ideal woman's "figure must be elegant and shapely, her shoulders symmetrical, and her back straight … She must be neither too plump nor too skinny." A *majdula* is also described in the following terms: "the upper part of her body is a stem and the lower part a sand-dune." In his eyes, excess of anything is ugly: "Moderation consists in the balance of a thing." Although the essayist had up to this point been talking of the human body, he continued: "One can also speak of 'balance' in the case of buildings, rugs, embroidery, clothes, or canals where water flows: by balance we mean evenness in design and composition." The thirteenth-century physician Abd al-Latif al-Baghdadi similarly stressed harmony and proportion, and was unusual in discussing beauty in relation to sculpture, though the sculptures he discussed were pre-Islamic and the work of Egyptians in Pharaonic times. He praised these statues for "their forms, their exact proportions, and their resemblance to nature." In art, as in nature, beauty was the result of harmonious proportions.

Discussions of beauty in medieval Arabic texts could tend towards the tautologous. Thus, the fourteenth-century philosopher-historian Ibn Khaldun in the context of a discussion of music pronounced that:

If an object of vision is harmonious in the forms and lines given to it in accordance with the matter from which it is made, so that the requirements of its particular matter as to perfect harmony and arrangement are not disregarded – that being the meaning of beauty and loveliness whenever these terms are used for any object of sensual perception – that [object of vision] is then in harmony with the soul which perceives [it], and the soul, thus, feels pleasure as the result of perceiving something which is agreeable to it.

Ibn al-Haytham, the eleventh-century author of a seminal treatise on optics, was a little less frustratingly abstract in his discussion of the same topic. Light, such as that emitted by the sun, the moon, and the stars, is beautiful. Colour produces beauty and therefore so do dyed clothes. Solidity, size, separateness, and motion all potentially contribute to the beauty of an object. The beauty of some objects depends on how closely and from what angle they are examined (for example, distance can erase blemishes). Position and order are absolutely crucial. Thus, in calligraphy "beautiful writing also is regarded as such because of order alone. For beauty of writing is due only to the soundness of the shapes of letters and their composition among themselves ... Indeed, writing is considered beautiful when of regular composition, even though the letters in it are not quite sound. Similarly, many forms of visible objects are felt to be beautiful and appealing only because of the composition and order of their parts among themselves."

Calligraphy

Not only did the poet and the *belle-lettriste* enjoy a much higher status than the artist or the architect, but the transcriber of works of literature, the calligrapher, was also accorded a higher rank. The art of calligraphy is celebrated in the *Arabian Nights* tale of "The Second Dervish," where a prince, having been transformed into an ape by a jinn, or sorcerer, arrived at a strange port. There he demonstrated his true nature by seizing a pen and paper and writing successive verses in the *riqa, muhaqqaq, rayhani, naskhi, thuluth,* and *tumar* scripts. Moreover, all the verses the ape-prince wrote made use of calligraphic imagery, as for example:

I swore, whoever uses me to write,
By the One, Peerless, Everlasting God,
That he would never any man deny
With one of the pen's strokes his livelihood.

138. Ibn Muqla's system for proportional calligraphy.

139. Specimens of scripts. From top to bottom: Kufic, *naskhi, rayhani, muhaqqaq,* and *thuluth.*

The oldest form of Arabic script is Kufic, where the letters tend to be rectilinear and in their earliest form rather stubby. As its rectilinear shapes suggest, Kufic had its origins as an epigraphic, lapidary script in ancient Arabia. The earliest Korans were written in the Kufic script and, indeed, until approximately the eleventh century, Kufic was the only script used for transcribing the Koran. Thereafter, it remained the sole script in use in the Maghreb (north and north-west Africa), but in the eastern lands, Korans and other sorts of books tended to be written in more cursive scripts. From the twelfth century onwards, *naskhi* was by far the most common script used in books, although Kufic continued to be used for decorating buildings and objects and as a magical and talismanic script.

The six scripts demonstrated by the ape-prince nearly match the famous six scripts of Ibn Muqla, "a prophet in the art of calligraphy." Ibn Muqla (886–940) was a vizier in Baghdad who set out the principles for a perfectly proportioned script (*al-khatt al-mansub*; FIG. 138). Ibn Muqla took as his unit a rhomboid-shaped spot of ink left by pressure of the pen on paper. Depending on the script chosen, the height of the letter *alif* (corresponding to our letter "a") might be equivalent to between three and twelve such rhomboid points. Ibn Zayyi, who hailed Ibn Muqla as a prophet, was certainly thinking of those rhomboids when he remarked that Ibn Muqla's "gift is comparable to the inspiration of bees as they build their cells." Turning now to the six scripts expounded by Ibn Muqla (FIG. 139), *naskhi,* or "copy hand," was something of a workhorse script, much used by scribes in government service and by jobbing copyists. In the rounded form it had its apogee in the thirteenth century. *Thuluth,* or "one third," is a large cursive script. It was much used for monumental inscriptions and gold lettering of Korans. *Rayhani,* or "of the basil plant," is an elegant development from *naskhi* and was quite often used for writing Korans and occasionally for decorating objects. Its long, thin verticals taper to sharp points. *Muhaqqaq,* or "certain," with its rounded letters, was used for Korans, but otherwise was less frequently seen. The *riqa* script was used for the hasty scribbling of memoranda and never for decorative purposes. Although the prince in the form of an ape had demonstrated his proficiency at *tumar*

(a large script which tended to be used for royal signatures), Ibn Muqla's sixth favoured script was *tawqi*, or "signature," a formal chancery script. *Nastaliq*, or "hanging" script (which to the outsider may seem to bear a passing resemblance to melted ice cream), was developed towards the end of the fourteenth century and was particularly favoured in Iran (FIG. 140).

However, the calligrapher's repertoire was not restricted to six classic scripts and *nastaliq*. There were all sorts of scripts used for decorative purposes or to amaze. *Ghubar* ("dust") was a miniature script used for *tour-de-force* feats of calligraphy, such as writing the whole of the Koran on the shell of a hen's egg. One of its early uses was for pigeon-post messages. *Makus*, or mirror script, in which the left reflects the right, first developed for use on seals, was also used for inscriptions on buildings. In *shatranji*, or chessboard script (FIG. 141), Kufic letters were rotated to make a symmetrical pattern within a sealed square. *Shikasta*, or broken form, evolved from *nastaliq*, is an emphatic style that dispenses with diacritical signs. The elaborate *tughray* script with its lengthy

140. Decorative specimen of *nastaliq* script. Victoria and Albert Museum, London.

Legend acribes the invention of *nastaliq* script to Mir Ali Tabrizi (d. 1346), an Iranian calligrapher who was initiated into the script by a dream vision of the Prophet's cousin Ali. It was promoted in Herat by the Timurid prince Baysunqur (d. 1434), a noted calligrapher in his own right. Thereafter it became the standard script employed in Iranian manuscripts.

141. Wall-tile panels in *shatranji* script, a square Kufic, from the 15th-century shrine of Abdullah al-Ansari, Gazargah (in the Herat region of Afghanistan).

verticals was developed by Ottoman Turkish officials as a way of authenticating documents that would be difficult to forge.

The Development of Calligraphy: 10th–13th Centuries

Collectors sought specimens of calligraphy by the acknowledged masters and Ibn Muqla's works especially attracted high prices. The existence of an "art market" for calligraphy and the high prices paid encouraged the production of forgeries. For example, a certain Muhammad ibn Muhammad al-Ahdab (d. 981), who was also known as al-Muzawwir ("the Forger"), was reported to have caused chaos with his mimetic talent. Techniques were also developed for simulating the ageing of paper. Besides attracting collectors and forgers, calligraphy was also for a long time the only art form to attract a literature of instruction and connoisseurship.

In the generation after Ibn Muqla, the famous man of letters Abu Hayyan al-Tawhidi (d. 1009/10) wrote a treatise on calligraphy which was really a collection of contemporary tips and past aphorisms on the art. Al-Tawhidi collected various views on such matters as the shape and preparation of the reed pen, on the formation of the letters, on the need to take care of one's hands, and on the usefulness of taking a nap. At one point, he remarks that "handwriting is a difficult geometry." At another, he compares handwriting to music, for the scribe behaved like a musician, sometimes mixing the heavy movement with the light one, sometimes taking away the light movement for the heavy one, and sometimes lifting one of them up to the other by adding a beat or subtracting a beat. "In his craft he proceeds with the finest degree of sensitivity possible in sensory perception, that associated with a fine soul."

Calligraphers enjoyed a higher status than painters until at least the fourteenth century. Ibn al-Bawwab (d. 1022 or 1032), a contemporary of al-Tawhidi, started in life as a painter of houses (of frescoes, presumably), but he worked his way up to become a book painter and then a calligrapher. He developed and refined the aesthetic propounded by Ibn Muqla, and wrote a mnemonic ode on calligraphy in which he stressed the importance of balance (*musanabah*), measure (*maqadir*), and spacing (*bayadat*).

In 1022 or 1032, Ibn al-Bawwab "completed the letters of annihilation and travelled towards the [scribal] practising house of Eternity." The next great master, Yaqut al-Mustasimi (d. 1299), was a Turkish eunuch who worked as a scribe in the employment of the last caliph of Baghdad. Yaqut was famed as the ultimate arbiter on all matters regarding *naskhi* script. After the fall of Baghdad

in 1258, the great centres for the production of artistic calligraphy were to be found in lands further to the east. Yaqut allegedly trained six pupils, masters of the six scripts, who all worked in the Ilkhanid lands.

The Illuminated Manuscript

The earliest illustrated Arabic book to have survived dates from the eleventh century. The astronomical treatise by Abd al-Rahman ibn Umar al-Sufi, *Kitab Suwar al-Kawakib al-Thabita* (*Book of Images of the Fixed Stars*), was produced in 1009. But well before then Korans were being decorated with designs that marked chapter heads and verse breaks, as well as marginal ornaments and frontispieces. These decorations were almost invariably abstract. (However, it should be noted that a couple of fragmentary pages of uncertain date showing pictures of buildings, constituting a Koranic frontispiece, have recently been discovered in the Yemen.) Fragments of ninth- and tenth-century Fatimid paintings and drawings on papyrus have also survived and, while some are mere crude doodles, others are evidently book illustrations.

The introduction of paper from the eighth century onwards assisted the diffusion of knowledge and in the long run made books cheaper. Although Chinese prisoners captured by Abbasid troops in the mid-eighth century introduced the Arabs to paper-making, it was only from the mid-tenth century onwards that most books were produced from paper and that consequently there was an explosion in the production of books.

It is in any case perfectly clear that illustrated texts were circulated in the Islamic Middle East prior to this point. Obviously, the large Christian communities continued to produce and purchase illustrated books, and Islamic illustrated books were heavily influenced by the techniques and visual clichés of Christian book illustration. We also read about the continued circulation of the illustrated books of the Manicheans, though these have not survived.

More generally, the Sasanian practice of producing illustrated histories continued in Islamic times. Al-Masudi describes how, in the Iranian city of Istakhr in 915 or 916, he came across a history of the Iranian kings, which had been translated into Arabic for the Umayyad caliph Hisham in 731. This book contained portraits of twenty-seven Sasanian rulers in their imperial regalia. The chronicler al-Tabari recorded in the year 841 that an Abbasid general was brought to trial for owning idols and illustrated books, but he defended himself by pointing out that his judge had an

142. "The Fox and the Drum," from a Herati version of *Kalila wa-Dimna*, 1429. Illuminated manuscript, 11¼ x 7¾" (28.7 x 19.7 cm). Topkapi Saray Library, Istanbul.

This collection of animal fables, originally from India, was translated from Persian into Arabic by Ibn al-Muqaffa in the late 8th century. From Arabic it was subsequently translated into various other languages (including back into Persian). There is no established version of the text. In one manuscript version (apparently dating from the 14th century), Ibn al-Muqaffa is made to maintain the merits of "the depiction of animal images in a variety of colours and pigments, so that they delight the hearts of kings; and their enjoyment is increased by the pleasure to be had from these illustrations." He also expresses the hope that the popularity of the text will give employment to painters and scribes. However, since there is no such injunction in an earlier manuscript, it is presumably an interpolation by another hand. It is clear from the number and provenance of the surviving manuscripts that the appeal of *Kalila wa-Dimna* was not just to "the hearts of kings."

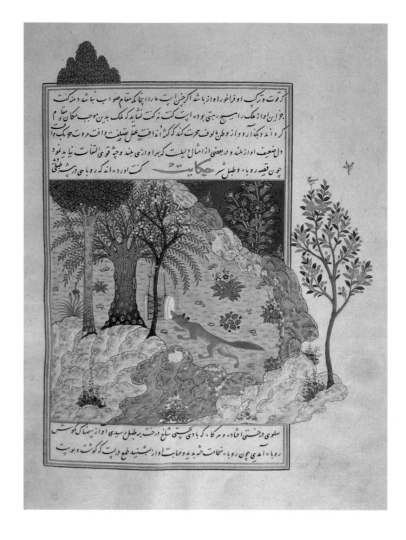

illustrated copy of *Kalila wa-Dimna*, the popular translation of Indian animal fables (FIG. 142). However, on the evidence of what has survived (which may of course be misleading), it would seem that it only became common for books to be illustrated from about the year 1200. Equally puzzlingly, by around 1350 the sophisticated vogue for pictures in books was over in the Arab lands, and though manuscripts did continue to be illustrated, the pictures were generally rather crude – closer to folk art than high art.

The art of Koranic illumination reached its peak in the thirteenth and fourteenth centuries under the patronage of the Mamluk sultans and the Mongol Ilkhans. Teams of calligraphers and artists worked on these volumes, which were lavishly decorated in gold and silver.

Instructional Works and Manuscript Illumination

Most of the titles that were illustrated were non-fiction, instructional ones. Often the illustrations were provided for works that had been written in pre-Islamic times and already had a long tradition of being illustrated. Thus the *Kitab al-Diryaq* (*Book of Poison Antidotes*) by Pseudo-Galen was illustrated as early as 1199 (FIG. 143). Similarly, Dioscorides' *De Materia Medica*, a treatise on natural remedies written in AD 77, was an obvious choice for illustration. However, while one might think in such cases that the pictures were to assist in the identification of the various plants and substances, in many cases the function of the pictures seems to be either decorative or anecdotal. For example, one finds fully-fledged genre scenes in a copy made in 1224 of the Dioscorides – as in the visual drama of a man bitten by a wild dog.

Paintings in such treatises on medicine, zoology, farriery, and philosophy commonly show signs of borrowing from the Hellenistic–Byzantine tradition of book illustration, so that the sages and doctors are made to posture like Christian church fathers. Author portraits or patron portraits often featured on the frontispieces of Arabic manuscripts and here again the Arab painters seem to have been following older precedents. Thus, the author portrait of Dioscorides in a 1229 manuscript of *De Materia Medica* looks as though it has been modelled on the image of a Christian evangelist.

Al-Jazari's late twelfth-century treatise on automata and handbooks on warfare were among the other types of non-fiction to be illustrated. Although al-Jazari's book on the construction of automata was popular in the Mamluk period, there is little or no evidence that the actual construction of automata was correspondingly in fashion. So, though the illustrations may look as though they serve a utilitarian purpose, perhaps they were intended to be purely decorative. Similarly, though Mamluk military manuals did feature plans of battle layouts, these were archaic, being borrowed from pre-Islamic military treatises, and as for the pictures of horsemen galloping around neat little ponds, these were evidently included to delight the eye rather than prepare the mind for battle. More generally,

143. Frontispiece to a *Kitab al-Diryaq*, by Pseudo-Galen, showing a ruler and court scenes, probably from Mosul, Iraq, mid-13th century. Illuminated manuscript, 12½ x 10" (32 x 25.5 cm). Vienna, Nationalbibliothek.

An example of social perspective, in which the prince is portrayed as larger than his subjects.

one wonders why only certain books were illustrated and why they were illustrated as they were. One factor that increased the chances of a book's being illustrated was the pre-existence of a body of imagery, whether in the form of pre-Islamic illustrated texts or of frescoes. As to why books had pictures at all, they (and this especially applies to illustrated frontispieces) may have been included in order to lure buyers, the paintings here having a similar role to modern dustjackets.

Illustrating the Imagination: The *Kalila wa-Dimna*, the *Maqamat*, and the *Shahnama*

It was relatively rare for works of fiction to be illustrated (for example, the *Arabian Nights* was never illustrated in medieval times). However, two masterpieces of Arabic literature were often given pictures. *Kalila wa-Dimna* has already been referred to above (see FIG. 142). Although the earliest surviving illustrated Arab manuscript of *Kalila wa-Dimna* dates from about 1200–20, there are various indications that the book was illustrated earlier and, indeed, that its images of animals draw on a pictorial tradition going back to pre-Islamic times. Most specifically, it draws on Soghdian frescoes at Panjikent (roughly, Transoxania – Soghdiana is the region centred on the cities of Samarqand and Bukhara, where a civilisation flourished in particular from the sixth to the eighth century) dating from the fifth to the eighth century, which depict scenes from the Indian prototype of the animal fable collection, the *Panchatantra*. It is surprising, then, that the earliest surviving illustrated manuscript dates from approximately the first two decades of the thirteenth century. However, it is possible that the book's very popularity ensured the destruction of earlier copies, as they were passed from hand to hand and fell apart after much reading. Illustrations to *Kalila wa-Dimna* only occasionally focused on the stories' dramatic moments and the animal protagonists tend to be formally posed in schematic landscapes. Much of Ibn al-Muqaffa's eighth-century translation deals in a veiled form with court intrigues, offering advice on such matters as making alliances, taking precautions against enemies, and using guile in warfare. It has been called a "mirror for princes," but literary evidence suggests that the book, which was revered as a stylistic model, was more read by bureaucrats and scribes in the service of caliphs and princes. In any case, it seems probable that the audience for the book and its pictures was a fairly elevated one.

Children certainly formed part of the audience for such books as *Kalila wa-Dimna* and the *Maqamat*, which raises the possibility that the pictures in these books may have been aimed at the

children of the rich. *Kalila wa-Dimna* was valued as a text for mastering Arabic. In the preface to one of the manuscripts of the latter, Ibn al-Muqaffa (or a later writer impersonating him) explains why he has produced a book of animal fables (FIG. 144). He argues, first, that children would be attracted by the placing of human speech in the mouths of animals, and, second, that the book would appeal because of "the depiction of animal images in a variety of colours and pigments, so that they delight the hearts of kings; and their enjoyment is increased by the pleasure to be had from these illustrations ..."

The *Maqamat* (FIG. 145) by al-Hariri of Basra (1054–1122) – loosely modelled on Badi al-Zaman al-Hamadhani's (968–1008) prototype of the genre of *maqama* stories – was the other great work of fiction that was sometimes illustrated, though, again, no illustrated versions have survived from before the early thirteenth century. Sometimes the artists selected images that are only marginal to al-Hariri's storylines. Thus, for example, in the thirty-ninth "session" the narrator al-Harith is on a boat, which stops at an unnamed island. The corresponding image in the Iraqi *Maqamat* of 1237 features harpies, sphinxes, and monkeys, which are not licensed by the text but which are the products of the artist's fancy. Nevertheless, most of the settings in which the old rogue Abu Zayd and al-Harith feature are pictorially less fanciful – mosques, libraries, courtrooms, taverns, schoolrooms – and perhaps it is more the world of the reader than the world of the story that is being illustrated.

144. The lion advised by his mother, from an Egyptian or Syrian *Kalila wa-Dimna*, 1354. Illuminated manuscript, 6¾ x 7¾" (17 x 20 cm). Bodleian Library, Oxford.

In his preface to the work, al-Hariri claimed that his writing had a didactic purpose and compared his stories about the wily rogue Abu Zayd to morally improving fables. Moreover, there is evidence that children who had succeeded in memorising the Koran were often made to learn the grammatically sophisticated text of the *Maqamat* by heart. This again raises the possibility that illustrated versions of these texts were aimed at children, to brighten the task and to help explain what was going on in difficult texts.

The *Shahnama*, written by Firdawsi around 1010, has claims to being the longest poem in the history of world literature, consisting as it does of some fifty to sixty thousand couplets. (There is no fixed text.) It begins with Gayumars, the first king of the

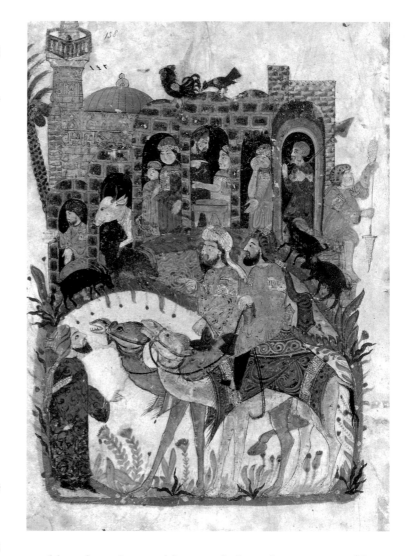

145. Village scene, from the Schefer copy of al-Hariri's *Maqamat*, produced in Baghdad, 1237. Illuminated manuscript, 13⅝ x 10¼" (34.8 x 26 cm). Bibliothèque Nationale, Paris.

The *Maqamat*'s title is usually translated as "Sessions," though strictly it means "Standings," as its protagonists stand to address one another. The book consists of fifty short chapters set in a wide variety of locations, in which the narrator al-Harith keeps encountering and failing to recognise a fluent and wily old rogue called Abu Zayd. These encounters serve as pretexts for the demonstration of Abu Zayd's (or really al-Hariri's) astonishing verbal artifice, his skill at punning, allusion, and other forms of word-play. The syntax is complex, much of the vocabulary is obscure, requiring glossing, and there is not much action in the stories. It seems odd, then, that this text should have been illustrated as often as it was – a total of eleven illustrated *Maqamat*s have survived that were produced between 1223 and c. 1350.

world, and continues with a mostly legendary account of Iranian history up to the conquest of Iran by Arab Muslim armies, when "the throne became a pulpit." The poet's hostility to Arabs is evident in the portrayal of Zahhak, a half-Arab cannibal king, and to the Turks in the people of the Turanians, who dwell north of the Oxus and who are the perennial enemies of the ancient Iranians. The *Shahnama* depicts a world of kings and warriors, who engage in fighting, hunting, and feasting. (However, Firdawsi's poem is by no means an unthinking celebration of kings, for it is often concerned with the problems unworthy kings cause their reluctantly loyal subjects.) Beyond the pageantry and martial fanfare, at a more profound level the poem is about the hardness of fate and the universe.

146. Rustam killing the elephant, from a copy of Firdawsi's *Shahnama* produced in Egypt, early 16th century. Illuminated manuscript, whole page 16 x 9¼" (41 x 25 cm). Topkapi Saray Library, Istanbul.

References in poetry of the 11th century indicate that the *Shahnama* was depicted in frescoes of princes' palaces. Firdawsi himself when he writes of Prince Siyavush, one of the many ill-fated legendary heroes of the epic, has him build a palace-city, Siyavushgird, and has its audience chamber decorated with "various paintings – scenes that showed great kings,/ Their banquets and their battles – on the walls;/ Here Rustam blessed with elephantine strength,/ Sat on his throne, surrounded by Gudarz/ And Zal and all his court; there Afrasyab/ Was shown with all his retainers, warriors like/ Piran and unforgiving Garsivav."

In order to compose his poem, Firdawsi drew on oral and lost literary sources, and may also have drawn on visual sources. Frescoes of episodes from Iran's legendary past painted in pre-Islamic and early Islamic times may well have provided inspiration for Firdawsi's verses (as well as for book painters who came to illustrate it). For example, a ninth-century wall painting discovered at Nishapur seems to show the *Shahnama*'s most celebrated hero, Rustam, battling against a force of evil (FIG. 146). Although the earliest surviving illustrated manuscripts of Firdawsi's masterpiece date from the Ilkhanid period, scenes from the *Shahnama* were used to decorate ceramics and metalwork in the twelfth and thirteenth centuries.

Rustam apart, one of the most popular choices for illustration was the prince and mighty hunter Bahram Gur, who is customarily shown sharing the same mount with his slave-girl Azadeh (FIG. 147). One finds alleged inscriptions from the *Shahnama* on tiles at the twelfth-century palace of Lashkar-i Pazar, praising

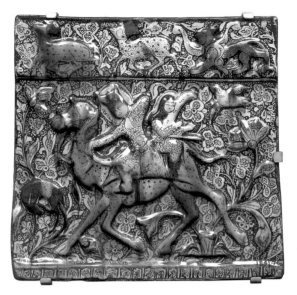

the Ghaznavids and their palace. This is possibly the earliest secular inscription on a building. Later on, quotations from the *Shahnama* were reproduced on lustreware tilework at such places as the shrine of Imamzadeh Jafar at Damghan in northern Iran (1266–67) and the palace of Takht-i Sulayman south-west of Tabriz (1270s). The appearance of texts from the *Shahnama* in religious buildings suggests that the poem could be read in a mystical sense.

Firdawsi's work provided the pretext for more spectacular and more opulent illustrations than any other work in Islamic literature. The pages were individually made for the books and page layout was carefully planned. The grander *Shahnama*s were worked by teams of painters and sometimes several hands collaborated on a single miniature. Some painters specialised in doing landscape, others did certain types of figure or battle scene. Therefore, such *Shahnama*s were almost invariably produced by court workshops. The earliest illustrated *Shahnama*s to have survived were produced in the Ilkhanate in the early fourteenth century and at first they tended to have very small illustrations occupying only a small part of the page. The so-called "Demotte" *Shahnama* (FIG. 148), which was produced at about the same time or a little later, has larger pictures. (The special problems posed by this manuscript are discussed separately in the Conclusion.) There was no fixed canon of illustration. Most painters tended to select moments of drama, but then to portray the drama symbolically rather than expressively, and in some paintings an

147. Tile showing the prince Bahram Gur and his slave-girl Azadeh on a camel, from the palace of Takht-i Sulayman, 1270s. Lustre and cobalt glazes, 12½ x 12¾" (31.5 x 32.3 cm). Victoria and Albert Museum, London.

148. Rustam slaying Shaghad, from the "Demotte" *Shahnama*, copied in Tabriz, c. 1336. Illuminated manuscript, 6¼ x 11⅜" (16 x 29 cm). British Museum, London.

animated landscape is made to do the work of the immobile and impassive characters (FIG. 149).

Taken as a whole, Firdawsi's poem is a gloomy epic about kings and heroes betrayed. Set in a malevolent universe, its story ends in a national disaster – the defeat of the Iranians by the Arabs. But one would not guess this from the way it was illustrated by Timurid and Safavid painters. The landscapes of tragedy sparkle with jewel-like clarity and the blood flows like fine wine. Illustrated *Shahnama*s are often discussed by modern scholars as if they were propaganda for imperial rule, by Ilkhanids, Timurids,

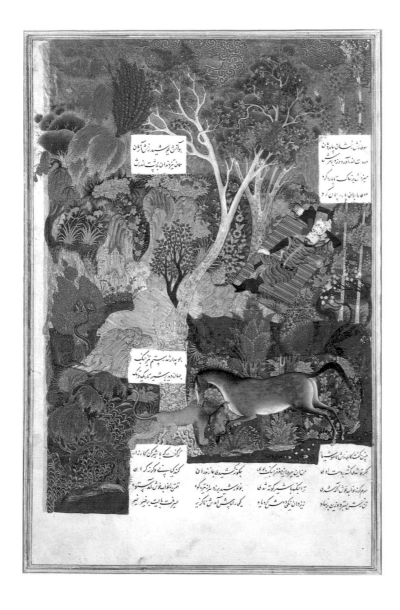

149. Rustam sleeping, from an unfinished *Shahnama*, 1512–22. Illuminated manuscript, 12¹/₂ x 8¹/₈" (31.8 x 20.8 cm). British Museum, London.

Even in illustrated books that seem to have been aimed at an adult market such as the *Shahnama*, one can detect elements of play and puzzle. A fashion developed in Timurid and later in Safavid painting for concealing the faces of men and beasts in brilliantly coloured and strangely contorted rocks, clouds, and trees. Sultan Muhammad, one of the leading painters in the service of the shahs Ismail and Tahmasp, was the supreme specialist in this quaint art form. In this, perhaps his most famous, painting, Rustam sleeps, while the faces in the rocks sneer, rage, and scream. Evidently rocks were not held to be subject to the decorum of the court and they usually appear to be much more passionate than the *dramatis personae* of the painting in which they appear.

or Safavids. However, as has been noted generally of works produced at court, the degree to which they can indeed be considered as imperial propaganda is doubtful. Surely it was the ruler rather than his subjects who was most likely to dip into the work he had commissioned.

Persian poets wrote of an ideal world of princes and lovers, well-watered gardens, and flowery meadows. It was a story-world in which both the external development of plot and the appearance of material things hinted at hidden and higher mystical truths. All this was reflected in painting. The painters allowed no shadows to darken their pure-coloured vision of the world. In the daytime the sun was always shining and the nights were as bright as day. Armies encountered one another in pretty landscapes, which looked more suitable for the meetings of lovers. Whether fighting, lamenting, or dying, the miniature figures in the idealised landscapes comported themselves with decorum (FIG. 150). These impassive-faced protagonists were restricted to a limited range of symbolic gestures. A finger in the mouth betokened astonishment. Hands held up to the ears signified respect. A person with a bare waist must be either a slave or a captive.

150. The Battle of Çaldiran, from a copy of the *Selimnama* of Sükru Bitlisi (d. 1520), 1525. Illuminated manuscript, 10¼ x 7″ (26 x 18 cm). Topkapi Saray Library, Istanbul.

The Battle of Çaldiran was fought between the Ottoman sultan Selim I and the Safavid shah Ismail in 1514. The Ottoman forces were victorious. In this decorously rendered version the Shah's dismay and surprise are indicated by the gesture of his finger in his mouth.

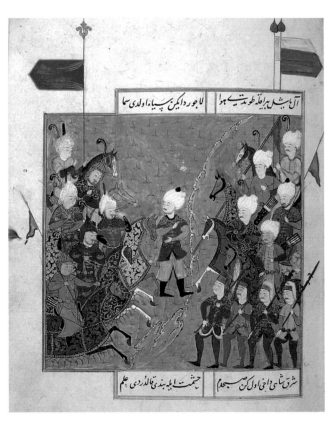

Passion, if passion there was, might also be suggested by the contorted and swirling forms of the rocks and trees in the landscape. The landscape might also comment on the attractions and the emotions of the people seen in it. Thus, the cypress tree was a tree, but it was also an image of the beauty and slenderness of the human form. The tulip hinted of love, while the violet betokened mourning. No Iranian would contemplate the image of the moon without thinking about the ideally beautiful human face.

One might have expected that Persian pictures were read, as Persian script was, from right to left and down the page. In fact, this almost never seems to be the case. Persian miniatures (unlike their Arab precursors) customarily had high horizon lines. In cases where

a sequence of actions was portrayed, the action tended to begin at the bottom of the page and move on upwards, so that the climax, perhaps a combat between two mighty heroes, takes place in the upper half of the page. As for the lateral aspect, there was certainly no rule that one read a picture right to left. The image of Rustam slaying Shaghad (see FIG. 148) in the "Demotte" *Shahnama* provides an example of the exact opposite, as the eye is drawn first to Rustam's horse impaled in a pit on the far left, then to Rustam in the centre, who has just launched the arrow of vengeance, and finally to Shaghad impaled by the arrow on the far right of the painting. More often, however, the directional arrangement of the painting was not so prescriptive and there was no strong central focus within it. Persian miniatures were for the most part pictures for the eyes to range over, moving from detail to detail, guided perhaps by the arrangement of the colours on the picture plane, or, at times, prompted by the direction of the gazes of the servants and spear-carriers within the picture.

By the mid-sixteenth century the great age of patronage of manuscript volumes had come to a close and illustrated books were being replaced by single-page drawings and paintings, which were often pasted into presentation albums (*muraqqa*s). Older illustrated books were sometimes dismembered and plundered to fill the albums. The new demand for single-leaf paintings meant that painters were less dependent on imperial patronage and were able to work for a wider market. Genre scenes and portrait likenesses were more often attempted. From the seventeenth century onwards, European influence led artists in Iran (and India too) to attempt perspective and modelling in light and shade (FIG. 151). The shadow of European art had fallen across Persian painting.

151. Miniature portrait of Fath Ali Shah Qajar (r. 1797–1834), Iran, early 19th century. Enamel on gold, 2³⁄₄ x 1³⁄₄" (6.2 x 4.4 cm). Khalili Collection.

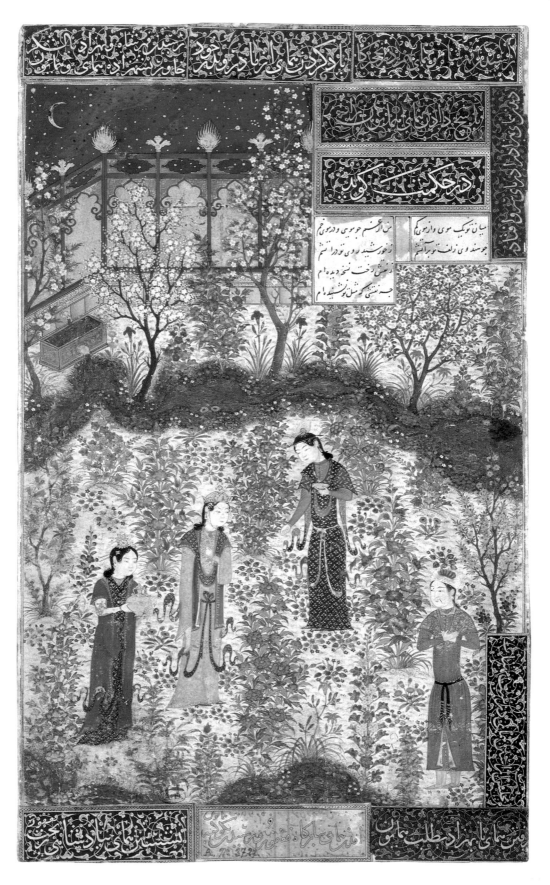

EIGHT

The Mysterious Universe

T he scientific knowledge available in the Islamic world during the medieval period was in many cases far in advance of that available in the West (FIG. 153). An examination of some aspects of this scientific knowledge can help answer the question why Islamic art of the Arab, Iranian, and Turkish peoples looks the way it does, by revealing what those peoples knew or believed about vision, colour, and form.

Optical Theory and Visual Effects

There were not one but at least two competing theories of optics. Ibn al-Haytham expounded the correct theory that images were perceived by the eye when light rays from the images in question reached the eyeball. Al-Kindi (d. 870), on the other hand, followed Euclid and taught that the eye emitted rays and that when these rays reached an object that object was perceived by the eye. Although al-Kindi's theory concerning eyebeams was part of an abstruse occult philosophy, his view of the matter was certainly shared by less esoteric thinkers. For example, Ibn Hazm (d. 1063), who lived in Cordoba and who wrote on love and the amorous gaze, wrote of the eyes' rays travelling out to encounter objects and cited experiments with mirrors in support of this erroneous view.

Islamic artists, particularly those working in such materials as stucco, textile, or wood, favoured abstract repeating patterns and such patterns did not presuppose any fixed point of view. Indeed, it is evident that the craftworkers on the Alhambra, for example, played with the effects that could be achieved by viewing the multi-layered designs from various angles while in motion.

152. Humay and Humayun in a garden, from a Herati album painting, c. 1430. 11½ x 6¾" (29 x 17.5 cm). Collection Musée des Arts Décoratifs, Paris.

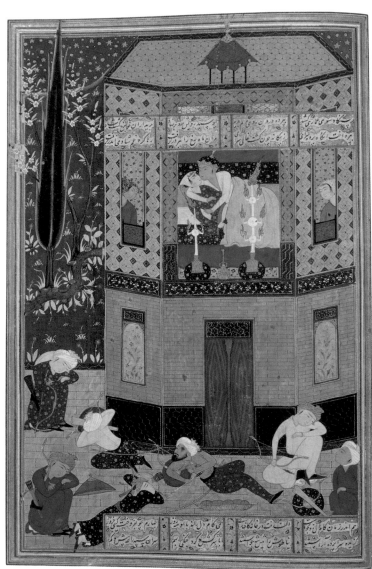

In a sense, even in the figurative art of the Islamic world, no fixed point can be assumed. The Muslim artist, uninterested in the principles of linear perspective, was determined to show the subject matter from the best possible vantage point or, more often, points. In a miniature painting featuring, say, a house or a castle, the painter usually tried to show as much of that building as was possible, including both the flanking walls and the roof, so that anyone looking at the painting has a simultaneous vision of the building from three of its four sides, and is granted both a bird's-eye and a worm's-eye vision of it (FIG. 154).

153. Iranian lustreware dish showing teacher and pupils, 12th century. Diameter 18²/₃″ (47.5 cm). David Collection.

154. Miniature of a love scene between Khusraw and Maryam, from an Iranian copy of the *Shahnama*, produced in Shiraz, 1599–1600. Illuminated manuscript, 13¹/₂ x 8″ (34.5 x 20.5 cm). India Office, London.

"Social" and "Narrative" Perspective

In the absence of linear perspective of the type expounded by Leon Battista Alberti and other theorists in Renaissance Italy, there was no single theory or strategy for arranging figures in picture space. The painter of the 1237 *Maqamat* of al-Hariri, al-Wasiti, for example, made frequent use of a double ground-plane. Nevertheless, despite sporadic attempts to indicate depth, Arab painters did not normally show figures close to the picture plane as being larger than those who were located further away in the notional distance. Sometimes, though, they made use of what is called "social perspective," emphasising the importance of certain people in the painting by making them much larger than other lesser figures in the picture. Thus, for example, the prince featured in the frontispiece to a thirteenth-century *Kitab al-Aghani* (*Book of Songs*; FIG. 155) appears much larger than his courtiers and attendants.

155. The frontispiece to the *Kitab al-Aghani* showing a ruler with attendants, Iraq, c. 1218–19. Illuminated manuscript, 6³/₄ x 5" (17 x 12.8 cm). Millet Kutuphanesi, Istanbul.

Painters' use of social perspective was not always consistent and, while rare, it is not unknown to find a miniature featuring servants towering over their master.

Iranian painters also sometimes made use of social perspective. Additionally, they occasionally used what may be called "narrative perspective," in which successive parts of the story were shown or more often implied in different parts of the picture. In the early fourteenth century, painters working in the Iranian Ilkhanate experimented with showing people and animals in foreshortening. In this they were influenced by Chinese art. In particular, the foreshortening technique used in the miniatures illustrating the *Manafi al-Hayawan* (*Uses of Animals*) clearly derives from Chinese painting. Similarly, the device of showing only part of the figure or object (FIG. 156), suggesting that there was more of it extending beyond the "window of visibility" afforded by the picture, also derived from Chinese practice. (An alternative way of suggesting the world beyond the picture frame was to burst it and to show lances or horses actually breaking out of the frame; this continued to be popular in later Iranian painting.) Like the Arabs, Iranian painters made unsystematic use of a kind of reverse perspective, in which, for example, the nearest side of the house would be shown smaller than the rest in order to allow the flanking sides to be seen.

156. Miniature of a horse from a copy of Ibn Bakhtishu's (d. 1056) *Manafi al-Hayawan* (*Uses of Animals*), 1354. Illuminated Manuscript, 13³/₈ x 9⁵/₈" (34.0 x 24.4 cm). Pierpont Morgan Library, New York.

Arab painters favoured a low horizon line. The Iranian painters at first followed the same practice, but, after the early decades of the fourteenth century, they switched to a high horizon line. A kind of roving bird's-eye view on the part of the spectator was thereby implied and it conveniently allowed that spectator to get a full view of carpets, roofs, and table tops. The high horizon line also gave plenty of space in which to develop what were often quite complex stories. The figures normally would be arranged in a receding succession of base lines, with the nearest objects at the bottom of the picture.

Colour Theory and Symbolism

There was no one single theory of colour in medieval Islamic lands and attitudes to individual hues derived from a large variety of sources, including religious and political symbolism, mysticism, folklore, optical theory, and artistic fashion. The original audience for Islamic art can be postulated as having a sophisticated and highly nuanced conception of colours and tones. Records exist of customers for dyed textiles ordering them in shades as specific as "gazelle blood," "onion-coloured," "musk-coloured," and so on.

Colours also played a crucial role in guiding the viewer in how to read a picture, and, despite the sporadic and inconsistent signallings of depth, artists' primary concern was almost always with the surface effect made by the juxtaposition of colours on the picture plane. Arab and Iranian painters (who, after all, spent much time in a sun-drenched world of saturated colours) favoured pure colours and almost never used light and dark tones to model form (and hence, for example, folds in draperies are indicated by lines, rather than light and dark tones). No single light source was assumed and consequently there was no logical depiction of shadows. Painters were not concerned with the effects that might be achieved by *chiaroscuro* or by highlights.

Again, those who look at paintings of nocturnal episodes, such as Humay and Humayun in a garden (FIG. 152, see page 193), or Bahram Gur sleeping with one of his seven princesses, are granted perfect night vision.

Medieval notions of colour were not necessarily the same as those we take for granted today. Thus, for example, the mysterious Ikhwan

al-Safa, or "Brethren of Purity," who collaborated on an ency-
clopedia around the late ninth century, referred to only the four
principal colours of the rainbow – red, yellow, blue, and green.
Later, the thirteenth-century cosmographer al-Qazwini put for-
ward a total of eight colours. Even then, it is worth bearing in
mind that not everything that would be classified as "blue" by a
modern European was so classified by a medieval Muslim. Indigo,
for example, seems to have been regarded as "dark," as a form
of black rather than blue, while often very light shades were classified
as "green."

It is easy to multiply examples of regional and chronologi-
cal differences in attitudes towards colour. Yellow, despite the great
tenth-century physician al-Razi's championship of its medicinal
effects, was a taboo colour in Fatimid Egypt, but after Saladin
overthrew the Fatimids in 1169, it was adopted by him and his
Ayyubid and Mamluk successors as the colour of the ruling dynasty.
The tenth-century historian al-Masudi seems to have been extremely
fond of red, writing that "red is the colour of children, women,
and joy. Red suits the eye best, because it enlarges the pupil, whereas
black narrows it." In Seljuq and Ottoman Turkey, red was the
colour for brides, but it was favoured by prostitutes in Mamluk
Egypt. In some parts of the Middle East and Muslim Spain, the
colour of mourning was white; in other parts it was black. Blue
(for example, blue eyes) was often associated with misfortune and
the evil eye, yet blue or black robes were widely favoured for
women's dresses and blue beads were worn to avert ill luck.

Although Sufis wrote copiously about colour symbolism they
do not seem to have shared any common colour code. Al-Suhrawardi
(d. 1191) conceived of the soul as progressing through the colours,
from black, which denoted the lowest state, through red, to white.
Al-Ansari's eleventh-century Iranian treatise on correct behaviour
for Sufi mystics proposed a system of ranking Sufis by the colour
of the robes they wore that is vaguely reminiscent of that which
prevails today among holders of judo belts: a robe of black (siyah)
or dark blue (kabud) for those who have tamed their carnal soul;
white (sapid) for repentance and purification; and blue (azraq) for
one who has reached the higher world. A robe of different colours
(mulamma) should be worn by one who has passed through all the
mystic stages. The Sufi Najm al-Din Kubra (1145–1221) taught that
the universe has seven levels, each with its own special colour:
Intelligence was white; Spirit yellow; Soul green; Nature red; Mat-
ter ashen; Image dark green; Material Body dark black. Elsewhere,
Najm al-Din Kubra wrote of white for Islam; yellow for faith;
dark blue for beneficence; green for tranquillity; light blue for

certitude; red for gnosis; black for passionate love and bewilderment. However, these and other sources are of little use in determining how colour was actually used in Arab and Iranian paintings. It would, for example, be unwise to deduce the social or spiritual status of a character from the colour of the robe he or she is wearing in an illustrated text. Colours were used instead to create visual effects on the picture plane. Indeed, in Iran from the fourteenth century onwards, one finds painters making deliberately anti-naturalistic use of colour, painting landscapes with blue trees, rainbow-coloured rocks, and green skies.

Pattern and Geometry

More than any other, Islamic culture has proved itself the best in the use of geometric pattern for artistic effect. It seems intrinsically likely that some of those who contemplated the abstract patterns with which architectural facades, tiled floors, bookbindings, and ivory caskets were decorated may have looked on those patterns as exteriorised representations of abstract, even mystical, thought. More prosaically, there may have been occasions when designers intended their complex abstract patterns to have a puzzle element; the eye perceives that there is an underlying pattern but cannot work out exactly what it is. This arises, for example, with the bevelled style of carving in wood and stucco, as practised in Abbasid Samarra and Tulunid Egypt, where so often the carved repeat pattern can be read as an abstract design, or as a bird or a fish, according to the viewer's predilection. A similar decorative playfulness lies behind the taste for human-headed and zoomorphic metalwork in the twelfth and thirteenth centuries (see FIGS 131 and 132), as we have seen, and later for calligraphic people and animals whose shapes are formed out of cunningly arranged Arabic letters. According to a medieval Jewish saying, "A mind settled on an intelligent thought is like the stucco decoration on the wall of a colonnade."

The artistic development of pattern in the wider Islamic world is generally best understood in terms of the practical experiments of designers and artisans with such basic devices as repetition, rotation, and reflection, rather than as conscious attempts to make abstract statements about the harmoniously patterned nature of a divinely ordered universe. In time, patterns devised by artisans tended to evolve autonomously into more elaborate forms. This becomes clear if, for example, one considers the evolution of designs based on lobed and horseshoe arches in Andalusia or, for that matter, the progressively more elaborate forms of *muqarnas* employed in Spanish Muslim palaces. With its tracery archways,

its *muqarnas*-studded zones of transition, and its wall surfaces covered with perfectly contiguous tessellated designs, the Alhambra is a triumph of the geometer's art.

We turn now to look at particular aspects of the evolution of abstract designs in Islamic art. The arabesque (a design based on curious intertwined foliage) seems to have evolved from the decorative use of acanthus and vine scrolls in the eastern Mediterranean area prior to the coming of Islam. (It is one of the many curiosities of Islamic culture that, while proscribing alcohol, it should yet make use of a decorative device that had previously been employed in classical and Christian times to allude to wine.) In time the arabesque became more abstract, more denaturalised, as Muslim designers explored the ornamental possibilities of repeated patterns of coils and spirals, which bifurcated and sent out shoots, which proliferated to fill the surface to be decorated. Customarily, the whole surface would be covered, as if the designers suffered from a horror of the void. Overlapping and interlaced arabesques could be used to create more complex effects and to give the illusion of depth in what was really a one-dimensional decorative surface (FIG. 157). A thoughtful person contemplating such intricate patterns would find it hard to avoid thinking of infinity.

More strictly linear, geometrical ornament in the early Islamic period also followed Greek and Roman designs and elaborated upon them. Octagons and star shapes had been used decoratively even in the earliest centuries of Islam. Egyptian designers from the mid-twelfth century onwards developed spectacularly elaborate and variegated patterns in a compartmentalised geometric style, most of them based on segments of circles and on star shapes. The eight-rayed geometric star shape (*shamsa*) was based on an eightfold division of a circle – equivalent to the rotation of a square within the circle. Koranic frontispieces commonly featured designs based on the star polygon and used interlacing, overlapping, and interlocking shapes to elaborate upon the original polygonal shape. Again, such complex, abstract, radiant designs seems to suggest

157. Frieze of blue-green tiles from Fathabad, near Bukhara, c. 1360. Glazed fritware, 68½ x 17″ (1.74 m x 43.2 cm). Victoria and Albert Museum, London.

158. Detail of a wood panel from a *minbar*, presented by the Mamluk sultan al-Mansur Lajin (r. 1296–99) to the Mosque of Ibn Tulun in 1296. Wood. Victoria and Albert Museum, London.

a spiritual meaning without actually specifying what that meaning might be (FIG. 158). One should certainly be cautious in assigning a fixed symbolic meaning to, say, the eight-pointed star as the "Breath of the Compassionate." If that was its fixed meaning, why do we find this star used as a decorative device in profane contexts, such as the walls of kitchens and brothels, and on drinking cups?

Broadly speaking, the development of elaborate geometrical patterns reached its peak in the fourteenth century in Mamluk Egypt and Syria, Ilkhanid Iran, and Nasirid Spain. However, having developed such geometrical patterns on a one-dimensional plane, Egyptian designers in the fifteenth century went on to adapt them for three dimensions. Thus, for example, the carved stone dome of Barsbay's Mausoleum-Khanqa in Cairo (1432) was covered with a star-pattern interlace. A yet more complex design of stars and polygons combined with an interlacing arabesque decorated the dome of the Mosque of Qaytbay (1474). Such designs reveal remarkable sophistication, as the domes in question were not simple hemispheres but rather rose steeply from drums and tapered sharply.

Geometry played at least as important a part in architecture as it did in decorative design. An early seventeenth-century treatise on architecture, the *Risale-i Mimariyye* (*Architectural Letter*),

lists the geometric shapes used in mother-of-pearl inlay work, and as we have already seen, geometric inlay provided the groundwork for the architect Mehmed Aga's education. In the *Risale-i Mimariyye*, a visitor to one of Mehmed Aga's architectural sites is quoted as saying approvingly to the author, "You related that previously the Aga took a fancy to the science. Now we have seen the science of music in its entirety in the building of this noble mosque." The intelligent visitor's observation anticipates Goethe's famous characterisation of architecture as "frozen music." Music was conceived of as both an art and a science in medieval Islam, for in its serious, scientific aspect the hidden geometry of the world could be expressed musically. When the Brethren of Purity, who put forward Pythagorean ideas about the musical harmony of the universe, wrote of "the music of the spheres," they meant this literally.

Astronomy and Astrology

According to the fourteenth-century Iranian Sufi poet Muhammad Shabistari, "The heavens revolve day and night like a potter's wheel [FIG. 159]. And every moment the Master's wisdom creates a

159. Celestial globe made by Muhammad al-Astrulabi, 1285–86. Inlaid bronze, diameter 5⅜" (13.5 cm). Khalili Collection.

160. Miniature from an early 11th-century copy of al-Sufi's *Kitab Suwar al-Kawakib al-Thabita* showing the constellation of Andromeda C as seen from the sky. Illustrated manuscript, 10¼ x 7" (26.3 x 18.2 cm). Bodleian Library, Oxford.

The images are based on earlier Greek treatises, but some of the iconography has been misunderstood and the costumes and faces featured have an oriental look.

new Vessel. For all that exists comes from one hand, one workshop." The study of astronomy was looked on with benevolence by the pious, for it could be regarded as a branch of religious time-keeping. The Muslim calendar was a lunar one, and the daily times of prayer were fixed by the passage of the sun. It is not surprising, then, that solar and lunar imagery has played such a large part in Islamic art. The *Kitab Suwar al-Kawakib al-Thabita* (*Book of Images of the Fixed Stars*) was written by al-Sufi at the end of the tenth century and was copied at the beginning of the eleventh century. It contains images of the various constellations and is the oldest illustrated book in Arabic to have survived (FIG. 160).

For many Muslims the study of astronomy was indissolubly tied to that of astrology. The Mongol Ilkhan of Iran, Hulagu (d. 1265), had an observatory built at Maragha which had astrological purposes and which was frescoed accordingly. When in 1428–29 the Timurid prince Ulugh Beg built an observatory at Samarqand (FIG. 161), there may have been an element of deliberate antiquarianism in the enterprise, a harking back to the early years of the Mongols in the Near East. A number of illustrated astrological manuscripts were produced under the patronage of the Timurids, of which the Iskandar Beg horoscope of 1411 (FIG. 162), a lavishly painted double page with zodiacal houses, astrological figures, and attendant angels, is certainly the most ravishingly spectacular.

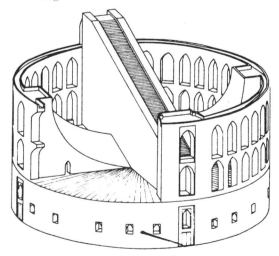

161. (Left) The interior of the Ulugh Beg observatory, Samarqand, 1428–29; and (below) a reconstruction of the observatory. Astronomical calculations were made from the passage of sunlight across the central graduated channel of the building.

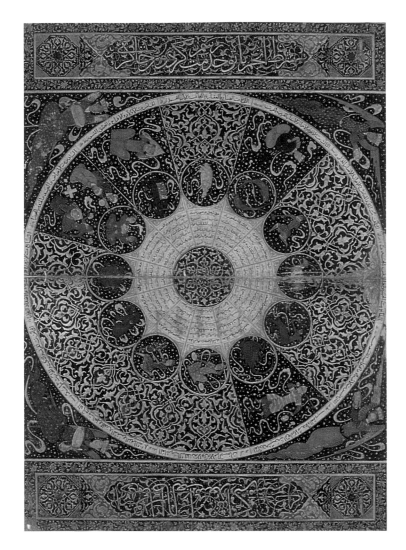

162. The horoscope of the sultan Iskandar Beg (b. 1384), produced at Shiraz, 1411. Illumination on paper, 10½ x 6½" (26.5 x 16.7 cm). Wellcome Institute Library, London.

163. The lid of the "Vaso Vescovali," showing planetary images, from eastern Iran or Afghanistan, c. 1200. High-tin bronze, inlaid with silver, diameter 7" (18 cm). British Museum, London.

The planets appear as personified images. Qamr (the Moon) holds a crescent; Utarid (Mercury) scrolls; Qahir (Mars) a severed head, and so on. There were various ways of depicting the Sun. Often it was shown as a disc with a human face, but sometimes a sphinx functioned as solar symbol. Occasionally, as here, the seven planets were joined by an eighth imaginary "planet" of Indian origin – that of Jawzahr, the dragon of eclipses.

Astrological imagery had already become common on metalwork in the twelfth century, at about the same time as the flowering of inlay decoration in general (FIG. 163). The twelve signs of the zodiac also frequently featured on metalwork. Astrological images were placed on cups, bowls, and the backs of mirrors, presumably with the aim of drawing down the benign influences of the planets. But images of the sun and its attendant planets may also sometimes have been intended as symbolic representations of the caliph or sultan and his courtiers. The ruler sat at the centre of his empire dispensing patronage and wisdom, like the sun at the

centre of the cosmos dispensing warmth and light. Solar imagery may also be detected in more abstract designs, such as patterns of roundels around a central disc, and it has also been suggested that the star polygon design, as it appears for example on the frontispieces of Mamluk Korans, is a stylised representation of the sun and the six planets.

Astrological influences also determined personal appearance. The polymath al-Biruni's (d. after 1050) *Kitab al-Tafhim Awail Sinati al-Tajim* (*Instruction in the Elements of the Art of Astrology*), written in 1029, describes, for example, the type of man who was governed by Leo: full height, broad face, thick fingers, big lips, grey eyes, broad nose, wide mouth, separated teeth, chestnut hair, prominent belly. *Firasa*, or divination from physiognomic appearance, complemented astrology. The ancient Greek Polemo's treatise on physiognomy was translated into Arabic in medieval times. Such stereotypical characterisations as "very fleshy cheeks indicate drunkenness and laziness" or "a rather thin face indicates greed, perseverance, and faithlessness" may possibly have had a role in determining the way artists depicted characters in, say, al-Hariri's *Maqamat* (where, for instance, Abu Zayd has a long, thin face). Al-Mubashir's *Mukhtar al-Hikam* described Plato as being "of brownish complexion and medium height. He had a good figure and was perfectly proportioned. He had a handsome beard and little hair on his cheeks …" The physical appearance of all the leading Greek philosophers, indeed, was lovingly recorded by Arab writers and artists (FIG. 164).

164. Portrait of Aristotle from a copy of Ibn Bakhtishu's *Manafi al-Hayawan*, early 13th century. Illuminated manuscript, whole page 9¼ x 6″ (23.7 x 15 cm). British Library, London.

165. An Egypto-Syrian geomantic machine, 1241–42. Inlaid brass, 7¾ x 13¼″ (19.6 x 33.7 cm). British Museum, London.

This is another example of the craftsmanship of Muhammad ibn Khutlukh al-Mawsili (see FIG. 16). In Arab geomancy in its simplest form, the diviner told fortunes and gave advice on the basis of random marks in the sand. However, this elegantly constructed device of brass inlaid with gold and silver mechanises the process of fortune-telling according to geomantic principles. Curved metal slides assist in determining the answer to the seeker's enquiry.

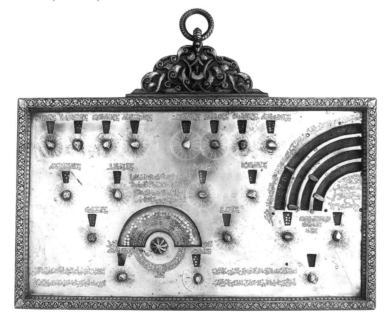

Astrology and architecture were also intimately connected. It was normal to commence work on a building only on an astrologically propitious day (FIG. 165). In Nizami's (d. 1209) long poem "Haft Paykar" (Seven Pavilions) from his *Khamsa*, Simnar the architect not only possesses the normal architectural skills, but also is versed in astrology and the use of the astrolabe (FIG. 166), and "like Apollonius wise, he can/devise and loose all talismans." Indeed, the founding of cities waited upon a favourable conjunction of the planets: when the Abbasid caliph al-Mansur (r. 754–75) founded Baghdad, he did so in consultation with Nawbakht the astrologer.

Science and Magic

The legendary prophet Idris, the Arab equivalent of Hermes, was held to be the founder of the occult sciences and also the originator of craft skills; and alchemical manuscripts did not restrict themselves to obscure discussions about the transmutation of base metals into gold or the quest for the Elixir of eternal life, but also commonly included detailed craft recipes. Thus, treatises attributed to the eighth-century alchemist Jabir ibn Hayyan expounded the secrets of such matters as mordants, dyes, glassmaking, and paste for the repair of glass and porcelain. The *Ghayat al-Hakim* (*Goal of the Sage*; probably early eleventh century and often spuriously attributed to al-Majiti, although its real author is unknown), a sorcerer's manual, stressed the importance of a knowledge of geometry and music as a guide to the workings of the cosmos. Much of the thought and imagery of pagan antiquity was preserved in magical texts like the *Ghayat*. These gave instructions on the fabrication of magical images, such as the engraving of a scorpion on a bezoar stone as a cure to heal wounds. Alchemical manuscripts were sometimes illustrated, though the paintings are often crudely executed (FIG. 167) and their meaning frequently obscure. Pharaonic Egyptian images appeared in the illustrations to alchemical manuscripts; Jewish demonology helped shape the Arab iconography of jinns and magical monsters (FIGS 168 and 169). Arabic and Iranian cosmographies (which were frequently illustrated) were much preoccupied with angels, demons (FIG. 170), and marvellous beasts.

Talismans, Monsters, and Mirrors

Some of what is now displayed in museums as Islamic "art" was not fashioned for aesthetic reasons, but rather was designed

166. Front view of an astrolabe, made by Abd al-Karim al-Misri, 1227–28. Brass, diameter 11″ (28 cm). History of Science Museum, Oxford.

167. The death of the alchemical king, from the *Kitab al-Aqalim al-Saba* (*Book of the Seven Climes*), by Abul-Qasim al-Iraqi, 13th century, copied in Egypt, c. 1670. Illuminated manuscript, 10¼ x 7¾″ (26.3 x 19.8 cm). Chester Beatty Library, Dublin.

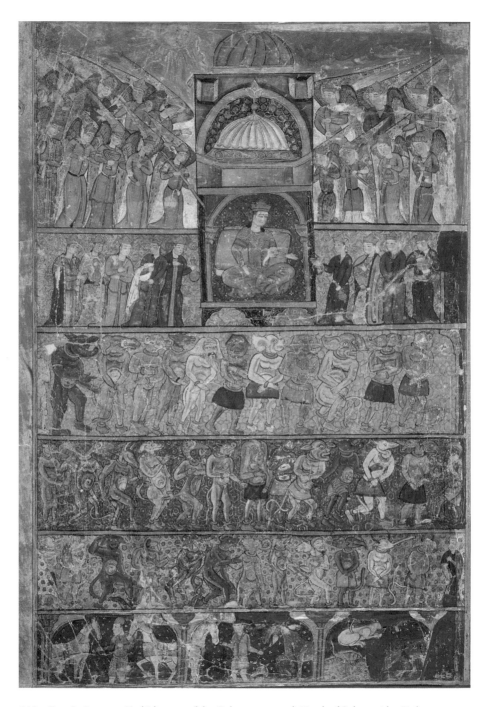

168. Frontispiece to a Turkish copy of the *Sulayman-nameh* (*Book of Solomon*) by Firdaws, painted c. 1500, showing Bilqis, the wife of Solomon, presiding over demons. Illuminated manuscript, 9⁷/₈ x 7¹/₂" (25 x 19 cm). Chester Beatty Library, Dublin.

Solomon was famed in Islamic literature as a master of jinns. Islamic images of jinns and similar creatures draw upon classical descriptions of monsters.

to further magical purposes. In particular, much of medieval Islamic jewellery was designed to serve as talismans, objects that have magical powers. The ninth-century philosopher and polymath al-Kindi in his treatise on light rays (which has survived in a Latin version under the title *De Radiis*) attempted to provide a philosophical rationale for talismans. He envisaged a universe of correspondences where each of the stars, through the rays they emitted, governed particular types of creatures and things. According to a saying attributed to the Prophet Muhammad, talismans should be made from silver; nevertheless many that have survived were made from lead or bronze. They usually bear writing in magical scripts, Koranic invocations, the names of protective angels, or magic squares. Solomon exercised power over the jinn by virtue of a talismanic ring engraved with "the most great name" of God. A separate legend concerns his seal-ring of brass and iron. What was known as "the seal of Solomon," a six-pointed star, often appears in books and on coins and metalwork. More generally, designs featuring sealed knots seem to have had magical connotations. Magic squares also appeared on a wide range of Islamic

Above left

169. A seven-headed dragon, from a copy of the 13th-century cosmographer al-Qazwini's *Ajaib al-Makhluqat* (*The Wonders of Creation*), Turkish, 17th century. Illuminated manuscript, 7¼ x 4″ (19.5 x 10.5 cm). British Library, London.

Above right

170. The monster Sannajah, from a copy of al-Qazwini's *Ajaib al-Makhluqat*, early 14th century. Illuminated manuscript, 8 x 6⅝″ (20.5 x 16.8 cm). British Library, London.

Al-Qazwini's treatise was a major source of descriptions of demons and monsters.

171. An Iranian talismanic shirt, 16th or 17th century. Cotton, 37³/₈ x 54³/₈" (95 x 138 cm). Khalili Collection.

Such shirts, woven of linen, cotton, or silk, were designed in consultation with the court astrologers and are covered with verses from the Koran, magical squares, six-pointed stars, mystic numbers, and letters. The shirts were worn as undergarments and were supposed to protect the sultans from death in battle, assassination, and disease. Similar shirts were also produced in Safavid Persia.

172. An Iranian talisman, with a Kufic inscription of *Sura* 112 from the Koran, 10th century. Lapis lazuli with a gold frame, 1³/₄ x 1³/₄" (4.5 x 4.5 cm). Khalili Collection.

Sura 112 is a profession of the incomparability and transcendence of God: "In the Name of God, the Merciful, the Compassionate/ say: He is God, One,/God, the Everlasting Refuge,/who has not begotten, and has not been begotten,/and equal to him is not anyone."

artefacts. A magic square is filled with numerals (or figures with a fixed numerical value) so arranged that the sums of all the rows will be the same, perpendicularly or horizontally. Garments, too, often had magical designs woven into them. The talismanic shirts (*tilsimli gomlek*) produced for the Ottoman sultans, among others, in the sixteenth century are particularly striking (FIG. 171).

The Arabic alphabet and various artificial invented alphabets were also used for magical purposes. Kufic was widely favoured for magical inscriptions (FIG. 172), perhaps because by the twelfth century the use of this script had a somewhat archaic flavour. However, sorcerers also made use of the so-called "spectacled letters." The latter were a family of invented alphabets, in which the letters characteristically had loops at the ends. Such alphabets could be used as codes or simply for mystification.

Apart from invocations to angels and demons, phrases from the Koran could be used for magical purposes. One esoteric device, that of the conjoined letters of *lam* and *alif* (which looks like a tilted and elongated "V"), frequently appears

as a repeat theme on metalwork and on the borders of carpets. Its meaning is unknown, but it probably had a magical or mystical significance. Shia and Sufi communities were accustomed to look on the world as a repository of hidden correspondences and secret codes to be deciphered, and it would be surprising if the artist and artisan did not occasionally cater for this occult way of looking at things.

Pious formulae or invocations of blessings, which were inscribed on household objects, were also intended to protect and bring luck. Craftworkers commonly designed their creations to be vessels of fortune and there is no sharp distinction between an object made for magical purposes and one that merely contains inscriptions or images that conventionally invoke blessings. When painters, ceramists, and metalworkers made use of the image of the human-headed bird, the harpy, they did so out of a sense of fun, or because they had a taste for the exotic and the fantastic. However, it was also an image that conferred good luck. The sphinx, which was associated with the sun, the Tree of Life, and life after death, makes its appearance in the iconography in the eleventh century (FIG. 173). From the mid-twelfth century onwards the unicorn also frequently featured in miniatures and in metalwork as a creature of ferocity and magical power. From the late thirteenth century onwards, Chinese phoenixes and dragons, which were also creatures of good luck, replaced the harpy and sphinx in the repertoire of the decorative arts.

173. North Syrian glazed dish showing a sphinx, 12th century. Ceramic with underglaze-painted decoration, diameter 7" (17.6 cm). Khalili Collection.

Mirrors, made of polished metal rather than of glass, also had magical associations and they were often used for magical purposes (FIG. 174), and commonly had magical or zodiacal imagery on their backs. According to a text ascribed to Jabir ibn Hayyan, mirrors made from a Chinese alloy called *kharshini* (copper, zinc, and nickel) could be used for the magical cure of eye diseases.

Magic cups had been used in Iraq and western Iran long before the coming of Islam. Magical texts were spirally written within the bowl and the purpose of such a cup was to catch a demon by suddenly turning it upside down. Sometimes the demon it was proposed to entrap was crudely portrayed on the bottom of the bowl. There was also a long tradition in Iran of cups and bowls used for divination, as well as magic medicinal cups. These bear inscriptions that invoke God and that boast that they offer the cure for scorpion stings, snake venom, the bite of a mad dog, difficult childbirth, nosebleed, and so on and so on. Such cups were probably owned by street-corner quacks who charged customers to drink water from them. It was common for these cups to carry claims that they had been made for some great Muslim ruler, though gross errors in entitulature give the lie to such claims (FIG. 175). Finally, a number of poison cups have survived dating from between the twelfth and fourteenth centuries. These were sometimes made of an alloy that reacted in the presence of arsenic. Alternatively, a bezoar stone might be set in the base in order to sweat out the poison. Celadon ware and jade were also thought of as alexipharmic (poison-averting).

While individuals might use magic mirrors and cups, magic might also defend whole cities. The dome of the royal mosque at the centre of al-Mansur's round city of Baghdad was surmounted by the statue of a horseman with a lance, and it was related that

174. An Egyptian magic mirror showing a seated ruler and jinns, with a central medallion of a mother and child, 15th century. Brass, diameter 4³/₄" (12 cm). British Museum, London.

Mirrors were sometimes used for the purpose of divination. Ibn Khaldun wrote about the *arraf*, diviners who gazed into mirrors or bowls of water. According to him, they "gaze at the surface of the mirror until it disappears." Then a white cloud appears and in that cloud they see the objects. However, this mirror was probably designed to protect the eyes of those gazing into it from disease.

175. A Syrian healing bowl allegedly made for Mahmud ibn Zanki, or "the son of Zangi," who was better known as Nur al-Din, ruler of Damascus from 1147 to 1174, 12th century. Brass, height 2¹/₂" (6.7 cm). Khalili Collection.

176. Lithograph of the walls of Konya's Citadel, from L. de Laborde, *Voyage en Orient*, I, 1839.

this horseman turned to point with his lance in the direction from which danger might threaten the city. Talismanic images and ancient statues were quite commonly displayed on the walls of Muslim cities, and it was hoped that their presence would help avert the attacks not only of foreign armies but also of diseases. A vast, headless statue of Hercules had pride of place in the magical defence of the Seljuq capital of Konya (FIG. 176). Additionally, a pair of carved winged jinn floated protectively over the main entrance to Konya's Citadel.

Egyptian mosques commonly made use of looted material (or *spolia*) from earlier Pharaonic buildings . It seems plausible that in so doing Muslim architects intended to put the supposed magical properties of Pharaonic artefacts in the service of Islam (while at the same time hinting at the supersession of the former by the latter). This practice could also be brought up to date. As the cities of the Crusader principalities fell one after another to the victorious armies of the Muslims, the churches and palaces were despoiled to adorn buildings in Egypt and Syria. The Gothic marble doorway of the Church of St. Andrew in Acre was taken to Cairo and incorporated into the *madrasa* (built 1295–1303) of the Mamluk sultan al-Nasir Muhammad. Here perhaps the purpose was not so much to provide talismanic protection as to commemorate victory and to proclaim the triumph of the Islamic faith over Christianity.

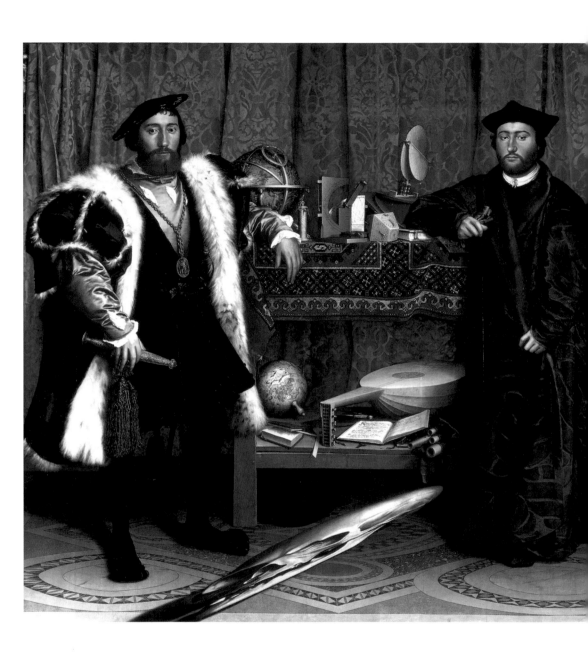

NINE

Beyond the Frontiers of Islam

I slamic regimes and Islamic art did not evolve within a self-contained environment. Both inside and outside the borders there were cultures and civilisations that influenced and were in turn influenced by developments in Islamic art and thought. The Middle East was composed of a multitude of overlapping worlds. Christians such as the Copts or Mozarabs lived and worked within Muslim frontiers. Jews or Armenians sometimes acted as the middlemen in material and cultural commerce. The Muslim world also exported artefacts to Western Europe. Not only did *mudejars* and Sicilian Arabs work for Christian markets, but craftspeople working in the great Muslim cities produced carpets, costumes, and all kinds of vessels that were specifically targeted at European markets. Chinese art had the greatest influence of all on that of the Islamic world. Here again the artistic traffic was not simply one way or on one level: Muslims did not just import or imitate Chinese luxury goods; they also attempted to improve on them. This penultimate chapter therefore will breach the frontiers of Islam both in the literal and geographic sense and in more metaphorical terms.

The "People of the Pact"

Unlike the pagan tribes, Christians and Jews were treated by the conquering Arabs as protected peoples, *ahl al-dhimma* (literally, "people of the pact"). As non-Muslims, Christians and Jews paid a special poll tax, but they were allowed to worship in their own way. In the early period Christians actually constituted the majority of the population throughout most of what we now think of as the Islamic lands. Many of the protected Christians

177. HANS HOLBEIN (1497–1543)
The Ambassadors, 1533. Oil on canvas, 6′9″ x 6′10¼″ (2 x 2.1 m). National Gallery, London.

The design of the carpet is based on largish octagons within squares and it must have been woven in Ottoman Turkey. In the variant small-pattern Holbein carpets, the octagons and enclosing squares are smaller. (An example of a small-pattern Holbein appears in Mantegna's *Madonna and Child Enthroned,* the centre panel of the St. Zeno altarpiece in Verona.)

under Muslim rule, particularly in Syria, were Orthodox, and regarded the Byzantine emperor and the Patriarch in Constantinople as the heads of their religion. However, there were other Christian churches under Muslim rule with large followings who differed in doctrinal and other matters from the Orthodox. Coptic Christians formed the overwhelming majority of the population of Egypt in the seventh century, and there were Christian communities in Armenia and Georgia, and others widely dispersed throughout Syria, Iraq, Iran, and Central Asia as far east as Mongolia and China.

Orthodox and Coptic Christian Art

Christians in most provinces of the caliphate converted to Islam, but the process was slow. Even when Muslims did become a majority in the various regions, there was still a tendency for certain trades and professions to be dominated by Christians, and much of the art and architecture that we classify as Islamic was actually the work of Christians. In the first century of Islam the Copts enjoyed a particular reputation as architects. When the Umayyad caliph al-Walid I (r. 705–15) wanted the mosque at Medina rebuilt, he summoned Copts from Egypt and Orthodox Christians from Syria to do the work. He also used them in Jerusalem and Damascus, and there are indications that Copts worked on the desert palaces of Khirbat al-Mafjar and Mshatta (in particular the striking carved vine decoration on Mshatta's exterior seems to have been done by Copts; see FIG. 69).

178. Coptic fragment of tapestry-woven textile, Egypt, 7th–8th century. Coloured wool and undyed cotton, 13⁷/₈ x 6³/₄″ (35.5 x 17 cm). David Collection.

Coptic weavers produced garments with abstract patterns too – there was a general tendency for designs to become more stylised and geometric in the Islamic period. Characteristic designs were based on long, narrow bands, fairly simple oval or square designs, and circular pieces.

After the downfall of the Fatimids, the political and economic status of the Christians seems to have declined somewhat, but they remained prominent in certain crafts. In the seventeenth century, the goldsmiths' guild in Cairo was predominantly Coptic Christian, as was that of the jewellers. Egypt was above all noted as a textile producer, and throughout the period covered by this book Copts dominated this industry. They were highly proficient in specific weaving techniques such as the flying shuttle, and large numbers of the tunics they produced have survived, many of them from excavations of Christian cemeteries. Some of the tunics feature religious imagery, but others are decorated with naturalistic representations of flowers or of mythological figures. The decorative vocabulary drew heavily on classical and pagan imagery, including Dionysiac figures, dancers, nereids, and conches (FIG. 178).

Artistic influence did not all run one way. Miniatures in Arab secular manuscripts of sages and doctors seem sometimes to have served as the models for Coptic portraits of evangelists. Indeed, by the twelfth century it is hardly possible to distinguish Coptic from Muslim work, as floral and geometric motifs invaded churches and what had formerly been distinctive Coptic art forms were slowly assimilated into the mainstream of what we call Islamic art.

There was an explosion of figurative imagery on objects in Syria, Iraq, and Anatolia in the twelfth to fourteenth centuries. To take a numismatic example first, in the twelfth century and the first half of the thirteenth, the Artuqids, a Turkish clan that ruled as a petty dynasty over towns in northern Syria, northern Iraq, and eastern Anatolia, began to mint bronze coins bearing figural imagery, some of which harked back to Roman and Sasanian prototypes. The heads of Roman emperors (FIG. 179) were copied with varying expertise. Astrological motifs, fantasies such as a man riding a serpent, and nomadic Turkish tribal branding marks, plus miscellaneous vaguely heraldic motifs such as the two-headed eagle, and even non-Muslim imagery, such as the enthroned Christ, were eclectically featured on the coinage of the Artuqids and their immediate neighbours. Part of the explanation for this phenomenon may be that the Artuqids and Anatolian Seljuqs ruled over a predominantly Christian population. Figurative Byzantine coinage had always circulated widely in the region and the Muslim rulers may have minted figural coins to meet the expectations of their subjects.

The neighbouring territory of the Ayyubids also produced some striking artefacts featuring Christian imagery, particularly in high-quality metalwork. A brass canteen now in the Freer Gallery

179. Artuqid coin featuring the head of a Roman emperor and an Arabic inscription. Bronze, diameter 1¼″ (3 cm). British Museum, London.

in Washington, D.C., is in the centuries-old pilgrim flask shape (FIG. 180), that is to say, it is round with a cylindrical neck. It was apparently produced around the middle of the thirteenth century. It features scenes from the Christian Bible, including the Annunciation, the Nativity, and the Presentation at the Temple – as well as more conventional secular imagery such as princely figures, jousters, musicians, and foliage.

There were still large numbers of Christians living under Muslim rule in Syria and Egypt in the twelfth and thirteenth centuries. Mosul in northern Iraq, which had been one of the Muslim world's leading centres for the production of metalwork, had a large Christian population, and around the time of the Mongol sack of Mosul in 1262 many of its craftworkers seem to have migrated into the Mamluk lands. So it is not surprising *per se* that the Freer canteen and similar objects should have been made for (presumably) Christian patrons. Some of the patrons could have been inhabitants of the Crusader states or visiting pilgrims. But other pieces are genuinely puzzling, such as the brass basin, formerly known as the "d'Arenberg Basin," which was made in Syria in the late 1240s (FIG. 181). The basin is decorated with hunting and battle scenes, but also five scenes from the life of Christ, framed within polylobed medallions. Thirty-nine monastic and saintly-looking figures with haloes are portrayed on the interior of the basin. Yet its inscription dedicates the basin to al-Salih Ayyub, the sultan who ruled over Egypt from 1240 and Damascus from 1249 onwards, and it celebrates his prowess as a leader of the *jihad* (in the context of the time, the holy war against the Christian Crusaders). He is praised as the defender of the faith, the warrior of the frontiers, the conqueror, and the victor. Here it is worth bearing in mind that Jesus is accorded the status of a prophet in Islam, so perhaps his appearance on the basin should really be seen as an example of Muslim iconography.

180. The Freer pilgrim canteen, Syria, mid-13th century. Brass, diameter 14½" (36.9 cm). Freer Gallery of Art, Washington, D.C.

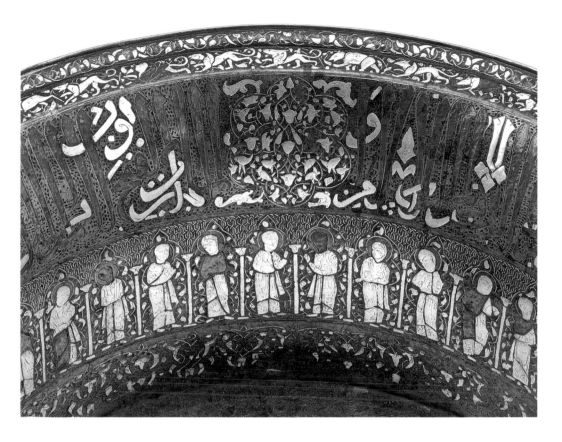

Certainly, not everything that looks Christian in Islamic art is intended to have a Christian significance. Haloes were commonly used in Muslim miniatures and decorative designs, not to indicate sanctity, but simply to emphasise the head of a figure and set it off from the background. A thirteenth-century Arab *Maqamat* shows the rogue Abu Zayd with a halo (FIG. 182), for example.

181. Detail of the interior of the so-called "d'Arenberg Basin," showing what appear to be Christian saints, Syria, c. 1240s. Brass inlaid with silver, height 9" (23.3 cm). Freer Gallery of Art, Washington, D.C.

182. A miniature from a copy of al-Hariri's *Maqamat*, showing Abu Zayd and two camel-riders with haloes, probably from Iraq, 13th century. Illuminated manuscript, 3⅝ x 7⅜" (9.2 x 18.8 cm). Bibliothèque Nationale, Paris.

Abu Zayd's halo here is purely for decorative effect.

Beyond the Frontiers of Islam 217

Armenian Christian Art and Architecture

Armenians, like Copts, prospered under the Fatimid caliphs in Egypt. Badr al-Jamali, the vizier who was effective ruler of Egypt from 1073 until 1094, was an Armenian. It was during his rule that the fortified gateways of medieval Cairo were rebuilt by three Armenian architects summoned from Urfa (FIG. 183). Armenians were noted specialists in building in stone. The shapes of their buildings and their decoration exercised a decisive influence on Seljuq architecture in Anatolia from the twelfth century onwards (FIGS 184 and 185). The conical roofs on tall drums that are characteristic of Armenian churches reappear on Muslim tomb towers. The characteristic layout of the Seljuq caravanserai had Armenian precedents. Armenians also wove high-quality textiles. Their carpets and other textiles were especially prized by the Abbasid court, and in this early period when someone wanted to praise an Iranian carpet it was common to do so by likening it to an Armenian carpet. Long after the heyday of the Abbasids, the thirteenth-century explorer Marco Polo believed that the best and finest carpets were woven by Armenians and Greeks.

183. The Bab al-Futuh (Gate of Deliverance), Cairo, 1087. Its stonework was far in advance of other Cairene buildings, which were mainly of brick.

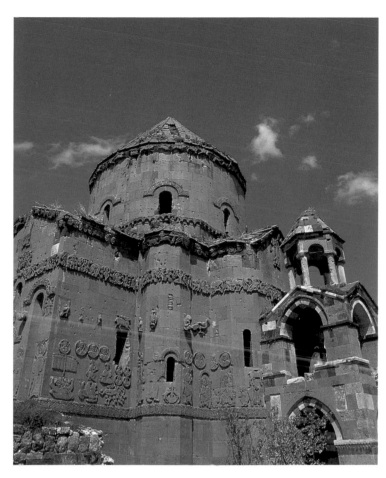

184. Detail of the exterior of the Armenian church of Aghtamar, Lake Van, Turkey, 10th century.

Armenian churches were decorated with exterior sculpture, a practice also imitated in Seljuq Anatolia. David and Goliath, among other biblical figures, may be seen.

185. Vegetal sculpture of the Seljuq school on the Çifte Madrasa, Erzerum, Turkey, begun 1253.

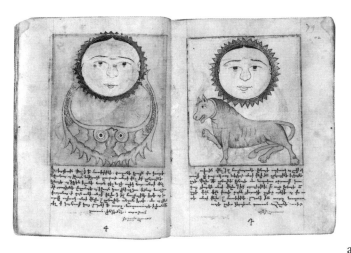

From the early sixteenth century onwards there was a renewed dispersal of Armenians throughout the Islamic lands as Ottoman Turkish and Safavid Iranian armies fought one another and ravaged the towns and countryside of Armenia. In 1605, after Shah Abbas decided to turn eastern Armenia into a depopulated defensive zone, large numbers of Armenians were forcibly resettled in a special suburb of Isfahan known as New Julfa (FIG. 186). (Jesuit and Carmelite missionaries as well as the occasional European craftworker also resided there, providing a possible conduit for influence of the techniques of European painters and of Christian iconography on Iranian art.) New Julfa became the centre of Iran's luxury crafts and trade. Armenians were prominent as goldsmiths and silversmiths, and above all Armenian merchants constituted a commercial elite that dominated both production of silk textiles and their export – for example, Armenians ran the overland silk caravans from Central Asia to Damascus and Smyrna (modern Izmir).

As late as the fifteenth century Christians were probably still in a majority in Asia Minor and this was certainly the case in territories ruled over by Ottoman sultans in the Balkans. Whether Orthodox, Coptic, or Armenian, the Christian population made a significant contribution to Ottoman art and architecture and it has been estimated that out of the 3,523 craftsmen who worked on the Suleymaniye Mosque in Istanbul, 51 per cent were Christian.

186. The colophon of an Armenian magical miscellany, 1610. Illuminated manuscript, $9^7/_8$ x $6^7/_8''$ (25 x 17.5 cm). British Library, London.

Armenian artists and craftworkers played a vital role in the Safavid and Ottoman empires. Christian forms and techniques influenced Islamic ones and vice versa. This particular Armenian magical compendium was probably written in Constantinople, and is modelled on Turkish astrological and magical works, though the technique of illustration is distinctively Armenian.

The Jewish Community and Islamic Art

It is less easy to present a similar account of the various aspects of the Jewish contribution to Islamic art. The Jews shared the Muslim prejudice against figurative imagery in art and it is usually impossible to point to distinctively Jewish imagery on textiles, metal, or glass. However, textual sources make it clear that Jews were extremely prominent in all these areas. We know that in Fatimid Cairo Jews were heavily involved in goldsmithing, glassblowing, weaving, and dyeing. In fourteenth-century Fez they were prominent in damascening metalwork, goldsmithing, and silversmithing. In Isfahan, Jews were engaged in dyeing and embroidering textiles. They played a major role in glass production in

the Levant. Benjamin of Tudela, who visited Tyre in 1163 (when it was part of the Crusader Kingdom of Jerusalem), reported that the city contained four hundred Jews who were involved in glassmaking and ship-owning. In the fifteenth and sixteenth centuries many Jews fled Christian persecution to settle in the Ottoman lands. Mehmed II encouraged them to come and settle in underpopulated Istanbul. Other Jews set up textile workshops in Palestine. Business partnerships between Muslim and Jew allowed businesses to function continuously without regard to religious holidays. Inevitably, Islamic art also exercised an influence on such things as Jewish manuscript illumination and synagogue architecture. Moreover, the influence of Islamic art forms was not restricted to Jews living in Islamic territory; it also extended to the Jewish communities within Christendom, and Jews, particularly Spanish Jews, were often transmitters of Arab sciences and arts to the medieval West.

Spain

Spain, Sicily, and southern Italy were the main channels for the influence of Islamic art and architecture in the West. An Islamic art in exile continued to evolve outside the frontiers of Islam and to produce supreme pieces in the territories to the north. Although the Muslim territory in Spain was confined to the southern region of Granada by the second half of the thirteenth century, nevertheless Muslim *mudejar* craftworkers continued to be employed in the territories that the Christians had reconquered. To take one example, *mudejar*s were largely responsible for the Alcazar palace in Seville (a city that had passed into Christian hands in 1258). In 1364 Pedro the Cruel of Castile ordered the building of this palace on the site of a largely demolished earlier palace. He recruited plasterers and carpenters from the Muslim capital of Granada as well as from Toledo. The general effect achieved is that of an Islamic palace in which richly decorated halls lead off from open courtyards. Multi-lobed and horseshoe-shaped arches frame the entrances to the halls, with stone carved like lacework (FIG. 187). Stucco and glazed tiles arranged in geometric tesselated patterns covered the surfaces of the walls. Columns and capitals were looted from the ruined Umayyad palace of al-Madinat al-Zahra and there are indeed indications that the *mudejar*s were consciously seeking to emulate the features of the old Umayyad palace. Kufic inscriptions both proclaim that "Allah alone is Conqueror" and celebrate the magnificence of Pedro. Carpet- and silk-weaving (FIG. 188) was another outstanding area of *mudejar* achievement. As with ceramics, heraldic shields sometimes appear in the midst of oriental patterns.

Overleaf
187. An interior courtyard of the Alcazar palace, Seville, begun 1364, showing Moorish arches and other details produced by *mudejar* craftworkers.

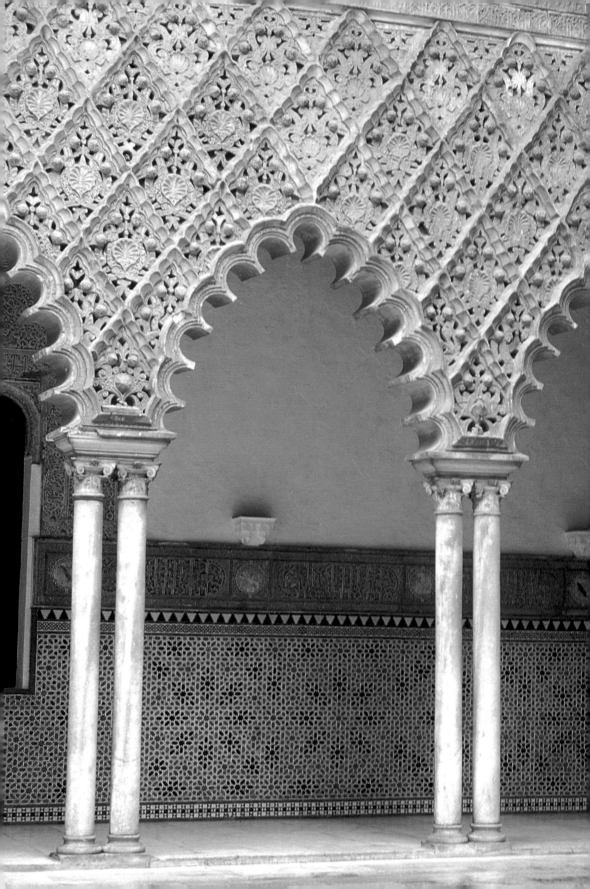

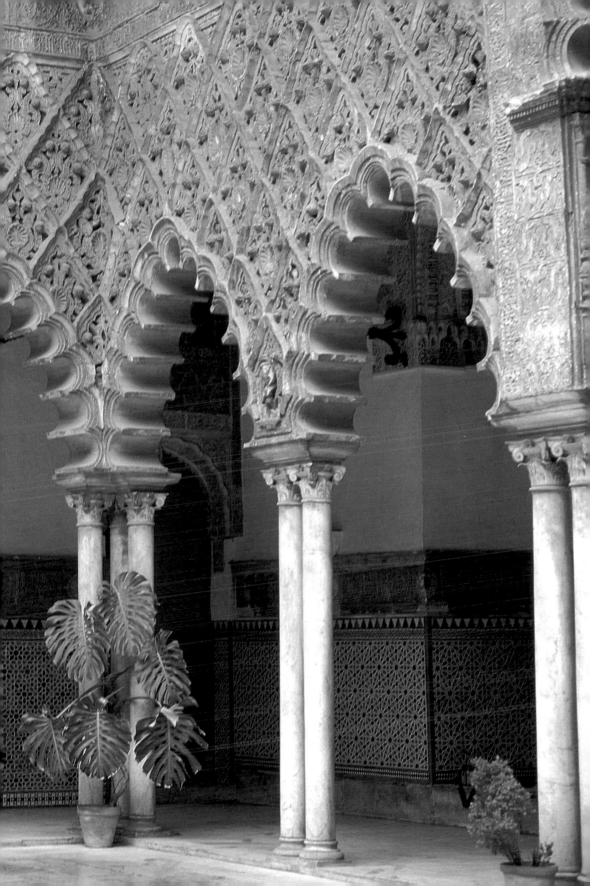

188. A fragment of Spanish coloured silk, 14th–15th century. 14⅛ x 21⅝" (36 x 55 cm). David Collection.

189. Hispano-Moresque dish from Valencia, 1450. Lustreware, diameter 18²/₅" (46.3 cm). British Museum, London.

The glaze and lustre techniques spread from Spain to Italy, and ultimately majolica too evolved from Hispano-Moresque ware. (The Medicis in Florence are known to have collected Hispano-Moresque lustreware.)

Besides *mudejar*s, Mozarabs (Christians who lived under Muslim rule) also carried with them memories of southern Spanish architecture when they migrated north to Christian lands. Islamic decorative themes and techniques were adopted wholesale even in parts of Spain that were far from Muslim Andalusia – for example, the Cistercian nunnery of Las Huelgas de Burgos in northern Spain, where the cloisters are decorated with stucco in the Islamic manner, with peacocks shown in an arabesque setting, as well as with Kufic inscriptions and floral scrolls. In ceramics also, Muslim techniques and traditions continued to develop in Christian Spain. From at least the fifteenth century onwards the finest lustreware, the so-called Hispano-Moresque ware, was produced in Manises near Valencia (FIG. 189). Although the techniques of lustre, painting cobalt in glaze and the use of tin glaze, as well as many of the basic designs, were all of Middle Eastern origin, nevertheless there was an increasing infiltration of Christian heraldic and other European figurative themes.

Sicily

Sicily had been ruled by the Muslims from 826 and the mainland of southern Italy came under their rule from 901 onwards. Then in

the course of the eleventh century Norman adventurers slowly conquered Apulia, Calabria, and Sicily. A mixed culture flourished under the Norman Hauteville dynasty, in which Greeks as well as Arabs played an important part. Although the basic structures of the cathedrals at Cefalu (1131) and at Monreale (c. 1174) are Western in shape (as best befitted the liturgy that was celebrated in them), nevertheless aspects of the decoration are unmistakably Islamic. Similarly, the twelfth-century Zisa palace in Palermo, with its *muqarnas*, its roundels with trees and peacocks, and its Kufic inscriptions, is purely Islamic in inspiration; and the honeycombed ceiling of the nave of the Palatine Chapel, built in 1132–43 (attached to the much-rebuilt Royal Palace), is a sort of encyclopedia of Fatimid painting in exile, richly decorated with figures and arabesques, framed by octagonal stars (FIG. 190).

The Muslim textile industry continued to flourish for a while under Christian rule and the Norman kings kept a silk workshop attached to the palace. The silk mantle of Roger II of Sicily, woven in 1133 or 1134, was made in the royal treasury

190. A scene at a wall fountain, from a ceiling panel in the Palatine Chapel, Palermo, 12th century.

or workshop (*khizana*). It features two tigers savaging a camel (FIG.
191).

Trade: Textiles and Metalwork

Medieval Sicily under the Normans and later the Hohenstaufen
continued to be a major producer of decorated silks. But the influ-
ence of Muslim textiles on Western Europe ran much wider
than that. Consider that the words alpaca, blouse, camelot, chif-
fon, cotton, damask, mohair, muslin, and satin all derive from Ara-
bic words or place names and have all passed into the English lan-
guage. Many of the oldest Islamic textiles to have survived have
done so because they were preserved in Christian churches where
they were used as hangings, copes, and so on. Muslim textiles were
treated as objects of prestige throughout Europe. Quattrocento
Tuscan painters such as Fra Angelico and Gentile da Fabriano repro-
duced Islamic fabrics in their paintings when they wanted to
suggest status or wealth. Islamic metalwork, including weaponry,
was also prized in Western Europe, and specific examples of Islamic
calligraphy, patterns, and ornamentation occur throughout West-
ern art.

Oriental carpets became favoured props in European painting
from the Renaissance onwards. Venice seems to have been the chief
point of entry for these luxury objects and the richness of Venet-
ian painting in the fifteenth and sixteenth centuries, with its
profusion of reds and golds, certainly owes much to the pres-
ence in them of Turkish carpets, which hang from windows, cover
tables, or are strewn over marble floors. One of the best-known
examples of the carpet in art is in Hans Holbein's painting *The*

Ambassadors (1533; FIG. 177, see page 213), where the two ambassadors stand in front of a table covered by a carpet with a striking geometric design, known as a large-pattern Holbein, precisely because it appears in this painting. Other types of Middle Eastern carpet have also been named after the painters in whose works they appear, though these labels are becoming obsolete. Thus, a "Lotto" carpet is more correctly known as an arabesque Ushak, and a "Bellini" is a particular type of Ottoman rug with an infolding of the inner border. In some cases, painters may have owned the carpets they painted, as such things could serve both as artists' props and as investments.

On the evidence of paintings, it would seem that Persian carpets only entered Europe in any numbers in the seventeenth century. Perhaps the latter development reflected growing European trade links with Iran via the Gulf. Alternatively, it may be that the more fluid lines of these carpets, which relied more on floral designs than strict geometry, consorted better with the Baroque taste of the age. Despite the Eastern provenance of the carpets, they do not seem to have been regarded as specifically exotic.

Although it was certainly not unknown for carpets to be used as floor coverings, this was rare until the eighteenth century. Egyptian Ottoman carpet-weavers produced round and cross-shaped carpets, which appear to have been designed specifically for Western tables. It seems likely that whole categories of carpet, such as the arabesque Ushak, were produced primarily for export to Europe. Carpets were also produced to be given as gifts to ambassadors – for example, the Polonaise carpets produced in seventeenth-century Iran. Since carpets were expensive to import, their designs were copied in England and elsewhere, and English manufacture of imitation small-pattern Holbeins began in the late sixteenth century.

It seems likely that many of the finest pieces of Mamluk metalwork were produced for export to Europe. As with carpets, much of the metalwork passed through Venice, and it seems that under market pressure from Europe new shapes were created in the Middle East. In the fifteenth century a lot of metalwork, intricately decorated with scrolls and arabesques, produced in western Iran by Mahmud al-Kurdi and others, was exported to Europe. The decorative style of this sort of Iranian work was copied by craftworkers in northern Italy and adapted to Western shapes of vessel. As was the case with carpets, European craftworkers also set to imitating the shapes and designs of Eastern metalwork. Venice, which took a leading part in producing metalwork in the Islamic

style, also began from the thirteenth century onwards to compete with Egypt and Syria in the production of enamelled glass.

Trade: Ornament and Pattern

Textiles and metalwork often carried calligraphic inscriptions and these caught the eyes of European artists and designers. Thus, it is quite common to find Arabic, or pseudo-Arabic, appearing on Renaissance artefacts. For example, the border of the tunic and greaves on Verrocchio's statue of *David* is decorated with mock-Arabic (FIG. 192). The Arabic script, which was not intended to be deciphered, was used purely decoratively. Indeed, in most cases the inscription is gibberish, the letters being joined in nonsensical ways. The technical term for this is Kufesque. Examples of Kufesque are also found in the decoration of medieval English and French manuscripts and enamels. Occasionally, however, the artist would make an accurate copy of Arabic, so it is not unknown for a painting or other object designed for use in a church to bear the Muslim declaration of faith – "There is no God but God and Muhammad is His Messenger."

192. ANDREA DEL VERROCCHIO (c. 1435–88)
David, 1473–75.
Bronze, height 49¼ (125 cm).
Museo dello Bargello, Florence.

The mock-Kufic ornamentation on the tunic border over his shoulder is clear.

During the Renaissance the Roman ornamental system known as the grotesque was rediscovered and this was combined with Eastern arabesques and knot designs. Thanks to various types of craft manual and pattern-book, knot designs became pervasive and appear on textiles, bookbindings, and interior decoration. Stylised plant forms in a drop repeat pattern also became popular from the sixteenth century onwards. Pomegranate and ogival patterns appearing on textiles probably also derive from Islamic exemplars.

The influence of Islamic art and architecture on the West ran wider than one might at first suspect. From the twelfth century onwards church facades

and other decorative details became more ornate and Romanesque buildings in France and elsewhere made use of such Islamic features as polylobed, pointed, horseshoe, and cusped arches, as well as rib-vaulting, polychromy, and rolled corbels. Often such features appear on churches that were on the pilgrim route to Compostela in Spain. Returning Crusaders may also have carried back to Europe memories of Muslim architecture. Writings in Arabic played an even greater part in the shaping of Western culture and it is impossible to think either of the twelfth-century Renaissance or of Scholasticism as developing in the way that they did without considering the earlier contributions made by Arab scholars and translators, particularly in the fields of science – one thinks of Ibn Sina (Avicenna; 980–1037), whose medical treatise was translated into Latin in the twelfth century and was the most important text for medical teaching in the West for three centuries – mathematics, and philosophy (and from the eighteenth century onwards *The Thousand and One Nights* exercised a vital influence on European and American fiction). This is a subject to which we will return at the end of this chapter, in considering the influence of Islamic art on that of the West up to the present day.

Islamic Art and the East: India

In 896 a brass statue of a four-armed Hindu goddess was brought from India to Baghdad. According to al-Masudi in the early tenth century, "the people nicknamed the idol *Shughl* – 'A Hard Day's Work' – because everyone stopped what work they were doing to go and see it during the days it was on view." But though carved and painted Indian idols may have fascinated the Muslims, their influence on Islamic art was inevitably slight. Even so, the protruding eye of western Indian painting of the eleventh and twelfth centuries and the pendant leg posture of seated Indian idols resurface in illustrated Arab manuscripts of the thirteenth century. Indian textile designs exercised a more pervasive influence. The Iranian scholar al-Thalabi (d. 1038) refers to the excellence of Indian velvets, and Indian dyed cloths were extremely popular in Mamluk Egypt. As regards cultural commerce in the other direction, the establishment of Muslim dynasties in India, beginning with Mahmud of Ghazna's invasion in the early eleventh century and culminating in the establishment of the Mughal dynasty in northern India in the early sixteenth century, imposed an Islamic and more specifically a Persian visual culture on large parts of India (FIG. 193).

193. The princes of the House of Timur in a Kabul painting, c. 1550–55. Gouache on gauze cotton, 42³/₄ x 42¹/₂″ (108.5 x 108 cm). British Museum, London.

A painted wall hanging in the Timurid Persian (though not Iranian) tradition. Humayun, son of Babur, the famous founder of the Mughal dynasty, ruled Delhi from 1530 to 1540 and again from 1555 to 1556. The painting probably originally showed Babur holding court, but it was subsequently added to and tampered with, so that it became a sort of group portrait of the Mughal dynasty in India. It was probably first painted by artists who had migrated from the Safavid court of Tahmasp.

Islamic Art and the East: China

All the cultural traffic that may have existed between Islam and Christendom and Islam and India (and for that matter between Islam and sub-Saharan Africa) shrinks by comparison when one comes to consider the range and scale of Islam's contacts with China. The Chinese emperor was recognised by the Arabs as being one of the great rulers of the world (he is portrayed as such in one of the frescoes of the Umayyad desert palace at Qusayr Amra in Jordan), and without trade with China, particularly in ceramics and textiles, and the influence of Chinese motifs, technology, and artistic styles, Islamic art would never have evolved as it did. Examples must be limited here, so this section will look at only some of the most important exchanges between China and the major dynasties of the Islamic world.

Early Contacts

Ceramics and textiles, China's most admired products, were exported to the West by overland caravan routes, the chief of which ran through eastern Turkestan to the high Pamir passes, down to Samarqand and Balkh (FIG. 194). The Battle of Talas, near Samarqand, in 751, where an Arab army defeated the mostly Turkish troops in the service of China, led to the rise of a Tibetan empire, which cut off direct overland communication between China and the Islamic lands for centuries to come.

Despite the military confrontation between Muslim and Chinese armies and despite the contraction of Chinese frontiers, maritime trade between Tang China and the Gulf ports of the Abbasid caliphate flourished, albeit intermittently. (The battle itself had most importantly led to the capture of Chinese papermakers, who were used to set up a papermaking industry in Samarqand; by the early eighth century the technology of papermaking had spread to Baghdad.) The late seventh and early eighth centuries saw a fashion for Chinese silver vessels and decorated glass in the Muslim world, and by the early ninth century half the population of the Chinese port of Guangdong (Canton) was in fact Muslim. Even the massacre in 878 of the merchant colony in Guangdong did not prevent the continuing growth of trade between the Middle East and China, through ports on the Malay coast and elsewhere.

194. The transport of Chinese porcelain in an Aqqoyunlu Turkoman scroll fragment, late 15th century. Silk, 9⅞ x 18⅞" (25 x 48 cm). Topkapi Saray Museum, Istanbul.

During the 15th century vast amounts of Chinese porcelain were exported to the Islamic world. Although probably executed in western Iran at the time that it was ruled by the Aqqoyunlu Turkomans, this image (actually of part of a wedding procession) not only shows Chinese people and Chinese blue-and-white ware in a cart, but also clear signs of Chinese influence in the artist's treatment of landscape. This is one of the album pictures classified as "Siyah Qalam."

After 960 the xenophobic Tang dynasty in China was ousted by the Song, who encouraged Muslim merchants not only to resettle in Guangdong but also to move into other cities. Moreover, for the first time Chinese traders competed with Arabs and Iranians in the Indian Ocean trade. Islam was so much the religion of international trade in the region that many Chinese converted to it (FIG. 195). Around the year 1000 the trade route began to shift from the Gulf to the Red Sea, with the Fatimid caliphate in Egypt being an important beneficiary.

The inventory of treasures of the Fatimid caliph al-Mustansir (1036–94), already mentioned in the context of palace life, includes objects that are of overtly Chinese provenance: a multitude of large porcelain pitchers of all colours, filled with camphor from Qaisur (Sumatra); a porcelain buffet supported by three legs and equipped with platters, each of which could hold 220 *ruks* (= 9 lbs, or 4 kg) of meat; great vats designed for washing clothes, each of which was supported on three legs depicting all sorts of animals (and each

195. The *mihrab* of the Mosque of the Immortal Crane in Yangzhou, China, c. 1275.

worth 1,000 dinars); a multitude of cases filled with porcelain eggs of the shape and whiteness of real eggs. In 1038 al-Thalabi wrote that:

> The Arabs used to call every delicately or curiously made vessel and suchlike, whatever its real origin, "Chinese," because finely made things are a speciality of China. The designation "china" has remained in use to this day for the celebrated type of dishes. In the past, as at the present time, the Chinese have been famous for the skill of their hands and for their expertise in fashioning rare and beautiful objects. The Chinese themselves say "Except for us the people of the world are all blind – unless one takes into account the people of Babylon, who are merely one-eyed."

The Mongols

The Mongol invasions of the Middle East and of China in the thirteenth century brought Chinese and Islamic culture closer together than ever before. Chinese scholars, administrators, and craftworkers followed their Mongol rulers into the Muslim lands. The *Pax Mongolica* and the relative safety of the overland trade route under Mongol control led to increased quantities of Far Eastern textiles arriving in western Asia. Such textiles were not just of importance in themselves but also for the designs they carried, which were copied by Muslim craftworkers in other media. Such was the popularity of Chinese textiles that some Muslim potters strove to get a textile effect in the decoration of their pots, hence the appearance of what are essentially striped and panel designs from textiles, as favoured by the Mongol elite, on Iranian and Syrian pots. From the late fourteenth century onwards, as a result of Timurid diplomatic contacts, a new wave of Chinoiserie motifs circulated throughout the Muslim lands and, to some extent, the International Timurid style can be understood as a fusion of traditional Muslim designs and new Chinese decorative, mostly floral, motifs.

Chinese Imagery and Mamluk Art

Although relations between the Mongols and the Mamluk sultans were initially hostile, after the Peace of Aleppo in 1322, trade flourished once more and, doubtless as one of the consequences, distinctively Chinese imagery begins to appear on Mamluk metalwork and ceramics. Thus Muslim artists based new designs on the Chinese lotus, but they did not understand that the lotus was a plant that grew in water and they turned it into a fantastic flower (FIG. 196). The craze for Chinese things in the Mamluk lands

196. A large Egyptian or Syrian basin with Chinese lotus-flower decoration, early 14th century. Brass inlaid with silver and gold, diameter 21⅛" (53.6 cm). British Museum, London.

Other motifs adopted but misunderstood by Mamluk ceramists include the dragon, the benign bringer of rain as well as the image of the emperor in Chinese art. Muslim dragons, even when they look like Chinese dragons, are fierce and nasty creatures. Chinese cloud bands or scrolls also appear in Iranian paintings and carpets, but Muslim artists were not aware of the way the Chinese discriminated between cloud, flame, and mushroom scrolls, and used them indiscriminately.

persisted throughout the fifteenth and early sixteenth centuries, and the penultimate Mamluk sultan, Qansuh al-Ghuri (r. 1501–16), possessed a fine collection of celadons. Like the Timurids, the Mamluks both imported Chinese ceramics and imitated them. Muslim potters produced imitations of blue-and-white ware, which began to appear in Syria at the end of the fourteenth century. However, they were not content just to copy the Chinese products. Again, they adapted Chinese motifs (among them the lotus, peony, chrysanthemum, and floral scroll) to un-Chinese panel layouts and they added extra colours.

Safavid Iran and Chinese Blue-and-White

The Safavids, who followed the traditions of their Timurid and Turkoman predecessors in so many things, maintained the cult of things Chinese. Shah Abbas (r. 1587–1629) owned a splendid collection of blue-and-white, celadon, and polychrome ware. Imitation blue-and-white ware dominated ceramic production in Safavid Iran, and here also stock Chinese images underwent curious transformations at the hands of Iranian artists. So Chinese sages became Safavid poets with wine bottles and the *contrapposto* pose favoured by the Chinese was taken up by mooning Iranian lovers. Chinese designs were also applied to such an intrinsically un-Chinese object as a *hookah* (a tobacco pipe that uses a ceramic vase containing water; FIG. 197).

197. A *hookah* base, south-east Iran, 17th century. Ceramic, height 6⅓" (16.2 cm). It is decorated in the Chinese style. British Museum, London

Ottoman Turkey and "Chinoiserie"

The Safavid enthusiasm for late Ming export ware of the sixteenth and seventeenth centuries and their readiness to imitate it is in contrast to the way things developed in Ottoman Turkey. The Ottoman sultan Selim I acquired a lot of china as a result of the Battles of Caldiran (1514) and of Raydaniyya (1517). Today the Topkapi collection in Istanbul, the legacy of centuries of Ottoman acquisitions, includes 1,300 celadons and 2,600 pieces of Ming ware. The court dined on Chinese porcelain; others had to make do with

local products, including imitations of true china. But the earliest Iznik pots tended to be modelled on examples of Turkish metalwork rather than on any ceramic prototype. Only from the 1520s onwards, in the wake of the looting of the Safavid and Mamluk porcelain collections, did the potters at Iznik seriously study the Chinese porcelains. What they tended to copy were not contemporary exports, but choice pieces that had been hoarded for decades or even centuries, so their copies often had a rather antiquarian flavour.

The Turks were also less prepared than the Iranians to accept Chinese designs and shapes, and took even greater liberties with the originals. It is indeed difficult to mistake blue-and-white Iznik ware for Chinese blue-and-white – most crucially, the decorators of Turkish pots had a far wider range of colours than was available to the Chinese. In the long run, Iznik ware absorbed what it wanted from the Chinese competition, and developed independently.

198. Detail of *Hatayi*-style ink drawing from an album of the Ottoman sultan Murad III (r. 1574–95). Ink on paper. Österreichische Nationalbibliothek, Vienna.

Chinoiserie motifs also appeared and were adapted on Ottoman metalwork, album pictures, and silks (FIG. 198). Designs, currently referred to as *chintamani*, frequently feature on Ottoman textiles (FIG. 199) and other objects, such as Iznik jugs, in the fifteenth, sixteenth, and seventeenth centuries. The pattern consists of repeated regular sets of three balls arranged in a pyramid, and sometimes these little pyramids are underlined by pairs of wavy "tiger-stripe" lines. It is widely accepted that *chintamani* has a Chinese Buddhist origin and that the original image is of three pearls borne on the waves of the sea, signifying good fortune. However, tracking down its original meaning in China does not mean that we

199. *Chintamani* designs on an Ottoman velvet brocade, 16th century. 37³/₈ x 44⁷/₈″ (95 x 114 cm). David Collection.

have understood its meaning in Ottoman Turkey. In Ottoman art the balls look more like planets than pearls (sometimes, indeed, they appear as closed crescents), while the stripes do not resemble the waves of the sea. The three balls might be taken as referring to the crescent moon which, from the fourteenth century onwards, became the emblem of the Ottoman dynasty. (All the same, though such an association seems eminently plausible, the three-circle design appears as early as the ninth century on Iraqi pottery.) Some scholars interpret the circles as leopard spots. The Ottoman Turkish term *pelengi* (leopard-like) refers to some kinds of design found on textiles. As for the tiger stripes, they have strong associations with heroism and vigour and, most specifically, with Rustam, the greatest of the heroes of the *Shahnama*, who is almost invariably portrayed wearing a tiger-skin. Yet it is still, of course, quite conceivable that when an Ottoman Turk looked at the *chintamani* design, Rustam or Timur or Buddhist jewellery did not come to mind because the pattern was just part of the background of everyday life.

The Influence of Chinese Ceramic Technology

The response in Islamic art to Chinese ceramics was certainly not limited to imitation or the influence of certain motifs.

Muslim development of frit technology in the eleventh century was in response to the new delicate and translucent Chinese porcelain of the Song dynasty then being first imported. According to al-Thalabi, the most favoured colour in these new wares was "apricot." This is at first sight puzzling. However, apricots growing in the region of Damascus were greyish-green in colour, so perhaps al-Thalabi was referring to celadon ware. This was the great age for the production of celadon – a porcelain with a greyish-white body and a thick translucent glaze varying from greyish-green and bluish-green to sea green (FIG. 200).

Above all, Muslim potters, desirous of emulating Chinese ceramics, developed the use of tin glaze (FIG. 201) to get an effect of whiteness that corresponded, however poorly, with that achieved by Chinese porcelain through use of kaolin and high firing temperatures. This white tin-glazed and decorated ware, such as Iznik, is now seen as almost more characteristic

200. Large Iznik dish of the Ottoman period, c. 1530–50. Underglaze blue decoration on ceramic, diameter 15½″ (39.4 cm). Khalili Collection.

The three bunches of grapes in the centre of this early Iznik piece are after a Chinese Ming-dynasty prototype.

of Islamic art than any other product and was in turn hugely influential on European ceramics and ceramic technology. Indeed, the very idea of decorating pottery with painted designs seems to have begun in the Middle East and was only later imitated in China. It is not just a matter of artistic techniques and motifs flowing downhill from China into the Islamic world. In the early fourteenth century the Chinese were learning from Muslim ceramic technology. They took to importing cobalt ore from the Muslim lands and painting cobalt under a glaze, just as Iranian potters did. Chinese weavers also copied Arab striped silks and went on to produce them for export to Egyptian and European markets.

Chinese Painting and the Decorative Arts

The Mongol elite in China and Iran were keen on Chinese paintings (particularly ones featuring horses) and they collected them avidly. It is evident from what Iranian painters produced that they also saw and studied Chinese scroll paintings. Manuscripts from this period might be painted in a mixture of Arab and Chinese styles and follow the Chinese calligraphic style of rendering trees and rocks. Characteristically Chinese features in Islamic painting include an emphasis on landscape, a calligraphic style of brushstroke, linearity, subdued colouring, and the imitation of the Chinese way of rendering vegetation, clouds, and water. (The grass is feathery, the trees are gnarled, the clouds are long and ragged like dragons' tongues.) As has been mentioned, Iranian painters also copied the Chinese use of the line of the frame to cut off the tops or the sides of things, so as to suggest that a scene extended beyond the edges of the painting.

Muslim painters in general marvelled at the Chinese skill in portraiture. The traveller Ibn Battuta, who visited (or at least claimed to have visited) China in the 1340s, described his astonishment in coming across portraits of himself and his companions in correct Iraqi dress on display on the walls and in the markets of some Chinese towns in no time at all after their arrival. He was told that the Yuan emperor had ordered that portraits should be made of foreigners in case they tried to leave the country without authorisation – an instance of the underlying xenophobia of the period of the Yuan dynasty (1279–1368).

The impact of closer contacts between China and Timurid Central Asia can be seen in such diverse aspects as a craze for jade-

201. A tin-glazed bowl with blue decoration, Iraq, 9th century. Earthenware, diameter 8¹/₄″ (20.9 cm). Khalili Collection.

carving, as well as Muslim attempts to imitate on wood or stone the style of carving that the Chinese had pioneered for working in lacquer. The Chinese were also especially esteemed for silks, felts, steel mirrors, and talismanic amulets.

The Return to the West: Islamic Art in the 18th and 19th Centuries

In the post-Renaissance period, Western painters sometimes included Islamic costumes and headgear in their paintings in order to create a wilfully exotic effect. The presence of an interlace design or an Ottoman carpet is most unlikely to represent a considered reference to Middle Eastern culture. In the eighteenth century this changed. European travellers visited Muslim territories more frequently and a visit to the Levant was sometimes added to the conventional Grand Tour.

Serious engagement with the key elements of Islamic art came with the French military expedition to Egypt in 1798, and the various publications subsequently produced by Bonaparte's team of scholars helped familiarise the West with Egyptian art and material culture generally. British possession of India also increased interest in Muslim and Iranian culture, but Spain was the closest source of Islamic inspiration. The design theorist Owen Jones (1809–76), having published an influential study of the Alhambra and its decoration, went on in 1856 to publish *The Grammar of Ornament*. He stressed the need for ornament to have a geometric basis and proclaimed that Muslim artists were responsible for some of the world's finest achievements in this field. The work of Jones and others at the Great Exhibition in London in 1851, especially in its Alhambra Court, did a great deal to popularise characteristically Islamic uses of pattern and colour.

London's Victoria and Albert Museum, which opened in 1857, also played a part in introducing the British public to oriental artefacts, especially textiles. Its oriental carpet collection was started in 1876, and in 1893 it acquired the large and spectacular Ardabil carpet, largely through a public subscription organised by William Morris. Morris also took a leading part in adapting Islamic decorative motifs for use in Western interiors. British men like F.

202. Turkish Iznik dish made for European export, c. 1580. Fritware, diameter 14³/₈" (36.5 cm). British Museum, London.

203. WILLIAM DE MORGAN
Panel of tiles with an
Islamic-inspired central
motif, 1888–97. Private
collection.

du Cane Godman and George Salting were leading collectors of
Iznik ware and Andalusian lustreware, and their collections
were to end up in public museums. William de Morgan carried
out experiments to reproduce and adapt the techniques used for
Iznik ware (FIGS 202 and 203) and, having mastered these, went on
to research the techniques used by Muslim potters for lustre-
ware. In the twentieth century, artists as different as Dulac –
who illustrated the *Arabian Nights* and the *Rubayyat of Omar
Khayyam* – Kandinsky, Matisse, and Escher have been influ-
enced in strongly contrasting ways by Islamic art. However, to fol-
low the impact of Islam on abstractionism and other modern
fine art movements would take us far from the original chrono-
logical limits and leading themes of this book.

Through a Glass Darkly: Western Visions of Islamic Art

A rt books have a tendency to treat objects as unproblematic and to plump for dates and locations that will give those objects a secure context, and art historians have a (perfectly understandable) tendency to fasten on superb art works and to construct a story almost exclusively from what is well-displayed in the showcases of museums. In such circumstances interpretation leans heavily on accidents of survival and uncertain ascriptions of provenance. As has been said, archaeological excavations and the study of a broader mass of less spectacular and usually fragmentary material can provide a useful corrective to this.

The Finds at Nishapur

There are still problems – only a very small number of extensive excavations have been carried out in the Islamic world and publication of the results is often fragmentary. But excavations at Nishapur, in north-east Iran, for example, have proved that it was one of the great ceramic centres of the Islamic world, and have enabled archaeologists to construct tentative hypotheses about the customers for these wares and their aesthetic tastes.

For reasons partly to do with the location of the finds of the various pottery types, it has been argued that Muslim immigrants in the area, who were descendants of early converts to Islam, favoured a form of austere white slipware that was often decorated with Arabic calligraphy; while their neighbours, who were

204. BIHZAD
Prince Bahram Gur slaying a dragon, from a Herati copy of Nizami's *Khamsa*, painted 1493. Illuminated manuscript, 5 1/8 x 3 9/16" (13.0 x 9.0 cm). British Library, London.

The artist has signed it "Painted by the slave Bihzad."

later converts to Islam and who still harboured a residual attachment to an older, pre-Islamic culture, preferred a highly distinctive buff-coloured type of Nishapuri ceramic, which often featured figurative imagery, much of which was of a traditional pre-Islamic Iranian sort (FIG. 205). This argument by its nature cannot be conclusive, but it seems plausible, and it is a rare instance of a modern attempt to relate the way Islamic artefacts looked to the taste of the period and place in which they were produced.

Above

205. Glazed earthenware bowl with figural images, produced in Nishapur, Iran, 10th century. Slipware with underglaze painting, height 3³/₈″ (8.5 cm), diameter 8⁵/₈″ (22 cm). David Collection.

The excavations at Nishapur were conducted before the Second World War, yet the results of finds from this site, and the consequent attempts to link changes in pottery styles with changing political and social affiliations among the people of the region, only entered scholarly argument in the West in the 1970s.

Opposite

206. MUIN Portrait of the painter Riza-i Abbasi, produced in Isfahan, Iran, 1673. Watercolour on paper, 7³/₈ x 4¹/₈″ (18.7 x 10.5 cm). Princeton University Library.

Here Muin, Riza's most gifted pupil, shows the master at work.

Art as Historical Source

If one is considering works of art from the point of view of the light they may shed on the culture in which they were produced, then of course the broken remains of pottery will serve just as well as fine art pieces. But in what sense can art objects be a source for history – other, that is, than for the history of art itself? What can buildings, paintings, and textiles tell us about medieval Islamic politics and society that documents cannot? In general, historians of the pre-modern Middle East have preferred to concentrate on documents – chronicles, biographical dictionaries, tax registers, and so on. Yet even the original writers of these documents, who lived and worked during the centuries discussed in this book, often provide information that is as vague, as speculative, and as much a matter of opinion and interpretation as that produced of necessity by writers on Islamic art today.

It is a mistake to think of the history of Islamic art as a solid body of knowledge. It is better to picture it as a net – that is, a lot of holes tied together by string.

The Individuality of Artists

Although it is certainly easy to write about the earliest centuries of Islamic art as the product of anonymous designers and craftworkers, in time the Muslim world acquired its flamboyant individuals and eccentrics, its Michelangelos, its Van Goghs, and, indeed, its Vasaris.

The earliest artists to acquire individual reputations and biographies were calligraphers. Many treatises were composed that gave guidance on the principles of calligraphy and provided

anecdotal information about the lives of the greatest calligraphers, but many of the recorded details of their lives must be seen as having been included simply to add to the calligrapher's status or edify the reader. These "histories" can be seriously misleading. The famous tenth-century calligrapher Ibn al-Bawwab, for example, was alleged to have invented the *rayhani* and *muhaqqaq* calligraphic hands even though these scripts were in use before he was born.

Painters were slower to be accorded status and individuality (FIG. 206), but here again the details provided in their early histories are incomplete or unreliable. Dust Muhammad wrote (in the florid style popular in sixteenth-century Iran) that in the reign of the Ilkhan Abu Said (r. 1317–35), "Master Ahmad Musa, who was his father's pupil, lifted the veil from the face of depiction and the style of depiction that is now current was invented by him." But nothing has survived from the early fourteenth century that can confidently be ascribed to this painter, and neither Dust Muhammad nor anyone else provides any more information about this allegedly ground-breaking artist.

Slowly, however, more anecdotal information about painters began to find its way into literature. Some of the anecdotes suggest that the status of the painter of miniatures was rising steeply, and of course the mere act of recording details of the artists' lives by their contemporaries enables us to be confident that perceptions about art and artists were in a process of development.

Bihzad (c. 1450–c. 1530), who was taught by Mirak, was perhaps the foremost individual genius in Iranian painting. He was certainly the first whose works (FIG. 204, see page 241) attracted a range of critical comment, even if the criticism is not as revealing as one might like. Babur's comment has already been quoted (see page 95). The sixteenth-century Iranian historian Khwandamir banally commented that "Master Kamaluddin Bihzad is a creator of marvellous pictures," and then went on to make the usual comparison with Mani, the legendary painter-prophet. Dust Muhammad called Bihzad "the rarity of the age." Qadi Ahmad, writing in about 1606, called Bihzad "the marvel of all the centuries," quoted some effusive poetry, and commented on how prolific he was as a painter, but his brief account does conclude with the curious detail that Bihzad was buried "within an enclosure full of paintings and ornaments."

Understanding the Literature

Dust Muhammad's account of past and present painters in 1544, a preface to an album of calligraphy and painting, is an important

source on the evolution of Islamic painting, as is Qadi Ahmad's treatise on calligraphers and painters compiled in about 1606. There is also a biographical dictionary produced by the notoriously vainglorious and irascible Sadiqi Beg (1553/54–1609/10), a former soldier of Turkish origins who rose to become court painter and chief librarian under the Safavid Shah Abbas, although this seems mainly to have been designed to denigrate the reputations of other artists and thus boost his own – he called himself "the second Mani and Bihzad of the Age."

Apart from such specialist treatises, painters began to feature in general biographical dictionaries in the Safavid period. In Ottoman Turkey, apart from rare portraits of artists (FIG. 207), it was the lives of architects, such as Sinan and Agha Ahmad,

207. Portrait of an Ottoman Turkish painter, 15th century. Album painting, colour and gold on paper, 11¼ x 7¼" (28.8 x 18.7 cm). Freer Gallery of Art, Washington, D.C.

One sign of the rising status of the artist in the late Middle Ages, in Islamic as in European art, is their appearance in portraits, as here. Turkish, Iranian, and Arab painters did not use easels but, as shown, customarily worked seated cross-legged on the ground.

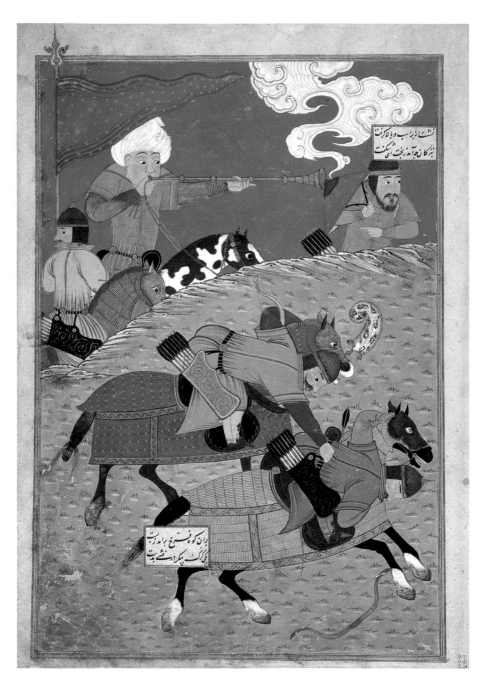

208. The battle between Zanga and Awkhast, from the *Shahnama*, Iran, 1494. Illuminated manuscript, 13⅝ x 9⅝" (34.6 x 24.4 cm). Arthur M. Sackler Gallery, Washington, D.C.

Here the artist's lack of a sense of historical development or awareness of the material culture of the past has allowed him to portray a fight between two of the legendary pre-Islamic heroes of the *Shahnama* with the protagonists wearing 15th-century costumes and one man firing a musket – very much state-of-the-art technology at the end of the 15th century in the Islamic lands.

that attracted the most literary attention. However, it does not seem that medieval Arab, Iranian, or Turkish writers were interested in the lives of the great metalworkers, potters, or workers in ivory.

But although there is a literature devoted to painting and architecture for the modern historian to draw on, we still have problems in understanding what that literature says. Thus, for example, according to Sadiqi Beg, "Just as there are six pens [that is, six styles of calligraphy], so in painting there are seven techniques: Islamic, Chinese, European, disjointed, cloud, *waq*, and Anatolian knot." One can guess at what is being referred to here, but it is much harder to be sure. There are enormous difficulties in attempting to match the vocabulary of the past to the surviving objects. Nor is it possible to accept without question visual and artistic evidence for what that past was like.

Modern histories of Islam often have recourse to images drawn from, say, the *Maqamat* to illustrate this or that aspect of Arab life. But miniatures in medieval books were not intended as documentary records. There are limits to their reliability as sources for such topics as contemporary architecture, dress, or gesture. Arab artists often copied or adapted classical prototypes, and the imitation of earlier works by later painters may reproduce anachronistic details of material culture. Similarly, artists might paint a contemporary object into a supposedly earlier scene (FIG. 208). Painters were not camera-holders or, for that matter, social historians. The architecture in their pictures is purely schematic. The plants shown in them correspond to nothing known in botany. The people in their pictures are often attractively dressed in brilliantly coloured robes, but this certainly should not be taken as documentary evidence for the usual costume of their type and class – although it may reflect the tastes in dress of a wealthy or even a princely readership (FIG. 209).

Art as History?

The Siyah Qalam albums illustrate the dangers awaiting too literal a reliance on works of art as visual history. The four albums of this name are today in

209. Abu Zayd's slave-girl, from a Syrian *Maqamat*, 14th century. Illuminated manuscript, 10 ⁴/₅ x 8¹/₄" (27.5 x 21.0 cm). Bibliothèque Nationale, Paris.

The opulence of the costume of the figure illustrated here is most unlikely to represent what a slave-girl owned by an itinerant preacher would actually have worn. Her robe of red, black, blue, and gold, decorated with *tiraz* bands, may simply be the product of the painter's fancy and delight in colour and pattern. Those who turn to art for evidence on such topics as the status and everyday life of women in pre-modern Islamic societies face very considerable problems.

210. Dancing demons from a Siyah Qalam album. Album painting, 8¾ x 18⅞" (22.5 x 48 cm). Topkapi Saray Museum, Istanbul.

"Siyah Qalam" means literally "black pen," and is the style of painting in which (according to Dust Muhammad) the mysterious Master Ahmad Musa worked. The wild energy and lack of decorum in such pictures is quite alien to the mainstream of Iranian and Turkish painting. The bodies of the men are usually delineated in thick, black, heavy folds, and the subject matter of these pictures is often conjectural. The shamans that some scholars have discovered in them are dervishes in the eyes of others. Similarly, the pagan monsters of the steppe can be reinterpreted as jinns.

211. A nomad encampment from a Siyah Qalam album. Album painting, 7¾ x 14⅝" (19.5 x 37 cm). Topkapi Saray Museum, Istanbul.

Some of the pictures in these albums are highly finished and on silk, while others are rough and on coarse paper. Some of the pictures have been hacked about and have corners or sides missing. Although some of the pictures in these albums are signed "Ustad Muhammad Siyah Qalam," this may of course be an attribution rather than a signature.

the Topkapi, Istanbul. They contain many scenes of nomadic steppe life, including monsters (FIG. 210), but in such a context the recurrent appearance of what seem to be black slaves is puzzling, and it is also odd that some of the steppe nomads, if such they be, are barefoot (FIG. 211). The Siyah Qalam pictures of nomadic life are not necessarily pictures of real life on the steppes. Rather, what we are looking at may be urban fantasies of nomadic life (somewhat similar to the manner in which eighteenth-century French aristocrats used to indulge in pastoral idylls about milkmaids and their swains). The influence of Chinese art is detectable in some of the scenes and of European art in others.

The Siyah Qalam pictures contain evidence and influences that could suggest they were produced anywhere from southern

212. Russian-looking hunters from a Siyah Qalam album. Album painting, 7¹⁄₈ x 10⁵⁄₈" (18 x 27 cm). Topkapi Saray Museum, Istanbul.

Russia in the early thirteenth century (FIG. 212) to Istanbul or Turkestan in the late fifteenth. Not only do we not know who painted these images, or where, or when: in many cases we do not even know what kind of scene it is that we are looking at.

Matching History and Artefact

All too often the artistic aims of the creators of Islamic art have to be guessed at – as does the social and economic context within which their work was produced. We rely on what is uncertain to shed light on what is obscure. There have been attempts to match periods of artistic efflorescence or decline with corresponding developments in society as a whole. Sometimes the match works well. The Mongol invasions of Iran and the sack of Iranian cities may well be behind the steep decline of Iranian metalwork from around 1225 until roughly the end of the century. The collapse, at least for a while, of the production of luxury metal- and glassware in Damascus corresponds with Timur's invasion of Syria in 1400–01. Usually, however, the match between history and artefact is imperfect. Iranian metalwork may have suffered, but whole new categories of high-quality ceramic begin to be manufactured in Iran after the Mongol invasion, including *lajvardina* and Sultanabad ware. Consider also that only after the political disintegration of the Seljuq empire around the mid-twelfth century does the bulk of what we are accustomed to think of as "Seljuq" art begin to be produced, when the greater and lesser dynasties who took over what had been Seljuk lands created court rituals and artistic culture modelled on their Seljuk predecessors. This

"Seljuk" art included *minai* ceramics (FIG. 213), inlaid metalwork, and tiles. Periods of political decline quite often corresponded with periods of cultural splendour.

There are many further puzzles in the chronology of dated or datable objects. Many literary references can be found to carving in ivory being done in pre-Mongol Iran, yet not a single piece has turned up to match those references. Why, indeed, does almost all ivory-carving seem to have been done in Spain in the tenth and eleventh centuries, and in Egypt in the twelfth century? Was ivory simply no longer fashionable in later centuries, or have some of the carved ivory pieces that have survived to the present day been incorrectly attributed? Why do the Mongol Ilkhans seem not to have cared particularly for jade, although the Timurids who came after them were wild about it? Plenty of painted glass lamps have survived from Ayyubid and Mamluk Egypt and Syria (and some from the culturally dependent Yemen), but hardly any from other regions and places. Why was the fashion for these glass mosque lamps so specific?

From Questions to Fascination: Two Examples

Open questions of this sort, conflicts of opinion, and quandaries over intentions, sources, use, time, and place have been a part of the history of Islamic art from the earliest scholars and writers to the present day; and these issues can be as much a part of the study of the great pieces of Islamic art as they are of mosque lamps or the pottery remains from Nishapur. This book will end with an examination of two major examples of Islamic art – one architectural and the other, one of the most important surviving examples of an illuminated manuscript. In studying them against their written history, from the seventh century to the present day, it is hoped that the reader will be helped to see not only the range of argument that surrounds so many issues of Islamic art and architecture, but also to understand the fascination which that art has exerted for so long.

213. *Minai* jardinière in the form of a camel, late 12th century. Enamel on pottery, height 15½" (39.5 cm). Khalili Collection.

A splendid example of Islamic lustreware.

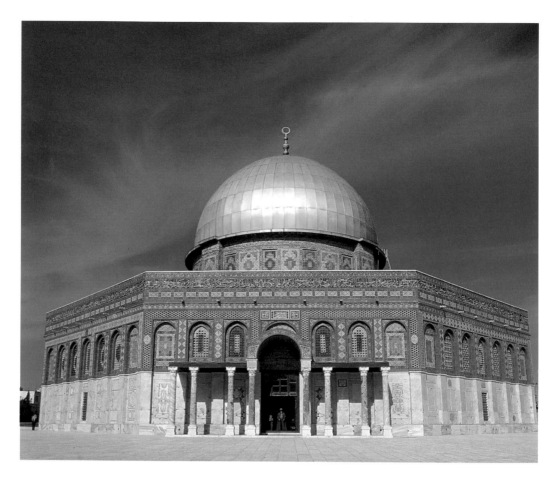

214. The Dome of the Rock, Jerusalem, late 680s–692.

The Dome of the Rock

The Dome of the Rock in Jerusalem (FIG. 214) is one of the very earliest Muslim buildings and certainly one of the most accomplished. Building work on it began in the late 680s and it was probably completed in 692, during the caliphate of the Umayyad Abd al-Malik (though those dates have in the past been challenged). The gilded dome crowns the inner octangular ambulatory curling round a projecting rock (FIG. 215). Both the inside and outside of the walls were once sheathed with mosaic decoration, mostly in gold and green, but the mosaics on the exterior, which had deteriorated over the centuries, were replaced with tilework in the Ottoman period. Apart from this, though, what kind of building is it? It is not a mosque or a mausoleum, and it is certainly not a secular building.

Rival explanations for the building's erection have been put forward from medieval times till the present day. In later centuries it came to be believed that, when the Prophet Muhammad ascended

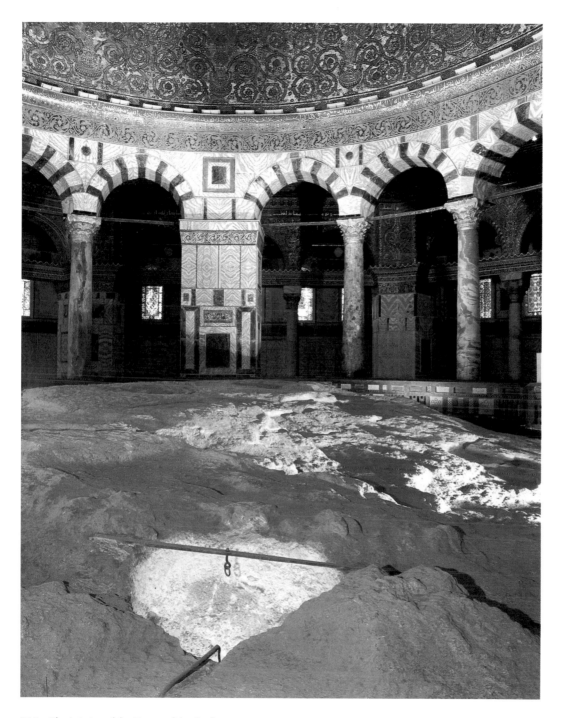

215. The interior of the Dome of the Rock.

The interior is decorated with inscriptions from
the Koran, which turn out to be the earliest
excerpts from the text to have survived.

by night to the heavenly spheres, he did so on a winged steed called Buraq, which in one leap travelled from Mecca and whose hooves touched the rock in Jerusalem, before ascending to the heavens (the *Miraj*). However, this story only seems to start circulating in the sixteenth century and there is no evidence that anyone was aware of it in the 680s. According to the Abbasid historian al-Yaqubi (d. 874), the Dome was designed by Abd al-Malik to serve as a rival shrine to Mecca, while a rebel called Ibn Zubayr held the latter place against him. The rock then would have served as a point to circumambulate and as a substitute for the Kaaba. Al-Yaqubi's interpretation (put forward, that is, almost two centuries after the actual construction of the building) has won favour with a few modern historians.

Others have preferred to follow al-Muqaddasi. Al-Muqaddasi (d. after 988), who as his name suggests was born in Jerusalem (al-Quds), when discussing the buildings of Abd al-Malik has this to say: "Abd al-Malik, seeing the greatness of the martyry of the Holy Sepulchre and its magnificence, was moved lest it should dazzle the minds of the Muslims and hence erected above the rock the dome which we now see there." So, if one follows al-Muqaddasi, the construction of the Dome of the Rock was a demonstration of Muslim triumph in the spiritual heart of Christendom. Its dome is almost exactly the same size as that of the Church of the Holy Sepulchre in Jerusalem, and several of the quotations from the Koran on its walls seem to be specifically addressed to the errors of the Christians – for example: "And say: praise be to God, Who has not taken to Himself a son, and Who has no partner in Sovereignty, nor has He any protector on account of weakness."

There are other possible readings of the Dome. It might be a kind of topographic marker of Jerusalem's place in the events of the Last Days, as the *omphalos*, the centre of the world, where the Messiah will make his final appearance. Or the Dome could conceivably have been intended to commemorate the Abrahamic nature of Islam – a commemoration, that is, of Mount Moriah where Abraham prepared to sacrifice his son. But such a link between Mount Moriah and the rock in Jerusalem only seems to emerge in the eleventh century. Then again, the Dome may have been intended as a kind of victory memorial, in which such spoils as the crown of Khusraw (Chosroes), the horns of Abraham's ram, and the pearl of Yatima were stored and displayed. Finally, the building of the Dome may have been intended as a symbolic rebuilding of the Temple of Solomon, on the site where the previous Temple had stood.

Not all of these interpretations are in direct conflict with one another. The building and its ornamentation suggest complex associations. Arab writers offer later explanations that are probably no more than guesswork, since a great deal of evidence about Umayyad achievements and intentions was destroyed by their hostile successors. The Abbasid caliph al-Mamun (r. 813–17) went so far as to substitute his name for that of Abd al-Malik as the builder of the Dome. Although this is the most intensively studied of all the buildings in the history of Muslim architecture, it seems likely that we shall never be certain what Abd al-Malik intended by it.

The "Demotte" *Shahnama*

Collectors, dealers, and the acquisitive drives of the great museums have rendered some services to Islamic art history. However, the existence of an art market and the profits to be made in it have provided inducements to forgery, to the provision of inadequate or spurious provenances, and in some cases to the damage of the objects themselves, with dealers breaking up hoards and cutting up books. This was the fate of a remarkable illustrated manuscript of the tenth-century poet Firdawsi's *Shahnama*, apparently transcribed and illustrated in early fourteenth-century Iran, which early in the twentieth century was in the possession of a French dealer called Demotte, who cut the book up and sold the illustrated pages individually. Much of the book has consequently gone missing. However, although it is widely agreed that the "Demotte" *Shahnama* is a thoroughly inappropriate name for this mutilated work, it is not so clear what we should call it instead. The sixty or so surviving pictures (out of an estimated original two hundred), with their selective range of images, provide all sorts of evidence about the manuscript's original provenance, but that evidence seems to point in several directions.

The *Shahnama* has been described as "undoubtedly one of the most complex masterpieces of Iranian art." The pictures are populated by largish figures who are usually engaged in dramatic, energetic action. Objects are inventively arranged in the picture space. The pictures do not have the jewel-like brilliance of later Persian miniature painting, for their colours tend to be relatively muted, reflecting perhaps the influence of Chinese scroll painting. The pictures are also of variable quality, which suggests that they were probably the work of several hands. It is widely agreed that this would have been an expensive book to produce, but we do not know how expensive, and though it has been hypothetically dated to between 1330 and 1336, we have no conclusive

216. Miniature of Alexander enthroned, from the "Demotte" *Shahnama*, produced in Tabriz, early 14th century. Illuminated manuscript, 11³/₈ × 7⁷/₈" (29 × 20 cm). Louvre, Paris.

evidence for a particular patron for this work. As with the Dome of the Rock, there are as many opinions about the so-called "Demotte" *Shahnama* as there have been scholars writing on it.

The *Shahnama* has been ascribed to various Mongol patrons, and the particular themes of its illustrations, such as enthronement (FIG. 216), politically active women, and legitimacy, have been described as reflecting the dog-eat-dog world of Ilkhanid politics (FIG. 217). As a work of covert political propaganda, it has been suggested, it is therefore most likely to have been created at Tabriz, the Ilkhanid capital, and to date from between November 1335 and May 1336, when the politics of the Ilkhanid court were especially turbulent. It has, however, also been ascribed to the later patronage of the post-Mongol Jalayrid sultan Uways I (r. 1356–74).

The precise opposite has also been suggested: that the book demonstrates an anti-Mongol stance, and that the message of its illustrations is that the Mongol presence in Iran should be resisted. (The *Shahnama* is, after all, one of the great works of Persian literature, celebrating among other things their resistance to an invader.) It is notable that one of the villains of the epic, Zahhak, is given a Far Eastern appearance in this version. But whatever allusions one scholar discerns in the images, another will see something wholly different. It may have been painted in Tabriz; it may not. It may date from anywhere between 1320 and 1400. It has been cut up, damaged, and restored.

Problems abound in our understanding of Islamic art; only a few have been mentioned above. There are many others – concerning, for example, the chronology and functions of the Alhambra palace, or the origins of the mysterious Siyah Qalam album paintings, or the production of Mamluk carpets. It is perhaps worth bearing in mind that many of the original patrons of Islamic art seem themselves to have had a pronounced taste for problems or puzzles. Hence calligraphy disguised as men or animals; hence chronogrammatic inscriptions on buildings, where certain letters of the inscription give the date of construction in a coded form; hence the hidden faces that can be discerned in the rocks and vegetation of many Persian miniatures; hence the ambiguous patterns of the bevelled style in Samarra, whose forms tremble on the edge between abstraction and representation. Islamic art engaged the minds as well as the eyes of its original consumers, and it should continue to do so for us. Insofar as the study of Islamic art can be considered to be the study of a body of knowledge, it is a developing one. The purpose of many of the objects displayed in the Islamic galleries of the world's museums can only be guessed at, while their attributions are frequently uncertain. In order to get a better understanding of those objects, we need to take them mentally out of their display cases and place them back in their original social, economic, and intellectual context.

217. Miniature of Faridun testing his sons, from the "Demotte" *Shahnama*, early 14th century. Illuminated manuscript, 6³/₄ x 11³/₈" (17 x 29 cm). Chester Beatty Library, Dublin.

Historical Events

Numbers in bold italic represent dates in the Muslim calendar

500–700

527–65 Reign of the Byzantine emperor Justinian I

531–79 Reign of the Sasanian ruler Khusraw I

c. 570 Birth of the Prophet Muhammad at Mecca

591–628 Reign of the Sasanian ruler Khusraw II

622 The beginning of the Muslim era. The flight of the Prophet Muhammad from Mecca to Medina (*h* and the establishment in Medina of the first Muslim state *1*

632 Death of the Prophet Muhammad in Medina *11*

633–40 Muslim conquest of Syria, Palestine, and Iraq *12–19*

642 Alexandria abandoned by Byzantine army. Muslims conquer Lower Egypt *21*

651 Muslims conquer western Iran *31*

661 Assassination of Ali ibn Abi Talib *40*

661–750 Reign of the Umayyad caliphs *41–132*

701–900

710 A Muslim army reaches the Indus *91*

711 Muslim troops invade Spain *92*

732 Charles Martel defeats Muslims at Poitiers *114*

749–1258 Reign of the Abbasid caliphs *132–656*

751 Muslim conquest reaches Tashkent. Defeat of the Chinese at the Battle of Talas *134*

756–1031 Reign of the Spanish Umayyads *138–422*

786–809 Reign of the Abbasid caliph Harun al-Rashid *170–93*

800–909 Reign of the Aghlabids in Tunisia, Algeria, and Sicily *184–296*

819–1005 Reign of the Samanids in Khurasan and Transoxania *204–395*

821–73 Reign of the Tahirids in Khurasan *205–59*

836 Abbasid capital moves from Baghdad to Samarra *221*

868–905 Reign of the Tulunids in Egypt *254–92*

883 Abbasid capital returns to Baghdad *269*

901–1100

909–1171 Reign of the Fatimids in Tunisia, Egypt, Sicily, and Palestine *297–567*

932–1062 Reign of the Buyids in Iran and Iraq *320–454*

945 The Buyids enter Baghdad *334*

969 Foundation of a new city at Cairo by the Fatimids *358*

977–1186 Reign of the Ghaznavids in Khurasan, Afghanistan, Iran, and northern India *366–582*

1001 First raids by Mahmud of Ghazna into India *391*

1038–1194 Reign of the Seljuqs *429–590*

1055 The Seljuqs enter Baghdad *447*

1056–1147 Reign of the Almoravids in North Africa and Spain *448–541*

1061 The Normans drive the Muslims from Sicily *453*

1072–92 Reign of the Seljuq sultan Malik Shah *465–85*

1095–99 First Crusade *488–92*

1099 Jerusalem captured by the Crusaders *492*

1101–1200

1127–1222 Reign of the Zengids in parts of Iraq and Syria *521–619*

1130–1269 Reign of the Almohads in North Africa and Spain *524–667*

1147–48 Second Crusade *541–42*

1171 Salah al-Din (Saladin) overthrows the Fatimid regime *567*

1187 Crusaders defeated by Salah al-Din at the Battle of Hattin *583*

1189–92 Third Crusade *585–88*

1194 The Khwarazm shahs defeat the Seljuqs in Iran .*590*

Art and Architecture Literature and Science

Art and Architecture		Literature and Science	
5–47	S. Vitale in Ravenna	c. 540	Death of the Arabian poet Imrul Qays
2–37	Hagia Sophia in Constantinople	c. 565	Death of the Byzantine historian Procopius
er 540	The rebuilding of Antioch by Justinian I	650–51	Establishment of standard text of the Koran *30*
5	Mosque constructed at Basra, Iraq (rebuilt AD 665/AH 45) *14*	696	The Umayyad caliph Abd al-Malik orders the introduction of Arabic in government offices *77*
3	Mosque constructed at Kufa, Iraq (rebuilt AD 670/AH 50) *17*		
570	Great Mosque at Qairouan, Tunisia (rebuilding in the 9th century AD) *c. 50*		
1–92	Dome of the Rock in Jerusalem completed *72*		
5	Aniconic coinage introduced by the Umayyad caliph Abd al-Malik *77*		
5–15	Great Mosque of Damascus *87–96*	751	Arabs capture Chinese papermakers; manufacture of paper at Samarqand *134*
7–09	Mosque of the Prophet at Medina restored *88–90*	c. 757	Death of Ibn al-Muqaffa, translator of *Kalila wa-Dimna* (*Kalila and Dimna*) into Arabic *c. 140*
9–17	Mosque of al-Aqsa in Jerusalem *91–99*		
724–43	The desert palace of Qusayr Amr *c. 106–27*	768–69	Death of Ibn Ishaq, biographer of the Prophet Muhammad *151*
5–843	Iconoclast period at Constantinople *108–228*	c. 813	Death of the poet Abu Nuwas *c. 197*
740s	The palaces of Khirbat al-Mafjar and Mshatta *c. 123–32*	869	Death of the prose stylist al-Jahiz, author of *Kitab al-Bayan* (*Book of Proof*) and *Kitab al-Hayawan* (*Book of Animals*) *255*
2–63	Foundation of the round city of Baghdad *145*		
1–86	Great Mosque of Cordoba (later enlarged) *168–70*		
336–37	Jawsaq al-Khaqani palace at Samarra *c. 222*	c. 870	Death of the philosopher al-Kindi *c. 256*
∎	Qarawiyyin Mosque in Fez founded *226*	874	Death of the historian al-Yaqubi *260*
3–52	Great Mosque of Samarra *234–38*	877	Death of Hunayn ibn Ishaq, translator of Greek works into Arabic *263*
)	Great Mosque of Sfax; Great Mosque of Susa *236*		
5	Friday Mosque at Shushtar *252*		
5–79	Mosque of Ibn Tulun in Fustat (Old Cairo) *263–65*		
ore 943	Mausoleum of Ismail the Samanid at Bukhara *before 331*	923	Death of the historian al-Tabari *311*
5	Work begins on the palace-city of al-Madinat al-Zahra in Spain *324*	956	Death of the historian al-Masudi *345*
)	Death of the calligrapher Ibn Muqla *328*	c. 960	Al-Sufi writes *Kitab Suwar al-Kawakib al-Thabita* (*Book of Images of the Fixed Stars*) *c. 349*
)	Mosque of al-Azhar in Cairo founded *361*	965	Death of the poet al-Mutanabbi *354*
m 990	Mosque of al-Hakim in Cairo *from 380*	967	Death of Abu'l-Faraj al-Isfahani, compiler of the *Kitab al-Aghani* (*Book of Songs*) *356*
06–07	Tomb tower of Gunbad-i Qabus *397*		
22	Death of the calligrapher Ibn al-Bawwab *413*	969	*Rasail Ikhwan al-Safa* (*Letters of the Brethren of Purity*) written *358*
57	The looting and dispersal of treasures and artefacts from the Fatimid palace in Cairo *459*	c. 1000	Death of the geographer al-Muqaddasi *c. 390*
1085	Great Mosque at Isfahan rebuilt for the Seljuq sultan Malik Shah *c. 478*	c. 1010	Firdawsi writes the *Shahnama* (*Book of Kings*) *c. 400*
87	New city wall built for Cairo *480*	1037	Death of the philosopher Ibn Sina (Avicenna) *428*
91–92	Great Mosque of Diyarbakir *484*	1039	Death of the mathematician Ibn al-Haytham (Alhazen) *430*
		1048	Death of the polymath al-Biruni *439*
		1064	Death of the Spanish scholar Ibn Hazm *456*
		1080s	Nizam al-Mulk, vizier to Malik Shah, writes the *Siyasatnama* (*Book of Government*) *470s*
21–22	Great Mosque at Isfahan rebuilt with four *iwans* *515*	1111	Death of the theologian al-Ghazali *504*
25	Mosque of al-Aqmar in Cairo *519*	1122	Death of al-Hariri, author of the *Maqamat* (*Sessions*) *516*
33/34	Roger II's coronation robe made in Sicily *528*	1160–87	Gerard of Cremona translates some 87 works, including the Koran, Aristotle, and Ibn Sina, into Latin *555–83*
35	Four-*iwan* mosque constructed at Zawara, Iran *530*		
40	Palatine Chapel in Palermo *534*	1177	The Persian poet Farid al-Din Attar completes *Mantiq al-Tayr* (*The Conference of the Birds*) *572*
53	"Bobrinski Bucket" manufactured in Herat *558*		
33–84	The Citadel in Cairo begun by Salah al-Din *579*	1198	Death of the philosopher Ibn Rushd (Averroes) *594*
94	The minaret of Jam at Firuzkuh, Afghanistan *590*		

Historical Events

1206–1555 Reign of the Delhi sultans in northern India *602–962*
1212 The Almohads defeated at Las Navas de Tolosa and subsequently withdraw from Spain *609*
1220 Mongol invasion of Transoxania *617*
1227 Death of Chinggis (Genghis) Khan *624*
1230–1492 Reign of the Nasirids from Granada *627–897*
1248 Seville passes into Christian hands *646*
1250–1517 Reign of the Mamluks in Egypt and Syria *548–922*
1256–1353 Reign of the Mongol Ilkhanids in Iran *654–754*
1258 Baghdad sacked by the Mongols. End of the Abbasid caliphate *656*
1260 The Mamluks defeat the Mongols at the Battle of Ayn Jalut *658*
1271 Journey of Marco Polo to China *669*
1281–1924 Reign of the Ottomans in Anatolia, the Balkans, and Arab lands *680–1342*

1316 Death of the Ilkanid ruler Uljaytu *717*
1323 Peace between the Mongols and the Mamluks *723*
1326 The Ottoman ruler Orhan takes Bursa *726*
1357 The Ottomans cross into Europe at Gallipoli *758*
1366 The Ottoman capital moves from Bursa to Edirne *767*
1370–1506 Reign of the Timurids in Transoxania and Iran *771–912*
1398–99 Timur (Tamerlane) invades India and sacks Delhi *801*
1400–01 Timur conquers Syria and sacks Damascus *803*
1404 The Castilian envoy Clavijo reaches Samarqand *806*
1453 Fall of Constantinople to the Ottomans *857*
1487 Portuguese round the Cape of Good Hope *892*
1492 Fall of Granada to the Christians *897*
1496 Columbus discovers America *901*
1498 Vasco da Gama reaches Calicut *903*

1501–1732 Reign of the Safavids in Iran *907–1145*
1516–17 The Ottoman conquest of Syria, Egypt, and the Yemen *922–23*
1520–66 Reign of Suleyman the Magnificent *926–74*
1526–1858 Reign of the Mughal emperors in India *932–1274*
1529 First Ottoman siege of Vienna *935*
1534 The Ottoman conquest of Baghdad *940*
1571 Ottoman defeat at the Battle of Lepanto *979*
1609–14 The Moriscos are expelled from Spain *1018–23*
1617 Pietro della Valle visits Isfahan *1026*
1619 Foundation of Dutch settlement in Batavia *1028*
1683 Second Ottoman siege of Vienna *1094*

1739 Delhi sacked by Nadir Shah *1152*
1798 Napoleon invades Egypt *1213*

Glossary

arabesque ornamentation based on intertwining leaf and flower motifs

bida innovation, especially unwelcome innovation not sanctioned by the Koran or by the practices (*sunna*) of the Prophet

caliph (Arabic *khalifa*) "deputy," commander of the Islamic community (theoretically) combining both religious and political functions

caravanserai a lodging place for merchants, with provision for securing goods and stabling pack-animals

cuerda seca a Spanish term for the "dry cord" technique, a way of separating differently coloured glazes on a tile during firing with greased lengths of cord

dervish another word for Sufi

dervshirme the Ottoman system of collecting Christian boys for training and conversion prior to service in the palace or army

dinar gold coin

dirham a silver coin

emir (Arabic *amir*) a prince or a military officer. (The title was applied to a wide range of ranks in the palace and army)

fals a copper coin

futuwwa a loosely linked group of brotherhoods, usually of young men, who came together in lodges for religious, charitable, craft, or even occasionally criminal purposes. Sometimes *futuwwa* brotherhoods were linked with guilds or with Sufi orders

hadith an orally transmitted saying of the Prophet or an account about him or his contemporaries. Such traditions both guide Muslims in their everyday life and form one of the important bases of Islamic law

hammam a public or "Turkish" bath

hisba the inspection of markets and public morals

Ilkhan a Mongol ruler, subordinate to the Great Mongol Khan

imam (a) a prayer leader in a mosque; (b) a religiously guided political leader

iwan a vault closed at one end and open at the other, a kind of open porch, usually opening onto a courtyard, a standard feature in particular of Seljuq mosques

jami the great mosque in a town in which the sermon was preached on Fridays (see *masjid*)

khan a caravanserai

khanqa a foundation for the maintenance of Sufis (see Sufi), often endowed and supported by *waqf* income (see *waqf*)

khizana treasury, storehouse, sometimes library

kitabkhana literally "book house," a library and scriptorium, where books were both stored and produced. In practice, *kitabkhana*s often functioned as centres for design innovation

Kufic a form of Arabic script. (A variety of ornamental forms of this script, such as plaited Kufic, are known)

lajvardina pottery with a cobalt blue glaze and decoration in raised enamelling

madhhab a Muslim law school. In Sunni Islam there are four main schools of law. Although they differ on many legal and ritual issues, there is nevertheless a substantial body of common ground between the four schools

madina city

madrasa a college for the teaching of the religious sciences. Such foundations and their teaching staff were normally sustained by *waqf* income

mamluk a slave soldier. Most commonly such slaves were imported from beyond the frontiers of Islam and then converted to Islam. From c. 1250 to 1517 Egypt and Syria were governed by a sequence of Mamluk sultans. Elsewhere in the Islamic world (e.g., in Abbasid Samarra) officers of *mamluk* origin were often the powers behind the throne

maqsura enclosed space offering the ruler or governor and his entourage some security while they prayed

mashrabiyya window grille or screen of turned wood

masjid literally "a place of prostration," and hence a mosque. *Masjid* tends to be used of a small building, or even room, while the larger Friday or congregational mosque is known as a *jami*

masjid-i jami Persian term used for a *jami*, or Friday mosque

mihrab a recess or niche on the *qibla* wall

minai a form of pottery in which the colours are applied first under and then over the glaze. It was known in medieval times as "seven-colour" pottery

minaret (Anglicisation of the Arabic *manara*) in theory a tower from which the call to prayer was given. In practice, minarets were used for a variety of purposes and, in particular, the multiple minarets of large mosques often have a purely decorative function

minbar pulpit

Mozarab a Christian living under Muslim rule in Spain

muallim an urban official appointed by the *qadi* to enforce trading standards (weights, measures, quality of the materials used) and to police certain aspects of morality (see *hisba*)

muqarnas a three-dimensional architectural ornament, formed by the juxtaposition of cones. Often used in zones of transition and arranged in such a fashion as to create honeycomb or stalactite effects

muraqqa an album of pictures. Such albums were commonly put together for presentation to princes

nadim a cup-companion retained by a caliph or other prominent figure. The *nadim* was a cultivated man who was paid to provide edifying or entertaining conversation at the dinner table

nastaliq a script invented in the fourteenth century and thereafter extremely popular in the areas dominated by Persian culture

pishtaq Persian term for a portal or a high arch framing an *iwan*. Usually the arch is within a large and ornately decorated rectangular frame

qadi a Muslim judge

qasr palace, castle, or enclosure

qibla the direction of prayer, towards Mecca

qubba dome

ribat in North Africa, a frontier fortress for warriors dedicated to a holy war. Also a term for a Sufi hospice

shaykh a title of respect to be used of any old man or senior figure. It can refer to a prince, a tribal chief, a village head man, or a group leader. However, in the context of this book, two uses of the word are particularly relevant. First, the term was used to refer to the master of a Sufi order. Second, in the early modern period, it was also used in the Arab world to refer to a head of a guild

Shia the religious party who support the claim of Ali (cousin of the Prophet Muhammad) and his descendants to leadership of the Islamic community. There are several branches of the Shia faith, who differ from one another in supporting different chains of succession

sinf (pl. *asnaf*) literally "kind or sort." Also a guild or body of craftsmen

sirdab, or *sardab* a cool sunken cellar in a building

Sufi a Muslim mystic or ascetic

sultan a political title first used in the eleventh century. The title was first granted by the Abbasid caliphs to the Greater Seljuqs. Political theorists tended to describe the sultan as the executive arm of the caliph

Sunni the adjective applied to the broad body of "orthodox" Muslims who hold that succession to leadership of the Islamic community after the death of the Prophet was elective rather than hereditary (thus distinguishing them from Shia, or Shii, Muslims).

Sunni Islam bases itself on the Koran and the practices (*sunna*) of the Prophet Muhammad

suq market

Taifa literally "party" or "section," applied to the kings who ruled in the successor states to the Spanish Umayyad caliphate after the latter's break-up in the early eleventh century

talar open columned hall or veranda

tiraz royal textile factory, often situated within the palace

ulama (sing. *alim*) Muslim theologians or lawmen

waqf land or other income-producing property dedicated in perpetuity to the upkeep and staffing of a pious institution

waqfiyya the legally attested document specifying the details of the *waqf*

zarif one of the refined, a dandy, a connoisseur

Bibliography

ABD AL-LATIF AL-BAGHDADI, *The Eastern Key [Kitab al-Ifadah wa'l Itibar]* (ed. and trans. by K. H. Z. and J. and I. E. Videan; London: Allen and Unwin, 1965)

ALEXANDER, D., *Arts of War: Arms and Armour of the 7th to 19th Centuries* (London: Nur Foundation, 1993)

ALLAN, J., *Islamic Ceramics* (Oxford: Ashmolean Museum, 1991)

— *Islamic Metalwork: The Nuhad al-Said Collection* (London: Sotheby's, 1982)

— *Metalwork of the Islamic World: The Aron Collection* (London: Sotheby's, 1986)

— "Abu'l-Qasim's Treatise on Ceramics," *Iran*, XI (1973), pp. 111–20

ARNOLD, T., *Painting in Islam* (Oxford: Oxford University Press, 1928)

ATASOY, N., AND RABY, J., *Iznik: The Pottery of Ottoman Turkey* (ed. Y. Petsopoulos; London: Alexandria Press, 1989)

ATIL, E. (ed.), *The Age of Sultan Suleyman the Magnificent* (exh. cat.; Washington: The National Gallery of Art, 1987)

— *Art of the Arab World* (exh. cat.; Washington: Smithsonian Institution, 1973)

— *Ceramics from the World of Islam* (exh. cat.; Washington: Smithsonian Institution, 1973)

— (ed.), *Islamic Art and Patronage: Treasures from Kuwait* (New York: Rizzoli, 1990)

— *Renaissance of Islam: Art of the Mamluks* (exh. cat.; Washington: Smithsonian Institution, 1981)

BAER, E., *Ayyubid Metalwork with Christian Images* (Leiden: Brill, 1989)

— *Metalwork in Islamic Art* (Albany: State University of New York Press, 1983)

— *Sphinxes and Harpies in Medieval Islamic Art: An Iconographical Study* (Jerusalem, Israel Oriental Society, 1965)

BAER, G., "The Organisation of Labour," *Wirtschaftsgeschichte des Vorderen Orients in Islamischer Zeit* (Leiden: Brill, 1977), pp. 31–52

BEHRENS-ABOUSEIF, D., *Islamic Architecture in Cairo* (Leiden: Brill, 1989)

BLAIR, S. S., *A Compendium of Chronicles: Rashid al-Din's Illustrated History of the World* (London: Nur Foundation, 1995)

— "The Development of the Illustrated Book in Iran," *Muqarnas*, X (1993), pp. 266–74

— and BLOOM, J., *The Art and Architecture of Islam 1250–1800* (New Haven and London: Yale, 1994)

BLOOM, J., "The Mosque of Baybars al-Bunduqdari in Cairo," *Annals Islamologiques*, 18 (1982), pp. 45–78

BOSWORTH, C.E., *The New Islamic Dynasties: A Chronological and Genealogical Manual* (Edinburgh: Edinburgh University Press, 1996)

BREND, B., *Islamic Art* (London: British Museum Publications, 1991)

BROWN, P., *The World of Late Antiquity: From Marcus Aurelius to Muhammad* (London: Thames and Hudson, 1971)

BUCKLEY, R.P., "The Muhtasib," *Arabia*, XXXIX (1992), pp. 59–117

BULLIET, R.W., "Pottery Styles and Social Status in Medieval Khurasan," *Archaeology, Annales and Ethnohistory* (ed. B.A. Knapp; Cambridge: Cambridge University Press, 1992), pp. 75–82

BURGEL, J.C., *The Feather of the Simurgh: The "Licit Magic" of the Arts in Medieval Islam* (New York: New York University Press, 1988)

BURGOYNE, M., and RICHARDS, D., *Mamluk Jerusalem, An Architectural Study* (London: World of Islam Festival Trust, 1987)

CAIGER-SMITH, A., *Lustre Pottery: Technique, Tradition, and Innovation in the Islamic and the Western World* (London, Faber and Faber, 1985)

Cambridge History of Arabic Literature: Arabic Literature to the End of the Ummayad Period (eds A.F.L. Beeston, T.M. Johnstone and G.R. Smith; Cambridge: Cambridge University Press, 1983)

Cambridge History of Arabic Literature: Abbasid Belles-Lettres (eds J. Ashtiany, T.M. Johnstone, and G.R. Smith; Cambridge: Cambridge University Press, 1990)

Cambridge History of Arabic Literature: Religion, Learning and Science in the Abbasid Period, (eds M.L.J. Young, J.D. Latham, and R.B. Serjeant; Cambridge: Cambridge University Press, 1990)

CANBY, S., *Persian Painting* (London: British Museum Publications, 1993)

CARBONI, S., *Il Kitab al-Bulham di Oxford* (Turin: Editrice Tirrenia Stampatori, 1988)

Carpets of the Mediterranean Countries 1400–1600 (ed. R. Pinner and W.B. Denny, 1986) = *Oriental Carpet and Textile Studies* II (1986)

CHARDIN, J., *Voyages de M. John Chardin en Perse,* 3 vols (Amsterdam: de Lorme, 1711)

CLAVIO, R. DE, *Embassy to Tamerlane, 1403–1406* (trans. by G. Le Strange; London: Routledge, 1928)

CLINTON, J.W., "Esthetics by Implication: What the Metaphors of Craft Tell us about the 'Unity' of the Persian Qasida," *Edebiyyat* IV (1979), pp. 73–96

CRANE, H., *Risale-i Mimariyye: An Early Seventeenth-Century Ottoman Treatise on Architecture* (Leiden: Brill, 1987)

CRESSWELL, K.A.C., *A Short Account of Early Muslim Architecture* (rev. ed. and supp. by J. Allan; Aldershot: Scolar Press, 1989)

CURATOLA, G. (ed.), *Eredita dell'Islam: Arte islamica in Italia* (Venice: Silvana Editoriale, 1993)

DODD, E.C., "The Image of the Word. Notes on the Religious Iconography of Islam," *Berytus*, XVIII (1969), pp. 35–79

DODDS, J. (ed.), *Al-Andalus: The Art of Islamic Spain* (New York: Metropolitan Museum of Art, 1992)

DOLS, M., *The Black Death in the Middle East* (Princeton: Princeton University Press, 1977)

DUNLOP, D.M., *Arab Civilization to AD 1500* (London: Longman, 1971)

ERDMANN, K., *Oriental Carpets* (London: Crosby Press, 1976)

ETTINGHAUSEN, R., *Arab Painting* (Geneva: Skira, 1977)

— *From Byzantium to Sassanian Iran and the Islamic World: Three Modes of Artistic Influence* (Leiden: Brill, 1972)

— *Islamic Art and Archaeology: Collected Papers* (ed. M. Rosen-Ayalon; Berlin: Mann, c. 1984)

— "The Impact of Muslim Decorative Arts and Painting on the Arts of Europe," *The Legacy of Islam* (eds J. Schacht and C.E. Bosworth; Oxford: Oxford University Press, 1974), pp. 290–320

— "Originality and Conformity in Islamic Art," *Individuality and Conformity in Classical Islam* (eds A. Banani and S. Vryonis; Wiesbaden: Harrasowitz), pp. 83–114

— and GRABAR, O., *The Art and Architecture of Islam 650–1250* (Harmondsworth: Penguin, 1987)

FERRIER, R.W. (ed.), *The Arts of Persia* (New Haven and London: Yale, 1989)

FIERRO, M., "The Treatises against Innovations (*kutub al-bida*)," *Der Islam,* LIX (1992), pp. 204–46

FRISHMAN, M., and KHAN, H.-U. (eds), *The Mosque: History, Architectural Development and Regional Diversity* (London: Thames and Hudson, 1994)

GAGE, J., *Colour and Culture: Practice and Meaning from Antiquity to Abstraction* (London: Thames and Hudson, 1993)

GARCIN, J.C., MARUY, B., REVAULT, J., and ZAKARIYA, M., *Palais et maisons du Caire, I. époque mamelouke* (Paris: Centre National de la Recherche Scientifique, 1982)

GARCIN, J.C., et al, *Etats, sociétés et cultures du monde médiéval, XV–XVe Siècles* (Paris: Presses Universitaires de France, 1995)

GOITEIN, S.D., *A Mediterranean Society: The Jewish Communities of the Arab World as Portrayed in the Documents of the Cairo Geniza,* 5 vols (Berkeley and Los Angeles: University of California Press, 1967–88)

— "The Main Industries of the Mediterranean Area as Reflected in the Cairo Geniza," *Journal of the Economic and Social History of the Orient,* IV (1961), pp. 168–97.

GOLOMBEK, L., and WILBER, D., *The Timurid Architecture of Iran and Turan,* 2 vols (Princeton: Princeton University Press, 1988)

— and SUBTELNY, M., *Timurid Art and Culture: Iran and Central Asia in the Fifteenth Century* (Leiden: Brill, 1992)

GOODWIN, G., *A History of Ottoman Architecture* (London: Thames and Hudson, 1971

GRABAR, O., *The Alhambra* (Cambridge, MA: Harvard University Press, 1978)

— (ed.), *The Art of the Mamluks* (*Muqarnas* II) (New Haven and London: Yale, 1984)

— and BLAIR, S., *Epic Images and Contemporary History: The Illustrations of the Great Mongol Shahnama* (Chicago: University of Chicago Press, 1980)

— *The Formation of Islamic Art* (New Haven and London: Yale, 1973)

— *The Illustrations of the Maqamat* (Chicago: University of Chicago Press, 1984)

— *The Mediation of Ornament* (Princeton: Princeton University Press, 1992)

— "Islamic Art and Archaeology," *The Study of the Middle East* (ed. L. Binder; New York: John Wiley and Sons, 1976), pp. 229–64

GRAY, B., *Persian Painting* (Geneva: Skira, 1977)

GRUBE, E.J., *Cobalt and Lustre: The First Centuries of Islamic Pottery* (London: Nur Foundation in association with Azimuth and Oxford University Press, 1994)

GUTHRIE, S., *Arab Social Life in the Middle Ages: An Illustrated Study* (London: Saqi Books, 1995)

HAARMANN, U. (ed.), *Geschichte der Arabischen Welt* (Munich: C.H. Beck, 1994)

HALDANE, D., *Mamluk Painting* (Warminster, Wilts: Aris and Phillips, 1978)

HAMILTON, A., *Walid and His Friends: An Umayyad Tragedy* (Oxford: Oxford University Press, 1988)

AL-HASSAN, A.Y., and HILL, D., *Islamic Technology: An Illustrated History* (Cambridge: Cambridge University Press, 1986)

HAWTING, G.R., *The First Dynasty of Islam: The Umayyad Caliphate AD 661–750*, (Beckenham, Kent: Croom Helm, 1986)

HILLENBRAND, R. (ed.), *The Art of the Seljuqs in Iran and Anatolia* (Costa Mesa, CA: Mazda, 1994)

— *Imperial Images in Persian Painting* (Edinburgh: Scottish Arts Council, 1977)

— *Islamic Architecture: Form, Function and Meaning* (Edinburgh: Edinburgh University Press, 1994)

— "*La dolce vita* in Early Islamic Syria: The Evidence of Later Umayyad Palaces," *Art History*, V (1982), pp. 1–35

— "Safavid Architecture," *The Timurid and Safavid Periods* (ed. P. Jackson; *Cambridge History of Iran*, vol. VI; Cambridge: Cambridge University Press, 1986) pp. 789–92

— "The Uses of Space in Timurid Painting," *Timurid Art and Culture: Iran and Central Asia in the Fifteenth Century* (eds L. Golombek and M. Subtelny; *Supplements to Muqarnas*; Leiden: Brill, 1992), pp. 76–102

HOAG, J.D., *Islamic Architecture* (London: Faber and Faber, 1987)

HODGSON, M., *The Venture of Islam: Conscience and History in a World Civilization,* 3 vols (Chicago and London: University of Chicago Press, 1974)

HOURANI, A., *A History of the Arab Peoples* (London: Faber and Faber, 1991)

— and STERN, S.M. (eds), *The Islamic City: A Colloquium* (Oxford: Bruno Cassirer, 1970)

HUMPHREYS, R.S., "The Expressive Intent of the Mamluk Architecture of Cairo: A Preliminary Essay," *Studia Islamica,* XXXV (1972), pp. 69–119

IBN ARABSHAH, *Tamerlane or Timur the Great Amir, from the Arabic Life of Ahmed ibn Arabshah* (Trans. by J.H. Saunders; London: Luzac and Co., 1936)

IBN KHALDUN, *The Muqaddimah: An Introduction to History,* 3 vols (trans. by F. Rosenthal; Princeton: Princeton University Press, 1967)

IBN AL-UKHUWWA, *The Maalim al-Qurba fi Ahkam al-Hisba* (ed. and summary trans. by R. Levy; London: Luzac and Co., 1937)

IBN TAYMIYYA, *Public Duties in Islam: The Institution of the Hisba* (trans. by M. Holland; Leicester, 1982)

IRWIN, R., *The Arabian Nights: A Companion* (Harmondsworth: Allen Lane, 1994)

— "Egypt, Syria and their Trading Partners 1450–1550," *Carpets of the Mediterranean Countries 1400–1600* (eds R.

Pinner and W.B. Denny, 1986) = *Oriental Carpet and Textile Studies* II (1986)

— *The Middle East in the Middle Ages: The Bahri Mamluk Sultanate 1250–1382* (Beckenham, Kent: Croom Helm, 1983)

AL-JAHIZ, *The Epistle on Singing Girls* (trans. and ed. by A.F.L. Beeston; Warminster, Wilts: Aris and Phillips, 1980)

— *The Life and Works of Jahiz* (trans. and ed. by C. Pellat; Berkeley and Los Angeles: University of California Press, 1969)

— *Le Cadi et la mouche: anthologie du Livre des animaux* (trans. and ed. by L. Souami; Paris: Sinbad, 1988)

JAMES, D., *Islamic Masterpieces of the Chester Beatty Library* (London: World of Islam Festival Trust, 1981)

— "Space-Forms in the Work of the Baghdad *Maqamat* Illustrators, 1225–58," *Bulletin of the School of Oriental and African Studies*, XXXVII (1974), pp. 305–20

JONES, D., and MICHELL, G., *The Arts of Islam* (London: Hayward Gallery, 1976)

KEYVANI, M., *Artisans and Guild Life in the Later Safavid Period: Contributions to Social-economic History of Persia* (Berlin: Klaus Schwarz, 1982)

KING, D., and SYLVESTER, D., *The Eastern Carpet in the Western World* (London: Hayward Gallery, 1983)

The Koran Interpreted, 2 vols (trans. by A.J. Arberry; London: George Allen and Unwin, 1955)

LANE, A., *Early Islamic Pottery* (London: Faber and Faber, 1947)

— *Later Islamic Poetry* (London: Faber and Faber, 1957)

LAPIDUS, I.M., *Muslim Cities in the Later Middle Ages* (Cambridge, MA: Harvard University Press, 1967)

LEWIS, B. (ed.), *The World of Islam* (London: Thames and Hudson, 1976)

LINGS, M., *The Quranic Art of Calligraphy and Illumination* (London: World of Islam Festival Trust, 1976)

LOWRY, G., and LENTZ, T., *Timur and the Princely Vision* (exh. cat., Los Angeles: County Museum of Art, 1989)

MASSIGNON, L., *La Passion d'al-Hallaj, martyr mystique de l'Islam*, 2 vols (Paris: P. Geuthner, 1922); trans. by H. Mason as *The Passion of al-Hallaj: Mystic and Martyr of Islam*, 4 vols (Princeton: Princeton University Press, 1982)

AL-MASUDI, *The Meadows of Gold: The Abbasids* (ed. and trans. by P. Lunde and C. Stone; London: Kegan Paul International, 1984)

MAYER, L., *Mamluk Costume: A Survey* (Geneva: Albert Kundig, 1952)

MEINECKE, M., *Die mamlukische Architektur in Ägypten und Syrien*, 2 vols (Gluckstadt: J.J.Augustin, 1992)

MEISAMI, J.S., *Medieval Persian Court Poetry* (Princeton: Princeton University Press, 1987)

MELIKIAN-CHIRVANI, A.S., *Islamic Metalwork from the Iranian World: 8th to 18th Centuries* (London: Victoria and Albert Museum, 1982)

— "Le Livre des rois: miroir du destin," *Studia Iranica*, XVII (1988), pp. 7–46

MEZ, A., *Die Renaissance des Islams* (Heidelberg: C. Winter, 1922; trans. by S. Khuda-Burksh and D.S. Margoliouth as *The Renaissance of Islam* (London: Luzac and Co., 1937)

MINORSKY, V., *Calligraphers and Painters: A Treatise by Qadi*

Ahmad, Son of Mir Munshi (Washington: Smithsonian Institution, 1959)

MITCHELL, G. (ed.), *Architecture of the Islamic World* (London: Thames and Hudson, 1978)

MORABIA, A., "Recherches sur quelques noms de couleurs en Arabe classique," *Studia Islamica,* XXI (1964), pp. 61–69

MORGAN, D., *Medieval Persia 1040–1797* (London and New York: Longman, 1988)

NECIPOGLU, G., *Architecture, Ceremonial and Power: The Topkapi Palace in the Fifteenth and Sixteenth Centuries* (New York and Cambridge, MA: MIT Press, 1991)

NORTHEDGE, A., "Planning Samarra: A Report for 1983–4," *Iraq,* XLVII (1985), pp. 109–28

PEDERSEN, J.,*The Arabic Book* (trans. by G. French; Princeton: Princeton University Press, 1984)

PELLAT, C., *The Life and Works of Jahiz* (trans. by D. M. Hawke; London: Routledge and Kegan Paul, 1969)

PETSOPOULOS, Y. (ed.), *Tulips, Arabesques and Turbans* (London: Alexandria Press, 1982)

PORTER, V., *Islamic Tiles* (London: British Museum Publications, 1995)

RABY, J., "Court and Export: Part I, Market Demands in Ottoman Carpets 1450–1550," *Oriental Carpet and Textile Society,* II (1986), pp. 29–38

— "Court and Export: Part II, The Usak Carpets," *Ibid,* pp. 177–88

RICHARDS, D.S. (ed.), *Islam and the Trade of Asia* (Oxford: Bruno Cassirer, 1970)

ROBINSON, B., *Persian Painting in the India Office Library: A Descriptive Catalogue* (London: Sotheby Parke Bernet, 1976)

— *Persian Painting in the John Rylands Library* (London: Sotheby Parke Bernet, 1980)

ROBINSON, F., *Atlas of the Islamic World since 1500* (Oxford: Phaidon, 1982)

RODLEY, L., *Byzantine Art and Architecture: An Introduction* (Cambridge: Cambridge University Press, 1994)

ROGERS, J.M., *Empire of the Sultans: Ottoman Art from the Collection of Nasser D. Khalili* (London: Nur Foundation in association with Azimuth, 1996)

— "Evidence for Mamluk-Mongol Relations, 1260–1360," *Colloque internationale sur l'histoire du Caire* (Grafenheinichen: Gottfried Wilhelm Leibniz, 1972), pp. 385–404

— *Islamic Art and Design: 1500–1700* (London, British Museum Publications, 1976)

— *The Spread of Islam* (Oxford: Phaidon, 1976)

— "The State and the Arts in Ottoman Turkey: The Stones of Suleymaniye," *International Journal of Middle Eastern Studies,* XIV (1982), pp. 71–86, 282–313

— and WARD, J.M., *Suleyman the Magnificent* (exh. cat.; London: British Museum Publications, 1988)

ROSENTHAL, F., *The Classical Heritage in Islam* (London: Routledge and Kegan Paul, 1975)

SABRA, A.I., *The Optics of Ibn al-Haytham* (London: Studies of the Warburg Institute, 1989)

SAFADI, Y.H., *Islamic Calligraphy* (Boulder: Shambhala, 1979)

SAFWAT, N., *Art of the Pen: Calligraphy of 14th to 20th Centuries* (Oxford: Oxford University Press, 1995)

SAVORY, R., *Iran under the Safavids* (Cambridge: Cambridge University Press, 1980)

SCHIMMEL, A., *As Through a Veil: Mystical Poetry in Iran* (New York: Columbia University Press, 1982)

— *Calligraphy and Islamic Culture* (New York: New York University Press, 1990)

— *Islamic Calligraphy* (Leiden: Brill, 1970)

— *Mystical Dimensions of Islam* (Chapel Hill: University of North Carolina Press, 1975)

SERJEANT, R.B., *Islamic Textiles: Material for a History up to the Mongol Conquest* (Beirut: Librairie du Liban, 1972)

SHATZMILLER, M., *Labour in the Islamic World* (Leiden: Brill, 1994)

SOUCEK, P. (ed.), *Content and Context of the Visual Arts in the Islamic World* (Pennsylvania University Park: Pennsylvania University Press, 1988)

SOUDAVAR, A., *Art of the Persian Courts: Selections from the Art and History Trust Collection* (New York: Rizzoli, 1992)

SOURDEL, D., and SOURDEL, J., *La Civilisation de l'Islam classique* (Paris: Arthaud, 1968)

SOURDEL-THOUMINE, J., and SPULER, B., *Die Kunst des Islam* (Berlin: Propylaen Verlag, 1973)

SOUSTIEL, J., *La Ceramique islamique: Le guide du connaisseur* (Fribourg: Office du Livre, 1985)

STEENSGAARD, N., *The Asian Trade Revolution of the Seventeenth Century* (Chicago: University of Chicago Press, 1975)

SWEETMAN, J., *The Oriental Obsession: Islamic Inspiration in British and American Art and Architecture 1500–1920* (Cambridge: Cambridge University Press, 1987)

THACKSTON, W., *A Century of Princes: Sources in Timurid History and Art* (Cambridge, MA: Aga Khan Program for Islamic Architecture, 1989)

AL-THALIBI, *The Latai'f al-Ma'arif of al-Tha'alibi* (ed. C.E. Bosworth; Edinburgh: Edinburgh University Press, 1968)

THOMPSON, J., *Carpet Magic* (London: Barbican Art Gallery, 1983)

WARD, R., *Islamic Metalwork* (London: British Museum Publications, 1993)

WATSON, O., *Persian Lustre Ware* (London: Faber and Faber, 1985)

WELCH, A., *Artists for the Shah* (New Haven and London: Yale, 1976)

WELCH, S.C., *A King's Book of Kings* (New York: Metropolitan Museum of Art, 1972)

— *Royal Persian Painting* (London: Thames and Hudson, 1976)

— *Wonders of the Age: Masterpieces of Early Safavid Painting, 1501–1576* (exh. cat.; Philadelphia: Fogg Art Museum, 1979)

WILBER, D., "The Timurid Court: Life in Gardens and Tents," *Iran,* XVII (1979), pp. 127–33

WULFF, H.E., *The Traditional Crafts of Persia* (Cambridge, MA: The MIT Press, 1966)

Picture Credits

Index